Inside Out: New Chinese Art

CURATORIAL
PRACTICE
ARCHIVE 2004

Inside Out

New Chinese Art

Edited by

GAO MINGLU

with essays by

NORMAN BRYSON

CHANG TSONG-ZUNG

DAVID CLARKE

GAO MINGLU

HOU HANRU

LEO OU-FAN LEE

VICTORIA Y. LU

WU HUNG

SAN FRANCISCO MUSEUM OF MODERN ART AND ASIA SOCIETY GALLERIES, NEW YORK

UNIVERSITY OF CALIFORNIA PRESS BERKELEY LOS ANGELES LONDON

This catalogue is jointly published by the San Francisco Museum of Modern Art, the Asia Society Galleries, and the University of California Press on the occasion of the exhibition *Inside Out: New Chinese Art,* organized by the Asia Society Galleries, New York, and the San Francisco Museum of Modern Art.

EXHIBITION DATES
Asia Society Galleries, New York, and P.S. 1 Contemporary Art Center, Long Island City, New York, September 15, 1998–January 3, 1999

San Francisco Museum of Modern Art and the Asian Art Museum of San Francisco, February 26–June 1, 1999

Museo de Arte Contemporáneo, Monterrey, Mexico, July 9–October 10, 1999

Tacoma Art Museum and the Henry Art Gallery, Seattle, November 18, 1999–March 7, 2000

Beginning in spring 2000, the exhibition will be presented in several museums in major Asian cities.

The *Inside Out: New Chinese Art* exhibition and related programs are funded with major grants from The Starr Foundation, the National Endowment for the Arts, The Rockefeller Foundation, The W. L. S. Spencer Foundation, and the Andy Warhol Foundation for the Visual Arts. The Taiwan portion of this project is supported in part by the Council for Cultural Affairs, Taiwan, ROC.

The New York presentation of *Inside Out: New Chinese Art* is also supported, in part, with public funds from the New York City Department of Cultural Affairs Cultural Challenge Initiative, E. Rhodes and Leona B. Carpenter Foundation, and the Annie Wong Art Foundation.

The San Francisco presentation at SFMOMA has been made possible by The Logan Family Foundation and Dennis and Shannon Wong. Additional support for related education programs at SFMOMA has been provided by a grant from the National Endowment for the Arts.

University of California Press
Berkeley and Los Angeles

University of California Press, Ltd.
London, England

NOTE TO THE READER
The preferred name order of each author and of each artist in the exhibition has been respected, and other names are given in their preferred forms, when known. In the plate captions, list of works in the exhibition, and biographical information, family names are shown in italics, as in **Lin Tian-miao** and **Shu-Min *Lin,*** in both of which *Lin* is the family name.

Two systems for transliterating Chinese words (other than names) into the roman alphabet are in common use. In the essays, the preferences of different regions and writers have been observed. In the documentation, the *pinyin* system has been used for most Chinese words.

LIBRARY OF CONGRESS
CATALOGING-IN-PUBLICATION DATA

Inside out: new Chinese art/edited by Gao Minglu; with essays by Norman Bryson. . . [et al.].
 p. cm.
Published on the occasion of an exhibition held at the Asia Society Galleries, New York, Sept. 15, 1998–Jan. 3, 1999, and the San Francisco Museum of Modern Art, Feb. 26–June 1, 1999.
Includes bibliographical references and index.
ISBN 0-520-21747-0 (hardcover)
ISBN 0-520-21748-9 (softcover)
1. Art, Chinese—20th century—Exhibitions.
I. Kao, Ming-lu II. Bryson, Norman, 1949-.
III. Asia Society Galleries. IV. San Francisco Museum of Modern Art.
N7345.I58 1998
709'.51'07479461—dc21 98-21532
 CIP

Publication Managers: Kara Kirk and Susan Chun
Editor: Joseph N. Newland
Designers: Catherine Mills and David Betz
Publication Assistant: Alexandra Chappell
Indexer: Susan Stone
Printed in Hong Kong

Cover: Zhang Huan, *To Raise the Water Level in a Fishpond,* performance at Nanmofang fishpond, Beijing, August 15, 1997, photograph by Robyn Beck.

Photography Credits: Illustrations have been provided by the artist or by the owner of the work.

10 9 8 7 6 5 4 3 2 1

As we approach the dawn of the new millennium, there is an undeniable recognition that China, and indeed the entire "Chinese world," has once again become a global player. We hear about economic and political developments in the region almost daily. What is less known is the incredible innovation and dynamic diversity of its cultural expressions. Artists in urban centers in China, Taiwan, and Hong Kong (now a Special Administrative Region of China) are expanding an artistic vocabulary that reflects the dynamic relationship between their multifaceted and long-standing connections to western forms and norms as well as ties to deeply embedded cultural identities and traditions. Their work challenges our traditional perceptions about Asian art and transforms the very definition of contemporary art in an international setting.

Inside Out: New Chinese Art introduces North American viewers to the dynamic new art being produced by artists in China, Taiwan, Hong Kong, and by Chinese artists who have emigrated since the late 1980s. It was with the recognition that contemporary Chinese art has emerged as an important part of the global cultural landscape that our two institutions—the the Asia Society and the San Francisco Museum of Modern Art—decided to jointly organize this major exhibition. Our partnership is crucial to articulating the organizing principle of the show: to understand contemporary Chinese art as simultaneously belonging to the international art community as well as the new "Chinese" culture. SFMOMA, as an internationally recognized institution of modern and contemporary art, can now add contemporary Chinese art to its program of exhibitions and collections, while the Asia Society, with its focus on creating better understanding of Asian cultures past and present, can illuminate the culturally specific nuances of new Chinese art. Indeed, our complementary strengths have been vital to the success of the project and to our ambition of breaking down the barriers between audiences for "contemporary" and "Asian" art.

We have been fortunate to find in Gao Minglu a guest curator whose grasp of contemporary Chinese art is as strong as our commitment to present it. Gao has been intimately involved with contemporary Chinese art, as a scholar and supporter, almost since its reawakening after the repression of the Cultural Revolution. An editor of the prestigious journal *Meishu* (Art Monthly) from 1985 to 1989 and principal author of the standard monograph

on the Chinese avant-garde of the mid-1980s, Gao made the proposal and was chair of the committee that organized the important exhibition of avant-garde art staged at the National Gallery in Beijing in February 1989, just months before the Tiananmen Incident. Although Gao left China and settled in the United States in 1991, his upbringing and experiences in the People's Republic of China inevitably influence his vision of Chinese art. But just as Chinese artists working abroad have become cultural nomads, embracing and exploring themes that arise from interaction with new environments, so has Gao's exposure to the full range of art produced by Chinese artists working worldwide stimulated his approach to this exhibition. Specifically, his exploration of two crucial issues, Chinese modernity and identity—the overarching themes of the exhibition—is a direct result of his awareness of transnational realities. Thus, the title of this exhibition, *Inside Out*, evokes not merely the diaspora and the relocation of individual artists but also the sense of a continuous interpretation of ideas between regions and individuals, of ideas not only traveling outward but also being internalized and of spaces themselves being transformed.

Just as the political and cultural circumstances of each region differ, so the artists' responses have been diverse. Cloistered from the outside world until 1979, artists in the People's Republic were suddenly exposed to the whole gamut of western art, from Renaissance painting to contemporary performance art. By 1985 a definable avant-garde had emerged and moved rapidly from direct political statement through ironic social commentary to a more personal expression, all the while adopting and adapting various media in a surge of creativity and experimentation.

Taiwan artists have been familiar with western contemporary art since at least the 1960s, and have generally eschewed overt political commentary. But, like their counterparts on the Mainland, they have imbued their works with locally specific references that reflect their quest for cultural identity. Likewise, Hong Kong artists have been galvanized by their new political status to examine their relationship with their erstwhile neighbor. Though some of the Taiwanese artists have chosen to return home after spending time in the West, a number of artists from China and Taiwan have left the region since the late 1980s and now are active in the United States or Europe. This mobility, as well as ready access to global art developments, evidences the fact that no matter where they are located, artists are responding to both their own heritage and to increasingly postnational audiences.

As the principal curator for *Inside Out*, Gao Minglu has been ably aided by Gary Garrels of the San Francisco Museum of Modern Art, and Caron Smith and Colin Mackenzie, former and current curators at the Asia Society Galleries. An international curatorial advisory committee assisted in the development of

the object list as well as in the final shape of the catalogue, and we would like to offer our personal thanks to David Clarke, Chang Tsong-zung, and Victoria Y. Lu for their guidance in this endeavor. We are especially grateful to the numerous individuals at both institutions who have worked extremely hard on all details of the exhibition and related programs. They are acknowledged elsewhere in this publication. A special thanks goes to President Nicholas Platt and Executive Vice President Marshall M. Bouton of the Asia Society for helping us think through the institutional strategy for the exhibition. John R. Lane, former director of SFMOMA, was an enthusiastic supporter from the beginning. We also thank Dr. Yu Yuh-chao and Ms. Luchia Lee of the Taipei Economic and Cultural Office in New York for their valuable advice concerning the Taiwan component of the exhibition and programs.

Many of the artworks in the exhibition were lent by the artists themselves or by private collectors who wish to remain anonymous, and we thank them for their generosity. In addition, we would like to express our gratitude to the following lenders for graciously sharing their works with us: Art Gallery of New South Wales, Sydney; Francesca dal Lago; Fukuoka Asian Art Museum; Hanart T Z Gallery, Hong Kong; Kent and Vicki Logan; Ludwig Museum, Cologne; Max Protetch Gallery; Cyrille Putman; Tapei Fine Arts Museum; Wen Pulin; and Zhen Guo.

In both New York and San Francisco, our institutions have been fortunate to find excellent partner venues. In New York, P.S. 1, Contemporary Art Center has proved to be the ideal counterpart to the Asia Society (two institutions with more different backgrounds could hardly be imagined). Without the involvement of P.S. 1, it would not have been possible to bring such an expansive collection of works to New York. In San Francisco, the nature of the partnership is preserved but the process is reversed: it was the Asian Art Museum of San Francisco, with its important collection of "traditional" Asian art, that responded with enthusiasm to the approach from SFMOMA. We extend therefore a special thanks to our local partner venues and to their respective directors, Alanna Heiss and Emily Sano.

We are also gratified by the exceptional degree of interest expressed by other potential venues. After opening in New York, *Inside Out* will travel to San Francisco and then to MARCO (Museo de Arte Contemporáneo), Monterrey, Mexico, and to the Tacoma Art Museum and the Henry Art Gallery, Seattle. The exhibition will also be seen in Japan and Hong Kong. A survey of contemporary Chinese art broader than those presented before will thus be seen in a wide range of international venues.

One of the exciting features of this project is its potential for breaking the traditional barriers between visual and performing arts through rich and multidisciplinary programming. Indeed, in New York, there has been a major initiative to commission new pieces of performing art and situate them

alongside the work of avant-garde performance artists. This interdisciplinary approach, we believe, will enhance understanding of contemporary Chinese cultures in diverse regions of the world.

Such a complex and expensive project could not have been realized without financial support from many sources. Our very special thanks go to The Starr Foundation, the National Endowment for the Arts, and The W. L. S. Spencer Foundation for major funding of the project. The Taiwan portion has been generously supported by the Council for Cultural Affairs, Taiwan, ROC.

Inside Out: New Chinese Art questions traditional assumptions about "Asian" art while expanding the horizons of "contemporary" art. We realize, of course, that such a trailblazing attempt to present the exhilarating and at times challenging art forms of Asia could never provide a comprehensive view. Rather, the exhibition is part of a long-term strategy of our respective institutions to redress the current lack of knowledge about the subject, and to suggest new methodologies for the study of Asian art in the next millennium.

Vishakha N. Desai
Vice President for
Cultural Programs,
Director of the Galleries
Asia Society

David A. Ross
Director
San Francisco
Museum of Modern Art

Ten years ago it would have been unimaginable for a curator of contemporary art in the West and a sinologist whose field is early China to be jointly involved in an exhibition of Chinese art of the past decade. That our voices are engaged in such a dialogue is a testimony to the speed with which notions both of what constitutes contemporary art and Chinese art are changing.

Spanning about fifteen years—the earliest works date from 1984, the latest commissions from 1998—this exhibition is a testimony to the remarkable diversity of forms and media embraced by Chinese artists and to the speed of change and development in contemporary Chinese art. The factors behind this phenomenon are explored in detail in the catalogue essays, but they can be summarized as regional diversity and individual artists' responses to fast-paced political, economic, and social transformations. It is perhaps in the People's Republic of China (PRC) that the greatest variety is encountered, and this stems both from its huge geographic scope (although the majority of artists in the exhibition work in Beijing or Shanghai, some come from as far afield as Lanzhou in the northwest, Yunnan in the southwest, and Fujian and Guangzhou on the south coast) and from the relatively sudden easing of restrictions after the political repression of the sixties and seventies.

The rapid turnover of styles among PRC artists is a reflection of their sudden exposure to the whole history of western art. From 1949 to about 1979, artists were restricted to a very limited range of choices: oil paintings in the socialist realist mode, folk and popular art forms, or traditional brush painting (although during the Cultural Revolution practice of the last named was frowned upon). From 1979 foreign art began gradually to be published in magazines such as *Meishu* (Fine Art) alongside more ideologically correct styles. All western art was thus new to the younger generation—be it Botticelli or Picasso, Dürer or Duchamp, or the artists of our time, from Rauschenberg and Warhol to the most current developments in Europe and America. Coupled with this sense of revelation was the age-old Chinese predilection for finding inspiration in the styles of other artists. For PRC artists of the eighties, the languages of Impressionism, Surrealism, Pop Art, and more conceptual practices stemming from the 1960s and 1970s were legitimate modes of expression.

The question of artistic appropriation (not one that has ever seriously troubled Chinese artists) is one that has to be addressed by western historians and critics of art. Are these works any more than pastiches of modes worked out, and sometimes long since discarded, in the West? The answer surely is yes. In virtually every mode or medium borrowed from the West something new has been added, some new twist given. To be sure, there are often references to their western sources, but even for viewers unfamiliar with Chinese culture, it is clear that these adopted languages are not merely being imbued with new meanings, but are often themselves being transformed into fusions of influences from both the West and Asia.

The complex responses of the artists to political and social changes are discussed in detail in Gao Minglu's essays. Here, it is sufficient to emphasize that the "Chineseness" of these works varies enormously from artist to artist, movement to movement, and even from work to work. For artists from the PRC, essentially, one can identify a number of expressions of tradition. If, as Chang Tsong-zung points out in his essay, many younger artists are deracinated from their pre-1949 cultural roots, then tradition for them is the post-1949 period. Their attitudes to that period are surprisingly mixed. Mao is, of course, an iconic image for many, but others seem more interested in commenting on contemporary society than in looking back to the era of the Cultural Revolution or before. The distinctiveness of their art lies in their individual understanding of the changes affecting their society. Wang Jin's *Ice: Central China 1996,* for instance, is a brilliant play on the seductiveness of consumerism, and Cao Yong's paintings reflect an increasingly uneasy awareness of the environmental destruction and social alienation underlying materialist triumph. Fang Lijun and Liu Wei in their paintings also convey a disconnectedness from values and community which anchored individuals in either traditional society or the era of Mao.

The different road taken by Taiwanese artists is also the outcome of the particular circumstances of their island. Although Taiwan was under martial rule until 1987, there was never the same authoritarian regulation of art as on the Mainland. Artists could and did travel abroad, bringing back and adapting western styles. The history of western oil painting was thus always familiar to Taiwan artists and was not seen as something new. Nor, moreover, had there been the wholesale co-opting of artists in the propaganda industry as in the PRC, no tradition of socialist realism. It is not surprising therefore that no exact parallel to the "humanist" and "Political Pop" trends of the PRC appeared in Taiwan, a capitalist society before it was a democratic one. Instead, Taiwan artists such as Fang Weiwen and Chen Hui-chiao adopt the language of Minimalism, but imbue it with quietist contemplative philosophy drawn from Daoist roots. Others, such as Wang Jun Jieh, seem to revel in the artificiality, the precision and sanitized quality of modern materials. Artists such as Hou Chun-ming and Huang Chih-yang stand

antithetical to them, concerned more with private emotions, taboos, fears, and fantasies, and draw on native Taiwanese folk traditions.

The Hong Kong artists selected here, on the other hand, make only limited reference to precontemporary art. Their concern is with identity and belonging, issues which in the context of Hong Kong's return to China and the end of colonialism have been thrown into stark relief. Reflecting the urgent sense of transition, contemporary art in Hong Kong has shown new force and inventiveness, particularly within the last two to three years, a fact reflected in the choices of artists in the exhibition. The works of Kum Chi-Keung and Ho Siu-kee, as examples, provide metaphors for the difficulty of passage as both a spiritual and a physical condition.

If the above sketch implies that there is no single archetypal quality of "Chineseness," this merely reflects the diversity of traditional Chinese culture, often deliberately downplayed in official accounts. There are, nevertheless, certain transnational themes that crop up in the works of artists both in China and Taiwan, and abroad. Whereas in Hong Kong the question of identity seems to be directed at the future more than the past, in Taiwan and to a certain extent in the PRC it evokes a nostalgia towards the past. While in Taiwan memories of the family loom large (see, for instance, Chen Shun-chu's *Family Parade,* pl. 59), in the PRC the Cultural Revolution is sometimes, surprisingly, evoked nostalgically.

One of the pervasive themes is the interest in exploring the forms and meaning of script. It is no coincidence that it is script, rather than religious images, which in other parts of Asia still exert a strong influence on artists, that constitutes the most enduring aspect of tradition and one in which artists continue to find inspiration (although artists in Taiwan exhibit a stronger interest in religion than those in the other regions). Control of the script was an imperial concern as early as the Qin dynasty (221–206 BCE), when heterodox versions were deemed a threat that required elimination. The obsession with pseudo-characters (graphs that look at first glance like real Chinese characters, but which on closer inspection turn out to be meaningless patterns invented by the artist) is common to artists from the PRC, Taiwan, and overseas. It is tempting to see the creation of these pseudo-characters as a deliberate attempt to subvert the most powerful tool of state ideology, but, if so, it does not seem to have attracted official opprobrium. The work of Wenda Gu and Xu Bing, at least, can be read on another level; the predilection for distorting and dissolving images so that they lie on the border of meaningless pattern is a hallowed tradition in Chinese art, stretching back through the spatial and semiotic ambiguities of scholar painting to roots in the tantalizing patterns of archaic bronzes.

It is interesting that some of the artists who deconstruct script now work outside China and consider themselves primarily as contemporary rather than Chinese artists. Others, such as Cai Guo-qiang, still draw on

Chinese themes but explore them through the distanced perspectives of expatriates catering to an audience that is more often non-Chinese. Exhibiting worldwide, yet frequently visiting China, these artists demonstrate through their work that the globalization of contemporary Chinese art has not resulted in homogenization but rather in increasing diversity and richness.

As advisory curators for the exhibition, we were faced with new and unknown artists and cultural contexts. Comfortable and safe assumptions and certainties drawn from our specialized fields of knowledge were thrown open to critical reconsideration. We suspect this process will be similarly experienced by much of the public for this exhibition. It is the very hybridity of many of the works in this exhibition that lends them their strength and freshness. They fit neither into traditional notions of "Chineseness" nor into the comfortable assumptions about what constitutes "contemporary art," and thereby force us to question definitions of both.

Gary Garrels Colin Mackenzie
Flise S. Haas Chief Curator *Curator and Assistant Director*
and Curator of Painting and Sculpture *of the Galleries*
San Francisco Museum of Modern Art Asia Society

> **Toward a Transnational Modernity:**
>
> An Overview of *Inside Out: New Chinese Art*

GAO MINGLU

Inside Out: New Chinese Art strives to present a survey of contemporary art from the Chinese societies of Mainland China, Taiwan, Hong Kong, and the overseas Chinese artist community that retains or respects its original content and milieu insofar as possible in the very different cultural and social context of the western museum space. The paradox of trying to present the art's originality on its own terms in such a different setting may best be indicated by the title *Inside Out*.

The primary goal of this exhibition is to enrich the western audience's understanding of contemporary art from the selected Chinese regions, both visually and conceptually. As a guest curator originally from China, my key concern during the two-year curatorial process has been to integrate the visual presentation of the artworks and a theoretical interpretation of the context within which "contemporary Chinese art" makes sense. Also, since there are significant historical, political, and regional differences between the four different societies represented, configuring an integrated but non-hegemonic structure was a challenge.

The exhibition has been constructed around the central issues of modernity and identity. At this moment it is crucial to discuss these issues in global terms, in relation to a transnational modernity, against the background of which we see the issue of identity in contemporary art practice in different Chinese regions in terms of local context and relationships inside and out. Transnational modernity and transitional identities have produced the dynamic visuality that this exhibition presents.

From a Chinese Modernity to Global Modernization
Although the nature of modernity and cultural identity has been debated within Chinese societies for nearly a century, it now has become a pressing issue in the post–Cold War world, as has been indicated by Samuel P. Huntington.[1] As some of the fastest changing areas of the world both economically and politically at the end of the twentieth century, Chinese societies have suddenly gained world attention because the issues of Chinese modernization and cultural identity have come to be seen as vital to a post–Cold War world order.

Some scholars have argued that Chinese art has been westernized since the seventeenth century, when China's painters came to accept western ideas regarding representation.[2] Around the same time a patron system emerged in south China, a sign of the beginning of a modern commercial art market.[3] Some might even argue that as early as the sixteenth century Chinese artists began to concern themselves with issues of modernity, as occured in the West.[4] I would argue, however, that in both the broader culture and in art a consciousness of modernity and the pursuit of a new, modernized nation with a concomitant anti-tradition did not emerge in China until the late nineteenth century. At the turn of the twentieth century, under continuous pressure from modern western military, economic, and cultural forces, Chinese intellectuals and artists began an art revolution by taking various western modern art forms as models to revive their weakened tradition, which was perceived as backward. This project of self-salvation, called the New Cultural Enlightenment Movement, reached a peak in 1919 in the May Fourth Movement, the first intellectual movement in modern Chinese history to establish a mainstream intellectual discourse directed against tradition and toward national salvation, democracy, and science—a project of Chinese modernity. Almost all of the influential philosophers, thinkers, and scientists active in the New Cultural Movement were engaged in the early 1920s in the intense Greater Debate between Science and Mysteries Study (*Kexuan da lunzhan*).[5] This framed what I call a self-defined modernity, driven by an aspiration for national strength and confined to specific and local social, cultural, and economic contexts, and which has influenced Chinese intellectuals and artists for most of this century. The practice and theoretical concerns of this modernity were rooted in a desire for internal strengthening in reaction to the impact of western forces. Chinese modernity could be labeled a defensive modernity, and it has been inextricably bound up with the articulation of a national identity and subjectivity. It did not seek a global role or interaction in a larger modern world.

The Anti-Japanese War and subsequent civil war halted this elitist modern art project, and it was reoriented on the Mainland by Mao toward a state-masses ideological art with a more radical tone of nationalism based on an iconoclastic philosophy that was both anti-traditional and anti-western. (Different historical circumstances prevailed in Taiwan and Hong Kong, as will be outlined below.) After Mao died and the Cultural Revolution ended in the late 1970s, a new artistic generation in the eighties embraced western modern art again and renewed the project of a self-focused modernity begun some sixty years earlier. The cultural debate climaxed on the Mainland around the mid-eighties, and with such trends as Searching for Cultural Roots (*Wenhua xungen*), Cultural Reflection (*Wenhua fansi*), and Culture Fever (*Wenhuare*), avant-garde art and literature movements with a more radical tone of social and cultural criticism emerged. Although the new art of

GAO MINGLU

the '85 Movement, so called, encompassed forms of almost every western modern movement from Dada to Pop, the art practice using various western-originated forms was self-oriented and not involved with the western mainstream for either direct input or evaluation; it was an internal dialogue answering only to its own social and cultural demands.

A Chinese modernity systematic in both ideological and economic terms, and possessing a significant connection between the Chinese and western art worlds, did not really come about until the late 1980s. It has only been since the basis of society has been altered by the emerging transnational economic system that any real interplay or clash of the East (or China) and the West has become possible. The Chinese consciousness of modernity has only recently begun to be transformed from a self-focused to an interactive one.

Chinese contemporary art was brought into the international arena by the end of the Cold War and the ensuing economic globalization. Western institutions and art markets discovered contemporary Chinese art and culture, and now, the Chinese in all three of our regions and abroad can identify themselves in the mirror of the West's definition of a Chinese modernity. For example, concepts like Neo-Confucianism, Confucian capitalism, industrial East Asia, and Post-Confucianism that first emerged in the West spread in East Asia during the seventies and eighties and began to be discussed in Mainland China after its economic boom of the early nineties. I would argue that the Chinese framing of modernization that prevailed until that time, which posited the confrontation between or combination of pure eastern and pure western cultures, is no longer a major issue for Chinese societies.

The debate over modern and traditional, East and West, occurred in the art of Taiwan and Hong Kong during the 1950s and '60s, when modernist, experimental painting movements appeared in these two regions.[6] Schools of modern ink painting that attempted to establish a modern Chinese art that combined traditional Chinese and modern western art peaked in the sixties and seventies in both Taiwan and Hong Kong. (A similar emergence of abstract modern ink painting took place on the Mainland in the early eighties, after the opening to the West.) The fact that in Taiwan this debate was carried out in purely cultural and utopian terms evidences a continuity with early modern painting movements during the twenties and thirties in Guangzhou, Hangzhou, and Shanghai, movements led by Gao Jianfu (1879–1951), Lin Fengmin (b. 1900), Liu Haisu (1896–1996), and others. In the fifties, most of the artists of the Eastern Painting Group, for instance, were the students of Li Chung-sheng (Li Zhongsheng; 1911–94), a Mainland-born painter who was trained in Shanghai and Japan and taught — along with Lin Fengmin, the academy's director—at the Hangzhou Academy of Fine Art until he went to Taiwan in 1949. Lin has been one of Taiwan's most influential artists and is considered the "father of modern art" there.[7]

In the seventies, Taiwan artists began to shift their attention to rediscovering and reestablishing a native Taiwanese art, in the process abandoning the modernist utopian dream of the fifties. Both the economic miracle that gave the Taiwanese a new confidence and the social changes resulting from the political crisis of losing a seat in the United Nations influenced art, prompting investigations of indigenous culture and redefining a modern subjectivity. In the eighties, due to an institutional growth pattern called the "museum age" and the return of a number of Taiwanese art students trained overseas, contemporary art showed a mature Taiwanese face, combining various traditional and western sources and, since the early nineties, becoming known in the international art arena.

Since the 1960s, Hong Kong has developed as a global economic center rather than the hub of or part of a nation. Hong Kong is instead a city/region with a peculiar international character and sited in a kind of spectacle that is "forever-present." Rather than identifying with a traditional or a native cultural past—as do people in Mainland China and Taiwan—Hong Kong people identify themselves with what might be described as a sort of mutational trans-metropolitanese that has been characterized by an unconsciousness of decentralization. Perhaps it was only when Hong Kong people watched on TV the ceremony of the colony's handover back to China and the institution of "one country, two systems" that they suddenly became aware of having a history and a "national identity" distinct from any other in the world. It was the coming of this transition that awakened contemporary Hong Kong artists to examine their unconscious past and unpredictable future, as presented in *Inside Out*.

In short, it has been forces active in the current global modernization and a concomitant consciousness of location, boundary, and relationships based primarily on economic factors that have brought to an end the heretofore self-focused and self-defined Chinese modernity and pushed Chinese intellectuals and artists toward a transnational modernity.

Modernization: Subjectivity and Identity

In our age the notion of modernity has lost its original meaning of the consciousness of a new temporal epoch and a new humanity within the social framework of what Max Weber called western rationalization.[8] This core of modernity that was the basis for the theory of western modernist and avant-garde—and postmodern—art was transformed in the 1950s into "modernization."[9] Modernization became the imagination of an advanced society in a space between the present and the future, the local and the international, the I and the Other. In different geographical areas, modernization produces a consciousness of subjectivity fixed to different social models.

The consciousness of what modernity is, especially for the people of nonwestern regions, has also changed since the beginning of these peoples'

modern history. For China, the crux has not been a consciousness of time but of one individual subjectivity within a strong sense of nationalism. Only after traditional servility (*nuxing*) was challenged could a new, powerful modern Chinese society come into being, and only then could a modern anti-tradition arise. This contradiction between self-salvation and anti-tradition caused an ambivalence central to the nature of Chinese modernity.

For the Chinese *modern* has meant a new nation rather than a new epoch.[10] Thus Chinese modernity is a consciousness of both transcendent time and reconstructed space with a clear national cultural and political territorial boundary.[11] National identity, however, has meant different things in the different Chinese societies and their art. In Mainland China in the 1980s, artists responding to a monolithic state ideology searched out a free subjectivity and presented an iconoclastic ideological utopia. This changed in the nineties to a project of anti- or non-ideology and dematerialization. This transition may be seen clearly in the contrast between the '85 Movement (sometimes called the '85 New Wave) and the Political Pop, Cynicism, and Apartment Art of the nineties.

Whereas the central concerns of Taiwanese art in the fifties and sixties were tradition versus modernity and western versus eastern, nativism subsequently became the primary issue. The Nativist movement of the seventies was the first Taiwanese turn to local culture,[12] and since the late eighties many artists have been exploring native religion, local culture, and folk art in conjunction with Chinese traditional and western elements, but in a way that subverts both.[13] Nativism may be different from nationalism; its meaning is perhaps more like that of tribalism. And, as the Taiwanese scholar Huang Wan-yao has said, the choice between tribalism or nationalism may be a key determinant of the fate of the Taiwanese independence movement.[14]

In contemporary Hong Kong, the issue is one of regional culture. Unlike nationalism and nativism, which seek an identity based on the past, regionalism can avoid the definition of a single historical tradition and be concerned with a spatiotemporal consciousness. This is possible in Hong Kong partly because it did not develop as a city within a nation but as an international financial center. Hong Kong people have identified themselves with something that is transnational, and this has been reflected in art there, especially since the mid-nineties. This is obviously a reaction to the end of the colonial period and reunification. Works by Hong Kong artists in this exhibition present this transitional moment in their concern with the issue of identity.

Chinese artists overseas may play the most important role in confronting and communicating with an international cultural mainstream. Rather than being part of a "diaspora," the identity and visual world of recent émigrés may be shaped by, and may be shaping, a "third space" that truly is between East and West.

Thus the visuality of each Chinese region reflects its own context of identity: nationalism in the Mainland, nativism in Taiwan, regionalism in Hong Kong, and the third space for Chinese overseas.

From a State-Elitist to a Transnational-Masses Society:
Individuality in Mainland China

The Cultural Revolution, a period when selfless devotion to Mao Zedong and his ideology dominated art and life in the People's Republic of China, ended when Mao died in 1976. A new era of political, cultural, and economic change began in late 1978 when leaders including Deng Xiaoping initiated reform programs that increased openness to the West. Since then a nationwide long march of economic reform and social transition has been carried out in the development of a "socialism with Chinese characteristics."

Chinese intellectuals and artists have had to constantly adjust their social position, seeking a free subjectivity in a struggle for spiritual liberty, nationalism, and individuality. The Chinese avant-garde art movement that flourished from 1985 to 1989 was very much a product of its period. It emerged from the intellectual engagements of the mid-eighties after the opening to foreign ideas and suffered as those concerns were suppressed or transformed by subsequent events. The culture then consisted of three different spheres: official culture, elite culture, and public culture. Avant-garde art was a product of the second. The elite were not defined economically but by intellectual influence, and the social and cultural weight of intellectuals grew during the mid-eighties, as the government encouraged them to contribute to society. Cultural activity in all areas—from universities to newspapers to television networks—increased. Many intellectuals felt a strong responsibility to the public and believed that official and public culture could be enlightened through their efforts. They promoted ideas in the mass media that generally were not those of the official political propagandists but were their own, and intellectuals saw themselves as something of modernist and enlightenment philosophers in their own historical context. The influence of elite culture was best exemplified by the production of television scripts like *River Elegy,* with its revisionist historical ideas, for public television. By this means, elite culture strongly influenced the public sphere, and was generally treated with deference by officialdom.

In the eighties, artists seeking modernity undertook three major tasks. First, the avant-garde artists saw themselves as cultural pioneers whose task was to enlighten the masses, fight for social reform, and rebel against the past. Second, they criticized the previous state-dominant ideology, which had long suppressed individuality. Third, avant-garde artists made the creation of art part of a cultural enlightenment program rather than a formalist activity, a social activity rather than the representation of an illusory reality.

This total avant-garde of the 1980s adopted a rhetoric similar to that

of the May Fourth Movement of 1919. Based on its goal of enlightenment, artists of the '85 Movement (*Bawu meishu yundong*) claimed that art has nothing to do with technique or style but should directly express ideas.[15] For example, the manifesto of the influential North Art Group said, "Our painting is not art anymore but a part of our complete new thought."[16] The movement's major tendency of humanism included two important groups: Rationalist painting and Current of Life painting. The Rationalists emphasized a positive and sublime spirit in creating a futuristic utopia in order to purify society (pls. 19, 20). The Current of Life group explored individual myths in abstract images or depictions of a primitive sort of life (pl. 2). Some directly expressed nationalistic themes and a quest for Chinese power. The conceptual artists of the '85 Movement criticized conventional art ideas and dominant art institutions. Using media such as language and readymades, they questioned art's old ideological subject matter as well as the new utopian subjectivity, devoting themselves to a project of anti-authorship and anti-subjectivity in an attempt to destroy any doctrine of art ideas, objects, or history (pls. 5, 15).[17]

The '85 Movement was not a new school of artists working in their studios, art schools, or universities; it was a broad movement encompassing social activities such as performances, meetings, lectures, conferences, and village-factory visits as well as many self-organized, unofficial exhibitions. Most of the latter took place in the public sphere, deliberately confronting both the public and the powers that be. The most sensational event was the *China/Avant-Garde* exhibition of 1989, which was shut down twice by the authorities.[18]

Since 1989 and the June 4 Tiananmen Incident, however, the government has attacked intellectual culture and the elite has become weak. Moreover, with the increasing emphasis on the immediate economic benefits of any activity, official and public culture now share common economic priorities, relegating the formerly elite intellectuals to a marginal position.

With the failure of the democracy movement and the intellectuals' modernization program of the eighties, and under the unexpected impact of commercialism and mass culture, many artists abandoned the humanist utopianism and hopefulness of the eighties. More neutral or even cynical attitudes gave rise to Political Pop and Cynical Realism, for example. In the early nineties, these forms of painting gained popularity in the international art scene. Soon after, however, the artworks were co-opted as part of international market production. This transformation of antagonistic criticism and spiritual pursuits to Political Pop's discourse of parody and pastiche may be interpreted as a mourning for both Mao's revolutionary utopia and the avant-garde enlightenment movement.

In the nineties, no artist has been able to escape from the commercial waves of the transnational economy. The art world is now dominated by a

concern for commercial success to the extent that most other critical criteria have been discarded. Realist painters have, for various reasons, attained the greatest monetary success. Avant-garde artists have lost their audience. The alternative of accommodating to the new commercialism or working in complete obscurity threatens their very survival as artists. Avant-garde artists, for whom critical recognition, not financial benefit, had been the only reward, now find themselves with no public outlet. A self-defined elite culture and avant-garde shifted their direction toward a new arena—the international system of art institutions and the transnational market. The overproduction of commercial art and mass culture has forced most conceptual artists in one of three directions. The most prolific are now working abroad. Many who have stayed in China isolate themselves from society in self-exile, giving rise to Apartment Art. Others have gone into the public sphere to directly confront society in order to shock the newly materialistic masses.

Contemporary Art in Taiwan: Roots and Transcendence

A consciousness of modernity has been evident in Taiwan since the 1950s, when art movements based on western universalist modernism gave rise to painting groups such as the Fifth Moon Group and the Eastern Painting Group. The "economic miracle" during the late 1970s and early eighties gave the Taiwanese people a tremendous amount of confidence and pride in a modernizing society. The subsequent lifting of martial law in 1987 and the emergence of a legal opposition party provided more freedom to the people. But the issue of an uncertain future regarding the Mainland has affected the society both politically and psychologically. It has given rise to controversy about the identity of Taiwan in terms of geography, culture, tradition, and politics. Never before have Taiwan's artists been so passionately involved in the issue of their identity and its boundaries as they are today. Currently, the search for cultural modernity takes an oppositional orientation, starting from the global modern or postmodern position and looking at native characteristics and local identity.

Since the eighties, the art world in Taiwan has become more pluralistic, with many different approaches to art incorporating numerous forms and ideas. There have been no dominant trends or movements. Various types of modern and postmodern art from abroad have been introduced, producing reproductions or variations of pieces of western origin. We might divide the different current approaches into two major aspects.

Rock 'n' Roll Postmodernism: Made in Taiwan

One tendency encompasses artists whose themes reflect Taiwanese reality; they combine modern urban and local folk cultures, industrial landscapes and agricultural ones, traditional high art and native low art, and the global and the local, all expressed in a Taiwanese postmodern manner. Such artists

GAO MINGLU

do not care about the original form, language, or text. Instead they super-impose, without conscious regard for the "origin," ideas and forms onto native culture and local context in a fluent, comprehensible language. Such strategies as simulation, appropriation, and masquerade were quickly adopted by these Taiwanese artists to transform the typical western con-temporary fashions into local colors. Moreover, traditional Chinese art, such as literati-style painting, has been transformed into a new local-style ink painting that combines high and low sources. This broad tendency can be called "Made in Taiwan," a phrase which brings to mind images of famous western brands produced in factories there.[19] Postmodern strategies have been married to the native folk culture (termed *xisang wenhua*, the tradi-tional form for wedding ceremonies and funerals) and have produced an urban leisure culture with an exaggerated face. Behind the mirage of happi-ness there nevertheless has resided melancholy, anxiety, and disappoint-ment deep in the hearts of the Taiwanese people.

These artists see the issues of native culture, folk art, urban leisure culture, politics, and sexuality as being linked together in a social and cul-tural monolith, and present them in high-key colors, violent images, and with powerful emotions. Their works are just like rock 'n' roll music, as Kao Chianhui, a Taiwanese critic points out.[20] American Pop Art's obvious influ-ence can be seen in paintings by Huang Chin-ho (fig. 35), Wu Tien-chang, and installations by artists such as Wu Mali, who uses mixed media to mirror the kitsch of mass culture and political strategy. But instead of its American fore-runner's positive enjoyment of consumer culture, Taiwanese Pop reveals the madness of urban life behind a happy mask. Wu Mali has presented giant images of toys, which could symbolize a society in which politics, business, and consumption are viewed in playful enjoyment, but may also allude to Taiwan's being like a toy in a larger world. The postmodernist aesthetic inten-tionally expresses a postmodern sociopolitical attitude. The painter Huang Chin-ho has said: "I seek to make an overall assessment of Taiwan's cultural tradition in order to open up new frontiers for the country's new aesthetics, which are distinct from those of China and the western world. . . . My can-vases strongly condemn the degeneration of the country's living environ-ment and the corruption of the people's spirits by the colonial rule that has afflicted Taiwan for centuries."[21]

"Chaotic" compositions are characteristic of Made in Taiwan artworks by Huang Chin-ho, Wu Tien-chang, Hou Chun-ming, Guo Zhenchang, and Yang Mao-lin, among others. Elements of fragmentation and deliberate chaos could be interpreted as a resistance to a totalizing authority. In Taiwan's political circumstances, searching for cultural modernity and iden-tity can take this oppositional orientation emphasizing the local in an anti-modern, anti-industrial/rationalized visuality. Modernity as such may be a symbol of power, authority, order, and totality, which the artists oppose.

Using only the materials and techniques of traditional Chinese ink painting, Huang Chih-yang executed a series of paintings entitled *Zoon* (pl. 58). The brushwork takes on an industrial hard-edge stroke, and rapidly painted arms, legs, bodies, and heads form monster-humans lacking gender or any identification with civilized people. The combination of the mechanical and the primitive goes far beyond the elegant aestheticism of traditional Chinese literati painting. Huang likes to identify the images of monsters in his paintings as himself. He says, "Man is such animal. I am such an animal."[22] Huang's paradoxical, bizarre images are particularly concerned with the confrontation between multiple elements: natural environment, traditional culture, urban material life, and human nature.

Sexuality is an important theme for certain Taiwanese artists. Many Chinese artists have seen the representation of sexuality not only as men enjoying women's bodies but also as symbolizing the birth or flourishing of national power. This has been true in the art of the Mainland since the eighties and of Hong Kong around the middle nineties, when it was promoting a local cultural identity. In the nineties, artworks with sexual themes have become a powerful vehicle to present the Taiwanese search for a native (or national) cultural and political identity. Most sexual works are filled with the atmosphere of violence, masculinity, and the desire for the female body. Masculinity is equivalent to nationalism. This tendency can be found in Hou Chun-ming's "pornographic print" paintings (pl. 56).

IT Park: Universalists in Taiwan

A second important tendency comprises young artists, trained overseas, who identify themselves as "Universalists" and produce mixed-media works similar in appearance to contemporary western art. *I-Tong/Gongyuan* or IT Park, established in 1988, is one of several alternative spaces that since the late 1980s have provided a forum for installations and conceptual art. IT Park has become a center for Universalist artists who are of Chinese descent, have studied in the American School of Taiwan, gone abroad for advanced study, and speak fluently foreign languages such as English or French. Apparently international citizens of the art world, these young artists pursue profound personal experience and individual feeling as a philosophical and religious meditation.

Their works may seem extremely close to western contemporary art, especially Minimalism. Tsong Pu (see pl. 66) has said, "My greatest ideal is to use the simplest of colors and to display everything entirely with the materials I use," and Lin Minhong wrote that "the meaning of my work is the process of being what you are seeing."[23] The difference, however, is that beyond the form, these artists strive to express impressions gained through observation of nature and life. Displayed material does not tell the audience about the philosophy and principles of art; it examines the relationship

between nature and the individual artist's feeling, and transcendent ideas that are colored by modern urban life.

Chu Chiahua was trained in Italy in the eighties, and upon returning to Taiwan in 1991, he began a new phase of artistic exploration, closely observing the visual effects of material objects and transforming visual reflexes into an artistic language. His materialist aesthetic stresses the possibility of an object's rebirth after artificial processing (pl. 67).

Chen Hui-chiao has created installation works possessing the characteristics of "female sensibility" (pls. 63, 64). One series using needles and thread brings traditionally female crafts—needlepoint and embroidery—into the realm of modern Taiwanese art. In one piece, more than ten thousand glittering silver needles trailing silk threads, all in chaotic disarray, pierce fabrics layered on top of one another. Chen has also arranged her needles and threads on a panel as a Minimalist painter arranges color fields on a canvas. She has written, "Everything is relative, such as the mutual correspondence of action and stillness and the succession of strong and soft. . . . This is unity, which I desire to express in my works, making a direct connection between appearance and the mind the ultimate truth of my knowledge. By casting away the prisons created by historical outlooks and purifying my inner self, I come into contact with the truth."[24]

This Universalist tendency is quite different from the Made in Taiwan painters. As part of Taiwan's cultural elite, the Universalist artists seek to find purification in their lives, and may transcend life as well. This is not, I believe, cultural escapism but rather a quest for transcendence as a reaction to increasing globalized materialism and to political and social crises.

Hong Kong Art: From Translation to Transition

Hong Kong has long been seen as a "cultural desert," and its people regarded as consumers with no sense of culture. Colonial policy did not seek to build a local cultural establishment, and the refugee psychology—most people there had left and/or were going somewhere else—had an effect, too. The phrase "East Meets West" has been used to describe Hong Kong culture, but mainly for tourist promotion. Conflicts between social, cultural, and economic forces that lay just beneath the East Meets West façade led to a series of strikes, lockouts, and riots in 1967 and to the language and student movements of the late sixties. After the political confrontation of 1967, by choosing the allure of consumerism over nationalism, while at the same time demanding a sweeping reform of colonial society, the populace of Hong Kong began to become aware of themselves as "Hong Kong people."[25]

During the sixties, as Matthew Turner has indicated, Hong Kong identity "emerged from a clash of discourses—citizen and compatriot, Chinese and western, morality and utilitarianism." Identity came to be based on lifestyle, on a shared recognition of similar self-images and existential choices,

now that Hong Kong people could no longer be guided either by the Chinese tradition or the Chinese modernity that had developed in Shanghai before the war. "Hong Kong was to become less a Chinese city with a remarkable history and more a remarkably a-historical 'Chinatown', and Hong Kong in the late sixties became a culture of translation rather than tradition."[26] Akbar Abbas has pointed out that the colonial itself is an unstable paradigm, and that unlike Chinese culture on the Mainland and in Taiwan, Hong Kong's urban culture is not linked to a long tradition nor does it express the hopes and aspirations of a people or nation.[27] The fashion, hybridity, and translation of Hong Kong culture were established in the decentralized space of a timeless spectacle.

In the sixties, some elite Hong Kong artists had hoped to bridge East and West, creating a modern Chinese ink painting and a modern Chinese art renascence. The leading figure was Lu Shou-kun (1919–1975), who built on the modern Chinese Lingnan School founded by Gao Jianfu in Guangdong in the 1920s. They shared with some Taiwan artists the goal of creating a new internationalist form, but the Taiwanese were reacting against a conservative traditional painting supported by the government, and the Hong Kong artists were fighting against the local dominance of low or popular culture.

In 1971 the Hong Kong–born population outnumbered first-generation immigrants for the first time. The combination of a majority with their roots in Hong Kong and the phasing out of the colonial system mandated in the 1984 Sino-British Joint Declaration combined to prompt questions about cultural conflict and identity.[28] In the eighties a new generation tried to articulate the absence of a nationalist narrative of identity. The identity expressed in the multimedia work of this new generation is, however, unstable, floating, and skeptical.[29]

A consensus was building that "colonialism has taken away Hong Kong people's sense of being Chinese. They need to build up their identity as Chinese."[30] Dancers, painters, dramatists, and designers increasingly rediscovered their Chinese heritage. Fashion designer Ragence Lam said, "I am beginning to feel a sense of belonging. I don't really have any roots, but now that we see more of the mainland Chinese I feel a need to identify."[31] But that confidence was shaken by the Tiananmen Incident of June 4, 1989—for only the second time in history there were large demonstrations. Hong Kong's democracy and liberty began to be viewed as part of local cultural identity for the future, and an ambivalence about national identity became a dominant psychological factor.

With the approach of Hong Kong being handed over to China on July 1, 1997, a new art quickly developed. In 1995, a new generation of Hong Kong artists suddenly appeared. That year dazzlingly fresh material was shown in the exhibitions *Red Movements*, *Who Is in Charge of Tomorrow*, *Basic Dimensions*, and *Location*. It started with *Pre-97: Proposal and Projections* in April and

ended with December's *Pre-97: Special Arts Zone*. In these projects, artists endeavored to portray social reality from such angles as "Identity Confirmation," "Red Humor," "Historical Sentiment," and "Political Shock."[32]

Avant-garde artworks with political and social messages were a new phenomenon. Previously, Hong Kong art showed tendencies toward escapism. Now questions were being raised about social authority and the lack of a common culture. Kum Chi-Keung, an artist born in Hong Kong in 1965, created *Transition Space*, in which two birdcages may stand for Hong Kong and the Mainland (pl.70). Kum says: "I have set free some dozens of birds in this hall. Able to fly as they wish, some of the birds may choose the new room, while some others may still stick with their old places, as if they could not forget their original cozy nests."[33]

On January 31, 1996, sixteen artists, most of whom were born in Hong Kong in the sixties, made a public performance intended to wake up Hong Kong's seemingly insensitive masses. They masqueraded as a group of mourners at a funeral and walked around the streets of the very crowded shopping district Jianshazui (Tsim Sha Tsui) carrying signs with slogans like "mourning human culture" (pl. 72). In their statement, they wrote:

> *Mourning—the weakened human spirit*
> *Treating—sick cultures and art*
> *Rejecting—being a cog in the economic machine*
> *Liquidating—the heritage of colonialism*
> *Calling—for the reestablishment of local culture*
> *Pursuing—a healthy spiritual culture.*[34]

Other artists sought to raise consciousness of and a concern for a national identity, whether positive or negative, optimistic or pessimistic. Danny Ning Tsun Yung's *Deep Structure of Chinese Culture*, 1991–97, is a series of installations involving many artists and intellectuals that refers to the paradox of a national identity and a local identity through such means as placing the viewer in a circle of standing tablets with mirrors facing the center and the backs painted solid red.

Art in Hong Kong has on occasion paralleled some of the avant-garde projects on the Mainland and in Taiwan in emphasizing masculine power as a symbol of nationalism in the face of the West's impact. For instance, a 1995 exhibition entitled *Penis Exhibition* organized by the Hong Kong Young Artists Association made references to a Hong Kong cultural renascence as symbolized by phallic images.

It seems, however, that this somewhat militant and vital avant-garde practice suddenly became quiet after Hong Kong reverted to China on July 1, 1997. One wonders if artistic practice will become a part of a universally indifferent cosmopolitan culture, or if artists will continue to take an adversarial position as an avant-garde with a specific target. If so, then what will that target be?

Modernity: Acceptance of and Antagonism toward a Transnational Society

Transnational forces affecting Chinese societies have prompted contemporary artists to address the interrelated issues of marketing, materialism, and institutionalism. Chinese artists have been forced to abandon their avant-garde mythmaking and innocence—perhaps even naiveté—and pragmatically address changing relationships between the local and global, the spiritual and material, art production and producer. They are striving to develop a common and reliable vocabulary to speak with their audience, a vocabulary that might be unfamiliar but which is derived from their own deep personal experience and which may provide a true expression of their subjectivity in a globalizing society.

The McDonaldization of Art

At the end of the twentieth century, the issue of modernity in Chinese societies is located in an age, as described by Fredric Jameson, of decolonization accompanied by the emergence of multinational capitalism and the great transnational corporations. Contemporary theorists have been concerned with the internal dynamics of the relationship between First and Third World countries, and in particular the way in which this relationship is one of necessary subordination or dependency and is based on economic infiltration rather than ideology and military power.[35]

Chinese artists were among the first to articulate the impact of huge transnational corporations in the transformation of Chinese society. About 1990, an art group in Wuhan known as the New History Group, led by Ren Jian, proclaimed that contemporary art had been transformed into product art: "No art, just product" and "Art as fast food, ready to serve people." Consumer fashion became the primary aesthetic.[36] In order to expose this shift, the group planned an extravagant artwork titled *Mass Consumption* that was to include rock music, portraits of famous businessmen, a fashion show, and the sale of 10,000 pairs of jeans designed by Ren Jian with the pattern of flags of every nation in the world (pl. 42). This event was scheduled to take place on April 28, 1993, at the new McDonald's restaurant in Beijing, said to be the biggest in the world. This was part of a phenomenon that might be tagged, as Jianying Zha did, the "Whopperfication of Chinese Art," or to be more site-specific, the "McDonaldization of Art."[37]

It might also be called "Coca-Cola–ization." In 1997, a nationwide consumer survey showed that Coca-Cola is the most famous and admired company in China. The previous year Wang Jin had proposed a project called *The Great Wall: To Be or Not to Be*. It would take place during the winter at a site in Gansu Province adjacent to a ruined section of the Great Wall and would involve forming a section of wall and a tower out of innumerable Coca-Cola cans and bottles. The "Great Wall" of frozen Coca-Cola would be of a "boundaryless" universal commodity, while the ruins of the actual Wall remain a

monument of an "eternal" boundary of a nation. The Great Wall of China becomes an abstract symbol of nationalism in transition as a new, open consumer society is wrought by the global economic system and the contradiction between acceptance and resistance is highlighted.

Dislocation: Avant-Garde and Kitsch

A shift in the art world on the Mainland from the ideological concerns of the 1980s to the monetary concerns of the 1990s is evidence of the process of globalized modernization. There has been a distinct shift from an avant-garde targeted on a local political and cultural reality to a neo-avant-garde visuality that strives to transcend local interests in favor of involvement in the international arena. This is less a product of internal factors than of the impact of outside forces. Thus the title *Inside Out* also reflects a transition in Chinese societies and in relationships between inside and outside through visual practice. If we do not keep in mind this transition in contemporary Chinese art and instead view such shifts from ideological perspectives current during the Cold War, we may misunderstand contemporary Chinese art in both its original context and in terms of global modernization. Such misunderstanding may create political and aesthetic dislocations.

For instance, virtually all of the international Chinese exhibitions in Hong Kong, Australia, and Europe since the early 1990s have presented Political Pop and Cynicism as the major non-official, avant-garde movements and interpreted them ideologically in light of the Tiananmen Incident of 1989. Further investigation and thought show, however, that Political Pop and Cynicism are nothing more than a combination of ideological and commercial practices. Most Political Pop artists are ambivalent about the Cultural Revolution and Mao's ideology. They glorify the persuasive power and unique aesthetic of Mao's propagandist art. Yu Youhan called Maoist art "pleasant to hear and to look at" (*xiwenlejian*); Wang Ziwei thinks that Mao himself was concerned about and communicated compassionately with the masses; and Wang Guangyi worships the power of print because we are living in an age of mechanical reproduction (pl. 34).[38] Although Political Pop allegorizes the Mao myth and Mao's utopia, the artists by no means criticize the discourse of power in Mao's Communist ideology and propagandist art, as many western critics have pointed out. Rather the artists still worship and desire to gain this power. From an ideological perspective, Political Pop is a continuation of pre–Tiananmen Incident avant-garde "red humor,"[39] but neutralizes its direct criticism of reality by utilizing its strategy of imitating both propagandist and consumer discourse while exhibiting an ambivalence toward the nationalism that is increasing among Chinese intellectuals in the nineties.

The ideological nature of Political Pop is similar to that of Sots Art, a Soviet avant-garde art movement in Moscow in the 1970s ("Sots" being short

for "Socialist"). It was based on Soviet mass-cultural imagery and a Soviet variation of American Pop Art that delighted in the spectacle of antagonistic semiotic and artistic systems confronting each other. For example, Kosolapov's poster *Symbols of the Century* that montages Lenin's profile and the Coca-Cola logo is similar to Wang Guangyi's *Great Castigation Series: Coca-Cola* (pl. 35). Coke's reassuring slogan "It's the Real Thing" and Lenin thus become interchangeable as mass-cultural products.[40] Sots Art and Political Pop share a similar ideological content—nationalist power. As Boris Groys analyzed, "In the Soviet politician aspiring to transform the world or at least the country on the basis of a unitary artistic plan, the artist inevitably recognizes his alter ego, inevitably discovers his complicity with that which oppresses and negates him, and finds that his own inspiration and the callousness of power share some common roots. Sots artists and writers, therefore, by no means refuse to recognize the identity of artistic intent and the will to power at the source of their art. On the contrary, they make this identity the central object of artistic reflection, demonstrating hidden kinship where one would like to see only morally comforting contrast."[41]

Political Pop attracted much more international institutional and marketing attention than Sots Art, however, as it emerged while the Communist world was declining and the Cold War was ending, and also because China has since become a major transnational market. Whereas the Sots artists emigrated to the US in the late 1970s and found commercial success there, none of the successful Political Pop artists has left China. On the contrary, they have become a part of an upper-middle class in the changing Chinese economy. The artists no longer strive to produce a confrontation with authority and the public as their predecessors did; they have changed from elite/amateur avant-gardists to professional, careerist artists. Sots Art is not a commercial, impersonal art that responds to and simultaneously strives to manipulate spontaneous consumer demand. But the nationalism and materialism of Political Pop, based on transnational political and economic circumstances, share common roots with government policy, and the art is in a position of complicity.[42]

The aesthetic allegory of both propagandist art and consumer mass culture that functions in Political Pop led me to label it "double kitsch"; the Political Pop artists are producers, and their trademark works are real commodities. In another words, they themselves become the "double kitsch." Consequently, the "presence" of the avant-garde in the international exhibitions and markets overseas might reflect an "absence" of the avant-garde inside China.

An example of this dislocation was found on a *New York Times Magazine* cover in December 1993. On it was a reproduction of a painting by one of the Cynics and the title of an article on the Chinese avant-garde: "Not just a yawn but the howl that could free China."[43] Ironically, if you had visited the artist,

you would have found him living in a big house in Beijing with a beautiful garden and a big gate between him and the ordinary people. Such new professional artists have been passionately involved in creating a Chinese leisure culture, which is an essential part of any capitalist society, rather than engaging in avant-garde culture.[44] Thus, what the Chinese avant-garde is, is questionable from a global perspective.

Aura, Purification, and Aesthetic Materialism
Chinese artists in both the Mainland and Taiwan have reacted strongly to the impact of materialism brought about by global modernization. In addition to embracing commodities, this materialism rooted in capitalist ideas encompasses a concern with time as a measurable entity that can be bought and sold just like any other commodity. There is also the cult of reason, action, and success, which have been promoted as key values in the triumph of a middle-class culture and the modern. This materialism growing out of a western consciousness of modernity also includes the doctrine of progress and a belief in the benefits of science and technology. The development of this core of bourgeois modernity created a split in the West between a cultural modernity and an aesthetic avant-garde that rejected bourgeois materialism and, since the nineteenth century, has been consumed with a negative passion.[45]

The Chinese may now be experiencing circumstances similar to those faced by the western avant-garde a century ago, in which there is a division between two modernities, a materialist one and an aesthetic one. The western aesthetic modernists expressed their disgust with materialism through means ranging from rebellion, anarchy, and apocalyptic visions to an aristocratic self-exile in an ivory tower for the creation of a purely aesthetic utopia expressed in various modern abstract forms. The Chinese avant-garde, however, has directly faced and challenged materialism as part of their social project rather than just as an aesthetic utopian program.

One response by the post-Tiananmen avant-garde on the Mainland has been a self-imposed exile from mass-consumer culture but with an antagonistic and strongly critical tone, giving rise to Apartment Art. In private spaces, artists of this group have created unsalable and unexhibitable works, such as Song Dong's *Water Writing Diary* (fig. 26). In performances in Beijing's East Village, Zhang Huan and Ma Liuming have confronted the system of art marketing and institutions and engaged in pseudo-religious meditations on highly personalized objects (including their own bodies and experiences) in private spaces to seek a now-disappeared spiritual "aura" and a "purification" in the midst of a materialist society (pls. 28, 29). A different response is to take to the streets, plazas, shopping malls, and other public spaces to create a sort of happening and mass art, using consumer goods as media and implicating the audience of consumers in the process of a happening or action. Wang Jin's *Ice: Central China 1996* and Lin Yilin's wall projects

(see my essay on the Mainland in this catalogue) are examples. Audience and artist are joined in a shared experience reacting to society's materialism.

Similar reactions to the encroachment of transnational mass consumption in Taiwan's flourishing urban culture are found in contemporary art there after the late 1980s. The Made in Taiwan artists deal with this explicitly in their work; they accept conflicts between materialism and spiritual purification and represent the material world as overflowing with images of urban leisure culture, nude women, and luxury goods. Their approach is similar to the Mainland painters of the New Floating World, led by Song Yongping, Cao Yong, and Su Xinping (pls. 40, 41, 44, 45). The motivation of the Made in Taiwan artists comes from the discovery of "folk kitsch" as characteristic of Taiwan's native culture, while that of the New Floating World painters comes from the artists' experience of double kitsch in which socialist kitsch and capitalist kitsch mirror each other.

Another trend in Taiwan is to react to the social space of the newly manifest materialist world by combining an ideal of purification with a profound reflection on the existence of the self and an investigation into the individual's position in society. This purification gives direction to a material aesthetic in visual art practice that differs from western avant-garde methods of dealing with the issue of fetishism. For instance, in 1994 an exhibition called *Urban Nature: A Dialogue Between Humanism and Materialism* investigated modern cosmopolitan life as an industrial experiment in which human beings are the animal subjects. Despite the superficially convenient communication and material accumulation of burgeoning metropolises that combine increasing population density with endless material production and consumption, the spiritual quality of individual life has not been sustained and enriched. In fact, individuals are becoming more absorbed in sheer utility and materialism, increasingly isolated from one another. Taiwan is an example of such an industrial society.[46]

In the exhibition, the artist Chu Chiahua put his apple-green 1970s Toyota, covered on one side by feathers, in the gallery. This piece highlights the fading away of nature from everyday life in a big city. Chu's oeuvre emphasizes the comparison and contrast of different types of materials and a type of materialism that is both familiar and alien; it is expressly derived from Taiwan's urban environment (pl. 67). The idea of "Aesthetic Materialism" has become central to Chu Chiahua's artistic style. He challenges the Taiwanese public, who recognize only simple use-value and give in to unchecked materialism, to appreciate the possibility of a materialist aesthetic rooted in their daily experience. Chu looks to the possibility of an object's rebirth after artificial processing. Displaying material as itself in this way may seem similar to Minimalism's development of the Duchampian designative readymade tradition and Frank Stella's positing that "what you see is what you see," but an essential difference is that Chu's readymade materials

do not pose a contradiction between the preindustrial craft of traditional art and the industrial production of modern commodities. Nor do they express a dialectic between modernism (high art) and mass culture (low art), as did the work of some Euro-American conceptual artists in the sixties.[47] Chu sorts out the variousness of personal experience and selects from otherwise neutral industrial materials those suiting his own taste and then endows them with a quality of "uniqueness" derived from an aesthetic orientation rather than a conceptual one. As Taiwanese critic Shih Rui-ren suggests, in a world over-flowing with products and famous brands, Chu seeks to find his favored brand, through which he can articulate a difference in indifferent urban life.[48]

Chu's materialism does not deal with ambivalent "readymades" that allegorize industrial material fetishism and raise ideas of "art." Rather, material to Chu is simply a part of nature mediated by human beings. Such a relationship between nature and humanity has traditionally been central to the meaning of life for the Chinese. This different concept of a readymade is inherent in his individually chosen material, rather than a personal fetish material chosen out of mass-produced objects. Other Taiwanese artists, especially the IT Park group, have also been involved in similar projects of purification.

Post-Orientalism in the Third Space: Chinese Artists Overseas
Since the late 1980s, various important Chinese artists who played a revolutionary role in that decade's avant-garde art movement, such as Wenda Gu, Huang Yong Ping, Wu Shan Zhuan, Xu Bing, and Cai Guo-qiang, have emigrated from Mainland China. After arriving in the West, these artists gradually softened the revolutionary attitude of the 1980s Chinese avant-gardists. In new cultural contexts and a postmodern, postcolonialist period, their original antagonism toward certain cultural entities (of both East and West) and a given political authority, as well as their idealism about revolutionizing both art and society, have lost their significance. The Chinese artists overseas have faced new challenges from mainstream western culture in a quite different context, even while questioning that culture. Gradually they have realized it is impossible to make one culture change by substituting another.[49] To be successful, these artists have adopted a strategy of neither emphasizing nationalistic cultural characteristics to play the role of a minority or exotic nor overtly de-emphasizing their Chinese identity and becoming internationalists. As they have begun to realize that cultural differences only appear in a situation of negotiation, they have presented Chinese traditional materials not as the touchstones of a monolithic entity but as dimensions of a material language, and as bridges over which different interpretations can cross.

This is possible, if not necessary, because, as postcolonialist culture critic Homi Bhabha suggests, cultural identity is not an irreducible given, nor are "dominant" and "dominated" separate or independently defined entities. Moreover, identity is also determined by a specific historical moment

and space (in-between, hybrid). Thus, the "oriental" identity of these artists is always in negotiation, involving the continual exchange of cultural performances that in turn produce a mutual and mutable recognition of cultural difference. The real situation and cultural space of these Chinese artists overseas is what Bhabha has called "the third space."[50] The Chinese artists overseas have had to rethink their origin and how on the one hand it can function in such exchanges as well as function in the "mainstream culture" as a way of representing their origin performatively. We may call this strategy of creating art by Chinese artist overseas "post-orientalism."

Two examples illustrate this transition. Cai Guo-qiang was a important member of an avant-garde group of the '85 Movement who moved to Japan in 1987 and then to the US in 1995. In China and Japan, he created a series of works in which gunpowder explosions left traces on the canvas (pl.1). Cai's intention was to extend the ancient oriental concept of "primary substance" to other kinds of cultural entities. He believed that non-Asian cultural features too were derived from such concepts, and that the idea of primary substance in Asian philosophy could be used as a foundation in any culture in the contemporary world. Since 1993, Cai has developed his Projects for Extraterrestrials, which have taken place in Johannesburg, South Africa; Otterlo, Netherlands; Hiroshima, Japan; and Bath, United Kingdom. This project transcends his early oriental ideal by asking the audience to realize a dimension of art that is transcultural and transpolitical, perhaps even universal.

Cai's recent work uses old and new materials to bridge cultures, as in *Cry Dragon/Cry Wolf: The Ark of Genghis Khan*, 1996. It consists of a number of sheepskin coracles forming the head and body of a dragon, and several Toyota engines as its tail. Genghis Khan's coracles symbolize military power and remind the audience of the Mongolian incursion into Europe in the thirteenth century, and the Toyota engines symbolize the rise of Asian economic power in contemporary society. The title *Cry Dragon/Cry Wolf* suggests the development of a world power, or, from a negative perspective, a "threat" from Asia. The work thus transforms a Chinese traditional material into a contemporary object and a sign of exchange. Cai's new installation for *Inside Out* utilizes a boat made of rice straw from his hometown of Quanzhou, an ancient seaport in South China. The boat flies a Chinese flag and hangs in the air, pierced by myriad arrows. *Borrowing Your Enemy's Arrows*, 1998, is based on a story from the third century CE in which a famous general realized that he lacked enough arrows for an upcoming battle. Rather than attacking, he made three hundred boats of rice straw with straw figures on them and sailed them toward his enemy on a misty morning. The foe peppered the boats with arrows, which the general recovered, and he went on to defeat his adversary. Once again, Cai uses a traditional story with an impressive visual form to comment on contemporary transcultural issues.

GAO MINGLU

In the early 1980s, Wenda Gu was the first Mainland artist to incorporate western Surrealism into Chinese ink painting. The result was a new movement of modern ink painting called Universal Current. However, Gu's period of Rationalist painting soon came to an end and he turned to creating provocative installations inspired by a strong Asian mysticism. He then became involved with "deconstructive calligraphy," a trend in Chinese conceptual art. In an interview from 1987 he ambitiously claimed that he wanted to "transcend the East and West" and find a new way in which he could define the general issues faced by all humanity.[51] He experienced culture shock after emigrating to the US and sought to challenge the international mainstream. Gu took up this challenge with body art. His first controversial work, exhibited in Los Angeles, was made from dozens of used sanitary napkins and tampons collected from women around the world. This was followed by a piece made from placenta powder. Recently, he has been working on a massive, global project called *United Nations*. He constructs different monumental forms, such as an American flag, a Chinese landscape painting, or an Islamic temple with its calligraphy, by using human hair or bricks made from human hair from people in different places. The works wed public, monumental forms with the most private of personal substances—hair. Unlike many Euro-American contemporaries whose art deals with bodily substances and crises of the human body, Gu's work doesn't address specific social, political, religious, or sexual issues. Rather, he explores the eternal human verities and the general human condition. However, Gu does project his own interpretation and understanding of the history and culture of the Other into his monuments made of others' hair. Gu describes himself as "a foreign intruder to any country, using local materials and local labor." For him, "the various 'misunderstandings' from different people, times, locations, are part of the value of the creation in itself. 'Misunderstanding' is the essence of our knowledge concerning the material world. The sum of various misunderstandings is the confrontational truth of my work."[52]

These two overseas Chinese artists, as well as Huang Yong Ping and Chen Zhen in Paris, Wu Shan Zhuan in Hamburg, and Xu Bing and Zhang Jianjun in New York, all face different challenges abroad and have learned to use an international, postmodern language, in their post-oriental works. This language is a kind of strategy that includes appropriation, allegory, masquerade, and cynicism; it differs from their original "grand" language in China when they were obsessed with seeking "truth." Now, most of them have abandoned the pursuit of "authenticity," "uniqueness," and "center" and replaced these ideas with relative concepts such as "moment," "nomadism," and "transformation."[53]

The global modernization shaping the contemporary culture of Mainland China, Taiwan, and Hong Kong has had its largest artistic impact on the pursuit

of subjectivity in these fast-changing societies. Modernization has also transformed Chinese artists' consciousness from a focus on an internally directed, nationalist modernity to an interconnected, transnational one—the artistic gaze now looks outward as well as inward.

As Anthony Giddens has pointed out, one of modernity's distinctive features is an increasing interconnection between the two "extremes" of extensionality and intentionality, between globalizing influences and personal dispositions.[54] This feature of modern history has now affected the "Third World" even more than it did the West. In contemporary Chinese societies, the transmutations introduced by modernization interlace in a direct way with individual life and the self. Thus unpredictable visual characteristics growing out of increasingly distinct individual experiences are proliferating in the contemporary art of all Chinese regions.

Especially on the Mainland is art being reconfigured as the society is altered. Avant-garde artists are subject to pressures from a changed power structure and a new interplay between the state, the market, and international institutions. The cultural devaluation of Chinese intellectuals and avant-garde artists has, ironically, prompted them to redefine the relationship between Chinese tradition and the West in more rational and pragmatic ways: the traditional is seen as more malleable and the western as more serviceable than envisioned by previous generations.

In a global, materialistic society, the previous (modern) Superman has become a small man, and the universal elitism that was the core of Chinese enlightenment movements in the 1920s and 1980s has been transformed into true individualism. Never before have Chinese artists been so emotionally concerned with their private lives and individual interests. The Apartment Art of Mainland artists and the universalism of Taiwan's IT Park artists obviously represent this new orientation. Chinese artists overseas, who are operating in a cultural space where the interconnection between extensionality and intentionality—in terms of both economic globalization and cultural identity—might be more easily articulated than in the People's Republic or on Taiwan, have also turned their attention from the presentation of cultural differences between "monolithic" cultural entities to the representation of interconnections and transmutations among different cultures. Most importantly (in terms of contemporary subjectivity), their artistic creativity derives from their own personal perception and interpretation.

It seems that in today's global "trans" age, it will become increasingly difficult, if not impossible, to define contemporary Chinese art phenomena by using only a few generalized and predictable categories based on a single perspective.

GAO MINGLU

NOTES

1. The debate about cultural identity—encompassing such issues as eastern vs. western —has been a sensitive issue for the Chinese since the mid-nineteenth century, and in some quarters it led to the endorsement of the modernization of Chinese society. Recently, some western writers have raised the specter of cultural confrontations between East and West. Samuel P. Huntington wrote an article and then a book about the topic; in *The Clash of Civilizations and the Remaking of World Order* (New York: Simon & Schuster, 1996) he posited that in the post–Cold War world the critical distinctions between people are not primarily ideological or economic but cultural, and that nonwestern civilizations, such as the Muslim and Confucian, will challenge western dominance and its "universal" ideas. The Muslim population surge has led to many small wars across Eurasia, and the rise of China could lead to a global war of civilizations. For reasons I develop herein, however, it may be that a clash such as Huntington described would only become possible after ideological and economic reconfigurations have gone further.

2. James Cahill raised this point. See his first chapter, "Chang Hung and the Limits of Representation," in *The Compelling Image: Nature and Style in Seventeenth-Century Chinese Painting* (Cambridge, Mass.: Harvard University Press, 1982).

3. See James Cahill, "The Shanghai School in Late Chinese Painting," in *Twentieth Century Chinese Art* (New York: Oxford University Press, 1988).

4. Jonathan Hay, "Modern Chinese Art," unpublished lecture.

5. Zhang Junmai et al., *Kexue yu renshengguan* (Science and the view of human life) (Shanghai: Yadong Press, 1925).

6. On Taiwan, see Hsiao Ch'iung-jui, *Wuyue yu dongfang—Zhongguo meishu xiandaihua yundong ziazhanhou Taiwan zhi fazhan, 1945–1970* (The Fifth Moon and Eastern painting groups: Chinese modern art movements in postwar Taiwan, 1945–1970) (Taipei: Dongda Press, 1991). On Hong Kong, see David Clarke, "Between East and West: Negotiations with Tradition and Modernity in Hong Kong Art," *Third Text* no. 28/29 (Autumn/Winter 1994), pp. 71–86.

7. *Li Chung-sheng: Xiandai xuihua xianqu* (Li Chung-sheng: A pioneer of modern painting) (Taipei: Shibao Cultural Press, 1984).

8. See Peter Bürger, "Literary Institution and Modernization," chapter one of his *The Decline of Modernism* (University Park: Pennsylvania State University Press, 1992).

9. Some major publications of the theory of avant-garde are: Peter Bürger, *Theory of the Avant-Garde,* trans. Michael Shaw (Minneapolis: University of Minnesota Press, 1984); Matei Calinescu, *Five Faces of Modernity: Modernism, Avant-Garde, Decadence, Kitsch, Postmodernism* (Durham, N.C.: Duke University Press, 1987); Renato Poggioli, *The Theory of the Avant-Garde,* trans. Gerald Fitzgerald (Cambridge, Mass.:, Harvard University Press, 1968); and Jurgen Habermas, "Modernity—An Incomplete Project," in *The Anti-Aesthetic: Essays on Postmodern Culture,* ed. by Hal Foster (Seattle: Bay Press, 1983).

10. In the West, according to Jurgen Habermas, the term modern in its Latin form *modernus* was first used in the late fifth century to distinguish the present, which had become officially Christian, from the past, which was Roman and pagan. Through various historical circumstances, the term *modern* has described again and again the consciousness of an epoch that distinguishes itself from the past and views itself as transition from the old to the new (Habermas, "Modernity—An Incomplete Project," pp. 3–4).

11. See my essay "A Total Modernity and Avant-Garde in Twentieth-Century China" in the forthcoming catalogue of an exhibition of contemporary Chinese art organized by

the Solomon R. Guggenheim Museum, New York.

12. The publication in serial form in 1975 of Hsieh Li-fa's *Riju shidai Taiwan meishu yun-dong shi* (The Taiwanese art movement during the Japanese occupation), published three years later in book form (third edition, 1992), marked the beginning of research into Taiwan's art history, which climaxed in the early nineties.

13. The late Alice Yang began to analyze this in "High and Low: The Cultural Space of Contemporary Taiwanese Art," in *Tracing Taiwan: Contemporary Works on Paper* (New York: Drawing Center, 1997), pp. 7–13.

14. See Huang Wan-yao, *"Aimei de Taiwan ren: Erben zhimin tongzhi yu jindai minzu goujia zhi rentong"* (Ambiguous Taiwanese: Japanese colonial occupation and modern nationalist and national identity)," *Hewei Taiwan: Jindai taiwan meishu yu wenhua rentong* (Searching for Taiwanese cultural identity) (Taipei: Lion Art Press, 1997), pp. 250–63.

15. I coined the term *'85 Movement,* or *Bawu meishu yundong,* in a paper given at a conference and published as *"Bawu meishu yundong"* in *Meishujia Tongxun* (Artists' Journal) 1986.3 (June 1986), pp. 15–23. After high-ranking officials objected to this designation, the term *'85 Art New Wave,* or *Bawu meishu xinchao,* was briefly adopted as a less objectionable alternative (the word *movement* being fraught with political implications). In the 1986 essay I discussed the connection between the '85 Movement and the May Fourth Movement in terms of Enlightenment discourse.

16. Shu Qun, *"Beifan Yishu Qunti de jingshen"* (The Orientation of the North Art Group), *Zhongguo Meishubao* (Fine Arts in China) no. 18 (November 23, 1985), p. 1.

17. For details, see my essay on Mainland China in this catalogue, "From Elite to Small Man"

18. See Julia F. Andrews and Gao Minglu, "The Avant-Garde's Challenge to Official Art," in *Urban Spaces in Contemporary China,* ed. Deborah Davis et al. (Washington, D.C., and New York: Woodrow Wilson Center Press and Cambridge University Press, 1995), pp. 221–78.

19. In 1989 Yang Mao-lin created a series of paintings on economic modernization called Made in Taiwan (*Taiwan zhizao*). The phrase also appears on Yang's painting entitled *Zeelandia Memorandum L9301,* 1993, in which images of a Dutch colonial figure and a traditional Chinese official refer to Taiwan's history.

20. Kao Chianhui, *"Xinyang chaoqianwei, jingshen xinpopu, yaogunhouxiandai"* (Beyond avant-garde, new spiritual pop, rococo postmodernism), in *Tangdai wenhua yishu sexiang* (Fine art/unrefined, visual culture in the '90s) (Taipei: Artists Press, 1996), pp. 67–75.

21. Artist's statement, in *ArtTaiwan: La Biennale di Venezia 1995* (Taipei: Fine Arts Museum, 1995), p. 53.

22. Artist's statement, ibid., p. 39.

23. Artists' statements, ibid.

24. Unpublished statement by the artist.

25. Xian Yuyi, *"Liushi niandai—lishi gailian"* (The 1960s—An overview of history), in *Hong Kong Sixties: Designing Identity/Xiangang liushi niandai* (Hong Kong: Hong Kong Arts Centre, 1995), pp. 80–83.

26. Matthew Turner, "60s/90s: Dissolving the People," in *Hong Kong Sixties,* pp. 13–34.

27. Akbar Abbas, "Hong Kong: Other History, Other Politics," *Public Culture* 9, no. 3 (Spring 1997), p. 303.

28. Xian, *"Liushi niandai—lishi gailian,"* p. 80.

29. See David Clarke, "Negotiation between East and West."

30. Li You, " Art the Luohu Bridge," *People's Literature,* 1986 no. 6.

31. In Turner, "60s/90s: Dissolving the People," p. 26.

32. Pun Ling Lui, "The SAR of Art" in *Qianfeng '95* (Forward '95) (Hong Kong: Hong Kong Development Council, 1996), p. 26. Some of the exhibitions and venues were: *Pre '97: Proposals and Projections, Stream Heritage: Transformation Installation*, and *Penis Exhibition* at the Fringe Club; *Pre '97 Special Art Zone* at Hong Kong University of Science and Technology; and *New Dimension Art* in the Hong Kong Cultural Centre foyer.

33. Kum Chi-Keung, *Qian '97 Yishu Tequ* (Pre '97: Special Art Zone), p. 20.

34. Unpublished statement on *Cultural Mourning.*

35. Fredric Jameson, "Modernism and Imperialism," in Terry Eagleton, Fredric Jameson, and Edward W. Said, *Nationalism, Colonialism, and Literature* (Minneapolis: University of Minnesota Press, 1990), pp. 43–66.

36. Unpublished statement, *"Xinlinshi 1993 daxiaofei"* (New History 1993—*Mass Consumption*), 1993.

37. At midnight on April 27, the Beijing Public Security Bureau summoned the artists for questioning and informed them that the activity could not take place.

38. These statements and those of other artists are published in the Political Pop section of the catalogue *China's New Art: Post-1989* (Hong Kong: Hanart T Z Gallery, 1993).

39. Chinese Political Pop and Cynicism may be traced back to the mid-1980s, when Wu Shan Zhuan and other Hangzhou artists created the series of installation works called *Red Humor* (1986–87; e.g., pl. 5) and a group of paintings called "gray humor," represented here by Geng Jianyi's *Second Situation, Nos. 1–4* of 1987 (pl. 22). The best-known representative of Cynicism, Fang Lijun, began to draw his cynical figures not after the Tiananmen Square crackdown but in 1988.

40. Margarita Tupitsyn, "Sots Art: The Russian Deconstructive Force," in *Sots Art* (New York: New Museum of Contemporary Art, 1986).

41. Boris Groys, *The Total Art of Stalinism: Avant-Garde, Aesthetic Dictatorship, and Beyond,* trans. Charles Rogle (New Jersey: Princeton University Press, 1992), p.12.

42. I analyze this phenomenon in *"Meishu, quanli, gongfan: Zhengzhi popu xianxing"* (Kitsch, power, and complicity: The Political Pop phenomenon), *Xiongshi Meishu* (Lion Art) 297 (November 1995): 36–57.

43. The article was by Andrew Solomon, in *The New York Times Magazine,* December 19, 1993.

44. For more details about these new middle class artists or "post-Tiananmen elite," see Jianying Zha, *China Pop* (New York: New Press, 1995).

45. Calinescu, *Five Faces of Modernity,* pp. 41–42. The concept of the two modernities is basic to the theory of modernity in the West and is discussed by Max Weber, Jurgen Habermas, Peter Bürger, and others.

46. Shih Rui-ren, *"'Duhui ziran zhan' —dangdai yishu dui duhui zhihan de duomian jianzhao"* (The exhibition "Urban Nature"—a reflection of the substance of the metropolis in contemporary art), in *Dushi zhongde siran: Renwen yu wuzhi de duehua* (Urban Nature: A dialogue between humanism and materialism) (Taipei: The Empire Art Educational Foundation, 1994), pp. 2–5.

47. This feature of the ambivalence of readymades and the articulation of contradic-

tions between different category pairs is discussed by Hal Foster in "The Future of an Illusion, or, The Contemporary Artist as Cargo Cultist," in his *End Game: Reference and Simulation in Recent Painting and Sculpture* (Boston and Cambridge, Mass: Institute of Contemporary Art and MIT Press, 1986), pp. 91–105.

48. Shih, *"'Duhui ziran zhan,'"* p. 5.

49. The East-West cultural debate that had begun in China around the turn of the century articulated three major issues: the differences and similarities between China and the West (*zhongxiyitong*); comparisons of the respective merits and flaws of Chinese and western cultures (*zhongxiyoulue*); and the future of Chinese and western cultures (*zhongxiqushi*). For almost all Chinese cultural pioneers, cultural conflicts such as traditional vs. modern or East vs. West were based on the notion that these were monolithic entities.

50. Homi Bhabha, "The Third Space," in *Identity, Community, Culture, Difference,* ed. Jonathan Rutherford (London: Lawrence & Wishart, 1990).

51. Fei Dawei, *"Fang Gu Wenda"* (To transcend the East and West: An interview with Gu Wenda), *Meishu* (Art Monthly) July 1987, pp. 12–16.

52. In Kim Levin, "Splitting Hairs: Wenda Gu's Primal Projects and Material Misunderstandings," in *Wenda Gu: Dio e i Suoi Figli/God and Children: Italian Division of United Nations, 1993–2000* (Milan: Enrico Gariboldi/Arte Contemporanea, 1994).

53. Portions of this section on Chinese artists overseas are derived from my "From the Local Context to the International Context: An Essay on the Critique of Art and Culture," in *The First Academic Exhibition of Chinese Contemporary Art 96–97* (Hong Kong: Hong Kong Art Centre, 1996), pp. 23–29 (in Chinese, with translation by Billy Wu).

54. Anthony Giddens, *Modernity and Self-Identity: Self and Society in the Late Modern Age* (Stanford: Stanford University Press, 1991), p. 1.

> **Across Trans-Chinese Landscapes:**
> Reflections on Contemporary Chinese Cultures

This exhibition presents Chinese artists from four regions: Mainland China, Hong Kong, Taiwan, and Chinese artists overseas. This Chinese world obviously cuts across national boundaries. Whereas the term *Chinese* is still used as a conceptual rubric to cover these regions, on the basis of their shared written language and/or ethnic origin, it is also clear that this is no longer a unified world like the Middle Kingdom of the past. Throughout these regions, deeply rooted cultural assumptions are being challenged by rapid modernization; changing political realities; and conflicting global, ethnic, and local identities. In Taiwan, a new native and indeed national identity is being forged, which clearly distinguishes itself from China, although the official title is still "Republic of China on Taiwan." In Hong Kong, politically a Special Autonomous Region (SAR) of the People's Republic of China since July 1, 1997, while the majority of its people still call themselves Chinese, a "subidentity" of being a "Hong Kong resident" is also being articulated. Even on the Mainland, where the nation-state model seems intact under socialism, regional identities, especially in the southern provinces, are becoming stronger, perhaps in tacit opposition to the "official hegemony" of Beijing. The market economy has created within China itself two radically different worlds—the thriving capitalist prosperity of the coastal cities and the rural hinterland, which remains largely poor.

And then there are the large Chinese communities in Southeast Asia and the migrant communities in North America and Australia; the latter may be called "Chinese diasporas,"[1] where the links with their separate homelands are reinforced on a daily basis by long-distance communication via phone, fax, and computer and by frequent airline traffic across the Pacific Ocean. Their politics of identity could be an extension of those of their homelands, but they have also taken on inevitably the "local" character of the country of their "permanent residence." The construction of these "diasporic identities" is fundamentally ambivalent, precarious, and indeterminate. In other words, it is increasingly difficult to forge a single Chinese identity based on political loyalty alone.

Consequently I would like to argue that contemporary Chinese culture is becoming increasingly "multicultural" and "trans-Chinese." The task facing a scholar or critic in this field has become curiously similar to that of

studying racial and ethnic minorities in the United States: how can one negotiate one's way across this increasingly diverse trans-Chinese landscape and maintain a cultural sensitivity to all their differences? In recent years I have become intrigued by this phenomenon of what may be called trans-Chinese multiculturalism, which I have been trying to unravel through personal observation and reflection, conversations with friends and colleagues, as well as reading a large amount of print and visual materials. By way of illustrating its tremendous complexity and dynamism, let me use the example of language.[2]

All Chinese speak Mandarin, the national language of China—this statement is still true superficially, but not entirely accurate. As the French philosopher Gilles Deleuze reminds us, "the more a language has or acquires the characteristics of a major language, the more it is affected by continuous variations that transpose it into a 'minor' language."[3] If in the trans-Chinese spheres Mandarin is regarded as a major language, the official spoken language of the modern Chinese nation-state, its hegemonic status is definitely being challenged on the contemporary scene. Ironically, its archenemy has been the other major language, American English, which has increasingly become the *lingua franca* of the business world and of international travel. This is of course due to the "global" economic trends of capitalism (some would call it American imperialism) which have permeated these territories and exert a direct impact on people's everyday lives. Especially in Hong Kong, Taiwan, and Singapore, young executives and managers are becoming practically bilingual, combining with ease English and another native tongue in their business transactions. On the other hand, bilingualism in speech does not necessarily mean the combination of English and Mandarin, although this has been the case with myself. Regional dialects continue to thrive alongside English and Mandarin as spoken languages. The Shanghai dialect has regained its popularity in the lower Yangtze area and in present-day Hong Kong. Whereas Cantonese continues to be widely used in Hong Kong and neighboring Guangdong Province, in Taiwan in recent years the spoken tongue in business circles has been Taiwanese (derived from one of the Fukien dialects) rather than Mandarin, which holds sway only in Taiwanese official circles. Another dialect with which I personally feel a warm empathy is Hakka, a minor language which has been used to great effect in the films of the internationally renowned Taiwanese director Hou Hsiao-hsien, such as *A Time to Live and a Time to Die.*

This multiplication of spoken tongues—and the constant shift from one to the other within the same daily discourse—has become a habit, sometimes out of necessity but sometimes as a way to indicate one's regional loyalties. Thus "dialogue" in these areas involves in the most practical sense a spoken knowledge of two or three Chinese "languages" in addition to English. In my view, to be attuned to the nuances of such a polyglot world is a prerequisite to understanding the culture of this contemporary trans-Chinese world.

LEO OU-FAN LEE

What does language have in common with art? Perhaps not much. But I believe it provides a necessary background to the equally complex "languages" in contemporary Chinese art. For one thing, traditional Chinese art was closely connected with the written form of Chinese, which is basically ideographic and as such lends itself to artistic transmutations. One thinks immediately of calligraphy, a dying art which continues to serve as a rich source of inspiration for many contemporary artists, who treat its ideographic tradition as visual stimulant. In Taiwan, the linkage between calligraphy and painting becomes the central compositional motif in the works of two established artists: Ko Chu (who works in the National Palace Museum), and Sang Ch'in, who is a well-known poet. In Mainland China, a most talented artist, Xu Bing, wants to subvert the printed form of written characters by undertaking the bold task of producing thousands of nicely bound traditional-looking volumes of "script from the sky" (*tianshu*), of which not a single Chinese character is legible (pl. 6). In a later, even more daringly avant-garde experiment, Xu inscribed Chinese on a female pig and English on a male pig—and made them mate in public as a form of performance art.

If the technology of print (including computers and Chinese word-processing) is threatening the "artistic" aura of calligraphy or the *written* word itself, it has contributed greatly to the prosperity of print culture—newspapers, journals, and books, without which modern Chinese literature would not have been produced. In fact, the past two decades have witnessed unprecedented growth in both the quality and the quantity of creative literature on both sides of the Taiwan Strait. This phenomenon is not merely due to political liberalization on the Mainland; it is also the healthy result of increased cultural and commercial interactions between Mainland China and Taiwan. The diverse works thus produced during the last two decades are too numerous to be treated in a short essay. I can only sketch out some of the new trends in the related fields of journalism, creative literature, and film in order to provide what I hope would be useful background to this exhibition.

Since the early 1980s, there has been a great flourishing of creative writing in China, which has been published in a large number of literary journals. In particular, the popularity of large-sized literary journals has spawned a new fictional subgenre—the medium-length story or novella (*zhongpian xiaoshuo*)—which can be printed out in one single issue of a journal and then republished as a book. The active promotion of medium-length fiction by the journal editors in the mid-eighties during the era of "culture fever" created a kind of "print public sphere" for the interaction of writers, artists, filmmakers, intellectuals, and scholars. These interactions have prepared the ground for creative cross-fertilization. It is now a well-known fact that some of the most acclaimed films made by the fifth-generation directors (Chen Kaige and Zhang Yimou in particular) were based on the medium-length stories or novels written in the eighties or later: *Red Sorghum* (based on

the novel by Mo Yan), *Raise the Red Lantern* (Su Tong), *King of the Children* (Ah Cheng), and *Judou* (Liu Heng; original title, *Fuxi fuxi*). Expectedly, the directors took great liberties with the fictional originals for artistic effect. A celebrated figure from this background is the playwright and painter Gao Xingjian, who now lives in voluntary exile in France and has his artwork exhibited in Parisian galleries and his plays performed at the theatrical festival at Avignon.

If literary journals have played a crucial role in facilitating literary and artistic creativity in Mainland China since the 1980s, the key facilitating medium in Taiwan and Hong Kong has been the newspapers. Whereas since 1949 journalism on the Mainland has been considered "Party literature," hence tightly controlled, newspapers in Taiwan and Hong Kong have inherited a much older tradition that is unique to modern Chinese journalism—the print space (one or more pages) in the daily newspapers called a "literary supplement," or *fukan,* which is devoted entirely to creative and critical writing. Long novels by established writers are first serialized in the daily newspapers before they appear as books. New writers are "discovered" when they first submit stories or poetry to the *fukan* editors, who wield enormous power and provide the kind of "cultural capital" writers need to get established. This editorial promotion could be extended to artists as well. The early fame of the native Taiwanese sculptor Ju Ming was established by the active championship of Hsin Chiang Kao (Gao Xinjiang), editor of the literary supplement of the *China Times,* who spearheaded a new cultural movement by promoting native Taiwanese art.

As in Mainland China, new trends were often closely shared in literature and art. Before Nativist art appeared, the dominant style in both art and literature in Taiwan was Western-inspired "modernism." Some of the early practitioners of modernist art migrated to New York, where they became firmly established. Their friends in creative literature did not leave Taiwan en masse, but rallied around the journal *Modern Literature* (*Xiandai wenxue*), published since 1960, which became the target of a Nativist reaction. In opposition to the modernist emphasis on experimental language and technique, advocates of Nativism called for a return to literary realism and humanistic values so as to give a truthful representation of the reality of the Taiwanese countryside (*xiangtu* or "country and soil" or "native soil") caught in the throes of modernization. While the two camps were embroiled in a heated literary debate in the seventies, the tensions created therein have also contributed positively to their artistic interaction. For all its sound and fury, the debate itself marked the transition phase of Taiwan's economic development (which some would call "modernization") as it moved from a rural to a heavily industrial society. With hindsight, the Nativist movement also can be seen to have marked the beginning of a search for Taiwanese identity—a politicized process that led to street demonstrations and the

formation of the opposition Democratic Progressive Party. However, the original Nativist ethos derived from a humanistic identification with rural values is also lost.

After the debate between Nativism and modernism had run its course in Taiwan by the late seventies, Mainland China was just beginning to rediscover western modernism. Writers and artists responded first gingerly and then enthusiastically to existentialist philosophy, stream-of-consciousness fiction, the theater of the absurd, and American "black humor"—all through a spate of new translations. They, too, launched in the mid-1980s a movement called "searching for roots" (*xungen*), which may be seen as something of a native reaction: they argued that the roots of Chinese culture had been buried underneath the layers of Party ideology whose prescribed "reality" was false. Thus, their "roots-searching" meant the reinvention of a new cultural mythology to displace the Party's entrenched view of Socialist Realism. Thus unlike the Taiwanese case a decade or so earlier, these Mainland Nativists eagerly embraced literary modernism as a handy aid to their new avant-garde cause. The western word *avant-garde* is translated fittingly as *xianfeng* or "forward wing" to characterize their daring spirit of onslaught on all aspects of conventionality and traditionalism.

Just as the avant-gardist movement was gathering momentum, the Party's crackdown on the 1989 Tiananmen Square demonstrations put a temporary end to its aspirations. Deng Xiaoping's policy of coupling political control with economic liberalization served to thwart the movement's radical edge and elitist ethos; the rapidly expanding market economy also drove many intellectuals, writers, and artists to more popular pursuits. While succumbing to the lure of money, they also began to redefine their self-identity and the purpose of their task: instead of being individual artists using the language of their own art to project a highly personal vision in order to "shock" conventional society, they have become cultural entrepreneurs who join forces with television and other media people in the "production of culture." In so doing they can still resort to artistically "subversive" tactics while making a profit. The Wang Shuo phenomenon is a "classic" example—a writer who uses his considerable talent to write both satirical fiction and television soap operas (*Yearning, Stories from the Editorial Department*). In this regard, Wang Shuo can be seen as a new entrepreneurial "avant-garde," one who unleashes the commercialized trend of popular culture on Mainland China.

The Wang Shuo phenomenon signifies that the traditional division between elite and popular culture no longer holds, even in "highbrow" Beijing. However, this does not mean that artistic standards are going down. While works catering to "popular tastes" have mushroomed, good literature continues to be produced, and it is marketed more aggressively than before. Another intriguing phenomenon which escapes attention is that recent

works by some of the best Mainland writers (Su Tong, Yu Hua, Mo Yan, Wang Anyi, and others) are now published in Taiwan, some under exclusive contracts. Their books, in beautifully designed and nicely packaged editions, are displayed prominently in Taipei's highly commercialized deluxe bookstores together with books by famous Taiwanese writers, most of them women (Li Ang, Zhu Tianwen, Zhu Tianxin). The business interactions between Taiwan and China have created a healthy climate for the production of creative literature and culture—in spite of incessant rumors about the decline of the number of readers and book buyers. Thus I would like to argue that the written word will continue to be printed, but increasingly it will cross-fertilize with new forms of technologically based audio-visual media—film, television, video—to create "mixed genres" of culture, both good and bad. In this regard, the cultural scene of Hong Kong provides an interesting case study.

In this former British colony of high finance, there has never been a firmly entrenched tradition of "high" culture. As a consequence, the works produced are never "pure." Thus there is hardly any market for serious fiction, which is often published and sold in Taiwan (for instance, the novels of Xi Xi, a talented Hong Kong woman writer). As is now well known, the prevailing genre of Hong Kong's popular culture is film, which has always been, as in Hollywood, an industry, not an art form. In this heavily commercialized world, even the most style-conscious auteur directors—such as Stanley Kwan, Wong Kar-wai, and Ann Hui—must endeavor to make films that are also commercially successful. Artistic originality in the so-called High Modernist sense is never a cherished value; rather, Hong Kong movie directors have made fine commodities out of the fine art of derivation.[4] They shamelessly copy Hollywood movies but manage to surpass them in style. In his early films, John Woo (Wu Yusen), currently the darling of Hollywood (*Hard Target, Broken Arrow, Face/Off*), brought a romantic flair to his violent heroes and a baroque opulence to his Hong Kong setting—something he has been unable to achieve in his recent blockbusters for Hollywood. Still, his film style is now widely emulated and in turn copied by other Hollywood directors.

If John Woo has made stylistic derivation into a fine commercial art, Jackie Chan has consciously aimed his movies at an expanding market of multinational and multicultural audiences in the trans-Chinese world. More than any other filmmaker he has the audacity and foresight to take his films—in both language and content—beyond the local Hong Kong setting, while still remaining faithful to the Chinese identity of his chief protagonist (played by himself). What Chan's kung fu predecessor Bruce Lee failed to achieve—to make a Chinese male like himself a big star in Hollywood—is now being realized by Jackie Chan and Chow Yun-fat, John Woo's favorite actor. This may have something to do with the changing ethnic composition of American society (Asian immigrants now constitute nearly half of California's population). But one should not belittle Jackie Chan's

"trans-Chinese" vision. From the typical Hong Kong locales in his early films, Chan's film settings have become increasingly global: Taiwan, Japan, Singapore, Malaysia, Australia (*Supercop*), the United States (*Rumble in the Bronx*), Africa, Europe, and even Ukraine and the Middle East. Although his films shown in the States are dubbed in English, the original versions are in Cantonese or Mandarin and also liberally spiced with English. Increasingly, this multilingual and multicultural landscape has become a given in Jackie Chan's movies, and a number of other Hong Kong films are following suit. A recent prize-winner, (*Comrades, Almost a Love Story Tian-mi-mi*), directed by David Chan, makes its male protagonist (played by a pop singer) a recent immigrant to Hong Kong from China, and has the denouement of its romantic plot take place in the Chinese communities of Vancouver and New York. Yet in spite of its contemporary twist, this very "Chinese" story is actually an adaptation of a Hollywood film called *Enemies, A Love Story* by Paul Mazursky. One is tempted to observe that while politically Hong Kong has become part of China, in film culture China and the rest of the world are becoming part of Hong Kong.

In Hong Kong, as noted earlier, even serious artists must make a living in the midst of commerce. While a few writers—Xi Xi and Dong Qizhang, for instance—can have their works published in Taiwan, most of them must compete for print space in the literary supplements, the *fukan,* of Hong Kong's daily newspapers. Some veteran writers, notably Jin Yong and Liu Yichang, were themselves editors of newspapers or the literary supplements. Jin Yong is now celebrated everywhere as the leading writer of knight-errant (*wuxia*) novels, all bestsellers. Two international conferences dedicated to his novels—one in Taipei, the other in Denver—were held in 1998. Liu has moved with ease in writing all kinds of fiction, from popular potboilers to modernist stories cast entirely as interior monologues, which were serialized in newspapers. Some of his serialized novels were extremely long. Thus when they were finally collected and published in two volumes, he had to cut them substantially. (In China, it was done the other way: material censored for journal serialization was restored when the novel was republished as a book.) Liu's case may be exceptional now, as most newspapers allow very limited space for serialized fiction. When I broached the idea of writing a novella of my own to the *fukan* editor of a Hong Kong newspaper, he welcomed my work with the proviso that it must not exceed ten thousand Chinese characters, which can be serialized in no more than a week. Hong Kong readers, he told me, have little patience to follow any fictional plot beyond one week.

Having sketched out in a selective fashion some of the new trends in cultural production in three Chinese regions, it remains for me to contemplate the last issue—trans-Chinese cultural consumption. I would like to argue that if cultural production still has its "local" origins—a movie made in Hong

Kong, a novel written in China—but circulates interregionally (a novel written by a Mainland writer but published in Taiwan and sold in both Taiwan and Hong Kong), cultural consumption has definitely taken on a trans-Chinese dimension because of the constant travel and migration of people from one region to another. Most of Hong Kong's residents are recent immigrants from Mainland China. Businessmen from Taiwan and Hong Kong travel frequently to the Mainland for business and pleasure. Increasing numbers of Chinese from all three regions have migrated to North America—so much so that Monterey Park near Los Angeles has become a "little Taipei" and parts of Vancouver, British Columbia, are another Hong Kong. In so doing they have created what might be called overseas Chinese "diasporas." And just as the experience of speaking Chinese becomes bilingual or trilingual, the experience of reading a newspaper or watching a movie in Chinese is also likely to be "pluralistic." What makes it more intriguing is the constant and intricate exchange between diaspora and homeland. A Taiwan businessman working for a multinational company sojourns in Los Angeles and reads during his after-hours a copy of the newspaper *World Gazette* (*Shijie ribao,* the overseas branch of the *United Daily News* from Taiwan), which not only includes news from all three regions but features several pages of entertainment: columns by Hong Kong writers, stories reprinted from Taiwan, as well as photos of singers and movie stars, both Chinese and American. If he goes out to a movie, the choices are even greater: he could go to the neighborhood cinema and watch a recent Hollywood movie (such as *Face/Off,* directed by John Woo), but more often he would rent a Chinese film from a video store, where he can choose films from all three regions in Mandarin or Cantonese, with or without English subtitles.

The circulation of these cultural goods also reaches the homeland: *Face/Off* was a critical and commercial hit in North America, but in Hong Kong it got only a lukewarm reception: there was nothing new, as the new film is derived from one of Woo's old Hong Kong movies. Most of Zhang Yimou's films were first shown in film festivals in Europe, then opened commercially in American theaters, and finally were permitted to be shown in China—and the receptions have varied greatly from area to area. Such complications have already raised the question: for whom are these works intended? The answer is no longer so clear cut, precisely because the audiences themselves have become mixed. We are no longer sure if a work produced in one region only embodies its local characteristics; in fact, the market economy has placed a high premium on reception and consumption. Was Zhang Yimou's film *Raise the Red Lantern* made only for a Mainland audience and intended only to attack Chinese feudal society, or did it contain elements of self-exoticization in order to appeal to the orientalist viewing habits of western audiences?[5] If works in mass media (film, television, pop songs) are already breaking the boundaries of their origin and expanding the market of their

targeted audiences, can serious works of literature and art be far behind? Is it still possible to separate art from commerce? If not, should we change forever the yardsticks with which we measure and appreciate art in this era of mechanical reproduction (to borrow from the title of a famous essay by Walter Benjamin)? And if it is still separable, how should we rescue art from commerce?

These queries and thoughts, by now already a commonplace, are triggered by my own "previewing" of some of the artworks of this exhibition. They are also intended to solicit further reflection and debate from the viewers afterwards. Whatever the conclusion, I think we all agree that contemporary Chinese art, as part of contemporary Chinese culture, can never again be uniform.

NOTES

1. See Ien Ang, "Migrations of Chineseness," *SPAN* 34/35 (1992–93): 4, 12.

2. This section of my essay is based on an earlier work titled, "Trans-Chinese: Notes on Language and Sensibility," published in *Venue* 1 (Fall 1997): 160–72.

3. Constantine Boundas, ed., *The Deleuze Reader* (New York: Columbia University Press, 1993), p. 147.

4. See my two articles on Hong Kong films: "Two Films from Hong Kong: Parody and Allegory," in Nick Browne et al., eds., *New Chinese Cinemas: Forms, Identities, Politics* (Cambridge: Cambridge University Press, 1994), pp. 202–15; and "Tales from the 'Floating City,'" *Harvard Asia Pacific Review* 1 (Winter 1996–97): 43–49.

5. For different views, see the interview with Zhang Yimou and other articles in *Public Culture* 5, no. 2 (Winter 1993): 297–316, 329–38.

NORMAN BRYSON

In the final scene of Xie Jin's *Hibiscus Town,* 1986, the villagers gather to cele-
brate the return of Hu Yuying, whose sufferings at the hands of Party officials
have provided the main plot of the film.[1] For Hu Yuying has been the victim of
a Party-led campaign to "cleanup" Hibiscus Town, to purge it of feudal and
bourgeois class elements, and to establish it as a model socialist community.
As the owner of a small but prosperous restaurant business, which the Party
promptly shuts down, Hu Yuying has been targeted by the campaign as a
conspicuous representative of the selfishness and profiteering that the Party
seeks to eliminate: she is denounced as a counter-revolutionary, financially
ruined, and reduced to sweeping the streets. In time, however, the Party
comes to modify its thinking about the economy. The world turns, and now
the very officials who had led the cleanup campaign find themselves
denounced and ostracized, while Hu Yuying is given official permission to
reopen her business. The banquet at which she entertains the entire village
is the celebration of her social reinstatement; as the villagers eat, drink, and
crack jokes, it seems that life has at last returned to normal. Then, one
minute before the film ends, into the scene of the village's united happiness
staggers Wang Quishe, a key official during the cleanup campaign, who is
now homeless, destitute, and crazy. Beating a broken gong, he walks through
the village shouting over and over the words, "Another movement! Another
movement!" Festivities cease, the villagers fall silent. Wang Quishe is now
only a crazy old man, but, "unless we are careful," one of them whispers, "his
words may come true." Another movement: what will it be next time?

Xie Jin's scene points to one crucial asymmetry between the People's
Republic of China and western countries with respect to the status of the
avant-garde. If in the West the historical problem of the avant-garde has
been its enduring weakness relative to the cultural and economic main-
stream, in China the situation has been almost the reverse: a political avant-
garde, the Party, has monopolized power for fifty years. In the course of their
history, western avant-gardes have had to contend with constant marginal-
ization; with the possible exception of the early Soviet avant-garde, ongoing
struggle against the insidious forces of the dominant political economy has
been the avant-garde's unremitting destiny.[2] The art from the People's Republic
presented in this exhibition describes a very different historical experience,
of the avant-garde (*xianfeng*) in office and in power—avant-garde practice in

varying degrees sponsored or underwritten by the state. For in certain respects, the state has itself realized as political praxis what in the West has been confined to aesthetic gestures: the battle cry of a radical break with the past, the utopian promise of starting over from a constantly recreated "ground zero," the voice of social critique, the claim that social change can be intensified and accelerated by those able to sense its global direction. If in the West the impulse to launch "another movement" has been channeled into an aesthetic ghetto, in the People's Republic it has been a state prerogative, and one formidably used.

In terms of a politics of cultural resistance, while western avant-gardes might have occasion to envy the centrality and the range of social effects produced by state-led avant-gardes, they might also recognize something depressingly familiar when it comes to the other side of this advantage: the difficulty of *differentiating* avant-garde practice from the sphere of state activity, the challenge presented by the state's preempting and absorbing the force of avant-garde strategies into its own sphere of influence—the whole problematic of complicity and entanglement which used to be called "recuperation."

That problematic appears to have become all the more complex since the institution of the Party's economic reforms under Deng Xiaoping, for now forms of thinking which earlier might have qualified as dissident or counterrevolutionary were capable of being reclassified and harnessed to the state's own program of economic diversification and the maximization of profit.[3] From this perspective, aesthetic practices that clearly advertised their relation to western precedents or counterparts, or that sought to build the institutions of an art market, could be recognized and tolerated as necessary components of the latest state drive toward modernization.[4] A society in need of advanced technology and consumer goods, and a new place in the global economy, must perforce accept new modes of aesthetic activity (conceptual art, performance art, installation art) alongside new music, new fashion, new cinema—and a new stock exchange.

Wang Guangyi's Great Castigation series, 1990–93, indicates at least one possible response to the climate of socialist-capitalist combination— which the paintings rewrite as "double kitsch" (see pl. 35). If the uncanny resemblance between state avant-gardism and aesthetic avant-gardism represented one range of possible complicities, the introduction of capitalist principles and a burgeoning art market represents another, and between them both sides of the "dual system" appear to have colonized all the available space in which an authentic avant-garde might possibly maneuver. Interestingly, however, the pessimism of Wang Guangyi's paintings seems exceptional within the present array of work from the People's Republic. In his Great Castigation series, the aspirations active in the social field on each

NORMAN BRYSON

side of the dual system (modified socialism, modified capitalism) are mocked and negated by reducing both to a level of kitsch design: each system is treated as a set of debased signifiers and formulae, as though both systems were already essentially dead. Perhaps as a kind of ironic self-protection, the Great Castigation series embraces this double failure as the work's own condition. And yet the majority of works shown here are able to find in the current situation a range of quite new possibilities.

What is striking about that situation is that the People's Republic is now a society where the principle of contradiction—the epic collision of socialist and capitalist cultures—has been allowed to develop to a unique and historically unprecedented degree (within certain bounds: the June 4, 1989, events in Tiananmen Square revealed them). The terrain opened up by colliding forces affords singular opportunities for aesthetic intervention and social critique. Here I will describe just a few of the paths which contemporary artists seem to have taken, some aesthetic practices and strategies that, at least to this observer, are both impressive and without obvious counterpart in the western context.

The first is the clarification of the changed relation of the subject to social space that is undertaken mainly, though not exclusively, by work in sculpture. Here "space" should be understood neither as a neutral container within which social processes occur, nor as the phenomenological horizon of individual perception, but rather as it is described by Henri Lefebvre: space as something that is *produced* by social forces.[5] If socialism and capitalism both generate specific kinds of space, this is not as an incidental by-product of their economic and political organization, but fundamental (both product and precondition of their systems). For some western commentators, what distinguished the organization of space in the People's Republic, at least until the mid-1980s, was its deliberate homogeneity, which notably departed from the Soviet model. There, a limited application of the capitalist process of accumulation resulted in rapid growth that deliberately privileged particular "strong points" in large-scale enterprises and cities.[6] Following a Leninist principle of uneven development, such strong points were able to achieve sometimes spectacular levels of development, but at the expense of peripheral areas that were "abandoned to stagnation and (relative) backwardness" (Lefebvre). The Cultural Revolution opposed the negative effects of the Soviet model by setting out to prevent the rift between strong and weak points, with particular emphasis being given to agricultural towns, and to undoing the opposition between town and country (for instance, through the transfer of urban groups to the countryside). At least in principle, the state aimed at the construction of a continuous national space in which collective ownership, combined with the avoidance of dominant "strong points," wove a seamless fabric of space from the capital to the provinces.

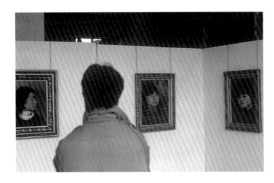

Fig. 1
GENG JIANYI
*Tap Water Factory: A Mutually
Voyeuristic Installation,* 1987

Fig. 2
WANG JIN
Ice: Central China 1996,
Zhengzhou City, Henan Province,
January 28, 1996

The transformations proposed in this space by the state's relative moderation of the controls on free expression are the subject of Geng Jianyi's *Tap Water Factory: A Mutually Voyeuristic Installation,* from 1987 (fig. 1). Looking from the outside in, viewers are constructed as anonymous members of collective space; looking from the inside out, the same viewers are framed as individual portraits inside ludicrous, mock-western frames. The wit of Geng's work lies in its clarification of the new public/private distinction opened in social space by the lightening of restrictions on individual expression; though at the same time the installation clearly satirizes the new "flexibility" that this situation opens up, the burden of being obliged to move from public to private and back again, which the latest stage of modernization now requires of its subjects. The tone of satire is considerably darker, however, in Wang Jin's *Ice: Central China, 1996,* a work from nine years later, when the negative consequences of socialist-capitalist coexistence have become much more apparent.

The ice wall that Wang Jin installed in Zhengzhou City in 1996 offers a stark view of the transformations wrought in space as a consequence of the new economic reforms (fig. 2). Zhengzhou City is an old industrial center, the capital of Henan Province, and as a result of the encouragement of the consumer economy, by the mid-1990s it was experiencing the boom conditions that have occurred in so many Chinese cities, in the period when national productivity and capital resources have been rapidly increasing. In the town center Wang Jin constructed a large wall of ice, into which had been set a selection of consumer items, expensive and desirable by any standards, including cellular phones, cosmetics, and jewelry.

The installation took place during the winter months in this cold northern city, though how many days the wall might have actually taken to melt will never be known, since it was swiftly dismantled by hands eager to lay hold of the goods it contained. The installation succeeded with admirable black humor in stating the terms of social atomization and divisiveness that are consumerism's bottom line, as well as spelling out the changed nature of the economic object. If the joke-stereotype of socialist goods is that they can never get beyond dramatizing the conditions of their own production, and that abysmal design values are deployed as a fetish to ward off the specter of the subject-as-consumer, now the shiny consumer-object was made the butt of a different set of jokes—and analyses. The first was that if the free trinkets in the ice wall illustrated the principles of the consumer economy, it was obviously by inverting them, since in consumerism proper "nothing is for nothing." The second was that if the ice wall had managed to cut through official pieties about the noble aim of achieving national prosperity, revealing instead the sheer force of greed that the new economy had released into social space, it was a greed from which no one could easily dissociate himself,

NORMAN BRYSON

since all concerned were its accomplices—the Party that had fostered the new economic climate, the citizens who tore down the wall with their bare hands, even the artist himself (where had Wang found the money for the installation? on what grounds could such artistic potlatch be justified?). The ice wall managed to suggest, as well, something rather subtle about the strange new economic temperatures present within the consumer economy: the bargain-basement heat of consumers inflamed by the display of goods was literally pitted against a glacial order of objects, which both catered to desire as never before, and at the same time immobilized desire, freezing and "reterritorializing" desire into the monumental form of the commodity fetish.

Besides the disruption and reformulation of social space, many of the works presented in *Inside Out: New Chinese Art* are strikingly concerned with the terms of discourse and the subject's place in discursive regimes; one can speak of a distinct art-and-language movement, including work by Wu Shan Zhuan, Wenda Gu, Xu Bing, Qiu Zhijie, and Song Dong. Perhaps the most conspicuous feature of this range of work is the centrality of the metaphor of script as a means of locating and analyzing issues of social orthodoxy and their relation to individuality, as well as the operations of power within individual subjects. In Wu Shan Zhuan's *Red Humor,* 1986 (pl. 5), the contents of consciousness are literalized as a set of disparate language fragments displayed on the walls, ceiling, and floor: political slogans from the Cultural Revolution appear alongside the newer slogans which, under Deng, had come to replace them; lines from classical poetry and Buddhist scripture are placed next to advertising captions, private messages, the title of a western artwork (Leonardo's *Last Supper*), medical texts, and jokes. On the floor, four large-sized characters announce the phrase "No one can interpret it" (*Wu ren shuo dao*).

If the installation is taken as a model of the circulation of social discourse within the individual subject, what it insists on is the radical heterogeneity of the ensemble: this is a subject defined as a more or less random collection of elements. While the political connotations of the work are somewhat elusive, what is clear is Wu's decision not to present the subject in dialectical terms: though the phrase "class struggle" puts in an appearance, together with other slogans new and old, these seem no more important than phrases like "Mr. Wang, I went home" or "No water this afternoon."[7] The mental "contents" on display refer to too many contexts and occupy too many levels for the subject they represent to be reducible to any of the global descriptions essential to the discourse of ideology (subject of class, subject of history). Though the work is strongly committed to the outlook of historical materialism—the subject does not appear as transcending the social field, but on the contrary as deriving from it in every way—what is missing is the coherence necessary to the operations of political discourse. Though many kinds

of language are included, the emphasis on plurality or hetero-glossia neutralizes and drains the ideational or "content" level of language itself ("no one can interpret it"): essentially the level of ideology is evacuated.

The emptying out of the semantic dimension of language is indeed the central gesture of many of these language works. In the piece entitled *"A History of Chinese Painting" and "A Concise History of Modern Painting" Washed in a Washing Machine for Two Minutes* of 1987/1993, by Huang Yong Ping, the text of art history is reduced to pulp (pl. 16). In Wenda Gu's Pseudo-Characters series, 1984–86, the ideograms convey a vestigial content, but their form has been severely distorted: characters are reversed, turned upside down, and rebuilt with their elements moved to the wrong place (fig. 3; pl. 3). In Xu Bing's *Book from the Sky,* 1987–91, boxed sets of books bound in blue paper covers seem at first sight to be authentic classical texts, printed in characters in Song script, but on further inspection none of the characters can be pronounced or understood (fig. 4; pl. 6).[8] Xu Bing's recent *New Language Project,* 1998, is a variation on the same idea. The work takes the form of an English-language dictionary where the alphabet is composed of elements of Chinese characters: as words in "English" the dictionary makes sense, but as "Chinese" the letters are meaningless. What are we to make of this semantic depletion?

To the western viewer, the act of randomizing language might seem to be a reworking of Surrealist automatic writing, or of William S. Burroughs' cutting-up the "word lines": a gesture of pure voluntarism in language, an utopian dream of escape from the orbit of the signifier and, by extension, from the social field. That may well be one aspect of these works, and yet the emphasis on semantic exhaustion or nullification seems to have a particular valence in the political context of the post-Mao years. Something of this may be sensed in Zhang Peili's *Water—The Standard Version Read from the "Ci Hai" Dictionary,* 1989, in which Xin Zhibin, a star newscaster on Chinese Central Television (CCTV), who earlier in 1989 had been the first to report the massacre in Tiananmen Square, recites the words of a dictionary *as if* they were the news (1992 version, fig. 25). The rubbing out of the text's semantic level has, in this case, everything to do with the waning of the Party's authority, and of the credibility and viability of its discourse. With Xu Bing and Wenda Gu the connection is not as direct as it is with Zhang, yet it is difficult to avoid taking the aesthetic gesture of effacing the contents of script as a metaphor for a society in which the coherence of the discursive field, and of the subjectivity proposed and assumed by that field, may no longer be determined at the level of ideology—that is, of the shared beliefs and values of its members.

Consider, for example, Qiu Zhijie's *Writing the "Orchid Pavilion Preface" One Thousand Times,* 1986 (pl. 8). The artist performed an exercise familiar to any serious student of Chinese calligraphy—copying again and again the perfection of Wang Xizhi's classic text, the *Lanting xu,* or *Preface Written at*

the Orchid Pavilion—with this difference, that the copies were all made on the same sheet, which at the end of this process became a mass of illegible black ink. It is not the force of the original that is at stake here: the "first" version of the *Preface,* written in the fourth century, was already lost by the seventh century, when the Emperor Taizong ordered it to be entombed with his own body in the Zhao Mausoleum at Xi'an; the authority of the *Orchid Pavilion Preface* is that of the copy itself. If in Qiu Zhijie's work orthography is a metaphor for social orthodoxy or cultural reproduction, the basis of the text's power is not to be found in its contents—in what its author said—but in the sheer force of cultural repetition, especially through the internalization of social authority that is performed within the calligrapher's body as he attempts to incorporate the text inside his own musculature and gestural reflexes. A comparable description of social power is suggested in Song Dong's *Printing on Water,* 1996, in which the artist, standing in the middle of a river, repeatedly strikes the surface of the water with a heavy, archaic seal (pl. 9). The seal leaves no trace; its semantic dimension is instantly lost. What remains, however, is the central gesture of the subject's interpellation within the graphic or social field, where power is located entirely within the individual subject's repeated action of creating and re-creating the authority of the seal within his own psychophysical being, again and again.

The contents of Xu Bing's imaginary books, or Wenda Gu's characters, or Song Dong's seal, are in each case drained of meaning. What that efface-ment dramatizes, beautifully and impressively, is that script—or the social field—may exist not only as a structure of contents or ideas; its coherence may instead come from its own compulsive systematicity, and at levels deeper than—or indifferent to—the ideological. What is perhaps being sketched here is an idea of power that, in the West, can be expressed only in tentative terms: that in societies of disciplinarity, ideology may no longer be required to be the primary cohesive force binding the subject in social space. What holds the social formation together are modes of activity whose basis lies at the microlevel, in the myriad acts of repetition and self-regulation by which the subject inscribes itself in social discourse. Viewed negatively, the art that enacts this position can be thought of as the expression of "cynical reason," as Peter Sloterdijk has described it.[9] The cynic knows his beliefs to be empty, he is already "enlightened" about his ideological relation to the world; to that extent he has rendered himself immune to the charge of bad faith, or of complicity with the dominant order. What this position constructively opens up, however, is a new territory of analysis and practice. For if power is no longer to be located at the macrolevel of the great ideologies, in the colossal and mythic confrontation of socialism and capital, and if it is instead to be found at a microlevel that is "below" politics and ideology, then individual subjects are able to intervene and innovate at their own scale and on their own terms. If the basis of cultural reproduction lies in the subject's own

capacities for compulsive repetition and system-building, the significance of aesthetic practice is that it permits those capacities to be deflected or redirected toward the subject's own ends. The art of the avant-garde becomes a model of the ways in which subjects—however great the historical pressures acting upon them—may organize and lead their own lives.[10]

NOTES

1. *Hibiscus Town* (Furong zhen), after the novel by Gu Hua; Shanghai Film Studio/China Film Corporation, 1986.

2. Peter Bürger, *Theory of the Avant-Garde,* trans. Michael Shaw (Minneapolis: University of Minnesota Press, 1984).

3. Julia F. Andrews has shown that the rapid development of avant-garde art in the period 1979–89, and especially in the years of intense activity from 1985 to 1989, had as its precondition a series of Party reforms and changes of personnel directly related to the goal of economic progress. See "Fragmented Memory: An Introduction," in *Fragmented Memory: The Chinese Avant-Garde in Exile* (Columbus: Wexner Center for the Arts, Ohio State University, 1993), pp. 6–13, and esp. pp. 8–10.

4. See, for instance, Li Honglin, "Open Policy Essential to Socialism," *Beijing Review* no. 13 (April 1, 1985): 15–18; cit. Andrews, "Fragmented Memory," p. 8.

5. Henri Lefebvre, *The Production of Space,* trans. Donald Nicholson-Smith (Oxford: Blackwell, 1991).

6. Lefebvre, *The Production of Space,* p. 421.

7. See Gao Minglu, "The Context in the Text: Meaning in Wu Shanzhuan's Work," in *Fragmented Memory,* p. 32.

8. See also Gao Minglu, "Meaninglessness and Confrontation in Xu Bing's Art," in *Fragmented Memory,* p. 28. The title of this piece has also been translated as *Book of Heaven.*

9. Peter Sloterdijk, *Critique of Cynical Reason,* trans. Michael Eldred (Minneapolis: University of Minnesota Press, 1987).

10. I would like to express my especial thanks to Gao Minglu for generously giving of his time in many stimulating discussions of avant-garde art in the PRC; and to Eugene Wang for his helpful comments on an earlier draft of this essay.

WU HUNG

This essay reflects upon the meaning of modernity and postmodernity in Chinese art from a particular angle. I have chosen *ruin,* and by extension *fragmentation,* as my focus for two reasons: first, it has been frequently noted that fragmentation characterizes both modernist and postmodernist art movements in the West, and a large body of literature has been devoted to this subject. Second, ruin and fragmentation are also important concepts in twentieth-century Chinese art, but their implications, and hence the notion of the modern and the postmodern, must be understood in relation to China's cultural tradition and political experience.

Whether discussing classical ruins or modern photography, western criticism generally links fragmentation to artistic creativity and imagination. This positive attitude grew out of a long tradition in Europe, in which ruins were represented from at least the Middle Ages. Beginning in the sixteenth century, ruins, both actual remains and fabricated ones, were installed in gardens. In the eighteenth century, according to Kurt W. Forster, ruins "became an intriguing category of building in themselves: the more strictly specialized and type-cast architecture became, the more ruins—structures which have outlasted their usefulness—it was bound to produce over time."[1] Sentiment toward ruins penetrated every cultural realm: "They were sung by Gray, described by Gibbon, painted by Wilson, Lambert, Turner, Girtin and scores of others; they adorned the sweeps and the concave slopes of gardens designed by Kent and Brown; they inspired hermits; they fired the zeal of antiquarians; they graced the pages of hundreds of sketchbooks and provided a suitable background to the portraits of many virtuosi."[2] It was this tradition that led Alois Riegl to write his theoretical meditation on the "modern cult" of ruins at the turn of the century.[3] The same tradition also underlies many modernist and postmodernist theories, which, taken as a whole, elucidate a progressive internalization of fragmentation from reality to art itself: the subject of fragmentation has gradually changed from the external world to the language, imagery, and medium of representation.

China's situation was different in two respects. First, in China, ruin sentiment was primarily a premodern phenomenon; in the modern era ruins acquired a dominant negative symbolism. Second, even in traditional China, the aestheticization of ruins took place mainly in poetry; visual images of

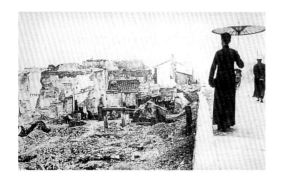

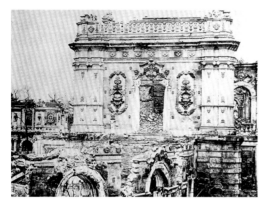

Fig. 5
Untitled (Ruined streets), 1911
School of Oriental and African Studies,
University of London

Fig. 6
Ruins of the Yuanming Yuan, gardens of
the Manchu royal house outside Beijing,
which were destroyed in 1860

ruins virtually did not exist. I reached this second conclusion after an exhausting but unproductive search for "ruin pictures" and "ruin architecture."[4] Among all the traditional Chinese paintings I have checked, fewer than five depict not just old, but *ruined* buildings. As for actual "ruin architecture," I have not yet found a single premodern Chinese case in which a building was preserved not for its historical value but for a ruinous appearance that would show, as Riegl has theorized in the West, the "age value" of a manufactured form.[5] There was indeed a taboo in premodern China against preserving and portraying ruins: although abandoned cities or fallen palaces were lamented in words, their images, if painted, would imply inauspiciousness and danger.

When this Chinese tradition encountered European "ruin" culture, two things happened: on the one hand, this encounter led to the creation of ruin images in Chinese art and architecture; on the other, these images, as modern memory sites, evoked the calamities that had befallen the Chinese nation. The first effort to document architectural ruins was made by European photographers beginning in the mid-nineteenth century. Their works mixed western sentiment for decayed buildings, orientalistic fascination with "old China," and archaeological or ethnographic interests. Although these works can be generally characterized as "orientalistic" or "colonialist," their impact on China can hardly be exaggerated because they initiated a modern visual culture. What ensued has been a separate history of ruins in China. Ruin images were legitimated; but what made them "modern" (i.e., what distinguished them from classical Chinese ruin poetry) was their emphasis on the present, their fascination with violence and destruction, their embodiment of a critical gaze, and their mass circulation. These features characterize an anonymous photograph that shows a street scene during wartime in the early twentieth century (fig. 5). The subject of the picture is a devastating destruction. First, the ruined buildings are still "raw," not yet sunk into the depth of historical memory; we may thus call them "ashes" to distinguish them from those aestheticized ruin images in classical poems. Second, the picture poses as a snapshot and hence captures a fragmentary visual experience. As a photographic image, it self-consciously preserves the transience of the present in a stable and reproducible form. Third, although the photographer is unknown, the intrinsic gaze, embodied by the street onlooker in the scene, is Chinese.

The last of these features makes this photograph a metapicture: the ruins are scrutinized and qualified by a Chinese gaze, and this gaze—a historic one, I must emphasize—had already been thoroughly politicized by the time the picture was taken. The same gaze, in fact, created the first and most important modern ruin in China: the remains of the Yuanming Yuan, a group of famous gardens of the Manchu royal house outside Beijing that were destroyed in 1860 by the joint forces of the British and French armies (fig. 6). Only in recent years has this ruin been made into a public park. For most of

the twentieth century, images of the destroyed gardens were known to the public largely through photographs. Articles and poems accompanying these photographs emphasized the gardens' symbolism as a "witness of foreign evils"; their anti-colonialist and nationalist sentiment separated them from traditional ruin poetry. In a more fundamental sense, these expressions signified the emergence of a modern Chinese conception of ruins, that architectural remains surviving from war or other human calamities were "living proof" of the "dark ages" caused by foreign invasion, internal turmoil, political repression, or any destruction of massive, historic proportions. This conception also made the Yuanming Yuan a symbol shared by individuals and the state. After the establishment of the People's Republic of China, the remains of the gardens were preserved as a "memorial to national shame in the pre-Revolutionary era." But when the unofficial art group the Star emerged after the Cultural Revolution, its members also painted the Yuanming Yuan and held poetry readings among the gardens' dilapidated stones (fig. 7; in this picture, first published in 1982 in France, the people's faces are covered to avoid identification and persecution).

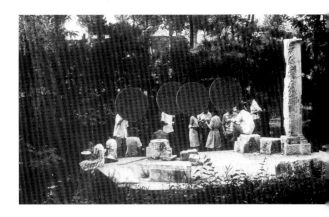

Fig. 7
Poetry reading organized by the Star group in the ruins of the Yuanming Yuan, c. 1981

This new conception of ruins explains the wide appeal of fragmented images in contemporary Chinese art after the Great Proletarian Cultural Revolution, the most recent human calamity (commonly recognized as the most severe political persecution in the country's long history). As in many other regards, the Star's inclination for ruins anticipated a major direction of the '85 Movement (or New Wave), which surfaced in 1984 and soon spread across the entire country. The extraordinary significance and complexity of this "avant-garde" movement still await further discussion. What matters for this essay is that for the first time in Chinese art, ruin images were created with frequency and intensity in various art forms, including painting, photography, installation, and happenings.

Wu Shan Zhuan's 1986 installation in Hangzhou, *Red Humor,* exemplifies one major tendency to evoke situations or experiences typical of the Cultural Revolution (pl. 5). A windowless room covered by layers of torn paper and pieces of writing, this work alludes to Big Character Posters, a major form of political writing during the Cultural Revolution. This connection becomes visible not only in the work's general visual imagery but also in medium (ink and "poster paints" on paper), color scheme (predominately red), production (random participation of the "masses"), and psychological impact (sense of suffocation produced by chaotic signs in a sealed space). But Wu was not simply restaging a vanished historical episode; instead he tried to create a new vocabulary of ruin images—forms that have been removed from the original context and begun to convey new social meaning. As Lü Peng and Yi Dan have observed, the words on the walls are not the revolutionary slogans fashionable during the sixties and seventies, but commercial ads that

Fig. 8
Artworks by the Xiamen Dada
group being burned after their
first exhibition, Hangzhou, 1986

began to fill Chinese newspapers from the mid-eighties. In Wu's simulation of Big Character Posters, therefore, ruins as remains of the past have become part of the present.

In this way, Wu Shan Zhuan separated himself from the previous "Scar" or "Wounded" (*Shanghen*) artists, who attacked the Cultural Revolution through their realistic but sentimental historical paintings. While these artists single-mindedly criticized the past and finally merged with official propaganda, Wu found the past *in* the present. In a broad sense, his art represents a radical departure from the traditional conception of ruins. According to Stephen Owen, "the master figure [of classical ruins poetry] is synecdoche: the part that leads to the whole, some enduring fragment from which we try to reconstruct the lost totality."[6] Wu Shan Zhuan's ruin imagery did not lead to the reconstruction of a "lost totality" in the imagination, but only to further fragmentation of the past as well as the present.

This critical spirit was shared by Huang Yong Ping but manifested itself in a different form. The name of the art group Huang and his colleagues formed in 1986, "Xiamen Dada" or "Dadaists of Xiamen," highlights their strategy of "quoting" (i.e., transplanting) names and formulas in a new context—a dislocation that critiques both the quotation and the situation. The public burning of their works at the end of their first group exhibition may have been inspired by Dadaist nihilism; but the photographic record of the burning (fig. 8)—the only surviving image of the event to reach a larger public—unmistakably recalled the burning of books and artworks during the Cultural Revolution. Huang's *"A History of Chinese Painting" and "A Concise History of Modern Painting" Washed in a Washing Machine for Two Minutes,* 1987/1993, shifted the focus from destruction to a "still life" of ruins: a conglomeration of paper paste—the remains of the two books—piled on a piece of broken glass supported by an old wooden trunk (pl. 16). The washing machine is not shown and the destruction of the books is only implied. Again, this work, when viewed in the post–Cultural Revolution context, delivers two overlapping messages: according to Huang himself, it expresses his negation of any formal knowledge, ancient or modern, eastern or western; but viewers who had gone through the Cultural Revolution still remember clearly how "knowledge" was negated and how similar art books were destined to be destroyed during the political turmoil.[7]

Related to these ruin images was an intense interest among many '85 Movement artists in disembodied *signs*—Chinese characters often, but also including isolated visual elements such as "standardized" colors, imprints, or figures. It is tempting to link this interest to the postmodern discourse on "language games" and the deconstruction of the "grand narrative" of modernity. Indeed some Chinese artists expressed their ideas with terms borrowed from theories of postmodernism introduced to China in the middle and late eighties. It should be emphasized, however, that the Chinese interest in the

fragmentation of language had its indigenous origin in the Cultural Revolution. That decade produced innumerable copies of a few sets of images and texts—mainly Mao's portraits, his writings, and his sayings—in every written and visual form (fig. 9). The chief technologies of cultural production during that period were *repetition* and *duplication*—two essential methods used to fill up a huge time/space with limited images and words, thereby creating a coercive, homogeneous verbal and visual language in a most static form. The metalanguage of the Cultural Revolution was therefore never a metanarrative. Consequently, the target of "postmodern" deconstruction mobilized by young Chinese artists was not really a Marxist scheme of grand social evolutionism, but the cultural production and visual language of the Cultural Revolution.

In addition to written characters, other material for repetition and duplication during the Cultural Revolution—including Mao's portraits, typical images in propaganda posters, and the color red—was reduced to isolated and hence illogical fragments. These forms were extracted from the original process of production and reproduction, distorted at wish for any possible formalist or ideological reason, and mixed with signs from heterogeneous sources. Such practices have become so common in Chinese art since the 1980s that they transcend the differences between individual trends (e.g., Political Pop, Cynical Realism, or Critical Symbolism) and actually unite these trends into a single movement. In fact, from a broad historical perspective, we could call mainstream Chinese art from the late seventies to the mid-nineties "Post–Cultural Revolution Art" because the basic means and goals of this art were to recycle, criticize, and transform the visual language of the Cultural Revolution. An important component of this art, fragmentation is "an attitude as well as a technique, a perception as well as a procedure."[8] But with the Cultural Revolution gradually receding into the past, images derived from this era were used increasingly less for political criticism and increasingly more for visual, intellectual, or even commercial purposes.

From the middle to the late eighties, images "fragmented" from the Cultural Revolution repertory, such as Wu Shan Zhuan's red stamps and flags, 1987 (fig. 10), and Wang Guangyi's *Mao Zedong No. 1*, 1988 (pl. 34), still provided definite references to their prototypes. But gradually such references were complicated or disguised. Works of Political Pop, arguably the predominant trend in the early and mid-nineties, did not simply cite and deface Cultural Revolution images but also distorted them and combined them with signs from heterogeneous sources: commercial trademarks and advertisements (Wang Guangyi, pl. 35), textile patterns (Yu Youhan), sexual symbols (Li Shan, pls. 37, 38), computer images (Feng Mengbo), legendary and folklore figures (Liu Dahong), and family portraits (Liu Wei, pl. 39, and Zhang Xiaogang, pl. 26). Although largely mixing and appropriating existing images, these works should not be simply equated with Jamesonian "pastiches,"[9] because

Fig. 9
Making images of Mao during the Cultural Revolution

Fig. 10
WU SHAN ZHUAN
Red Characters, 1987

Fig. 11
XU DAN
New Order, 1994
Installation in Guangzhou

Fig. 12
ZHAN WANG
Ruin Cleaning Project '94
Action and installation in Beijing, 1994

in these works the Cultural Revolution images remain central, and because artists were still trying to forge a distinguishable "style" and an artistic individuality.

Political Pop marked the end of Post–Cultural Revolution Art and ushered in a recent change in Chinese art around the mid-nineties: many artists have finally bid farewell to the Cultural Revolution and all its visual and mental baggage. Their works directly respond to China's current transformation, not to history or memory. It is perhaps still too early to summarize the general tendencies of these works; but some of them reflect a clear attempt to document the ongoing fragmentation of Chinese society. The Guangzhou installation artist Xu Dan, for example, combines disfigured plastic mannequins, war souvenirs, and an enormous image of a smiling policewoman in a work titled *New Order* (fig. 11). Viewers are confused by the random mixture of media, the incoherent size relationship of images, and the casual association between fashion and violence. The illogicality of this installation, according to Hou Hanru, mirrors "the fact that reality is full of conflicts and incidents, while chaos, entropy and permanent precariousness are the real 'rules.'"[10]

An important aspect of China's transformation in recent years is the rapid growth of the city. At the same time, the city has become increasingly incoherent and incomprehensible; its growth is visible from the forest of cranes and scaffolding, the roaring sound of bulldozers, the dust and mud — signifiers of a never-ending destruction and construction. Old houses are coming down every day to make room for new buildings, often glittering highrises in so-called postmodern styles. To some city residents, demolition means forced relocation; to others it means a deepening alienation of people from the city. The feelings of helplessness and frustration generated in this process are expressed in Zhan Wang's *Ruin Cleaning Project '94* (fig. 12): he chose a section in a half-demolished building for "restoration." He first washed it carefully and then painted doors and windows on it. But scarcely had he finished when the building was razed.[11]

Uncertainty in the external world forces people to turn to a smaller, private space. Indeed "interior furnishing" (*shinei zhuangzhi*) has become one of the most profitable businesses in recent years. New shops selling western-style furniture, modern kitchen and bathroom equipment, and fancy light fixtures are seen everywhere in Chinese cities, and one can find all sorts of "interior decoration" guides in bookstores. The common wisdom of interior decoration, however, still centers on the notion of a *jian* or "piece." A "big *jian*" means a piece of furniture or equipment that has acquired a conventional social meaning: it not only fulfills the need for convenience or comfort, but also demonstrates the owner's sophistication, social connections, and financial status. A well-furnished apartment is essentially a collection of such "big *jian*," which are sought-after goods but often prohibitively expensive

WU HUNG

even for a family of middle-level income. The accumulation of these *jian* thus demands long-term planning and hard work. This social practice has created a specific sense of interiority—a private environment in which men and women are linked with (and identified by) their "fragmentary" belongings. This "postmodern" sense of interiority is the subject of a series of oil paintings which Zeng Hao created between 1995 and 1997 (fig. 13). In each painting, isolated pieces of stylish furniture and audio-video equipment, like miniatures made for a dollhouse, are scattered on a flat background. Young urban professionals dressed in neat, western-style clothes are randomly situated amidst these enviable belongings, staring blankly at the empty space before them. In an interview, the artist related these fragmentary images to his experience in Guangzhou: "Every day you see, in home after home, everyone is filling his [or her] home with fancy stuff. It feels weird in such an environment."[12]

But to Zeng, what is weird—what has become fragmentary in present China—is not only space and objects, but also time and subjectivity. The title of each of his "interior" paintings indicates a moment: *31 December; Thursday Afternoon; Yesterday; Friday 5:00 p.m.;* or *17:05, 11 July.* There is no continuity between these moments; and we do not even know which moment is earlier or later because the year is never given. These titles thus function as fragmented signifiers which fail to link experiences into a coherent sequence. As a result, the interior space, with its fragmentary figures and things, is always in a perpetual present. These and similar works are the artists' direct observations and critiques of new social spaces now emerging in China's urban centers—spaces of commodity, privacy, and interiority. Related to this new social landscape are changing conceptions of time, place, and human relationships, which are given visual images.

Fig. 13
ZENG HAO
5:00 p.m., 1996
Courtesy of the artist

NOTES

1. Kurt W. Forster, "Monument/Memory and the Mortality of Architecture," in K. W. Forster, ed., *Monument/Memory* special issue, *Oppositions* 25 (1982): 11.

2. Michel Baridon, "Ruins as a Mental Construct," *Journal of Garden History* 5, no. 1 (January–March 1985): 84.

3. Alois Riegl, "The Modern Cult of Monuments: Its Character and Its Origin" (1903), trans. K. W. Forster and D. Chirardo, in Forster, ed., *Monument/Memory,* pp. 20–51.

4. I did this research for my paper "Ruins in Chinese Art: Site, Trace, Fragment," delivered at the symposium "Ruins in Chinese Visual Culture," held at the University of Chicago on May 17, 1997.

5. Riegl, "Modern Cult of Monuments," pp. 31–34.

6. Stephen Owen, *Remembrances: The Experience of the Past in Classical Chinese Literature* (Cambridge, Mass.: Harvard University Press, 1986), p. 2.

7. The meaning of such projects changed when Huang Yong Ping continued them outside China. For example, in 1991, at the Carnegie Library at Pittsburgh, he showed "book

ruins" made from hundreds of old art journals that he had soaked and put through a mincer. Divorced from the Chinese context, this project simply expressed his own negation of "book knowledge."

8. Craig Owens, "The Allegorical Impulse: Toward a Theory of Postmodernism," in Brian Wallis, ed., *Art After Modernism: Rethinking Representation* (New York: New Museum of Contemporary Art, 1984): 204.

9. See Fredric Jameson, "Postmodernism, or the Cultural Logic of Capital," *New Left Review* 146 (July/August 1984): 53–92, and esp. 64–65.

10. Hou Hanru, "Towards an Un-Unofficial Art: De-ideologicalization of China's Contemporary Art in the 1990s," *Third Text* 34 (Spring 1996): 37–52; p. 50.

11. See Ibid.

12. Quoted from Li Xianting, *"Pingmian er shuli di richang jingguan: Zeng Hao zuopin jiqi xiangguan huati* (Flat and detached scenes in ordinary life: Zeng Hao's work and some related topics)," in *Zeng Hao* (Beijing: Zhongyang meishu xueyuan hualang, 1996), p. 1.

CHANG TSONG-ZUNG

Chinese contemporary art came to the attention of the international art scene in the early 1990s. This was mainly the result of group exhibitions of Chinese artists and the inclusion of Chinese in international exhibitions and biennials. The interest was stimulated by the skill with which artistic tools familiar to western eyes were employed to achieve exotic results: one sees a freshness, a vitality, and inspiration from unlikely sources. Gradually attention was drawn to issues concerning modernity and alternative modernities, and Chinese art became a valid voice in contemporary international discourse. In China, however, critics mainly look at the creative scene through its sociocultural ramifications, in other words, the direction of new trends and their relation to politics. They are more concerned with modernity as a Chinese problem rather than as a contemporary international issue examined under the lens of postcolonial and postmodern studies. The interpretation and curatorial direction of Chinese exhibitions in the West therefore establishes a locus of dynamics that is potentially stimulating to artists and useful for understanding China's cultural role in the modern world.

In the international arena today we mainly see China's new experimental art, yet until the late 1980s cultural interest in China had focused on art's relation to history and tradition. Although Communism has never been sentimental about Chinese culture, with its modernization program expressly aimed at attacking traditional roots, in the 1980s this trend had to be reversed, or at least suspended, as China sought to assert its legitimacy in history through an emphasis on continuity with the past. The dismal failure of the Cultural Revolution (1966–76) signaled a need to reestablish political authority through alignment rather than confrontation with the past. In a bid to highlight China's glorious past, archeological discoveries were lauded; and traditional-style painters, who receive only a lukewarm acceptance in the West, were promoted to and accepted by the Chinese diaspora as modern masters who represent the new Chinese artistic orthodoxy. Those masters lauded in the 1980s, such as Li Keran and Lu Yanshao, were mostly senior painters who had maintained strong links with traditional styles but had demonstrated a contemporary spirit in their interpretation of brushwork, subject matter, and temperament. Their art asserts traditional aesthetic principles while changing its aesthetic taste. Without looking at art deemed

"unofficial" and "avant-garde," we already see a discrepancy between China's projected image and its political ethos, which was being reinforced by interpretation and selective acceptance by the Chinese diaspora. The dynamics between projected self-image and degrees of acceptance by its intended audience have continued to serve an unspoken function of arbitration in cultural politics, along with a subtle struggle for a voice in the shaping of the Chinese identity while maintaining an amicable dialogue.

Toward the end of the 1980s, the dynamics shifted somewhat as a new generation came of age. Most importantly the cultural dialogue now also involves overseas Chinese audiences steeped in western culture, and it increasingly involves a direct dialogue with the West, the fountainhead of "modernity."

It is important to mention this earlier history of contemporary art outside China because it has practically been excluded from the discussion of new Chinese art during the 1990s. This is due to two reasons. Firstly, the nature and subject matter of traditional-style art is restricted by its artistic language and has a limited ability to be seen and discussed in the context of contemporary issues. Secondly, for cultural and political reasons, experimental artists always play a more effective role in international discourses — not necessarily because of their artistic quality, but because of the currently perceived role of art. Unlike traditional-style art, experimental art is often seen to be the daring, inquisitive mind of society, which partly accounts for the emphasis of its "dissident" and "unofficial" character until recently.

There is a tendency in western art to look upon artists as shamans and inspired spirit mediums (artists like Joseph Beuys and Marcel Duchamp certainly perpetuated the myth) and for their work to invite intellectual commentaries and textual exegesis. By comparison, the "fine art" artists in China have historically looked upon themselves as intellectuals rather than visionaries; they take pride in being men of letters with cultural (if not political) responsibilities. The traditional hierarchy of poet/calligrapher/painter reflects this attitude. In this century, the transition from dynastic to republican China was brought about by intellectuals, many of whom were artists. The role of modern artists is therefore laden with political overtones. Until today, modern artists, both traditional-style and experimental ones, have been looked upon as progressive intellectuals whose works carry social and cultural implications.

Rather than viewing it as an example of conservatism, the ascendancy of traditional-style art in China since the late 1970s should be seen as the first rebellion against the orthodoxy of Communist Revolution. Chinese both at home and abroad felt a deep general resentment of destruction during the Cultural Revolution. The perception of cultural tragedy was perhaps stronger just across the border in Hong Kong and Taiwan, as the people there did not have to reckon with the realities of survival under a totalitarian ideology and could be more charitable toward their heritage. It did not matter whether the Chinese government took the program of culture in earnest. What was important

CHANG TSONG-ZUNG

was that its support of traditional-style artists gave the government a new image as the heir of a historical legacy. This goal was reinforced in real terms by the art market, as collectors in Hong Kong and Taiwan made many traditional-style painters cultural heroes with commercial success. In the 1980s, there was a happy confluence between the official line and its reception by the Chinese abroad.

These traditional-modernists did not fare as well internationally, although the traveling exhibition *Contemporary Chinese Painting from the People's Republic* that was organized in 1983 by the Chinese Culture Center in San Francisco under the directorship of Lucy Lim was a landmark, and it launched the careers of painters like Wu Guanzhong (b. 1919) and Li Huasheng (b. 1944), who rose to succeed the older generation of Li Keran (1907–89), Lu Yanshao (1907–93), and Zhu Qizhan (1892–1996). As a footnote to this history, it should be remembered that even though they may be known to art students today, only a few of this older generation were widely known abroad in the 1970s. Li Keran was considered the official master, but even old painters like Zhu Qizhan were relatively unknown. Many works of the traditional-moderns became available in the 1980s, but practically nothing on new, experimental art was distributed outside the Mainland. The first book-length survey—which included non-traditional art—was by Joan Lebold Cohen, *The New Chinese Painting, 1949–1986,* published in New York in 1987. Over the next several years books by art historians specializing in China such as Michael Sullivan, Jerome Silbergeld and Gong Jisui, and Julia F. Andrews added to the knowledge of China's modern and contemporary art scene. All in all, the interest in Chinese contemporary art was relatively restricted in the West, with the art essentially circulating among institutions devoted to Asian culture.

The emergence of experimental art beyond the Chinese borders began in the early 1980s when the early avant-gardists, such as the Star group (*Xingxing*), which first appeared in Beijing in 1979, immigrated abroad and organized small exhibits of "dissident" art. Most of their activities were concentrated in Japan and France. Again, this had little impact on the art world at large. A few Chinese artists were invited to participate in the exhibition *Les magiciens de la terre* organized in 1989 by the Centre Georges Pompidou in Paris, which placed them in an international context and gave proper credit to the artists without carrying the stigma of a "minorities" exhibition as do many "single nation" exhibitions.

The first exhibition of the "avant-garde" outside Mainland China to engender a wide response was *The Stars: 10 Years,* a retrospective exhibition shown in Hong Kong and Taipei in January and March 1989, respectively. I organized this exhibition with the help of Michael Chen, and the aim was to give a historical perspective on China's new art by commemorating its first famous avant-garde group. In both cities, the exhibition dominated the cultural

news for many weeks and marked the first public awareness of China's underground culture. Although the seminal exhibition *China/Avant-Garde,* which opened in Beijing in February that same year, was written up in *Time* magazine and the *Christian Science Monitor,* it did not lead to a sustained interest outside China, even though this exhibition was to become one of the landmarks in Chinese art history. This hints at the role Hong Kong, on account of its open and international media culture, was to play subsequently as a window on China's contemporary culture.

Growing public interest also reflected the rapidly evolving creative scene in China. By the late 1980s, experimental art had achieved a maturity that gave it a character distinct from what was happening in the West. Significantly, it had become the representative voice of the art world in China itself. The turn of political events also helped the fortunes of new art. In 1990, when I started to research an exhibition that became *China's New Art, Post-1989,* it was clear that the political crackdown of June 4, 1989, had symbolically terminated the forward-looking, experimental spirit of the 1980s. The plan was then changed to present an exhibition that would define the new spirit of the 1990s, and I invited Li Xianting to co-organize this endeavor. The result was a large exhibition, consisting of a hundred and fifty works that included paintings, mixed-media installations, and sculptures, which opened as the showcase exhibition of the Hong Kong Arts Festival in January 1993; it then traveled in a reduced form and with a new title, *Mao Goes Pop,* to the Sydney Museum of Contemporary Art. From 1994 until the end of 1997, with the original title restored, a reduced exhibition traveled to six venues in Canada and the United States. This widely traveled exhibition helped to create public awareness of Chinese contemporary art.

The exhibition attempted to delineate the spirit of the present decade, and contrasted it with the more exhilarating, but less focused, explorations of the 1980s. Art as a force that develops creative responses to sociocultural situations was emphasized. The change of title of *China's New Art, Post-1989* to *Mao Goes Pop* when the Sydney museum took the exhibition illustrates an inclination prevalent in western institutions: to stress the "dissident" aspect of such art. This would enhance an exhibition's sensational quality, but may also effectively limit it to a passive political voice. (As such, the early avant-gardists like the Star group eventually got maneuvered into a dead end.) Indeed, the Sydney showing broke attendance records and was enormously successful.

In Europe, a cultural show that opened at Berlin's Haus der Kulturen der Welt in January 1993, *China Avant-Garde,* also caused a stir. It consisted of visual arts, cinema, and poetry; its emphasis on avant-gardism was again based on its "unofficial" and "dissident" associations. However, the selection of visual arts was not well-defined nor as convincing as it could have been. The show appeared in Rotterdam and Odense in largely the original form. At

CHANG TSONG-ZUNG

the Museum of Modern Art, Oxford, it was reshaped to a more focused version comprising principally installation works, which helped to establish the artistic credibility of Chinese experimental art.

The circulation of substantial, multiauthor catalogues enhanced the reach of both *China's New Art, Post-1989* and *China Avant-Garde*; the latter was republished by Oxford University Press in 1994.

In the US, *Fragmented Memory: The Chinese Avant-Garde in Exile* at the Wexner Center for the Arts in Ohio, organized by Gao Minglu and Julia F. Andrews in 1993, was probably the first North American exhibition devoted to expatriate artists from the '85 New Movement (or '85 New Wave) and *China/Avant-Garde*. (A selection of paintings had been shown in 1991 at the Pacific Asia Museum in Pasadena, California.) The four installation and video artists in *Fragmented Memory* included the most famous from that period; although the show did not travel, it was propagated through its catalogue.

Starting in 1993, participation in major international events and venues started to be routine, and the rise in status of Chinese art in subsequent years was largely a result of international shows, especially the biennials of Venice in 1993 and 1995, of São Paulo in 1994 and 1996, and several exhibitions in 1997.

The Venice Biennale of 1993 was the first appearance of the Chinese avant-garde there. Director Achille Bonito Oliva came to research in mid-1992, and his display of post-1989 artists was congested, but still an exhilarating step for Chinese artists. The São Paulo Bienal of 1994 was particularly important for exposing China's new art to international curators and critics. A special exhibition presented under the auspices of the Foundation of the Bienal, which I organized, included six painters. The implicit messages about human nature and the morality of culture and power suited the theme of 1995 Venice Biennale's centenary exhibition, *Identity and Alterity,* in which Jean Clair included three Chinese artists, Liu Wei and Zhang Xiaogang from the São Paulo exhibit, and Yan Pei Ming, resident in France since 1981. This was a remarkable opportunity as it placed Chinese artists in a broad historical context. Also that year, a Korean pavilion was permanently added to the Biennale grounds, and the in-town exhibition *Transculture* organized by Fumio Nanjo included a number of Asian artists, including one Chinese, Cai Guoqiang, then living in Japan. This show examined the cross-fertilization of cultures, especially more "marginal" ones, and therefore formed a stimulating comment on Jean Clair's intellectually brilliant, though essentially eurocentric, exhibition. (Nanjo also featured Cai in his Universalis selection for the 1996 São Paulo Bienal.)

Since 1992 the rapid commercialization of Chinese society has started to pervade everyday life, creating in reverse an element of nostalgia for the purposeful, nationalistic eras of the Republic (pre-1949) and Maoist Communism (post-1949). It has also triggered an element of doubt about the

headlong plunge into rapid development. This initial questioning of the wisdom of modernity brings out an inherent uneasiness about the notion of "Chineseness" in contemporary culture, making a poignant contrast with Taiwan's and Hong Kong's recent obsession with their local identities. After all, the "centuries-old" seamless cosmology and coherent worldview of the Chinese people were only discarded in the first decade of this century, and the separate peace made with modern life in different Chinese territories would in the long run make sense only in the wider context of an overall reassessment of a new Chinese identity. This was the motivation for *Reckoning with the Past: Contemporary Chinese Painting,* the first exhibition organized for an audience abroad to bring together artists from China, Hong Kong, and Taiwan. It was organized by Graeme Murray and me with the Scottish Arts Council and opened at the Fruitmarket Gallery in 1996 before going to three other venues in Scotland and then traveling internationally until the end of 1999. The theme seems to have struck a chord with a prevailing European interest in the problem of identity, especially with regard to marginal identities and postcolonial issues.

Since 1995 art from Taiwan and Hong Kong have also been moving apace. Taiwan's first significant show abroad was *ArtTaiwan: The Contemporary Art of Taiwan,* which opened at Sydney's Museum of Contemporary Art in 1995, initiated as a result of the success of *Mao Goes Pop;* it then toured in Australia, and its catalogue is a valuable resource. For the 1995 Venice Biennale the Taipei Fine Arts Museum coordinated the exhibition *ArtTaiwan,* organized by an international team. The effort was repeated in the 1997 Venice Biennale with an interesting mixture of installations and paintings, which was well received. On a smaller scale, an exhibition of four Taiwanese painters based on the theme of Taiwan identity, *Man and Earth,* launched by the Asian Art Coordinating Council in Colorado, toured several regional museums in the US during 1994–95.

The new generation of artists in Hong Kong is ill equipped overall with traditional techniques, but the city's high-speed urban life and special historical position have stimulated an artistic sensibility inclined towards a subversive, anti-political, gamelike approach to creativity that differs from those in Mainland China and Taiwan. In 1996 Hong Kong launched its first official exhibition at the São Paulo Bienal with installation artist Ho Siu-kee. At the same Bienal there was a special exhibition of the Chinese painter Qiu Shihua, who won one of the four awards given to artists. I was the curator for both exhibitions.

The strategy of engagement and exotic appeal has been most effective for Chinese artists currently living abroad. Artists like Wenda Gu, Xu Bing, and Cai Guo-qiang have participated in numerous international exhibitions in recent years; Gu's dedication to avant-gardist usurpation of conventions and Xu's persistent exploration of the relationship between language and

power have become hallmarks of Chinese expatriate art. Artists like Huang Yong Ping and Chen Zhen in France, active in many important shows, have adapted their art to engage contemporary issues from the position of Chinese culture, often resorting to exotic elements in traditional customs.

Large thematic exhibitions of Chinese art held in Europe since 1996 include the oil painting exhibition *China!* at Bonn's Kunstmuseum (1996, toured until 1998), *Faces and Bodies of the Middle Kingdom* at the Rudolfinum of Prague (1997, in Finland 1998), and *Another Long March,* an exhibition of Chinese installation art at Breda, Holland (1997). The Bonn exhibition had no explicit theme other than the common medium of oil painting; it served as a popular general introduction. The exhibition in Prague elaborated on the diverse approaches to the human image, an idea made famous by Jean Clair's 1995 Venice exhibition. The Breda exhibition was an important installation show which, although shown in only one venue, gave recognition to the achievement of mixed media and multimedia art in China. Feng Mengbo and Wang Jiangwei were invited to participate in the 1997 *Documenta X* at the last minute, *Documenta*'s director Catherine David having attended the Breda opening. These and the Singapore Chinese artist Matthew Ngui were the only three Asians in *Documenta X,* significantly enhancing international standing of Chinese art.

Another important channel for mediation of Chinese art is multi-national thematic shows. Since *Les magiciens de la terre,* a number of curators have interpreted Chinese art in contexts of postcolonial dialogues, such as Fumio Nanjo in *Transculture* in Venice, Harald Szeeman's Biennial de Lyon in 1997, and Hou Hanru's *Hong Kong, etc.* at the 1997 Johannesburg Biennial. The significance of these exhibitions is in putting Chinese art at level dialogue with other cultures. The growing interest in East and Southeast Asia helps to put China in perspective as well. The mammoth project *Cities on the Move* at the Secession (1997, Vienna, traveling 1998), organized by Hans Ulrich Obrist and Hou Hanru, at once illustrates the chaos and confusion, as well as vital energy, of this region.

Activities in Asia in recent years have also increased awareness of Asian contemporary art as a whole. The two Kwangju Biennials (1995, 1997), the Asia-Pacific Triennials in Brisbane (1993, 1996), and regular Asian triennials at the Fukuoka Asian Art Museum have included a good number of Chinese artists. The Japan Foundation in Tokyo presented for the first time a one-artist retrospective show for the Chinese painter Fang Lijun in 1997, and also that year the Paris-based curator Fei Dawei—who organized what is probably the first Chinese avant-garde exhibition in the West, in Paris in 1990—organized an exhibition in Japan that included a Daoist tantricist as participant, widening the interpretation of contemporary art/culture practice.

While the discussion is coming full circle to Asia proper, it is perhaps profitable to study intellectual mediation in terms of geographical mediation,

and to look again at the example of Hong Kong, especially since many of the activities of Chinese art mentioned above were first channeled through the territory. As the most thoroughly "modern" Chinese urban space, Hong Kong is a natural processing plant of western ideas for China. Significantly, Hong Kong is also a refuge for traditional learning and customs, preserving special contacts with a Chinese past decimated by the Revolution on the Mainland. In interpreting contemporary culture, how the nature of Chinese modernity is understood remains a crucial issue. In China, modernity is popularly perceived as an unquestioned good, achieved by breaking the shackles of the past. In Hong Kong, it is clearly understood that modernity was brought about by colonialism, and its unresolved tensions with traditional customs raise complex questions of "Chineseness," not least the dual dilemma of "modern" Chineseness and a marginalized "Hong Kong" Chineseness. Such ambivalent considerations, coming from a position that is both inside and outside China, throw light on the issue of interpretation, especially concerning identity in terms of roots, cultural allegiance, sense of uniqueness, and the awareness of otherness.

Hong Kong, Taiwan, and China have different viewpoints relative to their distance from the Middle Kingdom. Taiwan's struggles for political self-determination have made its crisis of identity particularly acute; Hong Kong's recent reentering into the Chinese political sphere as a peripheral region has also underlined the importance of local uniqueness; yet in Mainland China identity is not taken to be an important issue. In China proper, "Chineseness" is construed as allegiance to nationalism. It is perceived as a political rather than a cultural concern. By bringing together contemporary art from the three regions, it becomes obvious that they all stand facing China's heritage as the "other," and their common legacy of modernity is colonialism. Modernity in Hong Kong and Taiwan was clearly brought about by British and Japanese colonialism; in China it was not due to foreign powers but has come by way of ideological colonialism, a more devious and thorough form of domination that had its roots in early Christian missionary enterprises and culminated in the religious zeal for reform of the Communists. Communism has created a more thorough alienation from, and antagonism toward, China's indigenous culture than any foreign colonial power could ever hope to have achieved. Without questioning fundamental ideological conversion, it is not possible to raise basic questions about China's modernity.

Using ambiguous territories like Hong Kong and Taiwan to understand Chinese modern art opens up a perspective from the outside as well as a look out from the inside. The fundamental change in worldview in China's modern era involves a radical revision in its outlook on history, on its past and the future. Symbolically, China officially changed its calendar from a lunar to a solar one in this century, and after the Communist victory in 1949 the government also officially adopted the Christian year, completing its historical

alignment with the West. Chinese contemporary culture is in the ironic position of unwittingly becoming an outsider to its own heritage, which in fact brings it closer to a western perspective than appearance would suggest. On the other hand, if coming to terms with the complexities of self-definition is to acknowledge the modern world, and to recognize other histories and other futures, then it is ever more urgent to approach interpretation as an open-ended task that needs constant redefinition of its shifting goal.

Plates

Plate 1
CAI GUO-QIANG
 Traces of Ancient Explosions, 1985
 Gunpowder and oil on canvas; 70 ⅞ x 49 ¼ in.
 (180 x 125 cm); collection of the artist

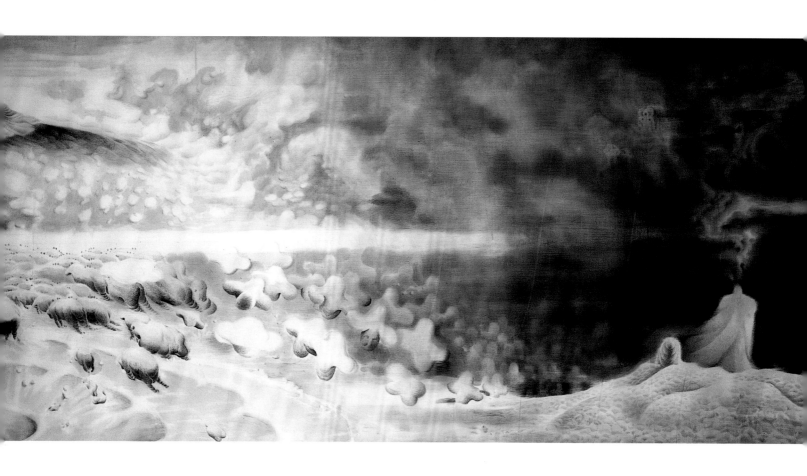

Plate 2
REN JIAN

Primeval Chaos, 1986–87 (detail)
Ink on polyester mounted on paper;
approx. 59 in. x 98 ft. 5 in.
(150 x 3000 cm); collection of the artist

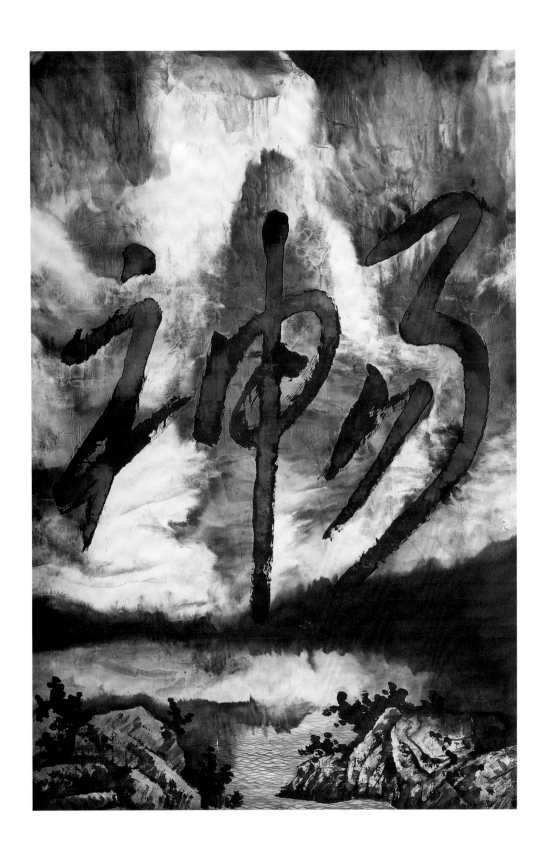

Plate 3
WENDA *GU*

*Pseudo-Characters Series: Contemplation
of the World*, 1984 (detail; see fig. 24)
Ink on paper; three hanging scrolls: each 9 x 6 ft.
(247.3 x 182.9 cm); collection of Zhen Guo

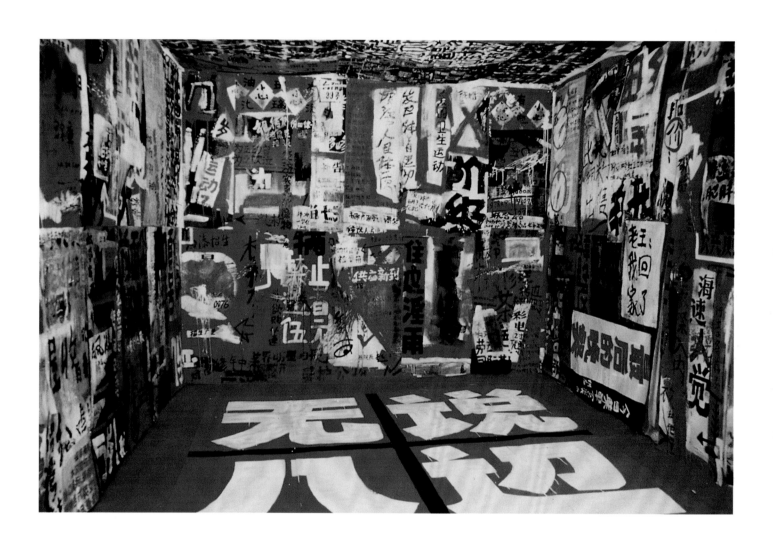

Plate 5
WU SHAN ZHUAN

Red Humor, 1986 (installed in Hangzhou, 1986)
Installation with works on paper; dimensions variable;
collection of the artist

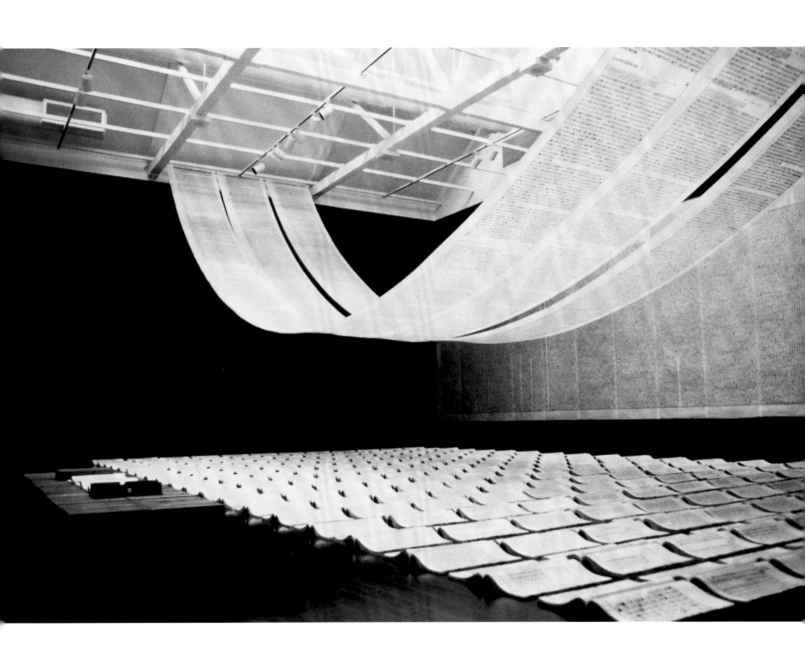

Plate 6
XU BING

Book from the Sky, 1987–91
(installed at the North Dakota Museum of Art, 1992)
Installation with hand-printed books; dimensions
variable; collection of the artist

Plate 7
***XU* BING**

Your Surname, Please?, 1998
Proposal for installation with computers, printer,
ink-on-paper calligraphy mounted on wood;
collection of the artist

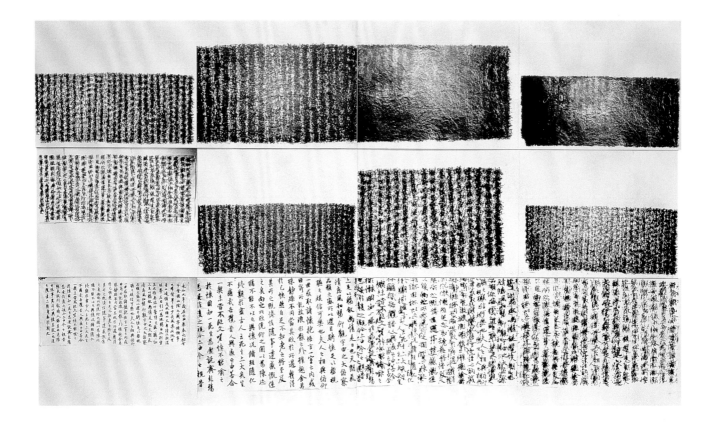

Plate 8
QIU ZHIJIE

Writing the "Orchid Pavilion Preface" One Thousand Times, 1986/1997
Installation with video documentation and ink-on-paper calligraphy;
installation approx. 16 ft. 6 in. x 16 ft. 6 in. (500 x 500 cm); calligraphy
29 ½ x 70 ⅞ in. (75 x 180 cm); courtesy of Hanart T Z Gallery

Clockwise from top:
Video still of artist at work; *The "Orchid Pavilion Preface"*
One Thousand Times; the work in progress

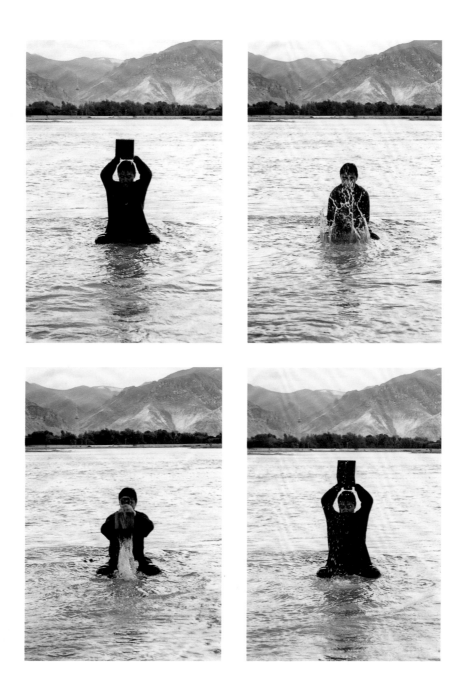

Plate 9
SONG DONG

Printing on Water
Performance in the Lhasa River, Tibet, 1996

Plate 10
***WANG* TIANDE**

Ink Banquet, 1996
Installation with table, eight chairs, bottle, and dishes,
painted with ink; and brushes; approx. 9 ft. 10 in. x 9 ft.
10 in. x 37 in (300 x 300 x 94 cm); collection of the artist

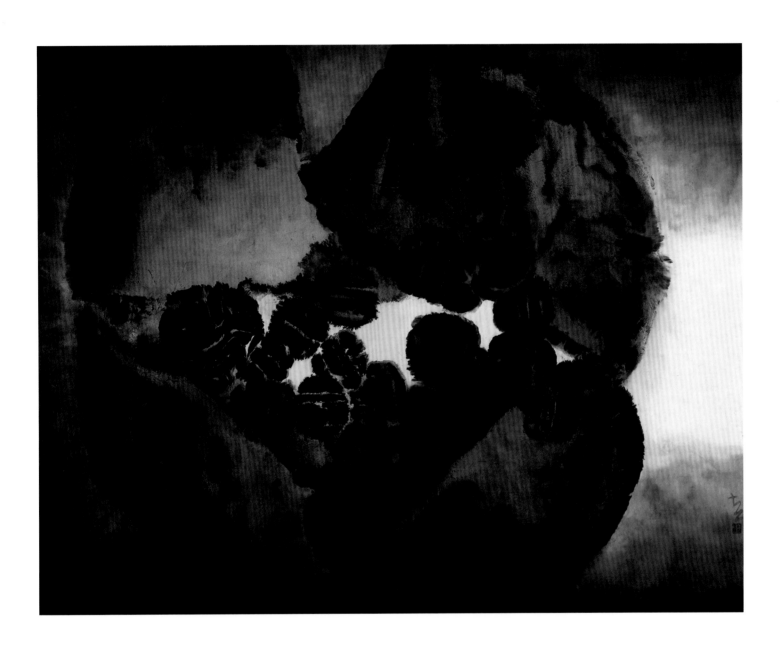

Plate 11
FANG **TU**

Escaping Square, Escaping Circle No. 2, 1997
Ink on paper; 57 ⅛ x 70 ⅞ in. (145 x 180 cm);
collection of the artist

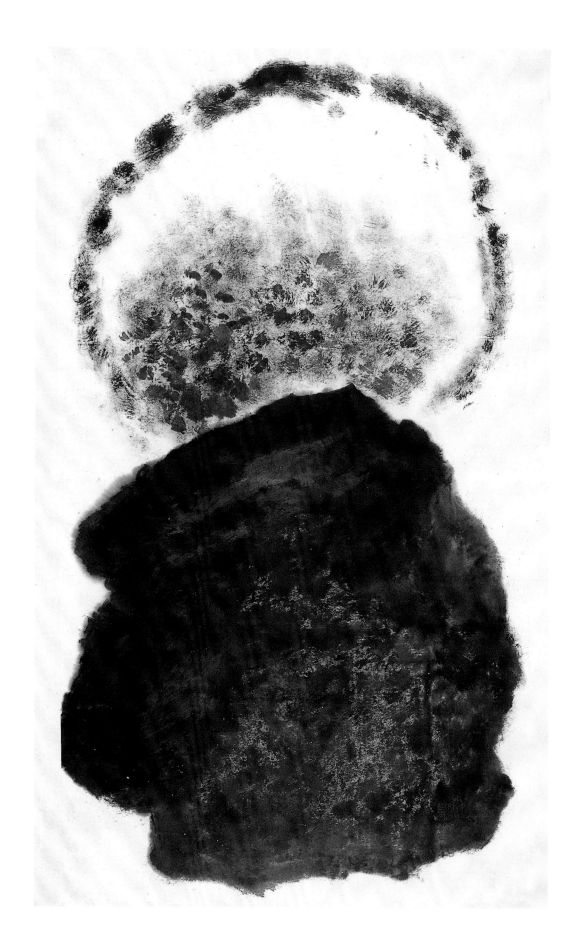

Plate 12
YAN BINGHUI

The Monument, 1993
Ink on paper; 70 ⅞ x 38 in. (180.1 x 96.5 cm);
collection of the artist

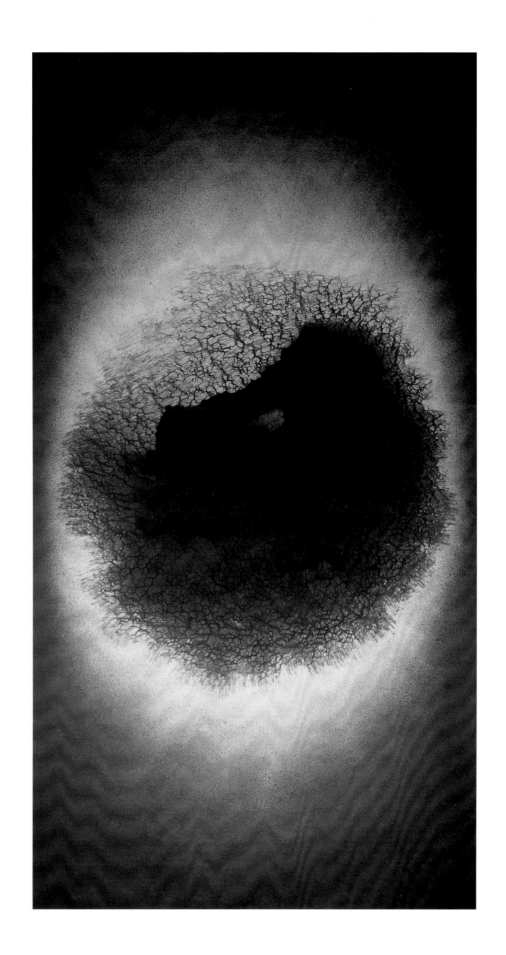

Plate 13
ZHANG YU

Light of Spirit Series (No. 49): The Floating Sphere, 1996
Ink on paper; 68 ⅞ x 37 ¾ in. (178 x 96 cm); collection of the artist

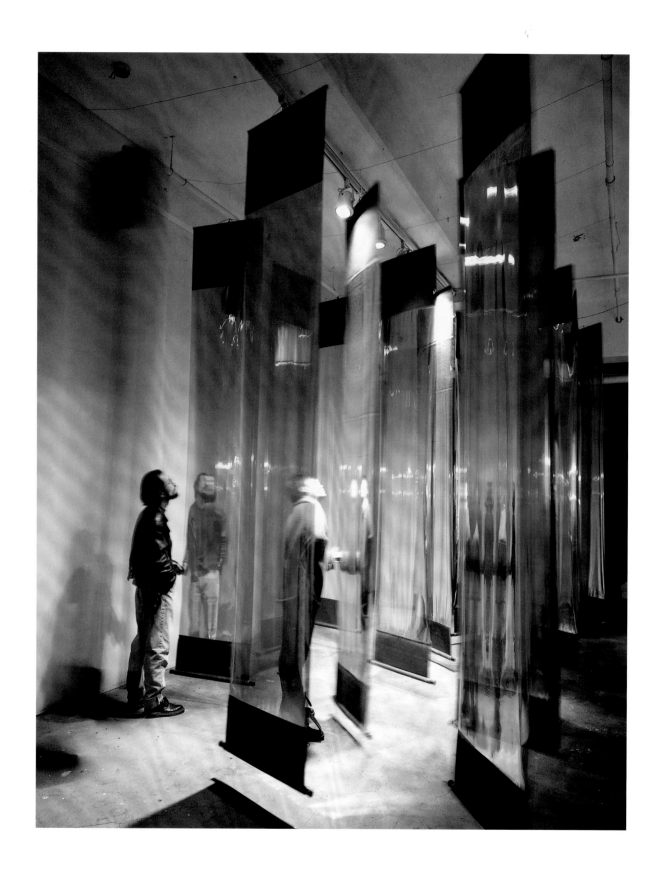

Plate 14
WANG **GONGXIN**

Untitled, 1994
(installed at the Bronx Museum of Art, 1994)
Installation with Mylar scrolls, silk; fifty pieces: each 110 x 24 in.
(279 x 61 cm); collection of the artist

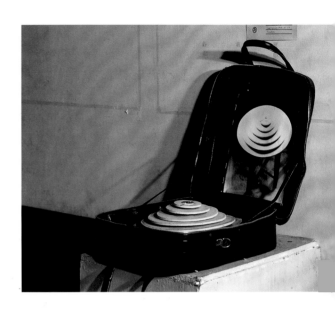

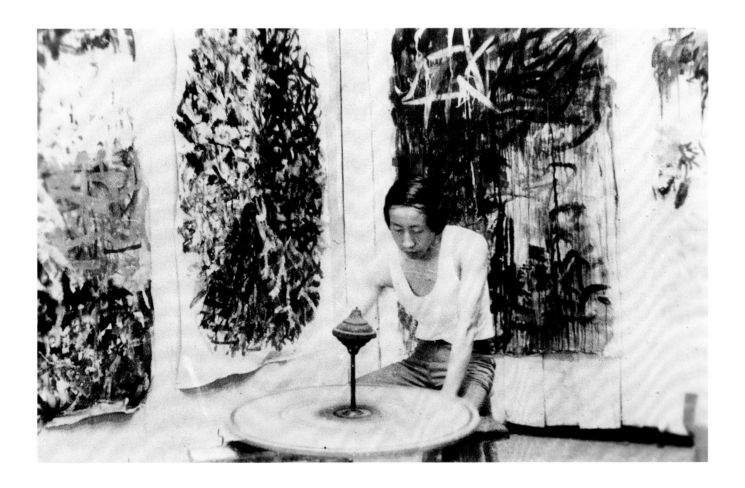

Plate 15
HUANG YONG PING

Top: *Turntable,* 1988 (installation view)
Wood; approx. 50 x 40 x 16 in. (127 x 102 x 41 cm); private collection

Bottom: *Roulette Wheel: Paintings Created According to Random Instructions,* 1985
(installation view); Wooden turntable; ink on canvas; Turntable: approx. 39 ³/₈ x 39 ³/₈ x 31 ¹/₂ in.
(100 x 100 x 80 cm); four paintings: each 59 x 47 ¹/₄ in. (150 x 120 cm); collection of the artist

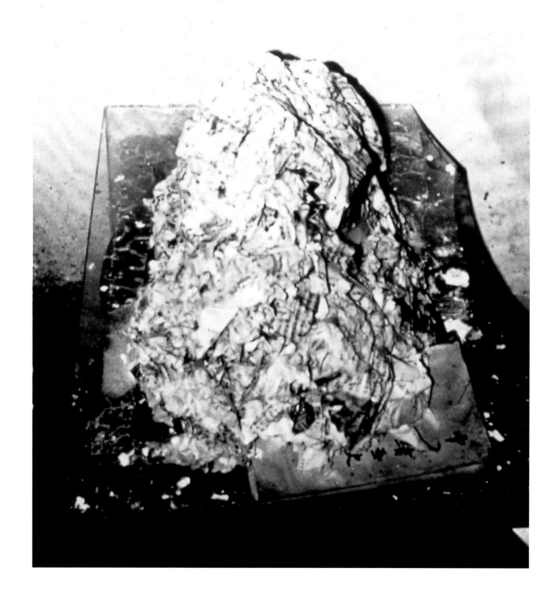

Plate 16
HUANG YONG PING
"A History of Chinese Painting" and "A Concise History of Modern Painting"
Washed in a Washing Machine for Two Minutes, 1987 (installation view)
Paper pulp; approx. 31 x 20 x 20 in. (80 x 50 x 50 cm); destroyed

Plate 17
**NEW ANALYSIS GROUP
(*WANG* LUYAN, *CHEN* SHAOPING, *GU* DEXIN)**
Tactile Art, 1988 (four panels)
Photostats; twelve panels: each 8 x 8 in.
(20.3 x 20.3 cm); private collection

Plate 18
ZHANG PEILI

X? Series: No. 4, 1987
Oil on canvas; 31 ½ x 39 ⅜ in. (80 x 100 cm);
private collection

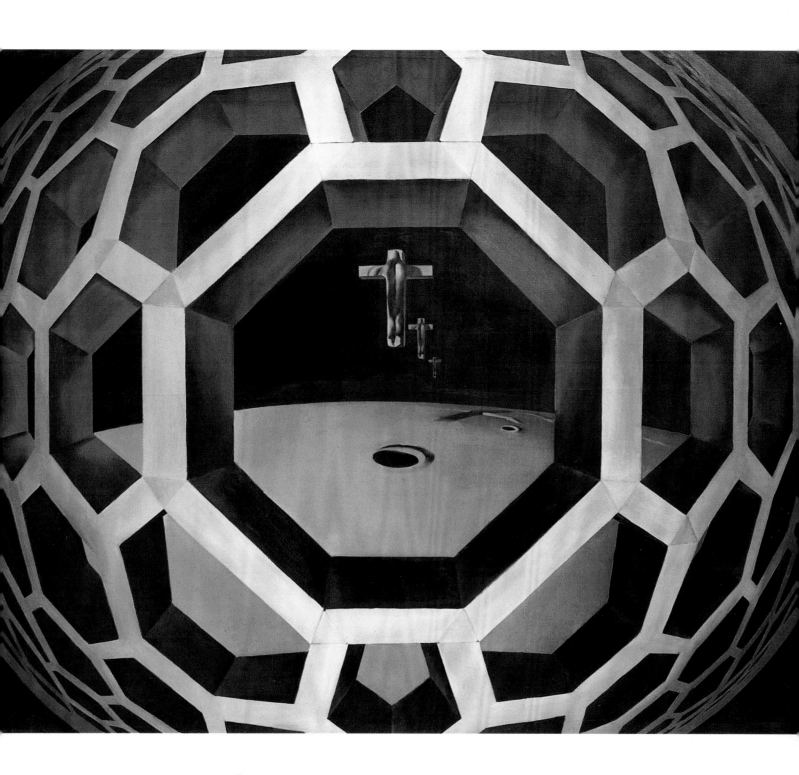

Plate 19
SHU QUN

Absolute Principle, 1985/1989 (detail)
Oil on canvas; 25 x 126 in. (64 x 240 cm);
collection of the artist

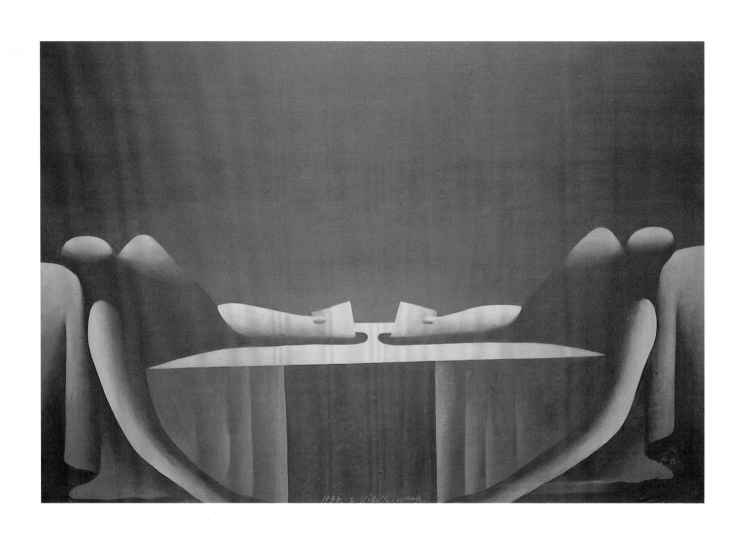

Plate 20
WANG **GUANGYI**

Post-Classical Series: Death of Marat, 1987
Oil on canvas; 59 x 79 in. (150 x 200 cm);
private collection

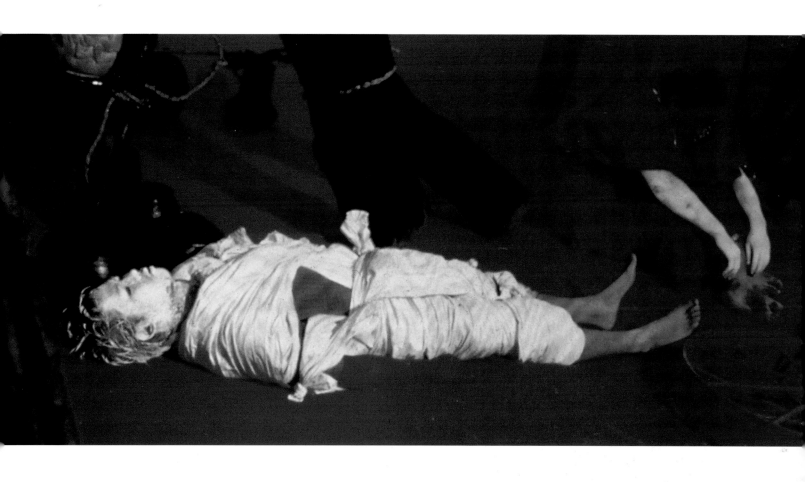

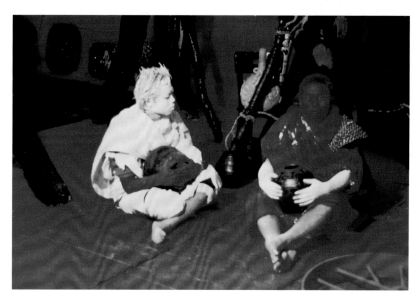

Plate 21
SONG YONGPING and *SONG* YONGHONG
Experiences on a Certain Day in 1986
Performance in Taiyuan, Shanxi Province, 1986

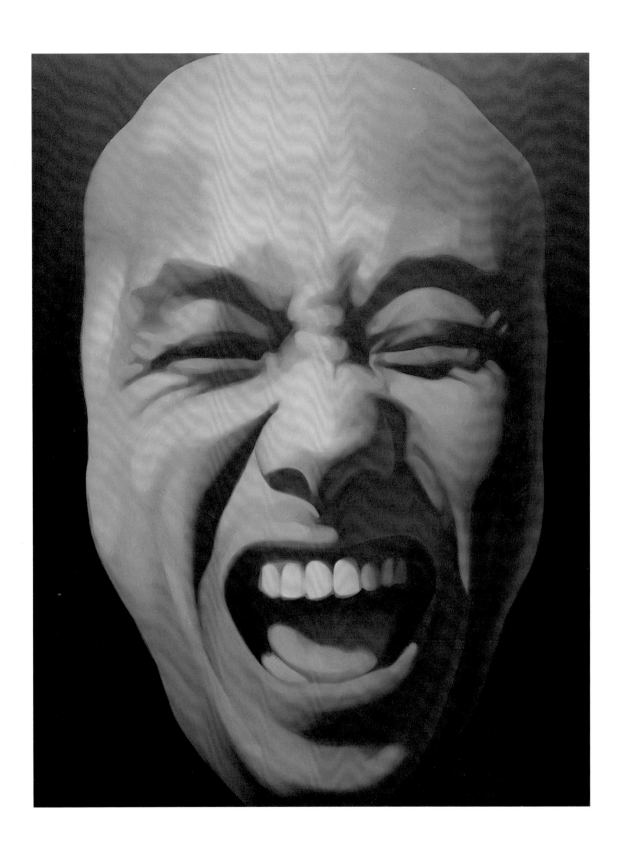

Plate 22
GENG JIANYI

The Second Situation, Nos. 1–4, 1987 (detail;
see fig. 21) Oil on canvas; four canvases: each
67 x 52 in. (170 x 132 cm); private collection

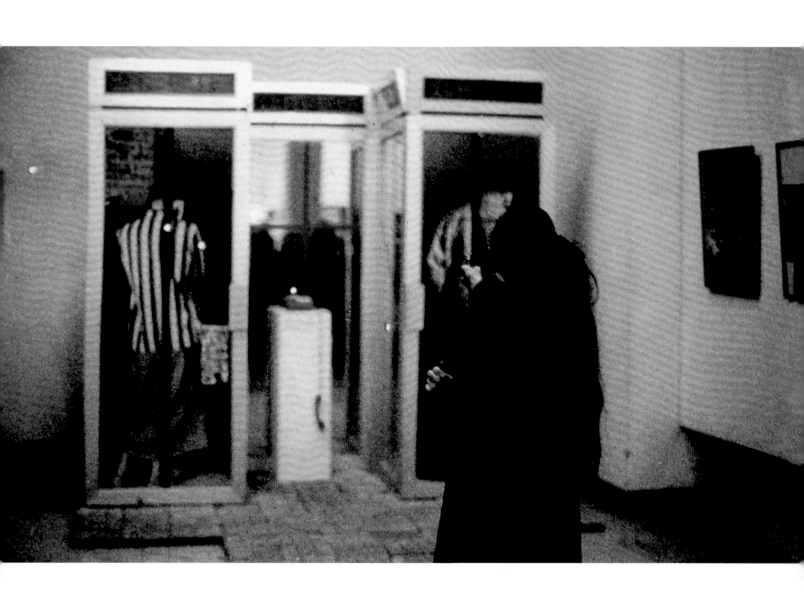

Plate 23
***XIAO* LU** and ***TANG* SONG**
*Two gunshots fired at the installation
"Dialogue" in the "China/Avant-Garde" exhibition,
Beijing, February* 1989, Performance in
National Gallery, Beijing, February 5, 1989

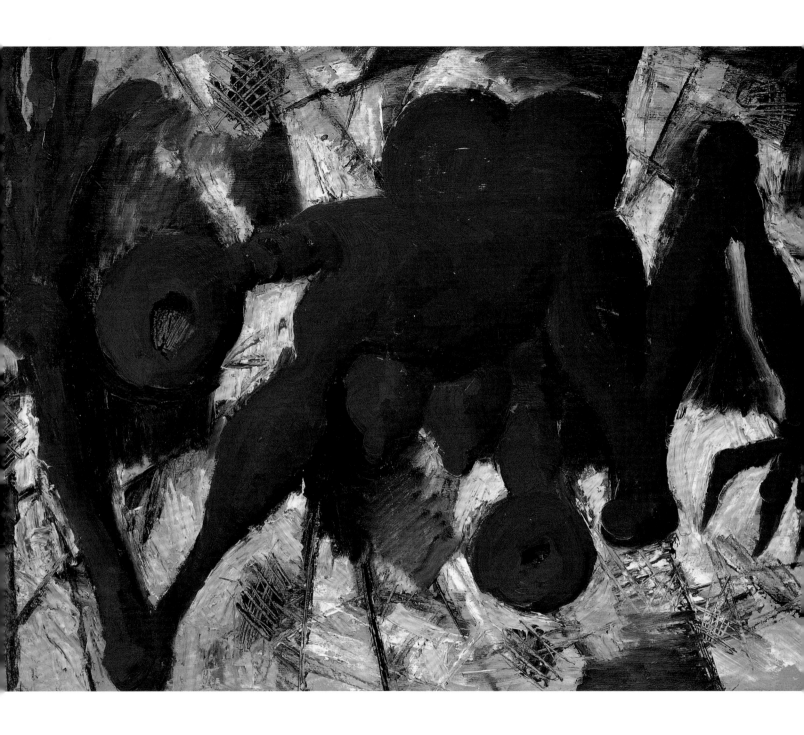

Plate 24
MAO XUHUI

Red Bodies, 1985
Oil on paper mounted on wood; 37 x 42 in.
(78 x 105 cm); collection of the artist

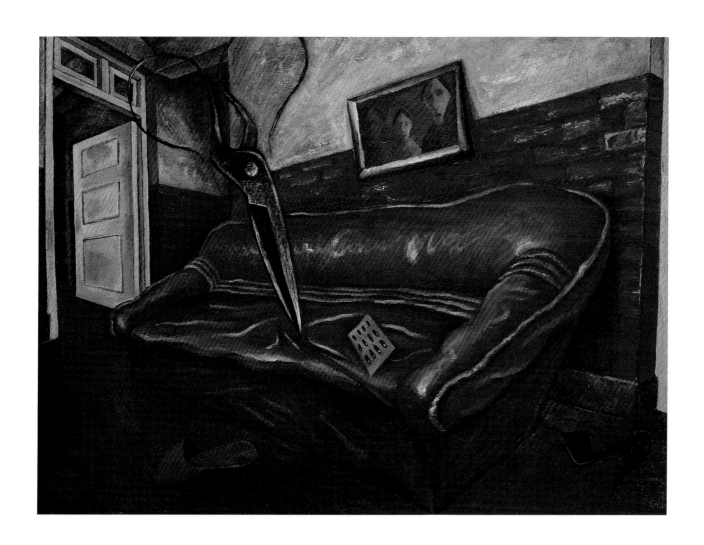

Plate 25
MAO XUHUI

 Scissors and Sofa No. 1, 1995
 Oil on canvas; 47 x 57 in. (120 x 145 cm);
 collection of the artist

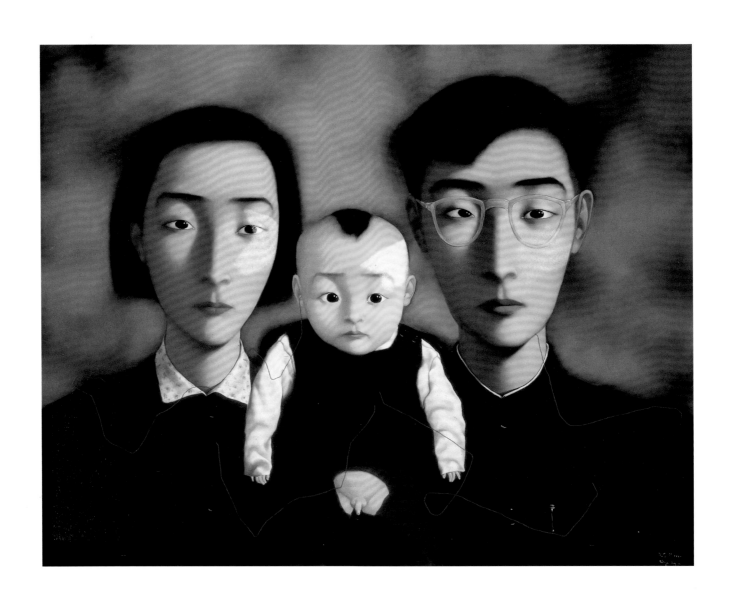

Plate 26
ZHANG **XIAOGANG**

Bloodline: The Big Family No. 2, 1995
Oil on canvas; 70 ⅞ x 90 ½ in. (180 x 230 cm);
private collection

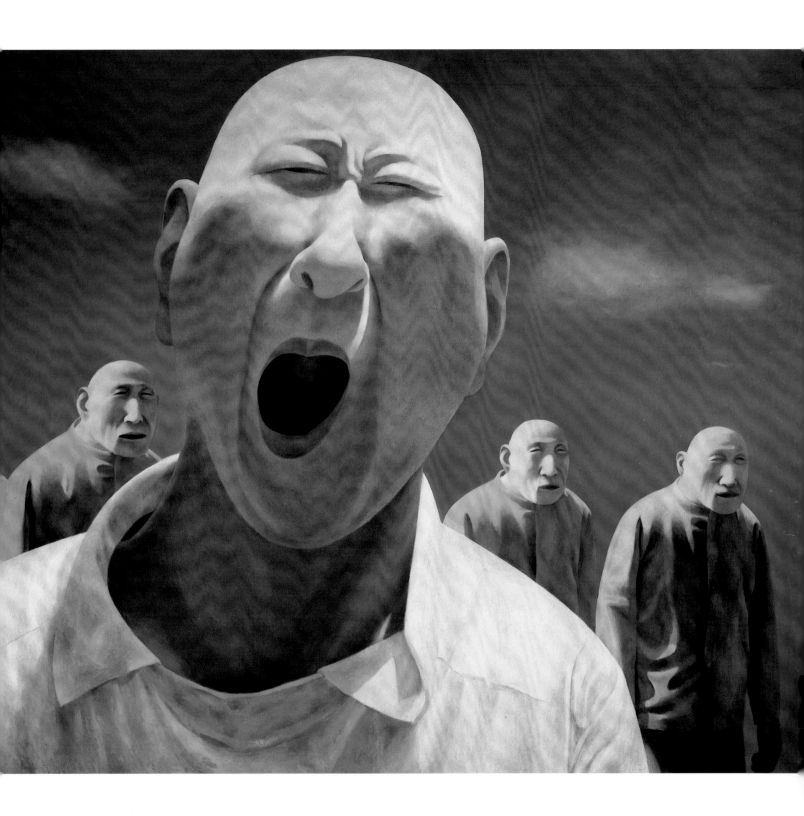

Plate 27
FANG LIJUN
Series 2: No. 2, 1992
Oil on canvas; 79 x 79 in. (200 x 200 cm);
Ludwig Museum, Cologne

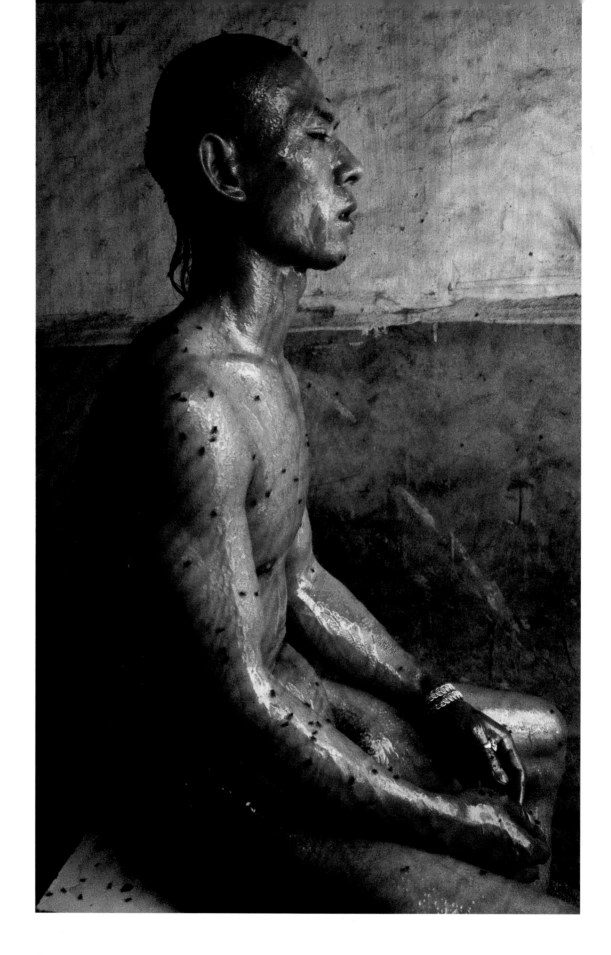

Plate 28
ZHANG HUAN

Twelve Square Meters
Performance in Dashan Village, Beijing,
May 31, 1994

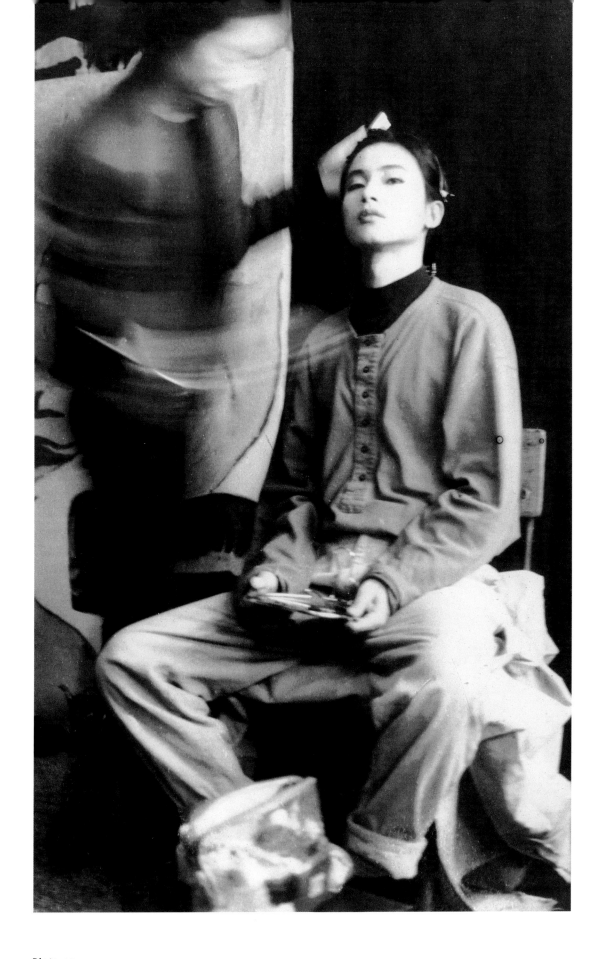

Plate 29
MA LIUMING
Fen · Ma Liuming
Performance in Dashan Village, Beijing,
November 13, 1993

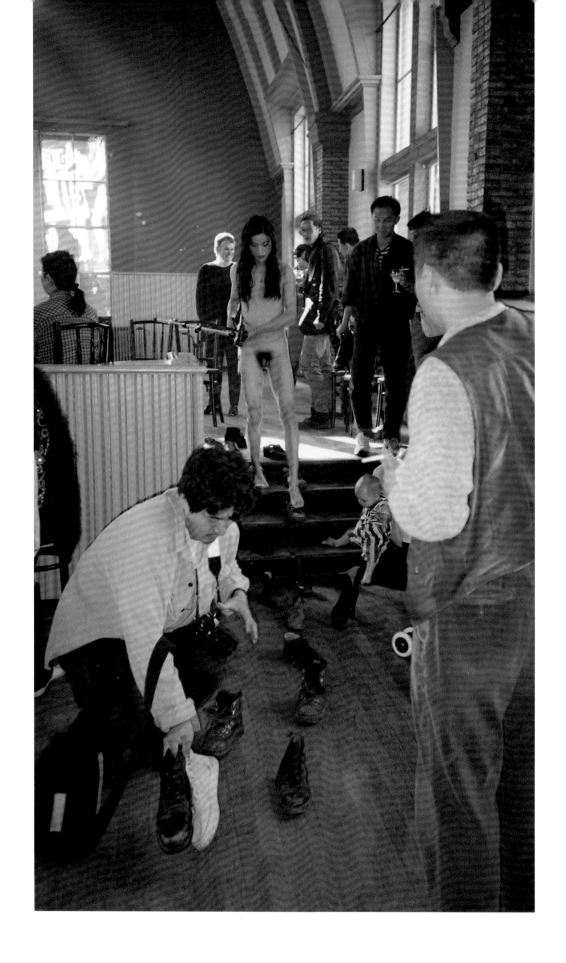

Plate 30
MA LIUMING

Fen · Ma Liuming
Performance in Breda, Netherlands, 1997

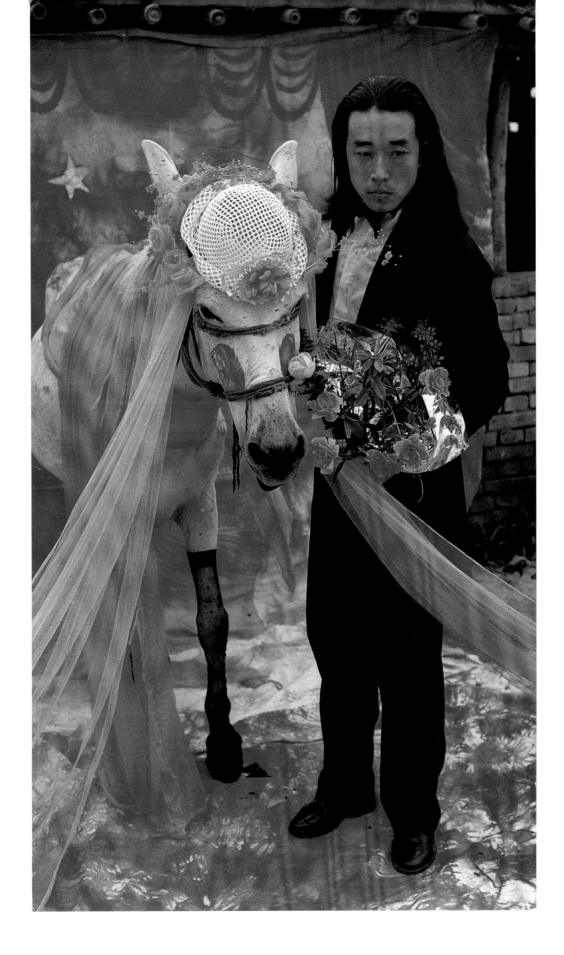

Plate 31
WANG JIN
To Marry a Mule
Performance in Laiguanying Village, Beijing,
July 28, 1995

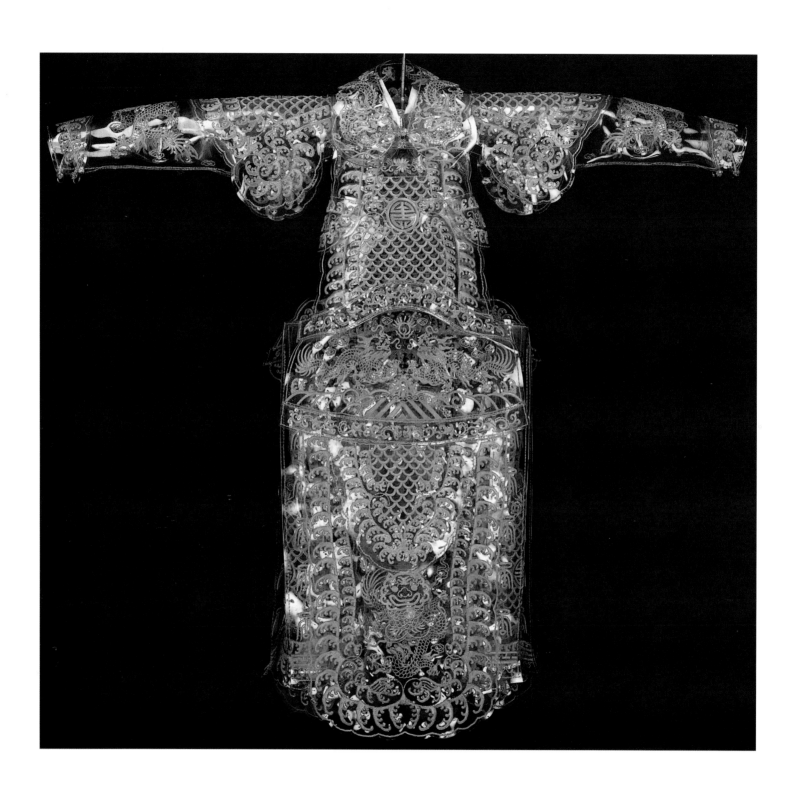

Plate 32
WANG JIN

The Dream of China: Dragon Robe, 1997
Polyvinyl chloride, fishing line; 78 x 70 ⅞ x 15 in.
(198 x 180 x 38 cm); collection of the artist

Plate 33
ZHANG PEILI

Screen, 1997
Installation with video; approx. 16 ft. x
25 ft. 3 in. x 25 ft. 3 in. (500 x 800 x 800 cm);
collection of the artist

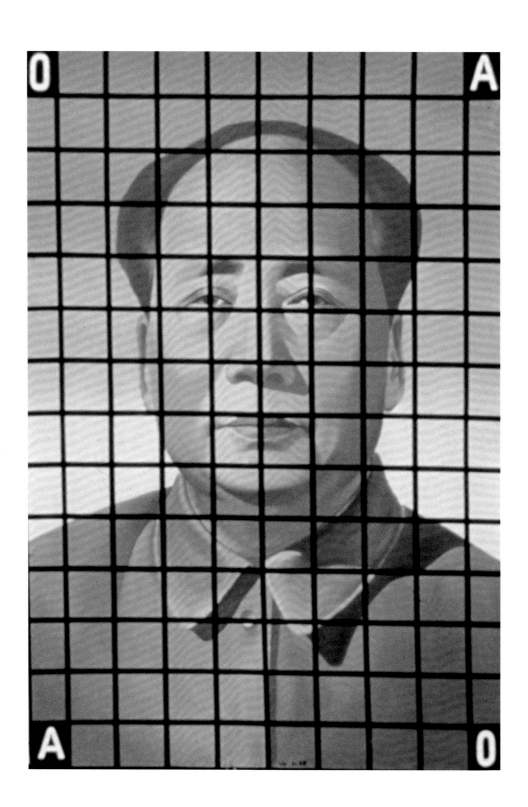

Plate 34
WANG GUANGYI
Mao Zedong No. 1, 1988 (detail)
Oil on canvas, 59 x 141 in. (150 x 120 cm);
private collection

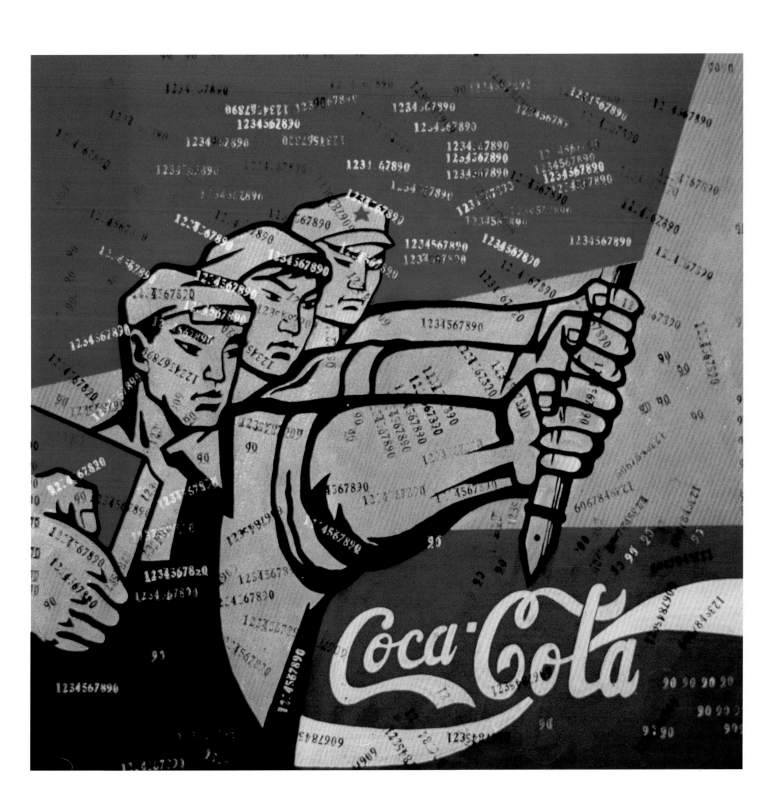

Plate 35
WANG **GUANGYI**

Great Castigation Series: Coca-Cola, 1993
Oil on canvas; 79 x 79 in. (200 x 200 cm);
collection of the artist

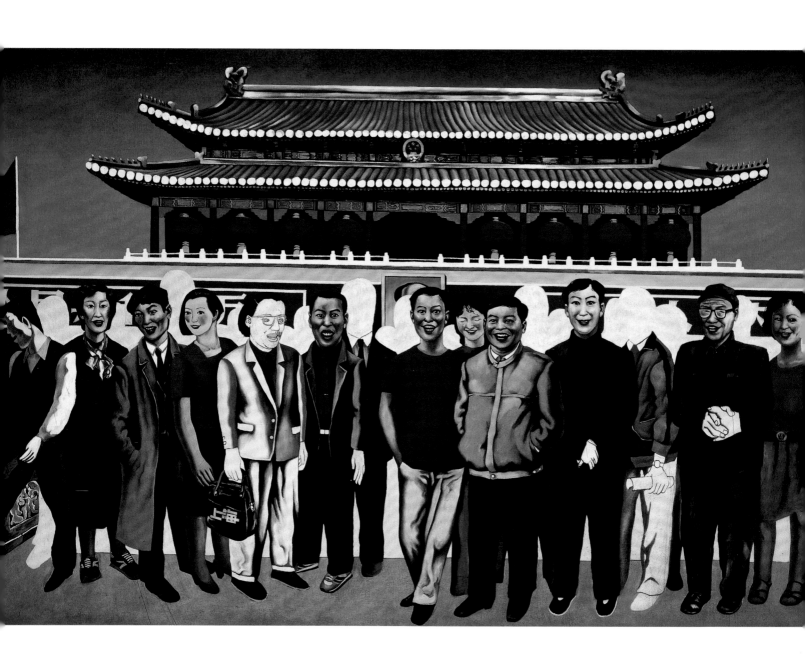

Plate 36
WANG JINSONG

Taking a Picture in Front of Tiananmen, 1990
Oil on canvas; 49 x 73 in. (125 x 185 cm); courtesy of Hanart T Z Gallery

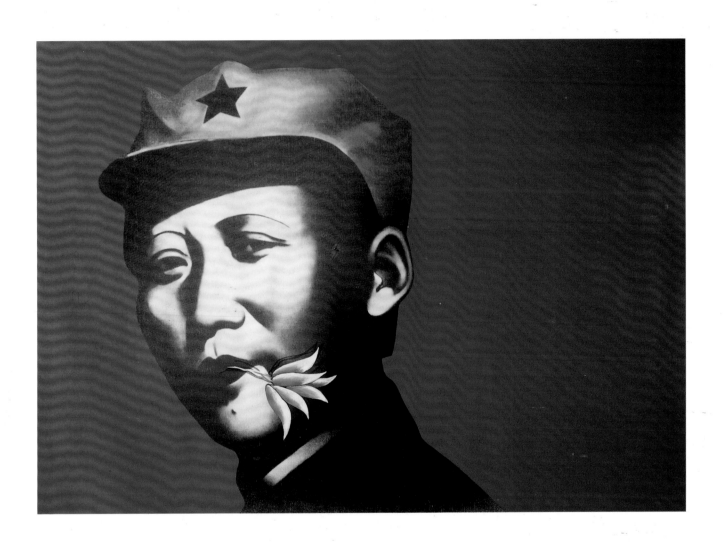

Plate 37
LI **SHAN**

The Rouge Series: No. 8, 1990
Acrylic on canvas; 41 ½ x 58 in. (105.4 x 147.3 cm);
collection of the artist

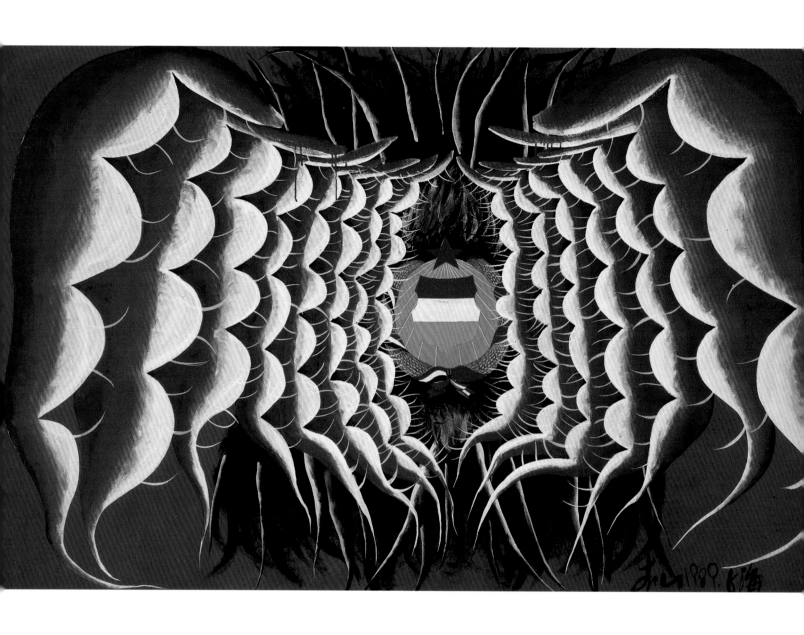

Plate 38
LI SHAN

Rouge C, 1991
Acrylic on canvas; 35 ½ x 47 in. (90 x 120 cm);
collection of the artist

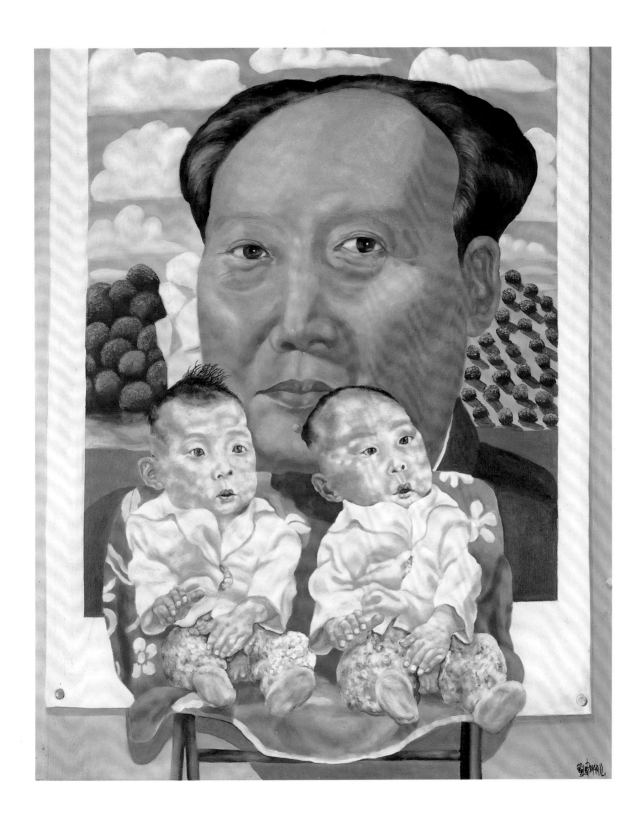

Plate 39
LIU WEI

New Generation, 1992
Oil on canvas; 41 x 33 ½ in. (104 x 85 cm);
collection of Francesca dal Lago

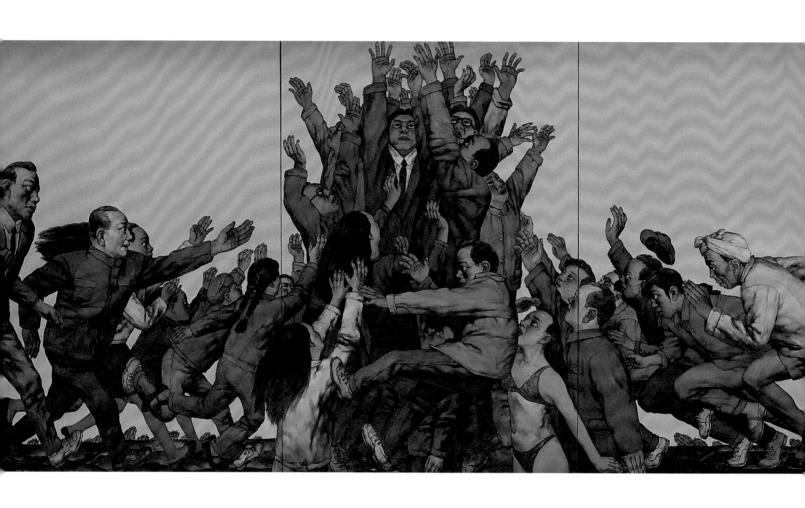

Plate 40
SU **XINPING**

Tower of the Century, 1996
Oil on canvas, 76 x 153 in. (194 x 390 cm);
collection Kent and Vicki Logan, courtesy of
Max Protetch Gallery

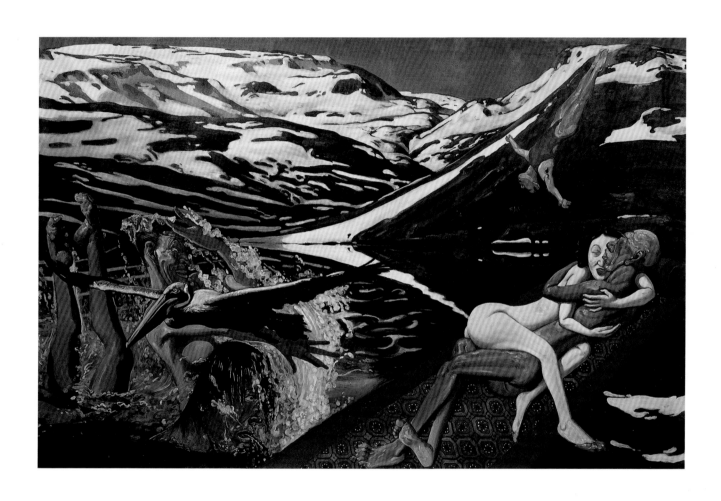

Plate 41
SONG YONGPING

Playing in Water, 1996
Oil on canvas; 51 x 75 ½ in. (130 x 192 cm);
collection of the artist

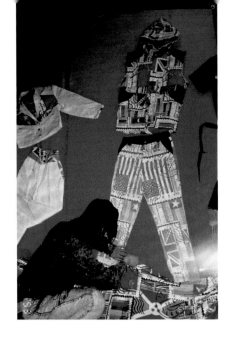

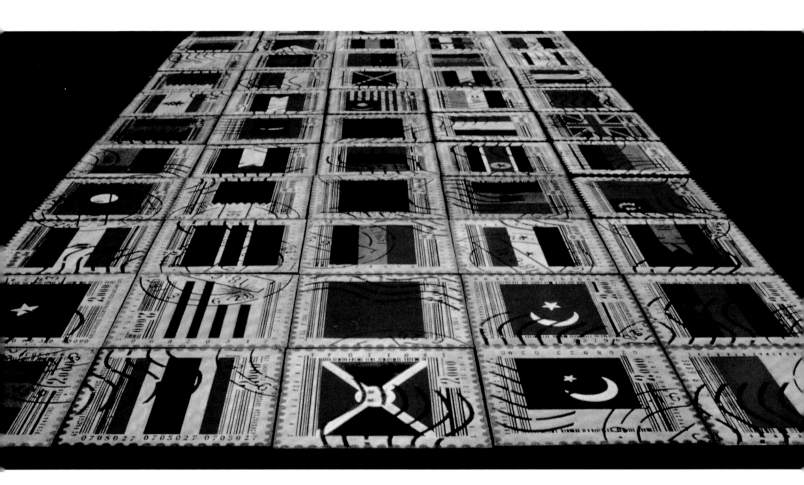

Plate 42
REN JIAN

A.D. 2000, 1991–93
Installation with oil on canvas and blue jeans;
dimensions variable; collection of the artist

Plate 43
HONG HAO

Selected Scriptures, 1995 (detail of one panel)
Silkscreen on paper; six panels: each 22 x 30 in.
(55 x 76 cm); collection of the artist

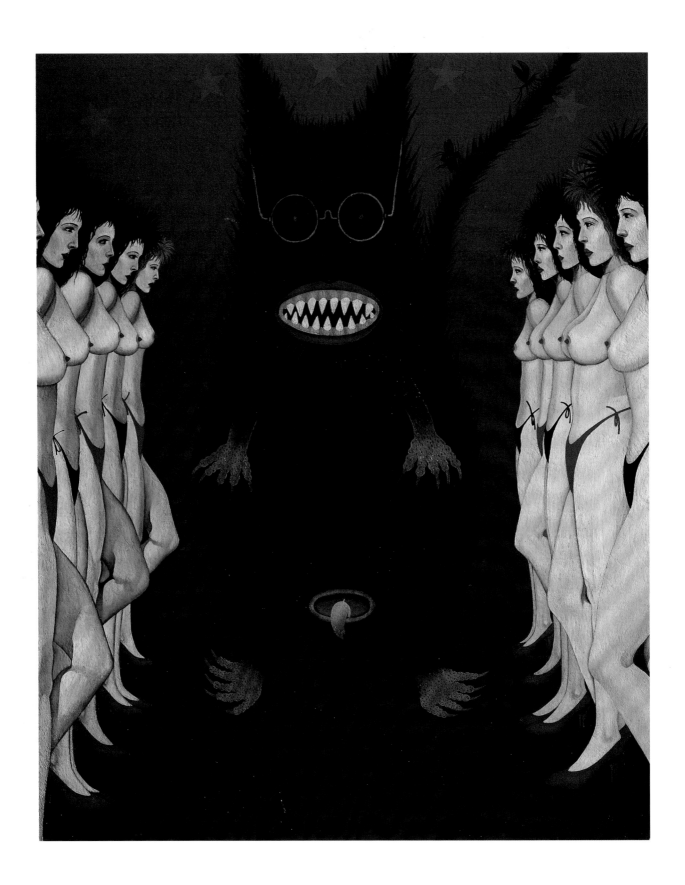

Plate 44
CAO YONG

The Age, Women, and the Environment No. 1, 1995
Oil on canvas; 47 ¼ x 39 ³/8 in. (120 x 100 cm);
collection of the artist

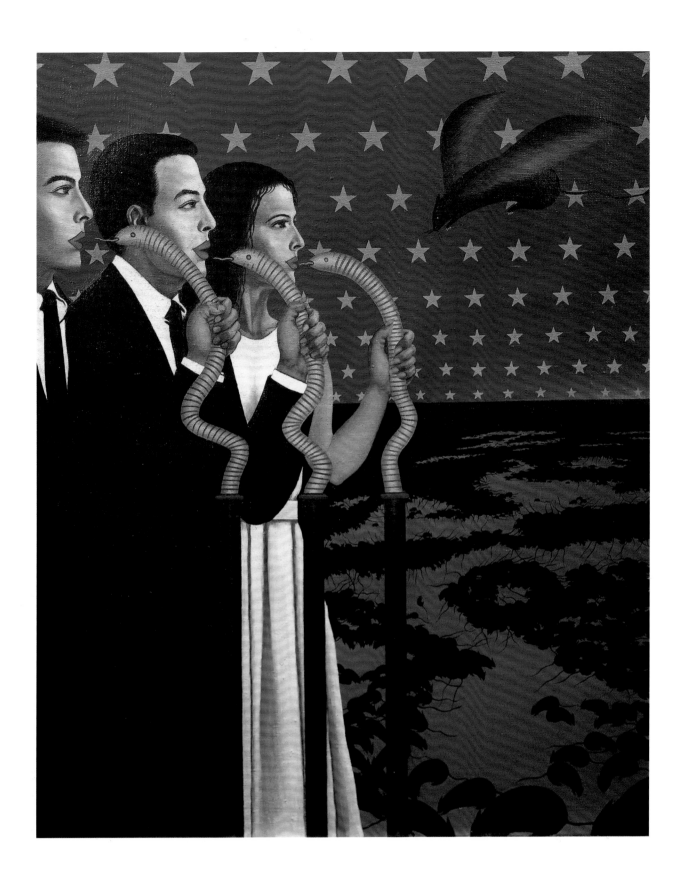

Plate 45
CAO **YONG**

An Emergency Broadcast about the
Prospects of the Quaternary Period, 1997
Oil on canvas; 39 ³/₈ x 35 ³/₈ in. (100 x 90 cm);
collection of the artist

Plate 46
SOUTHERN ARTISTS SALON
(*WANG* DU, *LIN* YILIN, *CHEN* SHAOXIONG,
LIANG JUHUI, and others)
The First Experimental Exhibition Part 1
Performance in Guangzhou, 1986

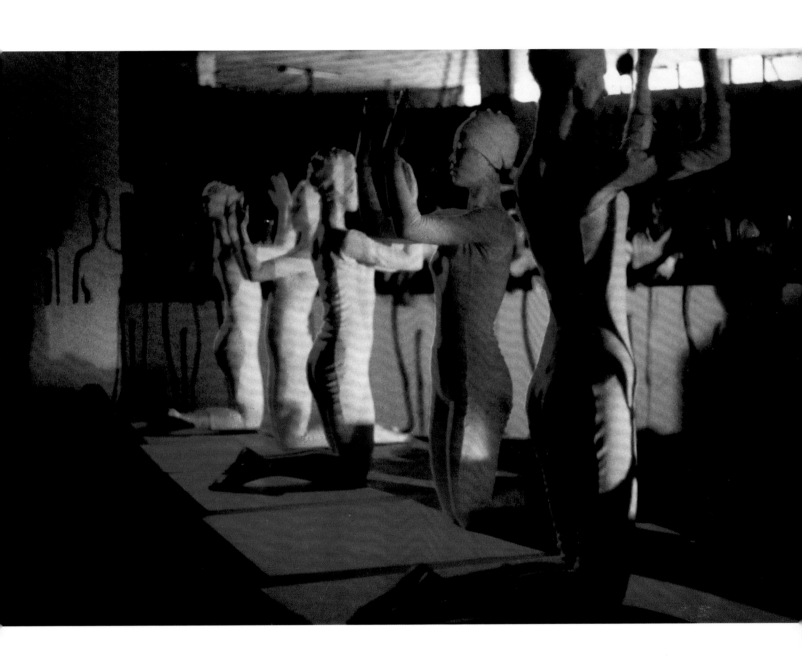

Plate 47
SOUTHERN ARTISTS SALON
(*WANG* DU, *LIN* YILIN, *CHEN* SHAOXIONG,
LIANG JUHUI, and others)
The First Experimental Exhibition Part 2
Performance in Guangzhou, 1986

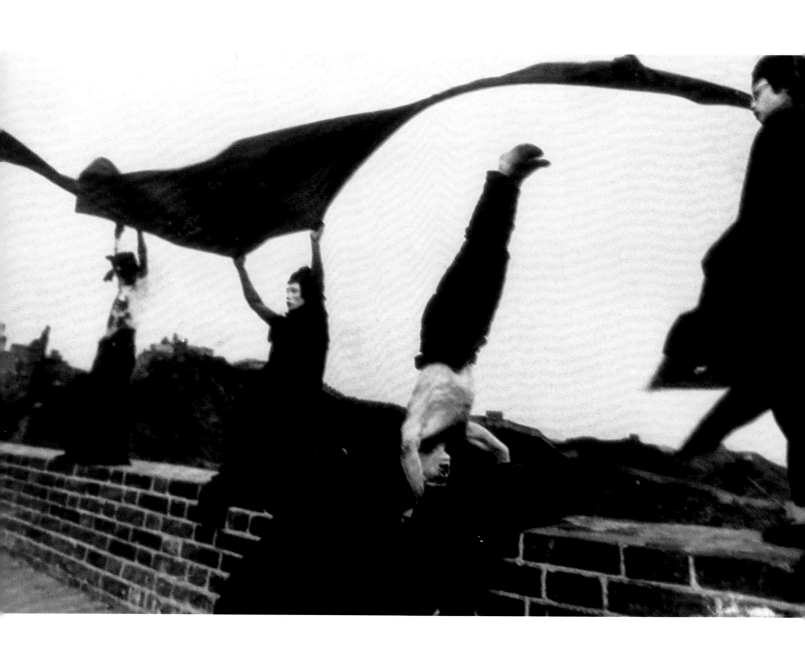

Plate 48
21st CENTURY GROUP
(*SHENG* QI, *KANG* MU, *ZHENG* YUKE, *ZHAO* JIANHAI)
The Concept of the 21st Century
Performance at the Great Wall of China, Beijing, 1988

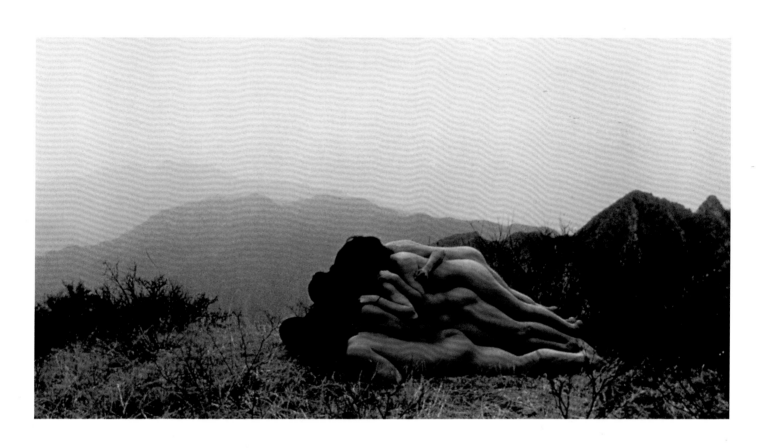

Plate 49
ZHANG HUAN

To Add One Meter to an Unknown Mountain
Performance at Miaofeng Mountain, Beijing, May 22, 1995

XU TAN
 Untitled, 1997

CHEN SHAOXIONG
 Landscape, 1997

LIANG JUHUI
 One Hour Game, 1996

LIN YILIN
 *Safely Maneuvered Through Lin
 He Street*, 1995

Plate 50
LONG-TAILED ELEPHANT GROUP
 Long-Tailed Elephant in a City
 Documentation of site-specific events and installations, 1995–97,
 collection of the artists

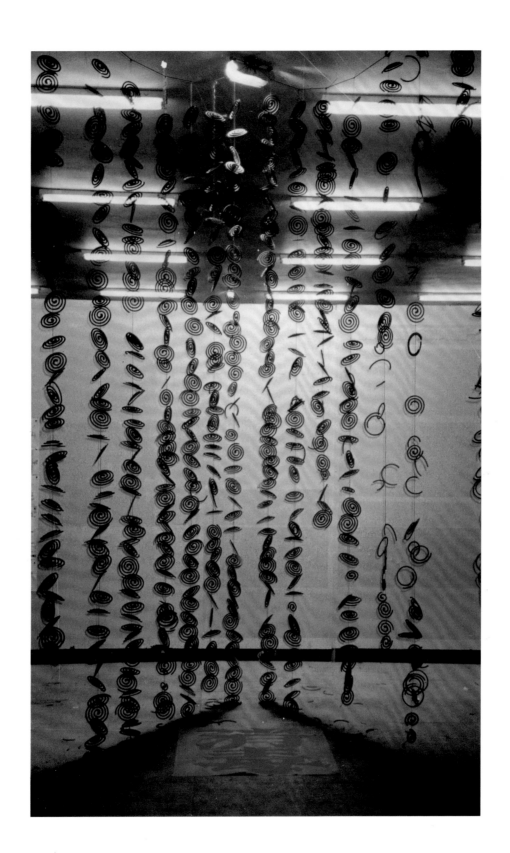

Plate 51
LIU XIANGDONG

Using Mosquito Repellent Coils to Disinfect,
1993–94; Installation with mosquito repellent
coils and water; 11 ft. 6 in. x 32 in. x 32 in.
(350 x 80 x 80 cm); collection of the artist

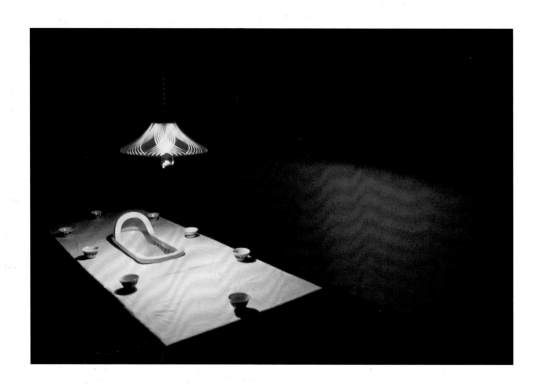

Plate 52
WANG PENG

We Live in Art, 1994
Installation with table, tablecloth, urinal, lamp,
and porcelain bowls; approx. 79 x 39 x 31 in.
(200 x 100 x 80 cm); collection of the artist

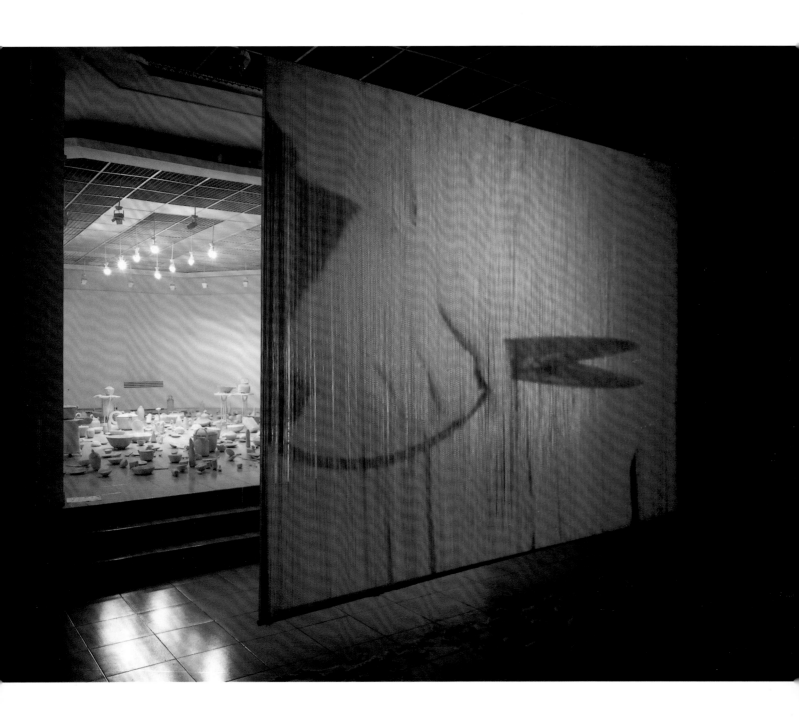

Plate 53
LIN **TIAN-MIAO**

Bound and Unbound, 1995–97
Installation with video projection and household
objects wrapped in thread; dimensions variable;
collection of the artist

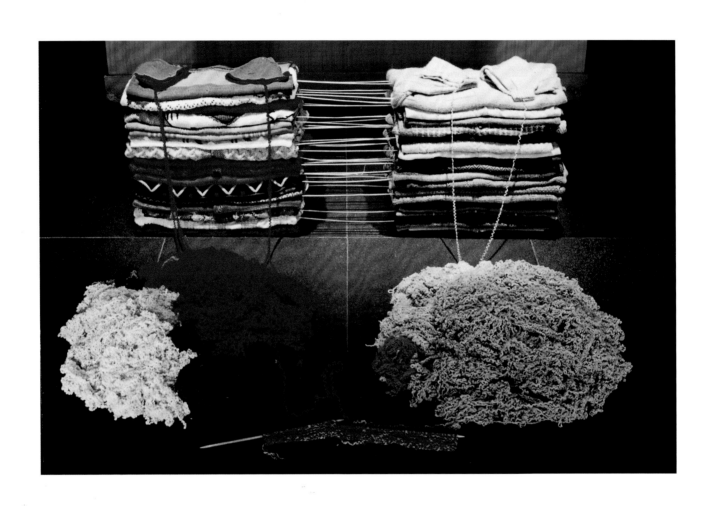

Plate 54
YIN **XIUZHEN**

Woolen Sweaters, 1995
Women's and men's woolen sweaters, unraveled
and wound yarns, knitting needles; dimensions
variable; Fukuoka Asian Art Museum, Japan

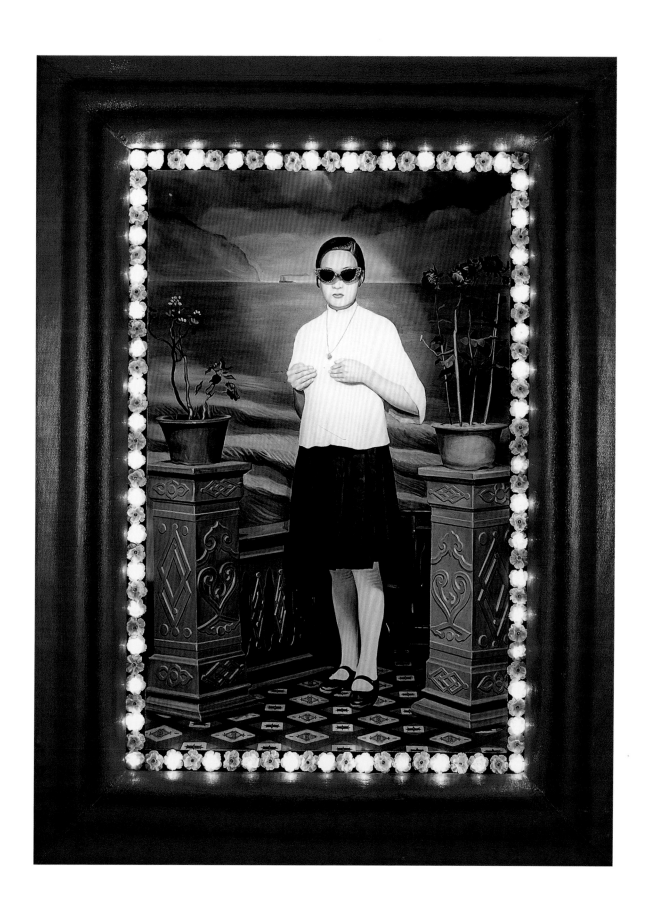

Plate 55
WU TIEN-CHANG

A Dream of a Spring Night, 1995
Oil and mixed media on canvas; 87 x 71 in.
(220 x 180 cm); collection of the artist

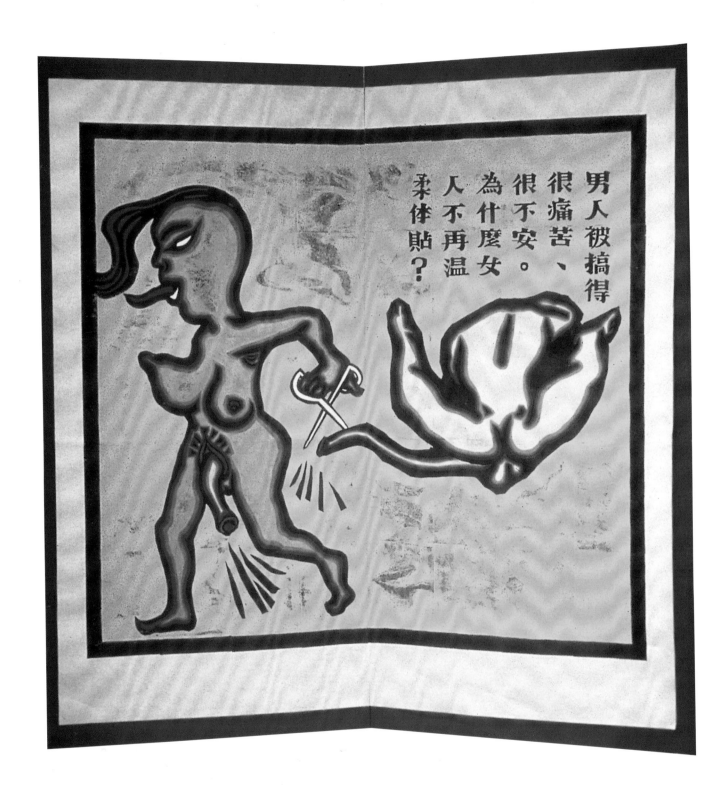

Plate 56
HOU CHUN-MING
New Paradise, 1996 (one panel)
Paint on paper mounted on wood; seven panels:
each 75 x 85 in. (190 x 216 cm); collection of the artist

Plate 57
SHU-MIN *LIN*

The Conqueror, 1993
Hologram; 96 x 24 in. (244 x 61 cm);
collection of the artist

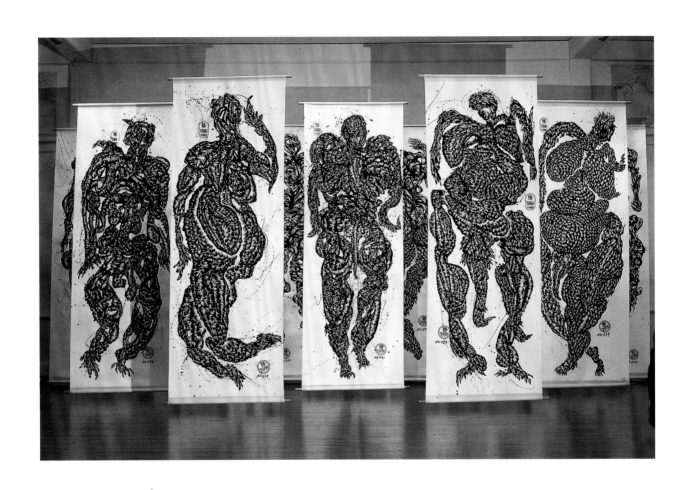

Plate 58
HUANG CHIH-YANG

Zoon, 1996 (installation view)
Ink on paper; hanging scrolls: each 17 ft. 1 in. x 59 in.
(520 x 150 cm); collection of the artist

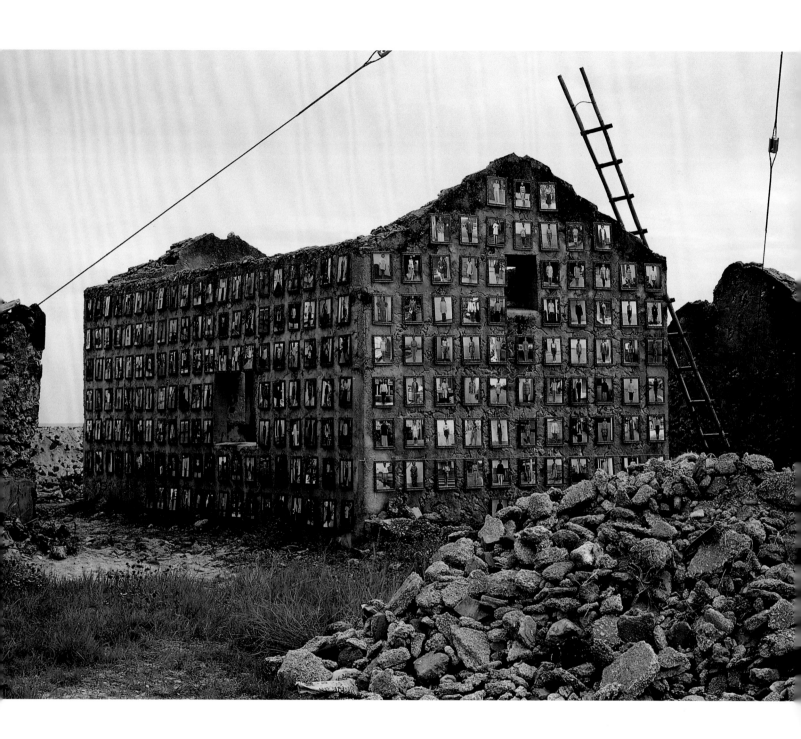

Plate 59
CHEN **SHUN-CHU**

Family Parade, 1995–96
Installation with framed photographs; dimensions
variable; each photograph 11 ³⁄₈ x 9 ¹⁄₂ in. (29 x 24 cm);
collection of the artist

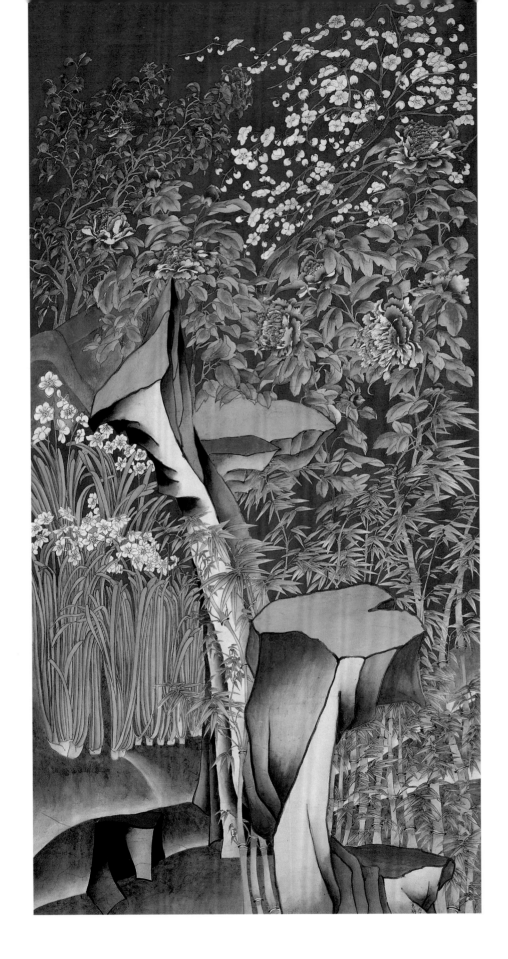

Plate 60
YUAN JAI

The Beginning of the Year, 1996
Color and ink on silk; 73 x 36 ½ in. (186 x 93 cm);
collection of the artist

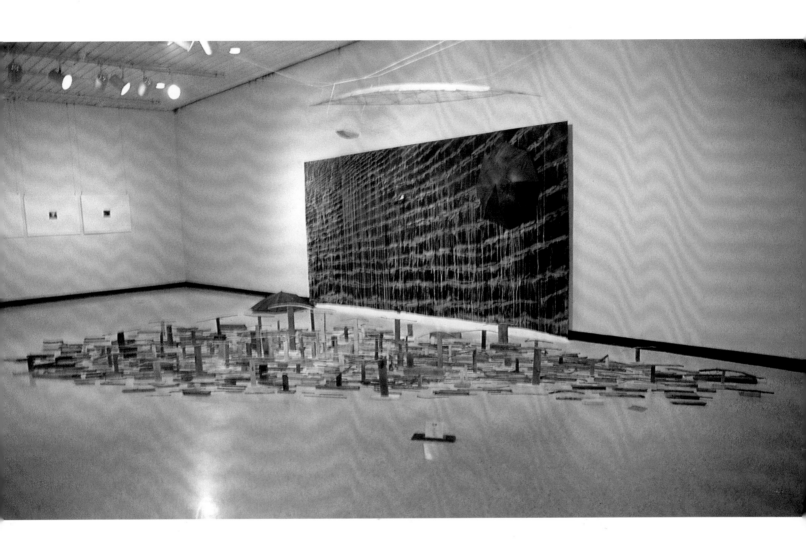

Plate 61
FANG WEIWEN

Seascape, 1995
Installation with carbon-powder painting, driftwood, paper
objects, and salt; approx. 19 ft. x 22 ft. 11 in. x 26 ft. 3 in.
(600 x 700 x 800 cm); collection of the artist

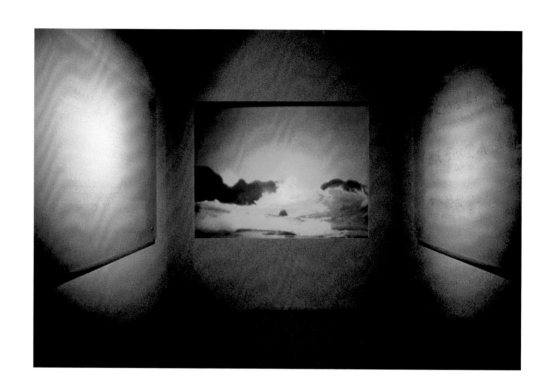

Plate 62
WU MALI

> *Epitaph,* 1997 (installation view)
> Video, sandblasted glass; 118 x 138 x 157 ½ in.
> (300 x 350 x 400 cm); Taipei Fine Arts Museum

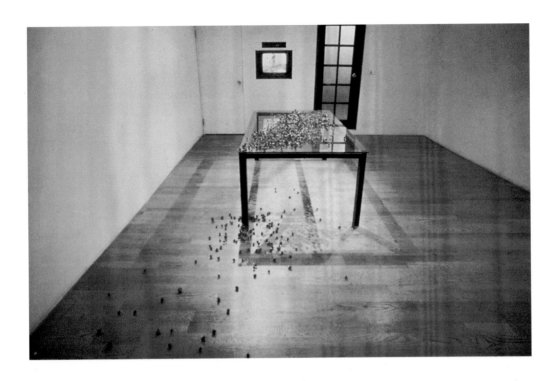

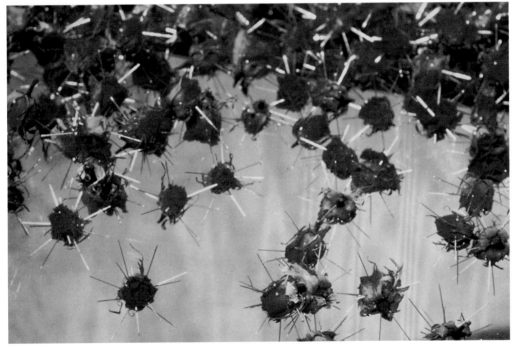

Plate 63
CHEN HUI-CHIAO

Thoughts of Flowers Go Deeper than Looking, 1993
Installation with table, roses, and acupuncture
needles; approx. 27 ½ in. x 78 ¾ in. x 12 ft. 5 in.
(70 x 200 x 380 cm); collection of the artist

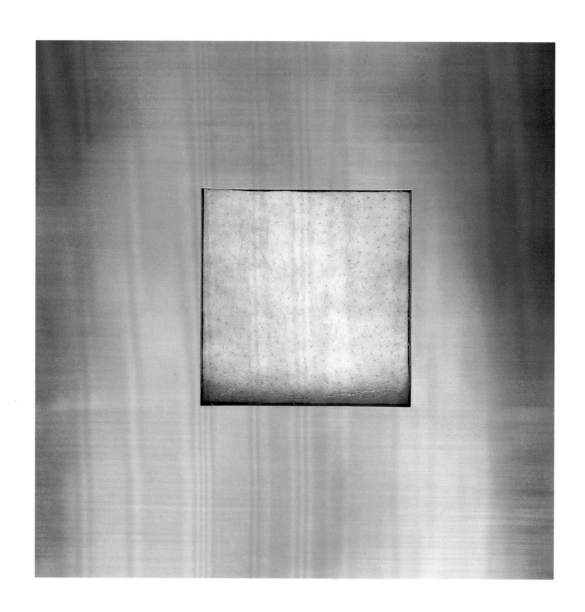

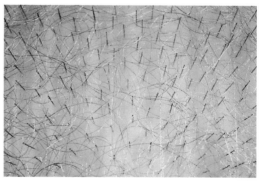

PLATE 64
CHEN HUI-CHIAO

Wings of the Senses, 1994
Stainless steel, needles and thread, and wool;
39 ³/₈ x 39 ³/₈ x 2 in. (90 x 90 x 5 cm); collection of the artist

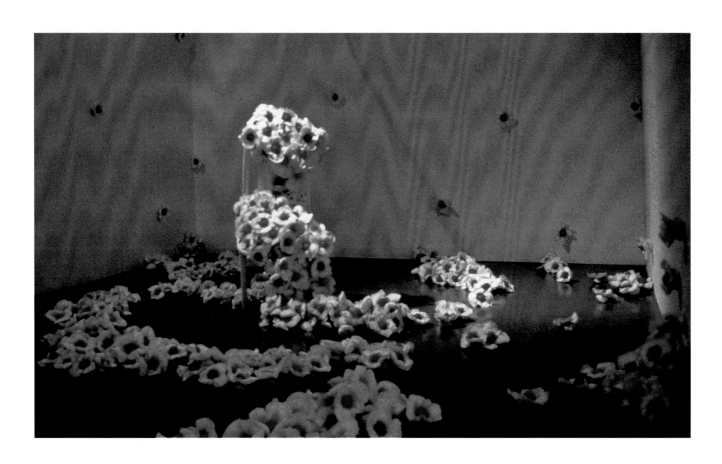

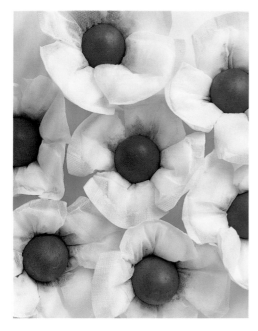

Plate 65
PHOEBE *MAN* (*MAN* CHING YING)
Beautiful Flowers, 1996
Installation with sanitary napkins, colored
eggshells, and chair with light bulb; dimensions
variable; collection of the artist

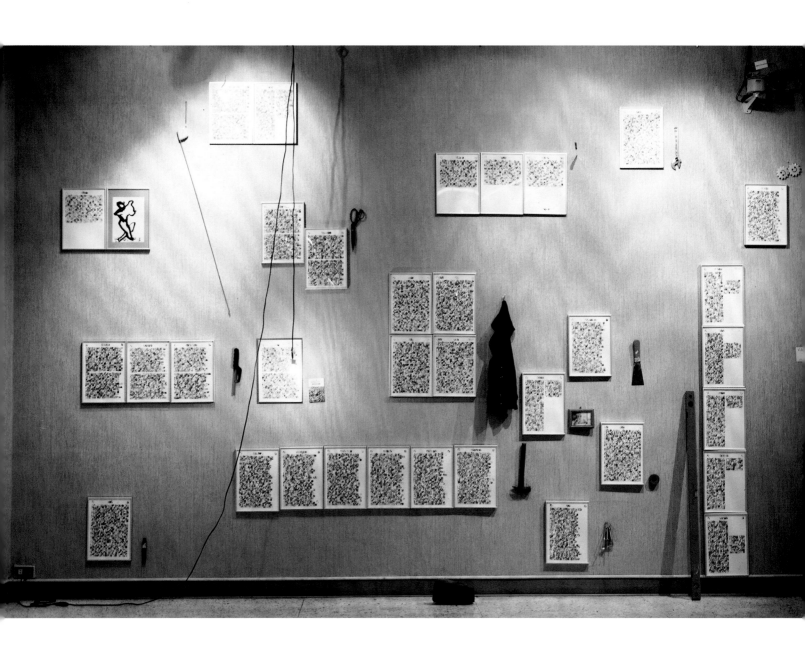

Plate 66
***TSONG* PU**

The "Independence Declaration" of the May Painting Group, 1996
(installation view); Ink and color on paper panels: installation
configurations and media vary; each panel: 14 ³/₈ x 10 ³/₈ in.
(36.5 x 26.5 cm); collection of the artist

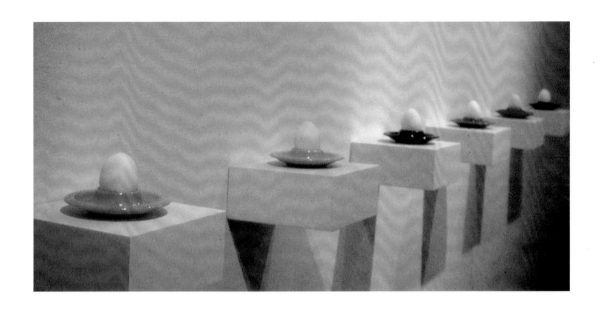

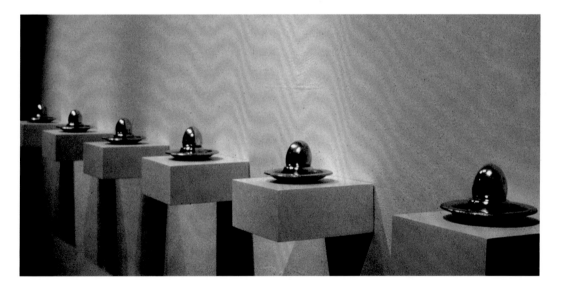

Plate 67
CHU CHIAHUA
 Comparison, 1994 (installation views)
 Real and metal eggs, porcelain and metal plates;
 twelve pieces: each plate diam. 7 in. (18 cm);
 collection of the artist

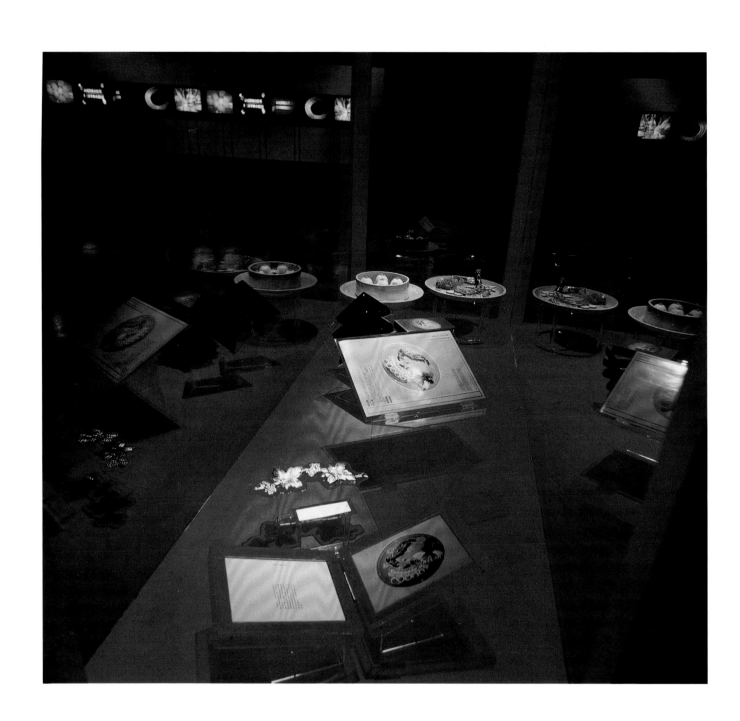

Plate 68
***WANG* JUN JIEH**

Little Mutton Dumplings for the Thirteenth Day, 1998
Installation with table, video, ceramic dumplings, menu,
and flyers; 59 x 47 ¼ x 47 ¼ in. (150 x 120 x 120 cm);
collection of the artist

Plate 69
DANNY NING TSUN *YUNG*
 Gifts from China, 1994
 Eight boxes, covered in paper, silk, or cloth and containing
 plastic film capsules, plastic CD containers, used newspapers,
 etc.; approx. 16 x 27 x 8 in. (40.6 x 68.6 x 20.3 cm);
 collection of the artist

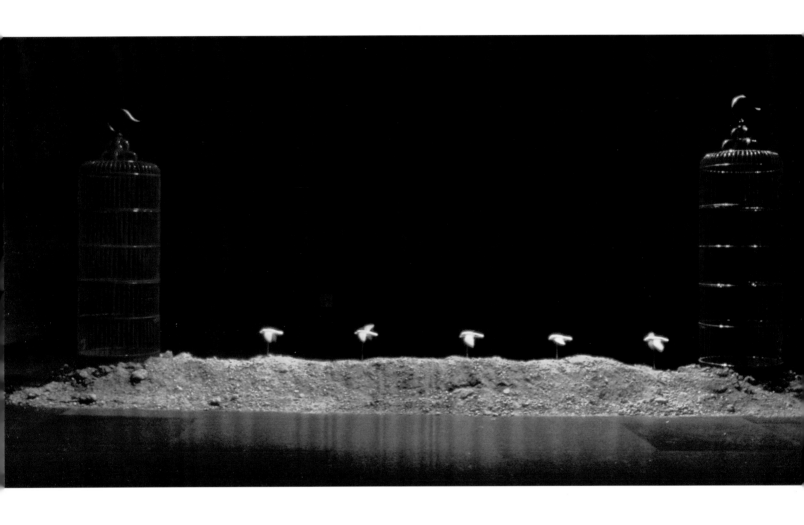

Plate 70
KUM CHI-KEUNG

Transition Space, 1995
Bird cages, yellow mud, and mechanical birds;
approx. 32 in. x 10 ft. 10 in. x 49 in. (80 x 330 x 125 cm);
collection of the artist

Plate 71
HO SIU-KEE

Walking on Two Balls, 1995
Installation with video, flip book, and two wooden
balls; dimensions variable; collection of the artist

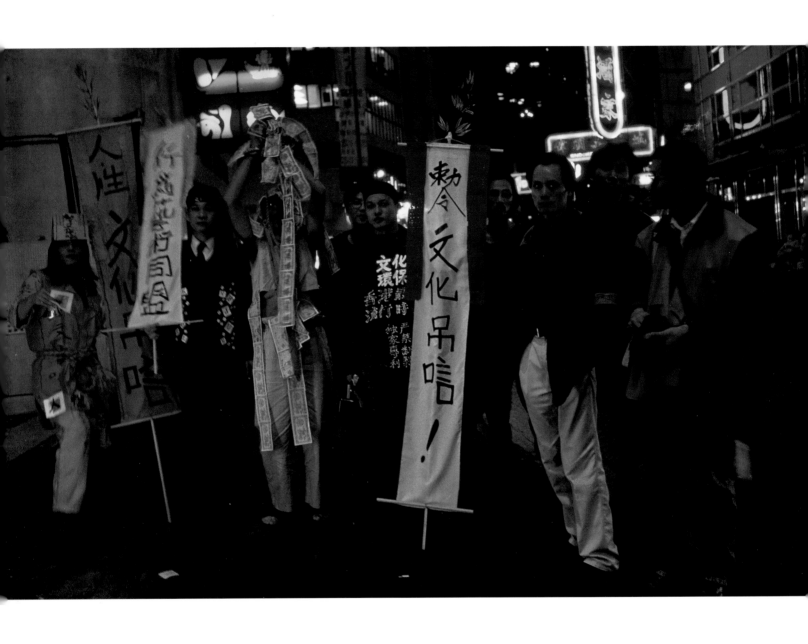

Plate 72
PAN XING LEI, *TO* WEUN, TIM *YU*, and *MA* JIAN

Cultural Mourning
Performance in Tsim Sha Tsui (Jianshazui),
Hong Kong, January 1996

GAO MINGLU

In the early 1920s, when the Chinese New Cultural Movement arose, ideas and forms of the western avant-garde were first introduced into China, either directly from Europe or indirectly through Japan. In the thirties, the Chinese avant-garde movement reached its first peak during efforts to transform China into a modern society. During the late thirties and early forties, some of the most radical avant-garde artists went to Yan'an, an important base of the Chinese Communist Party, to participate in the Anti-Japanese War and the Communist Revolution, while others remained in the cities to continue the "art for life's sake" project and fight the war. With the founding of the People's Republic of China in 1949, the avant-garde's activity ceased, although an ideological confrontation between the avant-garde of the thirties and Mao Zedong's ideas of art for the masses permeated the entire Maoist era.[1]

After Mao's death and the end of the Cultural Revolution in 1976, and with an opening of doors to the West, a new avant-garde movement emerged, again involved in a New Enlightenment Movement. This avant-garde first peaked in what is known as the '85 Movement. It involved about one hundred unofficial, spontaneously formed art groups that questioned tradition (both ancient and Mao's), criticized authority, and negotiated with western ideas and art in efforts to reform Chinese society both culturally and politically.[2] The '85 Movement—which sought to create a new form of elite culture in order to improve traditional culture and to enlighten the masses—laid the foundation of the present avant-garde art on the Mainland, though in response to a social transition from a state ideology with an intellectual elite to an increasingly transnational economy in which the middle class is gaining power, the idealism of the '85 Movement has been transformed into pragmatic directions and practices.

Every two or three years fast-changing political and economic circumstances have engendered a new art trend that becomes the new avant-garde mainstream. For instance, Rationalist Painting shifted in the late eighties from its initial utopianism to a denigration of idealism, and then in the early nineties it produced Political Pop. In the mid-nineties, shortly after Political Pop had gained international attention and success, and after the monolithic state ideology had begun to show fissures, a new avant-garde group making a private Apartment Art took over. Such frequent emergence of avant-garde art trends has sustained the dynamic vitality of contemporary art on the Mainland for twenty years.

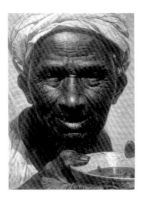

Fig. 14
LIU YULIAN, CHEN YIMING, LI BIN
Maple No. 1, 1979, illustration for a short
story by Zheng Yi

Fig. 15
LUO ZHONGLI
Father, 1980

The Rise and Decline of Humanism, 1978–1998

Although in the West humanism has, since the Renaissance, been differenti-
ated from the modern idea of individualism, in China after the Cultural
Revolution, the term *humanism* (*rendaozhuyi*) indicated the search for indi-
vidual freedom in conjunction with true mankind or fraternity. Around 1981,
a philosophical debate about humanism and alienation was initiated by
renewed research on Marx's *Economic and Philosophic Manuscripts of 1884,*
in which the young Marx criticized alienation in capitalist society and empha-
sized humanism as an alternative. This discussion indirectly criticized the
suppression of the individual's value in Mao's ideology and opposed the divi-
sion of people into different classes.

About the same time, a major art trend dealing with this desire for
humanism, New Realistic Painting (*Xinxieshi huihua*), began among artists of
the Red Guard generation. The Scar (*Shanghen*)[3] painters, most of whom
were academically trained, used the style of Russian critical realism to show
the emotional wounds inflicted on the Chinese populace—especially intel-
lectuals, students, and some old cadres—by the Cultural Revolution. *A
Certain Month of a Certain Day in 1968* and *Maple No. 1,* 1979, show the tragic
results of Red Guard battles (fig. 14). The Scar painters' subjects and emo-
tional content reflected their personal experience of suffering.

The Scar painters later shifted their focus from the emotional wounds
inflicted on urbanites—themselves—to a Rustic Realism (*Xiangtu xieshi*)
depicting the poor, innocent peasants and pastoralists in the countryside.
Luo Zhongli's monumental portrait of an ordinary peasant, *Father,* 1980
(fig. 15), and Chen Danqing's Tibetan Series, which represents the Tibetans'
simplicity and glorifies their dignity (see fig. 16), are typical.

Unlike the New Realistic painters, who used traditional realistic style,
members of the Star group (*Xingxing*)—who were self-taught artists—
worked in previously forbidden modern western styles, ranging from
Post-Impressionism to Abstract Expressionism. The main intent of their work
was to express a dream of the liberation of the common Chinese people and
to criticize the autocracy. Wang Keping's *Buddha,* 1980, a cynical turning of
the image of Mao Zedong into a Buddha, is typical (fig. 17).

In the mid-eighties when the '85 Movement emerged, many intellectu-
als and a new generation of artists who after the Cultural Revolution received
academic training and a strong dose of western modern influence formulat-
ed a modern utopianism and dealt with humanistic themes in a more univer-
sal and conceptual way. They searched for a Chinese modernity, and their
"humanism" referred to a rationalization and purification that would produce
a spiritual order on which a new future would be built; it implicated a
modern Chinese nationalism in its quest for salvation through a brave sacri-
fice. This humanism also embraced the desire for individual freedom, after
several decades of selfless devotion to Mao's revolution during which humanism

GAO MINGLU

was criticized as being bourgeois.[4] In the '85 Movement, different aspects of the humanist challenge to modern alienation were mainly developed by the Rationalist Painting trend (*Lixing hihua*) and the Current of Life Painting trend (*Shengming zhiliu*).

From a Utopian World to Double Kitsch: Rationalist Painting and Pop
Rationalist Painting—which included many groups of artists living in cities on the east coast of China—used cool, solemn, and sometimes grim forms to convey religious kinds of feeling. The major artists of Rationalist Painting included the North Art Group (*Beifang qunti*) in Harbin, Heilongjiang Province; the Pool Society (*Chishe*) in Hangzhou; the Red Brigade (*Hongselu*) in Nanjing; and some artists in Shanghai. Though considering themselves a transitional generation, they believed they bore responsibility for the nation's future.[5] Some in the northeast made the rather extreme claim that the culture of the temperate zone was dying and must be replaced by a new culture from the northern climes. They set in opposition a masculine strength believed inherent in northern Chinese culture with a comparative weakness of both Chinese traditional culture, which they associated with southern China, and modern western civilization. Deriving a style from Surrealism, they sought an imagery to express the strength and the silent, pure atmosphere of the frigid zone.[6] As Wang Guangyi, a major figure in this group, said, "Here, both creator and the created are moved by the atmosphere of the sublime and by dignity, rather than by common aesthetic and visual pleasure."[7]

Wang intended his 1985 series of paintings entitled Frozen North Pole to signify "a kind of beauty of sublime reason which contains constant, harmonious feeling of humanity" (fig. 18).[8] In these paintings orderly figures face toward the future. His subsequent Post-Classical series employed modified themes of classic western paintings. In *Death of Marat,* 1987, Wang abstracted the figure of Jacques-Louis David's 1793 monument to the martyred French revolutionary leader Jean-Paul Marat. He doubled it in a symmetrically opposed composition painted in a muted palette of grays (pl. 20). This rationalization of sacrifice as an instrument of a more perfect social order uses art like religion to depict a purified Chinese world.

By 1988, a "sociocapitalist" society began to develop in China, and the intellectuals were becoming fatigued from dreaming of an ideal future. Wang Guangyi, like many of his fellow artist-intellectuals, moved away from grand themes to specific analyses of the social environment. In 1988 he suddenly shifted to a cut-and-paste method. He started to criticize "the modern myth" (*xiandai shenhua*), which may refer to both Mao's revolutionary and the avant-garde iconoclastic utopias. He proclaimed that we must "liquidate the enthusiasm of humanism" (*qingli renwen reqing*) and that art is created only to achieve stardom in media society and the market.[9] He called art just a strategy (*youxi*), and Andy Warhol's Pop became his mode.

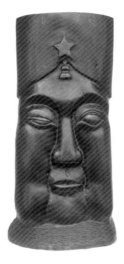

Fig. 16
CHEN DANQING
Tibetan Series: Going to Town, 1980

Fig. 17
WANG KEPING
Buddha, 1980

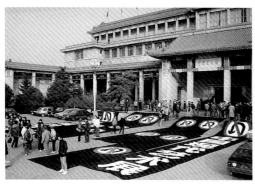

Fig. 18
WANG GUANGYI
Frozen North Pole, 1985

Fig. 19
The National Art Gallery, Beijing, on the opening day of the *China/Avant-Garde* exhibition, February 5, 1989. Note the "No U-Turn" symbol, part of the logo for the exhibition

Wang created a series of portraits of Mao Zedong, and in February 1989, just four months before the Tiananmen Incident, he caused a sensation by exhibiting *Mao Zedong No. 1* (pl. 34) in the *China/Avant-Garde* exhibition. *China/Avant-Garde* took place in the National Gallery in Beijing, two months before the student demonstrations began in Tiananmen Square. A large group show including 297 works in various mediums by 186 artists, it was the first, and so far the only, nationwide avant-garde exhibition held in Mainland China (fig. 19). In *Mao Zedong No. 1* a grid is superimposed on an official portrait of Mao and the whole is repeated three times: the revolutionary leader and the utopia he stood for are imprisoned within the measurable confines of an analytic frame. This work might have been created with a critical purpose rather than an overt commercial goal, for, generally speaking, the avant-gardists of the '85 Movement had not yet been involved in a commercial market.

After intellectual culture was defeated first by official power in the June 4, 1989, Tiananmen Incident and subsequently by mass commercial culture, Wang Guangyi painted a series of oils called Great Castigation in which he juxtaposed political images and commercial signs (pl. 35) They present heroic figures from the Cultural Revolution along with company logos such as those of Coca-Cola and Kodak. The paintings are meant to show that though the two systems (political and commercial) are not united, the principal goal of each is to convince the population of the authenticity and singularity of its products.

Since the early nineties, however, official culture and popular culture have blended in the commercial society encouraged by Deng Xiaoping's economic reforms. This has been a challenge to the avant-garde artists. Given the weakness of intellectual culture and the impact of the commercial tidal wave, the notion of an avant-garde enlightenment became meaningless. Some of the artists therefore shifted from a serious attitude to a trivializing one in the face of an inverted social structure: the old ideological industry had begun producing a kind of "political kitsch," and popular culture was grinding out "commercial kitsch." "Double kitsch" combines the two mass cultures: socialism and capitalism.[10]

The mass media's overwhelming of the population with propagandist images (such as Mao's art) or advertisement and entertainment symbols (such as Coca-Cola and Marilyn Monroe) apparently levels the differences between Mao's mass culture and Hollywood. The utopian avant-gardists reacted against both political and commercial power and began a new project of deconstruction, directly imitating the discourse of double kitsch. Political Pop serves as a mirror for both sides of this "double kitsch."

It was dubbed "Political Pop" because it combines Cultural Revolution political themes and the form of American Pop Art. Ironically, Political Pop attracted tremendous attention from overseas art markets and museums and quickly became an international commercial success. In addition to

GAO MINGLU

resembling the coexisting discourses of state propaganda and consumption, double kitsch easily fits into a transnational art market system, in which it was promoted as a new political statement and a commodity. A new double kitsch avant-garde evolved from both the internal logic of China's avant-garde and outside observers' commercial and ideological fascination. Wang Guangyi's painting became a kitsch advertisement of an advertisement, and he himself became a producer of commodities instead of a preacher.

Other Rationalist painters, such as Shu Qun, Li Shan, Yu Youhan, and Ren Jian, did the same. In *Absolute Principle* of 1985, Shu Qun, a colleague of Wang's in the North Art Group, put Christian iconography into a rationalistic grid, which represents an order the artist considered capable of creating a sublime realm with which to purify reality (pl. 19). In the late 1980s, however, he too turned away from this vision, and he created a different version of *Absolute Principle* that was displayed in the *China/Avant-Garde* exhibition. Shu added three more panels to the painting, and now the Christian iconography and the grid progressively disappear. This fadeout mirrors the demise of the intellectuals' idealism about modernization (westernization).

Ren Jian and Li Shan devoted themselves to exploring eastern mysteries and creating abstract forms and images based on traditional Chinese concepts of the beginnings of the human world. In the mid-eighties, Ren Jian believed that art is a means to research natural history and social questions. A 1985–87 a series of paintings gave form to his philosophical reconfiguration of the human world. A thirty-meter-long ink painting called *Primeval Chaos*, 1986–87, pictures the origins of life (fig. 20, pl. 2). However, Ren's abstract cultural imagination fell down to the ground of reality in the early nineties. His Desiccation series includes *A.D. 2000*, 1991–93, a composite of 108 painted postal stamps showing various national flags and printed with the year "2000." There is also a postmarked date "1991.3–6," the time of the work's creation (pl. 42, below). The work symbolizes the fact that no human endeavor will be able to escape from the international system and that a country can be ordered by mail in the next century. To state even more

Fig. 20
REN JIAN
> *Primeval Chaos* (detail), 1986–87
> Collection of the artist
> See also pl. 2

emphatically that art is becoming a product in a booming transnational consumer society, in 1993 Ren and some colleagues planned an extravaganza called *Mass Consumption,* including a fashion show and the sale of jeans made of national flags, to take place at the McDonald's in Beijing (pl. 42, above), but the authorities prevented it.

The mid-nineties also saw a new tendency one may call the "New Floating World" (*Xin fushihui*), after the Japanese genre *ukiyoe,* "pictures of the floating world." The artists of this group use Political Pop's strategies of imitation and appropriation, but target popular mass culture. They use pastiche to picture the rapidly changing secular world and to mock human desires for material goods, power, and sex. This "New Floating World" characterizes the multifarious leisure cultures of booming cosmopolitan life, especially of the emerging middle class. Su Xinping's *Tower of the Century,* 1996, symbolizes the century's Chinese mass movements, revolutionary and economic, led by Mao and Deng respectively, and deals with such themes as glorification versus destruction, utopia versus materialism, and socialism versus capitalism (pl. 40). Rather than the coexistence Political Pop depicts, Cao Yong's works allegorize the confrontation between Chinese state ideology and western materialism; his double kitsch is more paradoxical. In the center of his painting *The Age, Women, and the Environment No. 1,* 1995, is a powerful, crude monster with a halo of five red stars from the Chinese flag flanked by chorus lines of bare-breasted western women, emblematic of forces injected into Chinese society by modernization (pl. 44).

Individuality in Difference and Indifference: Current of Life and Cynicism
The '85 Movement trend called Current of Life (*Shengming zhiliu*) included many artist groups in western China, including the Southwest Art Group (*Xinan yishuqunti*) led by Mao Xuhui and Zhang Xiaogang. The trend addressed the value of humanism in the breaking down of a collective rationalization that had suppressed individual consciousness and desire. Interested in foreign philosophy, psychology, and literature, these painters took the term "current of life" (*élan vital*) from Henri Bergson to describe the natural disposition of life that embraces violence, irrationality, and intuitive action. Mao Xuhui, for instance, was interested in pure instinct. In about 1985 he wrote, "When I put into the magic bucket of artistic form the things in life that disturb people, that are irrational, that are disorderly, that have a strong presence even though they are undefinable, then I feel delight."[11] Indeed, he unleashed such feelings in one of his earliest paintings, *Red Bodies* (pl. 24). While the Rationalist painters looked forward to a purified future, Current of Life painters looked the other way, back- and inward, in images of distorted bodies or of peoples who live a simple life. Zhang Xiaogang's *Eternal Life,* 1988, which depicts minority people surrounded by animals, is a typical example of the

GAO MINGLU

latter. It symbolizes a "purity" of rustic life which the artist, as a modern man, identifies as a true and original human consciousness. This kind of imagery, often based on experiences in Tibet or other remote areas, appeared frequently in the 1980s. Simultaneously, in literature, there was a searching for roots (*xungen*) movement that posed the problematic of "native soil writing" versus "urban literature."[12] Perhaps one of the most important features of twentieth-century Chinese culture is that artists searching for aesthetic modernism frequently look back to traditional roots to explore certain human values. It may also reflect vacillation between an embracing humanitarianism and self-indulgence, between social responsibility and elite escapism, between the earthy "soil" and an imaginary utopia.

The rapid growth of consumer society in the nineties affected these painters too. People in a monolithic state may all be the same, but the consumer masses are indifferent, like any mass commodity. Zhang Xiaogang's slick-surfaced *Bloodline: Family Portrait No. 2 (Happy Family)*, 1995, portrays a perfect, modern, single-child family (pl. 26). The child's male genitals are proudly exposed, announcing the good fortune of having produced the preferred gender, but the apparel, facial features, and gazes of the mother, father, and son reflect little difference in gender or even age. Zhang shows the paradox of inner emptiness in the face of the pursuit of individualism in an increasingly commodified society.

A different response to worldly pressures is self-exile from the exterior environment. Mao Xuhui shifted his attention from an intuitive inner world to a private living space. Over the last few years he has repeatedly painted pictures of his own apartment and its chairs, tables, sofa, door, and stairs—but empty, bereft of its inhabitants, except occasionally in a family picture hanging on the wall. Mao's repetitive dwelling on personal objects reflects a self-indulgence and a fetishism that endows privately owned material with a kind of "aura," like that Vincent van Gogh gave his peasant's boots. There is a conflict between Mao's two fetishisms, private objects and mass-produced commodities filling his private space, and in *Scissors and Sofa No. 1*, 1995, the scissors poking toward the sofa may represent an outside power's threat to his peaceful insular environment (pl. 25).

Cynicism (*Fangfeng*), or Cynical Realism (*Wanshi xianshizhuyi*), is another way employed to present an awkward self-identity formation. Several artists who began to paint in the late eighties and early nineties exhibit a free-floating cynicism unrelated to any dogma and uncommitted to any belief system; they have reacted with a sense of humor to the existential situation. Fang Lijun has repeatedly painted typicalized Chinese men without hair, with small eyes, and usually with tensionless smiles. Although his characteristic men appeared in drawings from 1988, they were still in something of a village community. But beginning with the oil paintings of the early

1990s there was a shift in meaning (pl. 27). The men might refer to the artist himself in a gesture of indifference, self-mockery, and powerlessness—as a figure called a *pizi,* or "riffraff."

Cynicism can be traced back to the "gray humor" paintings of artists in the Pool Society led by Zhang Peili and Geng Jianyi in the mid-1980s. Reacting to an inevitable but unfamiliar urban modernization, they presented a neutralizing attitude and a new realistic technique that duplicated the referent, not to represent but rather to project it into a decontexualized frozen moment. Then the real, the original referent—whether Zhang's industrial rubber gloves (pl. 18) or Geng's emotional faces (fig. 21, pl. 22)—becomes the unreal and a distance is produced between artist, image, and audience.

Gray humor edged in the direction of Cynicism, which had a more allegorical tone, in the late eighties; after the Tiananmen Incident, Cynicism became one of the major avant-garde trends. In *Taking a Picture in Front of Tiananmen,* 1990, Wang Jinsong arrays a group of citizens as if taking a commemorative picture (pl. 36). Since 1949, when Mao Zedong stood on Tiananmen, the Gate of Heavenly Peace, to announce the founding of the People's Republic of China, it has been customary for Chinese people to have their picture taken in front of this revolutionary monument. The people in Wang's painting exhibit the relaxed, casual attitudes and quotidian pleasures of modernization—the women wear fashionable suits, the young men are dressed appropriately for jobs with foreign companies, and a newly urbanized worker fresh from the countryside retains his ruddy complexion. Against the backdrop of the monument of the Revolution, the banality of middle-class pleasures provokes a cynical smile, for the picture is to record not a revolutionary memory but a tourist one.

A Transcendental Realm of Ink Painting: Scholar Painting and Universal Current
Traditional-style Chinese painting was revitalized after the Cultural Revolution as both an aesthetic investigation and a rebellion against the propagandist ink painting of the Maoist era. In the late seventies and early eighties,

one dominant trend of ink painting was a formalist school that emphasized a stylized combination of traditional literati painting and western modern art styles under a slogan "no subject matter, just form." It was initiated by an older, French-trained academician, Wu Guanzhong (b. 1919).[13]

In the mid-eighties, an avant-garde ink painting group rebelled against highly stylized traditionalism and incorporated some western avant-garde forms and ideas. They freed the medium from the specific techniques of orthodox aesthetics and developed it as a contemporary medium. Most of the practitioners lived in Hangzhou, Shanghai, Wuhan, Beijing, Tainjin, or other cities. Considering themselves Rationalist painters, the artists devoted themselves to the creation of universal pictures transcending the self-expression (*ziwo biaoxian*) of both traditional literati painting and western modern formalism.[14] Their painting frequently presents some concept of a universal structure with a somewhat religious meaning, for example, Wenda Gu's *Contemplation of the World,* 1985, and Ren Jian's *Primeval Chaos;* or a mysterious personal inner world, like the ego of Sigmund Freud (fig. 22). Because these artists strove to represent a universal world supported by various kinds of historical, philosophical, and even scientific knowledge, their paintings were called "scholarly painting" (*xuezhe huihua,* which is distinguished from traditional literati painting or *wenrenhua*). The most influential artist of this group was Wenda Gu, whose experimental ink painting employed traditional techniques of washes and splashed ink to create an imagery of energy, *qi,* and a flowing stream, *liu.* Therefore, this kind of "landscape painting" was also called "Universal Current" (*Yuzhouliu*) after the mid-eighties; it influenced a new generation of ink painters of the nineties.

If the works of the generation of the eighties expressed the artists' ambitions to transcend tradition and the modern, and reflected their ambivalence about nationalist concerns and anti-tradition—and had a violent and masculine tone—the works of the new generation of the nineties indicate a direction toward harmony and peacefulness. Although the ink painting of the new generation can still be called Universal Current, the painted world is

Fig. 22
WENDA GU
The Silent Door God, 1986

Fig. 23
FANG TU
Infinite Sky, Infinite Earth, No. 9, 1996
Collection of the artist, Guangzhou

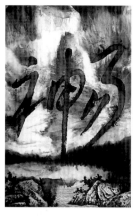

more lyrical, and the artists are like "hermits" who have escaped from a secular material society to enjoy meditative experiences at home.

In his *Infinite Sky, Infinite Earth, No. 9,* 1996, Fang Tu, a young painter living in Guangzhou, used brush and ink wash on paper but abandoned the natural forms of the grand landscape tradition for a formal arrangement including squares and circles, which are ancient emblems for heaven and earth. Fang's lines within squares evoke the hexagrams of the *Yi Jing* (*Book of Changes*). The medium is not used to display a mastery of technique; instead, like religion (except rationally), it draws the viewer toward universal mysteries to engender a meditative remove from the material world (fig. 23).

Conversely, Wang Tiande's *Ink Banquet,* 1996, is an allegory of a tradition materialized (pl. 10). Wang painted the surface of a large banquet table set for eight people with black ink, leaving large areas of white in reserve: the classical ink palette appears on an object of the real world, and the undulations of everyday form become the hills and valleys of a landscape. It poses the question: Should the tradition of literati painting be brought down to earth and into the mass culture or be kept by a cultural elite for the pursuit of a transcendental realm?

Conceptual Art: From Anti-Utopia to Dematerialization 1985–98

The other major trend In the '85 Movement in addition to the humanist painting group was conceptual art. Like the humanists who, in their devotion to modernity and progress, saw themselves as a cultural elite and spiritual revolutionaries, the conceptual artists were also "revolutionaries." However, in their idea of "Art," the conceptualists sought not only to go beyond the long-dominant propagandist art for Maoist ideology but to break with all traditions *and* the new schools of art that emerged after the Cultural Revolution, including their colleagues in the '85 Movement. The conceptualists' main concern was to eliminate any utopian or subjective illusion. Their project of anti-subjectivity and anti-authorship was pursued through the mediums of the Chinese language, readymade objects, and performances using their own

bodies. The most influential artistic and philosophical sources were Dada and traditional Chan (Zen) Buddhism. Almost all of the conceptual artists, including Huang Yong Ping, Wu Shan Zhuan, Wenda Gu, and Xu Bing, acknowledged the influence of Chan Buddhism, which, like Dada, attempts to break free from any doctrine, dogma, text, or authority.

Anti-Subjectivity and Anti-Authorship

Wenda Gu, Wu Shan Zhuan, and Xu Bing were among the artists who created series of works or installations using Chinese characters. Wenda Gu's language project investigated the intrinsic nature of aestheticizing characters or text by destroying the basic structure of the Chinese character while retaining its calligraphic presentation in order to create a conflict between linguistic meaning and aesthetic pleasure. In his Pseudo-Characters series of splashed ink on huge sheets of rice paper, 1984–86 (fig. 24, pl. 3), Gu used traditional calligraphic techniques but wrote restructured characters with components upside-down, reversed, or wrongly written. The production of these works demonstrates a paradox: whenever a calligrapher is writing, an aesthetic affectation may override any concern with the text. This factor is always present, especially if a traditional master's model is being copied. Gu was a radical destroyer of the power of traditional writing.

Wu Shan Zhuan has questioned meaning through the creation of linguistic context by juxtaposing randomly selected phrases and slogans. In his installation *Red Humor,* 1986, he used the format of the Cultural Revolution's wall posters, but the messages were drawn from the surrounding environment and conveyed the multiple dimensions of contemporary political, social, and economic information (see pl. 5). The texts written all over the room's walls, floor, and ceiling include political slogans such as the Maoist-period "Exercise for strength in the class struggle," price notices, advertisements, newspaper headlines, commonly used phrases, classical poetry, Buddhist texts, traffic signs, weather forecasts, even some lines of ancient poetry and the title of Leonardo's *Last Supper.* Wu bypassed his own subjectivity by randomly selecting the text. In creating a recontextualized meaning, viewers might sense a playful and happy attitude and Wu's Chan Buddhist–like quick wit. Wu proclaimed that an artist is not to function as the dominant factor in art production. Language itself is a subjective product, and the artist is a material for the art object: "Wu is an example of material. Nothing can escape from being material."[15] Wu is very much concerned with anti-authorship.

Xu Bing hand-carved more than two thousand wooden type elements and printed them in traditional style on long scrolls and in books. But none of the characters in *Book from the Sky,* 1987–91, can be pronounced or understood, because the artist invented each one by rearranging elements from real Chinese characters (pl. 6). This extraordinary piece took three years of intensive labor, but for Xu Bing it was "just a big joke."[16] By removing all

Fig. 25
ZHANG PEILI
*Water—The Standard Version
Read from the "Ci Hai" Dictionary,*
1992 version
Collection of the artist

semantic significance from the "writing" itself Xu left a giant space for the audience to invent meaning. He erased with meaninglessness the traces of his own ego as the creator of a spectacular but fake monument.

Zhang Peili has always been interested in the significance of communication by both language and action. His video work *Water—The Standard Version Read from the "Ci Hai" Dictionary*, 1989/1992, investigates the meaning of spoken language (fig. 25). For the duration of the twenty-minute video, Xin Zhibin, the government's highest ranking broadcaster on CCTV, the state-controlled Chinese Central Television, reads the definition of "water" from a dictionary. As her employer, the artist replaced the state in deciding what would be "broadcast." He chose a text from a standard reference book on language, the *Sea of Words (Ci hai)*. Here, each element has equal weight—the spokesperson, the dictionary, the artist. None is itself the authority.

The New Analysis Group (*Xinjiexi*) consisted of three artists, Wang Luyan, Chen Shaoping, and Gu Dexin, who worked on the *New Analysis* project for eight years, 1987 to 1995. Decrying the individualism of contemporary art, they sought to expunge subjectivity by creating a rationalized discipline to order the artist's mind. The New Analysts developed a set of rules agreed upon by all three artists before beginning to make objects. They progressed step by step, with one artist taking an action, such as drawing a line or making a mark, in accordance with the rules while other two watched as judges. Then they switched positions and proceeded until the project was finished. Their first group project was *Tactile Art,* 1988, a series of diagrams variously showing degrees of temperature, the sizes of spaces, and categories of human feelings. The viewer is to examine and judge the data presented by the marks on the diagrams (pl. 17).

Huang Yong Ping (who moved abroad in 1988) might be the most extreme artist in the contemporary Chinese conceptual endeavor. In the first stage of his anti-style, Huang claimed that mass-produced industrial parts were more truthful and powerful than any subjectivity-infused artwork. He replaced paintbrush with airbrush, oil paint with industrial materials, and the studio with a factory, where he had made his paintings in 1982.[17] He then created the Roulette Wheel series, eliminating the subjective component of artistic creation by applying paint and ink to paper in a random manner determined by spinning a wooden wheel (pl. 15). Next came the founding in 1986 of the Xiamen Dada group and his publication of the article "Xiamen Dada: A Kind of Postmodernism?" (*Xiamen Dada: Yizhong houxiandai?*),[18] in which Huang criticized all subjective desires and dogmas, including those of Rationalist Painting, and advocated the destruction of all doctrines and texts, following the iconoclasm of Chan masters, especially the sixth patriarch, Hui Neng (638–713). Invoking both Dada and Chan, he designated destruction as a new direction for Chinese postmodernism. After their 1986

exhibition closed, Huang and the other twelve Xiamen Dadaists burned all of their works under the pretense of rendering them uncollectable.

Next, Huang started to attack the writing of art history, calling it a history of the war of art. He said terms such as "avant-garde" and "challenge" used to describe artists vying among themselves mostly came from the language of the military, and that art historians, critics, curators, professors, the journals, and finally audiences have created an art world that perpetuates an art war between different schools of art and even different countries. Therefore, Huang washed both *A History of Chinese Painting* by Wang Bomin and *A Concise History of Modern Painting* by Herbert Read in a washing machine for two minutes and displayed the resulting pile of pulp; it was included in the *China/Avant-Garde* exhibition in 1989 (pl. 16).

Fig. 26
SONG DONG
Water Writing Diary, 1995

Apartment Art: We Live in Art

Facing many difficulties during the nineties—such as a lack of acceptance of the avant-garde by both official and commercial galleries in China, being ignored by the media, lack of attention by the organizers of some Chinese avant-garde exhibitions overseas, and a paucity of financial resources—conceptual artists have had to retreat to confined spaces. They have been forced to do or keep their work at home; to employ inexpensive materials in small-scale work that can be displayed in a private space; and to communicate only with a small audience of artists and interested persons. Thus I call this phenomenon Apartment Art (*Gongyu yishu*). This new practice of conceptual art began to occur in some big cities, especially in Beijing and Shanghai, in the middle of the decade; it has produced a number of unsalable and unexhibitable installations, some of which are called Proposal Art (*Fangan yishu*) and can only be communicated on paper.

State ideology has gradually lost its totalizing social dominance in China, and seeking a legitimizing worldview has increasingly become a personal affair. In this context, the project of anti-ideology is rendered insignificant. Apartment Art instead may deal with nonsense or meaninglessness. It has lost the option of attempting to move or impress an audience—much less the broader public—which avant-garde figures of the eighties strove to do. And rather than promoting anarchistic urges, some artists have now given way to longing for a new ideological system, to formulating a distinctive personal discourse in an admittedly polymorphous, polycentric world. There is a resistance to all totalizing ideologies in order to be free from any particular one, yet this resistance is also a way of cultivating a private, meditative world apart from the current materialistic society.

Song Dong's work is an example. Song is an ordinary middle-school teacher who lives with his wife, also an artist, in a room some ten meters square. Many projects have been made in this small room, most of them

Fig. 27
LIN YILIN
Facing the Wall
Installation in Guangzhou, 1993

sketched on paper. One of Song's projects is to practice Chinese calligraphy every day on a chunk of ordinary stone or the surface of a table, using a traditional brush dipped in clear water rather than ink. The characters soon vanish, and he writes again. Although the calligraphy's physical traces disappear, the feeling and the psychological experience remain in his memory (fig. 26). He does this, he has said, just as a monk takes a morning lesson in a temple. In 1996 Song went to Tibet, to a river near the capital Lhasa, where he repeatedly "stamped" the water with a big seal carved with the character for "water" (*shui*). The action was to create a connection between a sacred environment and a secularized, private heart (pl. 9).

Qiu Zhijie's *Writing the "Orchid Pavilion Preface" One Thousand Times,* 1986, is another example of this kind of meditation but one that questions the idea of originality (pl. 8). The *Lanting xu* or *Preface Written at the Orchid Pavilion* was written by one of the most famous ancient calligraphers, Wang Xizhi (307–65). The original version was said to have been buried with the emperor Tang Taizong about three centuries later because he was passionate about Wang's calligraphy. The two extant versions of the *Orchid Pavilion Preface,* considered to be the most important examples of traditional calligraphy, are copies of Wang's original. Qiu Zhijie wrote the *Orchid Pavilion Preface* about a thousand times on the same sheet of paper, which became completely black. His writing practice represents the search for origin in the absence of the original. Perhaps the origin is not in visible documents but rather in the cumulative memories and imagination of many individuals through a textualized history. If so, then culture, history, knowledge, and even human subjectivity are fundamentally rooted in contingency and discontinuity; we are just poor people at a fragmented historical moment in an institutionalized society. Qiu's philosophy states, "If there has never been a complete condition of original freedom, the only freedom I can have is the freedom limited by institutions."[19]

One of two women artists who make Apartment Art represented here is Yin Xiuzhen, who is married to Song Dong. She unraveled two piles of sweaters, one women's, one men's, into balls of wool and then reknit the yarn on bamboo needles into a single garment (pl. 54). Yin offers a simple, homely statement of gender deconstruction and re-formation. For almost two years, Lin Tian-miao worked at home obsessively wrapping thread around hundreds of cooking utensils (see pl. 53), reducing them to objects with the meaning, from Minimalist art, of "what you see is what you see." Indeed, they do not implicate anything but themselves with the mark (or trace) of the artist's labor, although the boredom implicit in the process and the product is an important aspect of some Apartment Art, which is often extremely private and insular, as it lacks a broad audience.

In the face of a new international art market system, other artists take the institutional system itself as the content of their art. Their works tend to

be representations and investigations of the system in which artwork is determined to be art by the system rather than by an individual artist. Applying Craig Owens's notion of "frame," we can say that the Apartment Art artists shift attention away from the relationship between a work and its producer, and a focus on the "location" in which the work of art is encountered, and onto its "frame," and the insistence on the "social" nature of artistic production and reception.[20] For the humanist artists of the '85 Movement, the canvas was the location where a utopian world might be produced (or manipulated); for the Apartment Art artists of the nineties, the frame is a network of institutional practices that define, circumscribe, and contain both artistic production and reception.

In *We Live in Art,* Wang Peng put a urinal that refers to Marcel Duchamp's *Fountain* of 1917 on a dining table set Chinese style (pl. 52). The work represents a shift in the art world: Duchamp's concept that industrial overproduction can be treated as an art object in a museum has been transformed into a new concept that art work has already been turned into production in a transnational art market system, which is the only one that can be free to define, manipulate, and ultimately to benefit from the codes and conventions of cultural production. Now, for us, as individuals, we live in this system of art production and are determined by and benefit from it.

A public project similar to Ren Jian's *Mass Consumption* designed to take place at the Beijing McDonald's, Wang Jin's project *Ice: Central China, 1996,* allegorizes that consumer society and its public may be the real creator of art rather than the artists themselves (fig. 30).[21] An alienation from a materialistic life that first emerged in the West and has penetrated the whole of modern culture is now developing in China. In Guangzhou, the largest commercial center in south China, Lin Yilin has done performances in both interior and outdoor spaces, including the street, for example, building a brick wall around himself and putting dollar bills into the cracks between the bricks (fig. 27). It represents the alienation from materialism on the one hand, and on the other, from art institutions in which the subjectivity of the author is passive and helpless.

Performance Art: Social or Political Happenings in the Public Sphere
Performance art in public in China was concentrated in the second half of the 1980s. There was little before 1985, but its relative extremity attracted attention and controversy. In the mid-eighties performance art was more artistic and philosophical, focusing on both the art environment (pls. 46, 47) and individual experience (pls. 21, 48); then in the late eighties the focus shifted to creating confrontation in the public sphere, especially in the performances that took place during the *China/Avant-Garde* exhibition. Three hours after the doors to the National Gallery opened on *China/Avant-Garde,* the artist Xiao Lu shot a pistol at a reflection of herself in a mirror in her own artwork

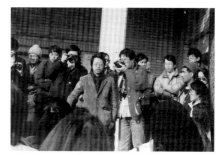

Fig. 28
After Xiao Lu and Tang Song made a video of shooting their artwork twice with a pistol during the opening of *China/Avant-Garde* on February 5, 1989 (see pl. 23), police arrive at the National Art Gallery.

Fig. 29
The closure of *China/Avant-Garde* because of the illegal gunshots is explained to the public by the exhibition's chief curator, Gao Minglu.

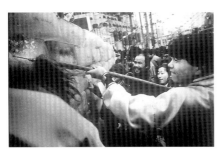

Fig. 30
WANG JIN
Ice: Central China 1996, Zhengzhou City,
Henan Province, January 28, 1996

(pl. 23; the mirror was placed between two telephone booths in which were painted views of the backs of students, one male and one female, presumably talking to each other on the phone). After the gunshots, the Beijing police closed down the exhibition for a time (figs. 28,29). The piece was later referred to as "Tiananmen prefigured in art," and the National Gallery was called by one conservative critic a small Tiananmen Square in the art world.

Since the early 1990s, performance art can only take place in private spaces. In "Beijing East Village," a kind of art colony in a rural area, a number of performance artists did performances related to issues of sexuality, gender, and personal suffering in or around their homes. The most influential artists of the East Village group are Zhang Huan and Ma Liuming. Zhang Huan is concerned with the general living situations of ordinary people as refracted through his own individual experience. In *Twelve Square Meters,* 1994, he sat in a public toilet in the village for three hours, naked and covered with honey to attract flies (pl. 28). The artist seeks the certainty of his own existence through acts in which he undergoes physical and mental pain. Ma Liuming's performances use his girlish-looking face and male body to deal with the themes of hermaphroditism (pls. 29, 30). These sorts of performances reflect diverse psychological meanings: masochism and extreme narcissism, fear and desire. In 1995, the police forced the artists to move out of the East Village, and most of their recent performances have been done overseas.

Although performance art of late has largely gone underground or moved into apartments, the booming consumer culture of the nineties has prompted some artists to execute projects to shock a materialistic public. In 1996, the Zhengzhou City government commissioned Wang Jin and his associates to create a sculptural monument as part of the opening ceremony for the city's first large shopping mall. On the public plaza in front of the mall they created *Ice: Central China 1996,* a thirty-meter-long wall of ice in which were embedded many luxury consumer goods—jewelry, cosmetics, toys, cellphones, pharmaceuticals, and the like (fig. 30). Upon seeing the entrapped goods, the public began to dig them out by any means available, and finally brought down the wall. Wang Jin used the desire for commodities to create his work and to comment on the material fetishism of contemporary culture. The original goal of the project, according to Wang, was to cool down and purify the public with the ice, with reason.

On the whole, avant-garde contemporary art in Mainland China has turned from a serious concern with humanism and the criticism of reality and political authority to a more cynical or mundane approach. The grand subject matter and utopian vision of the eighties have been abandoned in favor of confronting real situations. Now, artworks do not just represent one individual's philosophical idea, imagined utopia, or personal emotion. In the practice of the Chinese neo-avant-garde art of the nineties, art has been located

in a social context, not just as a pure ideological or cultural production, but as a production determined by multiple pressures, including the state, the market, mass culture, international art institutions, and so on.

The transformation of contemporary Chinese avant-garde art during the past two decades has been determined by the transitional nature of the social structure in which the consciousness and position of the artists have been framed. Chinese society is changing from a state/elite cultural structure to a transnational/masses cultural structure. The avant-garde artist in contemporary China is at a crossroads, faced with either jumping into the circle of the new middle class as a career artist or continuing to be an independent intellectual, the role that had been at the core of the contemporary Chinese avant-garde.

NOTES

1. See my essay "A Total Modernity and Avant-Garde in Twentieth-Century China" in the forthcoming catalogue of an exhibition of contemporary Chinese art organized by the Solomon R. Guggenheim Museum, New York (1999). Some other writings related to this issue are: Michael Sullivan, *The Meeting of Eastern and Western Art* (Berkeley: University of California Press, [2nd rev. ed.] 1989; Mayching Margaret Kao, "The Beginning of the Western-style Painting Movement in Relationship to Reforms in Education in Early Twentieth-Century China," *New Asia Academic Bulletin* (Xinya xueshu jikan [Hong Kong]), 1983–84, pp. 373–97; idem., "China's Response to the West in Art, 1898–1937," Ph.D. diss., Stanford University, 1972; Ralph Croizier, "Post-Impressionists in Pre-War Shanghai: The Juelanshe (Storm Society) and the Fate of Modernism in Republican China," in *Modernity in Asian Art,* ed. John Clark, University of Sydney East Asian Series (Sydney: Wild Peony, 1993), pp. 135–54; Shirley Sun, "Lu Xun and the Chinese Woodcut Movement, 1929–1935," Ph.D. diss., Stanford University, 1974.

2. See Gao Minglu et al., *Zhongguo dangdai meishushi 1985–1986* (History of Contemporary Chinese Art 1985–1986) (Shanghai: Shanghai People's Press, 1991). This book describes and analyzes the movement and the groups in detail.

3. This term, *shanghen,* is generally translated as "scar" in writings on visual art but as "wounded" in works about literature.

4. Such criticisms appear in Mao's Yan'an Talks of 1942, for example. In the early-1980s debates about the concept of humanism in Marx's writings, *humanism* was used to refer to concepts of individual value, human nature, and human freedom. This use of the term is not meaningful to most western readers. When contemporary Chinese artists use "humanism" in their writings, they usually mean something like individualism. Here, in order to avoid complication, I will continue to use the term as Chinese artists and intellectuals do.

5. On December 2, 1985, for example, the Pool Society's *Exhibition of '85 New Space ('85 Xinkongjian)* opened in Hangzhou in Zhejiang Province. The artists described their intention as a brave sacrifice *(yongganzhe de xisheng)* for the future (Hong Zaixing, *"Yongganzhe de xisheng* [The sacrifice of the brave]," *Meishu* [Art monthly], 218 [February 1986] : 44–46).

6. See an unpublished article by Shu Qun, a member of the North Art Group, *"Yige xinwenming de danshen* (The birth of a new civilization)," 1985.

7. Wang Guangyi, *"Women zhege shidai xuyao shenmo yangde huihua* (What kind of paintings do we need in our age?)," *Jiangsu huakan* (Jiangsu painting monthly [Nanjing]) 1986.4, p. 6.

8. Ibid.

9. Yan Shanchun, *"Wang Guangyi hewu tan shehua he youxi* (Wang Guangyi and I talk about the myth and strategy)," *Xinmeishu* (New art magazine) 2 (1988): 25–31; another version is in Yan Shanchun and Liu Peng, eds., *Dangdai yish chaoliu zhongde Wang Guangyi* (Wang Guangyi in the trend of contemporary art) (Chengdu: Sichuan Art Press, 1992).

10. I coined the term "double kitsch" to characterize an aesthetic in contemporary Chinese culture. In his well-known article "Avant-Garde and Kitsch," Clement Greenberg analyzed the features of Stalin's mass culture and capitalist mass culture as kitsch in comparison with avant-garde culture, a product of an elite culture (see Clement Greenberg, *The Collected Essays and Criticism,* ed. John O'Brien [Chicago: University of Chicago Press, 1986]). In China today these two have been combined and resolved perfectly.

11. *"Yishu biji* (Notes on art)," unpublished article, as cited in Gao et al., *Zhongguo dandai meishushi,* p. 254.

12. See David Der-wei Wang, "Introduction," *From May Fourth to June Fourth: Fiction and Film in Twentieth-Century China,* eds. Ellen Widmer and David Der-wei Wang (Cambridge, Mass.: Harvard University Press, 1993), pp. 1–14.

13. See Wu Guanzhong, *"Lun xhousianmei* (Abstract aesthetic)," *Meishu* 154 (October 1980): 37–39.

14. See Fei Dawei, *"Xiang xiandainai tiaozhan—fang Gu Wenda* (To challenge modernism: an interview with Gu Wenda)," *Meishu* (July 1987): 53–65.

15. Wu Shan Zhuan and Inga Svala, "Tourist Information: Alphabetical Aphorisms," a selection of writings distributed by Wu and Red Humor International, 1992–93.

16. Author's interview with Xu Bing, September 2, 1987.

17. Huang Yong Ping, *"Tan wode jizhang hua* (On a few of my paintings)," *Meishu* (January 1983): 22–26.

18. In *Zhongguo meishu bao* (China art newspaper), 1986, no. 46, p. 1.

19. Qiu Zhijie, "The Limitation of Freedom: The Issues of 'Ego,'" unpublished article, p. 5.

20. Craig Owens, "From Work to Frame, or, Is There Life After the Death of the Author?" *Beyond Reconstruction* (Berkeley: University of California Press, 1992), p. 126.

21. See my other essay in this volume.

Striving for a Cultural Identity in the Maze of Power Struggles:
A Brief Introduction to the Development of the
Contemporary Art of Taiwan

VICTORIA Y. LU

A large number of Han people migrated to Taiwan from China—mostly from the southern coastal areas of Fukien Province—during the Ming (1368–1644) and Ch'ing (1644–1912) dynasties, bringing with them traditional Greater Chinese culture. During Japan's fifty-year rule over Taiwan (1895–1945), the colonizers' cultural juggernaut had a great effect on the island. In art, the Japanese colonial government promoted the study of western-based styles of oil painting and Japanese gouache painting through the sponsorship of the Taiwan Governor-General Art Exhibitions. Taiwanese academic artists— some of whom studied in Tokyo—imitated the French-influenced Japanese styles, which included the Plein-Air, Post-Impressionist, and Fauvist. However, works of artists such as Huang T'u-shui (1895–1930), Liu Chin-t'ang (1895–1937), Ch'en Ch'eng–p'o (1895–1947), and Ch'en Chih-ch'i (1906–31) were deeply rooted in agrarian village life and showed a genuine concern for the artists' homeland.

After the conclusion of the Anti-Japanese War, civil wars in Mainland China led to the retreat of the Nationalist government to Taiwan and an influx of immigrants fleeing Communist rule. Nationalist control brought with it various changes and yet another wave of Greater Chinese culture. Three masters from the Mainland—Puru (P'u Hsin-yü; 1896–1963), Huang Chun-pi (1898–1991), and Chang Dai-chen (1899–1983)—were the central figures of a revival in Taiwan of traditional ink painting. In disputes over what Taiwan's orthodoxy should be, the Nationalists promoted traditional Chinese painting. Gouache painting was considered a representation of Japanese national painting and was discarded in the face of strong anti-Japanese sentiment. However, the seeds of the rejection of a cultural identification with Mainland China were planted by the February 28 Incident of 1947 and subsequent violence, in which thousands of Taiwanese protesting the Nationalist takeover were killed by the Nationalist government. This ripped open a deep wound between the Nationalist Mainlanders and the Taiwanese who had migrated to the island earlier.

Among those Taiwanese artists who specialized in western-style painting during the early postwar period, Liao Chi-ch'un (1902–67) showed enthusiastic support for the development of modern art. His students organized the Fifth Moon Painting Group (*Wuyue huahui*). About the same time,

students of Li Chung-sheng (1911–84) formed the Eastern Painting Group (*Tong fan*). These two groups influenced by western Abstract Expressionism of the 1950s and 1960s sought to achieve an internationalization of modern art. They also vigorously condemned traditional art. The heated debate between the modern and the traditional schools subsided at the end of the sixties, when the major players went abroad one by one.

During the 1970s a number of opposition political parties sprang up. They not only gained momentum for political liberalization but also awoke the public's interest in their social and political rights. In literature and art, there was widespread activity rooted in folk and local cultural traditions. This movement, which evoked a sense of nostalgia, reflected a return to the grass roots and was the first self-conscious wave of "Nativism" (*Hsiangt'u chui*) in Taiwan. Yen Shui-long (1903–97) had for years shown concern for Taiwan's folk art and had studied the culture of the indigenous people in Taiwan (descendants of Malay groups who predated the Chinese migrations). He utilized visual elements to activate folk art and expand a repertoire of images and symbols reflecting local colors. The painter Hung T'ung (1920–87) had at one time served as a shaman. In the 1970s, his paintings enjoyed an unprecedented popularity. He depicted scenes of people's daily lives, suffused with the vibrant and contrasting colors typical of folk art. He also incorporated dynamic pictographic symbols and developed a unique personal language, full of magic and illusions, that conveys the fantastic power of popular beliefs. Most of the other grass-roots painters followed the style of western realism or Photorealism.

Difficult Circumstances for Cultural Identity and the New Nativist Movement

A number of historical forces and artistic developments combined to make the Taiwanese art scene of the 1980s more complex. During this decade a significant number of artists returned to Taiwan after being educated abroad. They brought back with them influences of western art movements dating from the 1960s and after, including new forms of abstraction, Pop Art, Arte Povera, Fluxus, and conceptual art. They made considerable contributions to museum exhibitions and various art activities, and their involvement in making art, teaching, criticism, or art administration would shape the direction of Taiwan art in the 1990s. Another important development in the eighties was the opening of the Taipei Fine Arts Museum—the first modern art museum in Taiwan—in 1983. It offered ample space for large-scale art exhibitions and provided an opportunity for government-sponsored art competitions.

A new Nativist movement (*Pent'u chui*) that arose in the 1980s appears to lack focus and direction when compared with the first grass-roots movement of the seventies and its nostalgic tenor. This was partly a product of different historical forces and foreign intrusions: the remnants of Japanese colonialism, the far-reaching impact of postwar American influence on the

island, and the rejection of a cultural identification with Mainland China that had begun with the February 28 Incident. A serious gap developed between the popular thought of Taiwan and the cultural tradition of Greater China. Moreover, the desire for improved living conditions and material goods was a key motivating force. In art, the stylistic developments of both the grassroots movement of the seventies and the new Nativist movement of the eighties consistently intertwined themselves with the preservation and expansion of economic benefits.

The internal structure of Taiwan's local culture had become very complex. After the Nationalist government lifted martial law in 1987, a maze of political factions contended for power, and the Taiwanese people made a vigorous effort for their independence and right to govern. This gradually caused the identity issue of local culture to become a political one. Some people even confused the political issue of uniting with China versus an independent Taiwan with the issue of cultural identity. Simultaneously, a new generation of artists enthusiastically embraced western Neo-Expressionism and the style of other New Image movements in America and Europe. They also added symbols and signs reflecting Taiwan's local cultures. This Taiwanese version of New Image painting became very popular in Taiwan in the late 1980s.

Wu Tien-chang was a member of the Taipei Painting Group (*Taipei hsientai ishuch'ün*). He and his colleagues used symbols and metaphorical designs to reflect on and explore the intrinsic nature of Taiwan. In his earlier works, Wu targeted political and social controversies through the presentation of what he called "historical images" (figs. 31, 32). In recent years, he has moved away from a polemical stance critical of Taiwan's political and social conditions and instead has utilized metaphors to arouse a viewer's reminiscences of the past. His paintings are infused with the distinctive regional flavor of Taiwan and a sense of nostalgia. His works in this exhibition are representative of this period (pl. 55).

Hou Chun-ming is another artist who belongs to the New Image painting movement. During his school years, Hou's works were rejected from exhibitions due to their sexual connotations. Hou continues to provoke audiences by making libido a theme in his art. Seeking inspiration from traditional mythology and fantastic stories, Hou combines images and text in a deliberate effort to expose the absurdity of traditional taboos on sex (pl. 56). He employs a variety of mediums and forms—including performance, installations, prints, and paintings—to stir up viewer reaction to all sorts of prohibitions.

The new Nativism of the 1980s involved significant joint efforts in music, dance, theater, cinema and the visual arts. Lin Hwai-min founded Cloud Gate Dance Company, the island's first professional modern dance troupe. A number of theatrical performance groups were also founded in the eighties. Hou Hsiao-hsien's movies exhibited a local consciousness and won him several international awards. This movement evolved after Taiwan began to

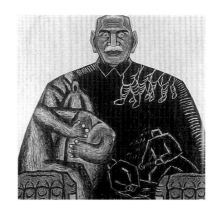

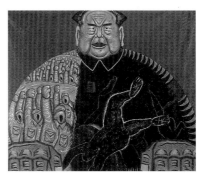

Fig. 31
WU TIEN-CHANG
Portraits of the Emperors Series: About the Government of Chiang Kai-shek, 1990

Fig. 32
WU TIEN-CHANG
Portraits of the Emperors Series: About the Government of Mao Tse-Tung, 1990

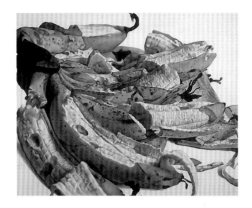

Fig. 33
Y. J. CHO
Banana Series VIII, 1975

Fig. 34
YAN MING-HUY
Three Apples, 1988

prosper economically, and awakened a desire for an independent identity. But the people's search for a cultural identity was loaded with political complexity and obstacles, which prevented the development of a common vocabulary or a particular style in the arts.

This complex pluralism continued into the 1990s. Affected by the political dispute over unification with Mainland China versus an independent Taiwan, artists had an even greater problem defining their cultural identities. In addition, an economic downturn in the art market drove artists in two different directions. Some danced in step to the tune of politics; others completely abandoned the baggage of local consciousness and moved energetically into the international art arena. The current leaders of Taiwan's government, eager to gain international diplomatic recognition, actively encouraged the exportation of art more than before.

The Cultural Identity of Feminists

Although over several millennia of Chinese history there have been powerful female political figures, such as the Empress Wu Tse-t'ien (r. 690–705) and the Dowager Empress Tz'u-hsi (1835–1908), the achievements and contributions of women have never been heralded. Reflecting the powerfully patriarchal nature of society, men's accomplishments have been the focus of history and emulation in all realms. The feminist movement in Taiwan began in the 1970s when women scholars and promoters of social causes returned after completing their studies abroad, bringing back western experiences and ideas of feminism. At that time, during the heyday of Nativism, Y. J. Cho exhibited her large Photorealist series Bananas, which some critics consider the earliest examples of feminist art (fig. 33). Yan Ming-huy was the first female artist in Taiwan to express an explicitly feminist creative consciousness (fig. 34). The late 1980s were the dawn of a female art, and "gender" became an identity issue independent of that of Taiwanese identity and one more strand in the pluralism of the nineties.

Having received her artistic training in Düsseldorf, Germany, Wu Mali was deeply influenced by Joseph Beuys. A charter member in Taiwan's feminist movement, Wu excels at utilizing strategic means to make her thoughts known, exposing social problems and analyzing them in depth. She has frequently participated in social movements, allowing her creative works to reach the masses, putting Beuys's thought into practice. In recent years, Wu has gradually departed from taking this kind of frontline action. She has retreated into the realm of pure art, using conceptualized visual elements with poetic qualities to disclose critical vocabulary, as in her video installation in this exhibition, entitled *Epitaph* (pl. 62).

The works of female artists have tended to be narrative, symbolic, and allegorical. These artists have often recorded diarylike observations of events in their own personal lives and immediate surroundings. One of the

VICTORIA Y. LU

resources for their creations is their everyday, sometimes trivial activities. For example, Chen Hui-chiao uses the items that a woman frequently encounters—such as needles, velvet, embroidery, and dried roses—and transforms them into a secret code that is associated with her life and imaginary spaces (pl. 64).

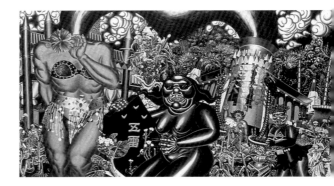

The Camouflage of Pluralism of the 1990s

Moving in tandem with the diversification of political viewpoints and a breakdown of social mores, Taiwanese culture of the nineties has camouflaged itself in the complexity of pluralism. The development of art supported by various communities has also diversified. In the mid-eighties, art museums spearheaded the direction of Taiwan's contemporary art. At the end of the decade, along with the dramatic appearance of commercial galleries, alternative spaces organized or supported by artists themselves, such as Space II, IT Park, and Up Art Gallery in the south, became the primary exhibition arena for emerging artists, and joined the government-sponsored art museum as a vehicle for promoting artistic expression.

Besides Chen Hui-chiao, three other IT Park members were invited for this exhibition. Tsong Pu (pl. 66), Chu Chiahua (pl. 67), and Chen Shun-chu (pl. 59) take serious political themes or social conditions and transform them through ridicule or satire into farcical creations—eccentric, funny, or pitiful. These artists nurtured and influenced by western Dada, Arte Povera, and Pop Art became the leaders of conceptual art in Taiwan. They break down the original meanings of words and images in order to question the truths of society, tradition, and history. From the ordinary things in life, they inspire others with extraordinary cognitive experiences. Neo-Eclecticism (*Hsien chechung chui*) evolved in the alternative spaces with primary concerns being artistic concept and mediums.

In contrast, a group of artists who stylistically are related to the New Image work eschew involvement with the ever-changing and uncertain world of politics. They follow their own artistic compasses and choose to search inwardly, through the expression of images, for spiritual peace and comfort. Fang Weiwen was born and reared in Brunei. His installation in this exhibition elevates cross-cultural experiences of his youth into a universal prayer that reflects his view of life (pl. 61). His *Seascape,* 1995, is raised to such a level that it has the effect of a memorial tablet inscribed with history and tributes.

The Reinvention of the Tradition

The aesthetic viewpoint of traditional Chinese painting was initially based on searching inwardly to understand and express one's spirituality, and on the concept that humanity and the universe are one. In contrast to western art, in which there is a sense of the transitory as observed by a person during a limited span of life, Chinese art revolved around the eternity of the universe and

the transformation of nature. There was a perpetual revolving relationship between the universe and Chinese art expression, which to western eyes lacks dramatic changes in content, mediums, and technique even over a thousand years. In the 1990s, a few Taiwan artists were reborn from the Chinese cultural tradition. Although they use traditional mediums and tools, they are making a new contribution by greatly changing the visual composition of their paintings.

Yuan Jai, who works doing research at the National Palace Museum in Taipei, draws her inspiration from the "classical eclecticism" of Tung Ch'i-ch'ang (1555–1636) and the interesting distortions of ancient figure-painting style of Chen Hung-shou (1598–1652). She paints complex imaginary landscapes filled with fantastic scenery on silk. She also paints bright and splendid flowers, surpassing those of the high T'ang (618–907). Although her paintings reveal the aesthetic taste of traditional court painting, they resemble even more the spectacular and variegated colors of the electronic media of the late twentieth century (pl. 60). Huang Chih-yang, who uses the traditional medium of ink and rice paper, depicts the delirium and confusion that permeate cosmopolitan Taipei today. Painting neither imaginary scenery nor metaphorical symbols of local culture, he escapes from the confinement of traditional Chinese ink painting and creates a metaphysical aesthetic through the pure joy of the brush and ink (pl. 58).

Art reflects its times and environment. Again and again, contemporary artists of Taiwan have been trapped and confused in the maze of political power struggles. In the first half of the twentieth century, it was the repression of the Han Chinese culture by the colonial Japanese government. This was followed by the rejection of Japanese culture by the Nationalist government on Taiwan. Differences between the descendants of earlier immigrants from the Mainland and those who arrived in the postwar period resulted in a major rift and left a scar on Taiwan's history. Presently, Taiwan and China are in an awkward relationship of distrust due to their long period of separation. The extremely difficult circumstances surrounding issues of cultural identity in Taiwan cannot be fully understood or appreciated by those who simply take a political stance with the Mainland.

The art of Taiwan in the 1990s mirrors the island's present condition. Because of the confusing and intricate web of cultural identities complicated by a series of difficult political, social, and economic circumstances, the work of Taiwan's contemporary artists does not reflect a single common local style or distinctive creative mode. Taiwanese art is eclectic. Moreover, the works of the Taiwanese artists in *Inside Out: New Chinese Art* are very different from those of artists on the Mainland. After the war, the economy grew rapidly in Taiwan and there were more frequent interactions with the West, which heavily influenced Taiwan's artists.

VICTORIA Y. LU

Most recently, Taiwan's striving for international diplomatic recognition led contemporary artists to move into the international art arena. Actually, since the 1960s, the longing of Taiwanese artists to become more international has not abated. Taiwan's geographically isolated location makes it essential for artists with such aspirations to reach out, as have the Japanese fashion designers who have gained such enthusiastic recognition overseas. It is not difficult to understand why Taiwanese artists have looked more outwardly in contrast to their Mainland counterparts, who looked more inwardly, in developing their cultural and artistic genres.

DAVID CLARKE

The Sino-British Joint Declaration of 1984 set the clock ticking for Hong Kong's 1997 transfer to Chinese sovereignty, and it may be taken as having initiated a new era in the territory's history. Despite its unprecedented nature, this agreement to hand over one of the capitalist world's leading cities to Communist rule did not provoke widespread public opposition in Hong Kong at the time of its signing. Whilst resentment at having one's future decided by external parties was commonly felt, the agreement was mostly regarded as a fait accompli. In June 1989, however, after the brutal suppression of the democracy movement in Beijing, things changed dramatically. Hong Kong people took to the streets in large-scale demonstrations, and fears about a loss of freedom after Hong Kong's return to Chinese rule became widespread. China under Deng Xiaoping had theretofore seemed to be on a convergence course with Hong Kong, experiencing a large measure of economic liberalization. But now memories of the Cultural Revolution era were awakened.

A consequence of this shift in local perspective was a degree of political crisis for the colonial regime: the relatively paternalistic approach practiced up to that point was no longer viable. Organized political groups with prodemocratic agendas began to appear in the territory. London's response was to appoint a politician as the final British governor of Hong Kong (rather than a foreign service professional, as had previously been the norm). In order to retain credibility in a suddenly politicized environment, the new governor, Christopher Patten, inevitably had to make concessions, and in due course the first wholly democratically elected legislature in the colony's history came into existence. As a direct consequence of Patten's granting of a degree of political autonomy to Hong Kong, Sino-British relations went into a steep decline, and the possibility of a "through train," a smoothly managed transition of sovereignty, was sacrificed.

The demands for greater political self-determination that emerged in the period after 1989 had their parallels in the cultural arena in a growing concern for Hong Kong cultural identity. Earlier Hong Kong artists of ambition had often engaged self-consciously with media and motifs that carried strong Chinese associations of a traditionalist nature, even if these were

Fig. 36
ANTONIO MAK
Horse Lover Goes West, 1992
Collection of the estate of the artist

counterbalanced by references to Abstract Expressionism, Constructivism, or other overtly western modernist styles. By contrast, the artists who came to maturity in the 1980s and 1990s tended to eschew traditional Chinese references. Working within a stylistic language borrowed largely from western modernism and postmodernism, these younger artists have often made art with a more specifically local address. Hong Kong's population had increased dramatically in the postwar years due to the influx of immigrants from the Mainland, but the generation coming to maturity in the 1980s was the first to grow up in the now-modern city itself, taking it as their cultural frame of reference. Many of this more affluent generation were able to gain art training overseas in Britain, continental Europe, or North America, and they are thus more international in outlook than their forebears, and not just more local.

Cultural identity has been a motivating factor for a great deal of art produced in recent years, but there are ways in which the situation of Hong Kong artists differs subtly from that of a great many of the artists elsewhere who have otherwise analogous concerns with the politics of identity. In most cases such identity politics draws upon religious, ethnic, or nationalistic narratives, but none of these is available to a sense of Hong Kong identity. Indeed the latter two may be taken to be ranged against it, serving to support a sense of Chinese identity that must at some level be in contest with a sense of Hong Kongness. At the level of "political" politics a rhetoric of national liberation could not provide the driving force that it has in other colonies: in Hong Kong's case it supports the process of incorporation into another entity rather than a desire for autonomy. At the level of cultural politics this unavailability of ethnic and national markers means that "traditional" references are largely unavailable. To use ink and the Chinese brush on an absorbent surface, or to make use of misty mountain landscape as your subject, is inevitably to let a rhetoric of Chineseness, which will occlude a sense of Hong Kongness, speak in your work.

Hong Kongness must inevitably be a weak, "postmodern" or nonessentialist identity, requiring oblique expression in the absence of the usual rhetorical resources for identity politics. Antonio Mak (1951–94), for instance, rarely made a direct reference to Hong Kong in his work, let alone attempted to promote Hong Kong cultural identity in a positive sense. Nevertheless the ironic, distanced way in which he treated Chinese and western references in his works did open up a Hong Kong space. Chinese and western references fail to add up in his 1992 sculpture *Horse Lover Goes West* (fig. 36), for instance, thereby undermining the cliché about Hong Kong as the place where "East meets West." Even the Chinese title of this work, *Mami xiyouji,* diverges from the English one with its explicit westward pointing, introducing an eastern reference to the Chinese classic *Journey to the West,* or *Xiyouji.*

Hong Kong films make use of Cantonese (and particularly the idiomatic and creolized version of that dialect now widely employed in the city) as a

DAVID CLARKE

means to mark out Hong Kongness. This way of signifying the local is less available to visual artists, but Mak often introduced verbal allusions in his works, thereby tapping into this resource. Oscar Ho Hing-kay, in his graphic work, also finds a way of bringing language into play through the inscriptions on his images. The coexistence of calligraphy and imagery has a long history in Chinese art of course, but Ho normally eschews the standard Chinese written style, inscribing his Stories Around Town series in a way that evokes the patterns of Hong Kong Cantonese speech.

Ho's Stories Around Town, which he has worked on over a number of years, offers a fabricated history of Hong Kong. Fictional in nature, the stories sometimes draw on existing urban myths and rumors or even actual events (such as a meeting between Triad gangsters from Hong Kong and officials of China's Public Security Bureau; fig. 37). Such a strategy of fabrication can be seen as a response to the fact that official, textbook history belongs to either British or Chinese national narratives, and cannot be simply recovered in a straightforward account of autonomous local identity. By introducing a supernatural dimension to his stories, Ho has found a way of exploring the challenges facing Hong Kong subjecthood, rather than simply celebrating it.

Both Mak and Ho belong to that generation of artists who returned to Hong Kong in the 1980s after studying overseas, and who were so important in the development of a more local-centered artistic culture in the territory. Danny Ning Tsun Yung also belongs to that generation, and indeed he was amongst the first to return. He came back from the United States in 1979 and has played a major role in the local avant-garde visual and performing arts scene since that time. His primary vehicle has been Zuni Icosahedron, a performing arts collective he helped found in 1982, and of which he is the artistic director. Several of his sculptural or installation pieces came into being in association with particular Zuni stage productions, and they function as both stage props and independent artworks in a similar way to certain pieces by Robert Wilson. The mirrored forms resembling giant ancestral tablets that make up *Deep Structure of Chinese (Hong Kong) Culture No. 4,* 1991, for instance, were also used in a theater piece of similar title. In the installation work the tablets were arranged in a circle, but on stage they were placed facing the audience on an altarlike structure at the back of the performance space, a positioning which more closely evokes the customary arrangement of ancestral tablets in a lineage hall.

Modified ancestral tablet forms are again used in *Deep Structure of Chinese Culture No. 5* of 1996. In this work the tablet forms are made of transparent acrylic and filled with ice cubes. A time dimension is introduced into the work through the gradual melting of the ice, which enables previously inserted wooden sticks to float upwards. The sticks have been inscribed with a reference to Article 23 of the Basic Law of the Hong Kong Special Administrative Region (SAR), a controversial section which requires the SAR

Fig. 37
OSCAR HO
Stories Around Town Series:
Brotherhood with the Triad, 1995
Collection of the artist

Fig. 38
DANNY NING TSUN YUNG
The Star, 1994
Collection of the artist

government to enact laws against acts of "subversion against the Central People's Government." The writing on the sticks is both upside down and mirror-reversed. The transparent tablets were also used by Yung in his stage production *The Book of Mountain and Ocean,* 1996. A wall of tablet forms was constructed at the front of the stage and filled with ice during the performance itself. Light was then projected through the ice towards the audience.

On several occasions Yung has made ironic use of Cultural Revolution–era symbolism, and in this respect his work seems closer to the concerns of certain Mainland Chinese artists than to those of other Hong Kong artists. His *The Star* of 1994, a twelve-meter-tall, truncated five-point star form in red (fig. 38)—which reads ambiguously as either rising from or descending into the ground—can be compared with the work of the various Political Pop artists who similarly manipulated Maoist imagery in the early 1990s. Late-colonial Hong Kong had no explicit public iconography of state power comparable to that which was imposed in Mainland China, and so no equivalent deconstructive strategy was open to local artists. Nevertheless, after June 1989, Cultural Revolution–era imagery was employed in Hong Kong as a way of expressing anxieties concerning the approaching return to Chinese sovereignty. This, I feel, is the difference of intention between Yung's *The Star* and the work of the Political Pop artists: they referenced Maoist imagery in order to comment on the past, whilst Yung dealt also with fears concerning a possible Hong Kong future. The temporary installation of *The Star* at a prominent waterfront site near the Hong Kong Cultural Centre during early 1994 gave it an identity as an alien, invasive presence that it would not have so clearly possessed had it been exhibited in the bare white cube of a gallery space.

Mainland-trained artist Pan Xing Lei, who has resided in Hong Kong since 1992, also manipulated PRC symbols in works of the late colonial period that were produced with the return of sovereignty in mind. For example, in 1995 he created photographic images of himself wearing a jacket with the design of the Communist Chinese flag on the back, posing in front of various Hong Kong landmarks. This pre-envisioning of Hong Kong life under Chinese rule was also present when, in the same year, he did a performance piece (again adopting a "Mainlander" role) in which he taught Putonghua, the official spoken national language of China, to an audience of Cantonese speakers. The texts used in his art gallery classroom were from the Basic Law, which was being promulgated at that time.

In September 1996 Pan gained local notoriety in Hong Kong when he covered a nineteenth-century statue of Queen Victoria with a layer of red paint, and attacked its nose with a hammer. Generally speaking the local reaction to this gesture was very unfavorable, both within and without the arts community. Damage to a work of art (even a not particularly outstanding one) was seen as a dangerous precedent by people worried about the possibility of future artistic censorship. Equally worrying was the implication that

DAVID CLARKE

Hong Kong culture could be reduced to colonial culture, to something "un-Chinese" that needed to be cleared away. Pan's attack on an antique colonial symbol which had been relegated to a marginal site by the colonial government itself, and whose political potency had long since been lost in the eyes of local people, seemed too easy a gesture. It was interpreted as working against the project of affirming a Hong Kong identity, which so many local artists have espoused.

When artists such as Ho, Mak, and Yung returned to Hong Kong, they needed to play a somewhat pioneering role in the development of an avant-garde art presence in the territory. Within the last few years, however, a large number of younger artists have become active on the local scene. Although some of these are still in the process of defining their styles, a great deal of interesting art is beginning to emerge. Kum Chi-Keung and Phoebe Man (Man Ching Ying) belong to this younger generation, and share with other members of it an interest in installation art. This medium may be preferred by younger artists in part because of the high cost of studio and storage space in Hong Kong, combined with the almost complete lack of a market for locally produced avant-garde art. Installation art can be disassembled into its constituent elements after showing for easy storage, and possible recycling into future works. Such recycling of elements certainly occurs in the case of Kum, who is best known for his installations that use bird cages as the primary element.

Keeping birds is a popular hobby in Hong Kong, and it is not uncommon to see men strolling outdoors, cage in hand. Kum's employment of cages may therefore be taken as an explicitly local reference. Installation art, as other artists such as Kith Tsang have also discovered, provides a ready means of indexing the local through the use of actual objects. Redolent with specific local associations, items of material or popular culture may evoke a Hong Kongness invisible in historical narratives or high cultural artifacts.

Cages almost inevitably introduce the theme of freedom and oppression into Kum's work, and fears about life after the handover may be being referenced (as for example in *Transition Space* of 1995 [pl. 70], where mechanical birds are represented as moving between one cage and another). Emigration, an option chosen by many Hong Kong people in the years since the Joint Declaration, is also alluded to, as is the overheated Hong Kong property market. On occasion Kum has stacked bird cages to resemble tower blocks, commenting upon the cramped mode of living that is the norm in the territory's urban areas.

Phoebe Man is a member of the Para/Site group, which includes several of the more interesting younger artists at work in Hong Kong. During 1996 Para/Site held a series of shows in a temporary art space in one of the older districts of Hong Kong Island, and all the works shown, including Man's, were site-specific installation pieces. In many of her other installation

works, however, a relation to a particular site has not been a crucial factor. This is true, for instance, of *A Present for Her Growth* I of 1996, a gender-marked work which brings together references to both pregnancy and menstruation. The materials used are light bulbs, sanitary napkins (with traces of red paint resembling blood), and eggshells (which have also been painted red, and thus recall the gifts given in Chinese culture on the birth of a baby). These elements are purposely still identifiable: the artist, as in certain earlier works, deliberately presents us with taboo objects and thus a sense of decorum breached. At the same time the materials are transformed to a much greater extent than Kum's birdcages. Man creates balls of flower forms that carry associations not reducible to those of their constituent parts.

As Hong Kong art has developed a greater autonomy it has attracted wider international interest, and Ho Siu-kee was one of the first of the younger Hong Kong artists to be given a significant international platform: inclusion in the 23rd International Biennial of São Paulo in 1996. Of the Hong Kong artists that have been selected for *Inside Out: New Chinese Art,* Ho is perhaps the least involved with issues of cultural identity. Questions concerning the body seem to motivate his practice instead, perhaps by way of a retreat from a public domain in which he feels a lack of power. Ho takes a particular interest in constructing prosthetic objects that aim to challenge habits of perception or action. Rather than extending the body's power, his devices tend to disable it, forcing a relearning of basic taken-for-granted skills. His *Gravity Hoop* of 1996, for instance, consists of a stainless steel hoop form and a digital print showing the artist in the process of employing it (fig. 39). He hangs upside down from the top of the hoop in what looks like a topsy-turvy parody of Leonardo's "Vitruvian man," rediscovering how to look at the world. In *Walking on Two Balls,* 1995 (pl. 71), a video is presented of a performance in which Ho is attempting to progress forward whilst balancing precariously on two ball-shaped sculptural objects he had constructed. Ho's concern is not merely allegorical, but one can't help seeing this work as representing the situation of an artist attempting to acquire the responsiveness and fine sense of balance required to operate in the hybrid and ungrounded cultural space of Hong Kong.

This short essay has attempted to provide information about the broader context within which the Hong Kong artists represented in *Inside Out: New Chinese Art* have been working. Both the politicized nature of Hong Kong cultural space in the period around the 1997 transfer of sovereignty and the necessarily oblique nature of the strategies used by art which seeks a political engagement and involvement with identity issues have been emphasized. I hope that this approach will give the viewer some insight into the work of the artists included in the exhibition, but I would not intend to suggest that I have given a comprehensive picture of all that is of interest in contemporary Hong Kong art.[1] To do so would require more space than I have at my disposal

(and, indeed, an even larger exhibition than the present one). Whilst the Hong Kong artists in *Inside Out,* and others I have mentioned in this essay, have been formed by the Hong Kong cultural landscape and need to be understood in relation to it, it would not be fair, I think, to treat them as collectively offering a tableau of the current art scene in the territory. That such a tableau would be a difficult one to construct is evidence, I would say, of the maturity and consequent diversity of the art being produced in Hong Kong today.

NOTE

1. A number of earlier essays on the art of Hong Kong (and China as a whole) can be found in my book *Art and Place: Essays on Art from a Hong Kong Perspective* (Hong Kong: Hong Kong University Press, 1996). "Varieties of Cultural Hybridity: Hong Kong Art in the Late Colonial Era" (*Public Culture* 9, no. 3 [Spring 1997]: 395–415) might also be taken as complementary to the present text.

> **Strategies of Survival in the Third Space:**
>
> A Conversation on the Situation of Overseas Chinese Artists
> in the 1990s

HOU HANRU AND GAO MINGLU

Hou Hanru: The first question that I'd like to examine is how overseas Chinese artists are seeking their own positions in the international art world today.

At the time of the '85 Movement (or New Wave) of Chinese avant-garde art, the central issue that we faced was the cultural and artistic modernization. Our concerns focused mainly on China's own reality, and the attempt to introduce western modern/contemporary art and culture to influence the situation and hence to solve some urgent problems. From 1989 on, more and more people raised the question of the internationalization of art. However, since no one had direct experience of living out of the country, our ideas were more or less naive, such as: Chinese art should be similar to Chinese soccer, in that some day it should go out of the country and enter the international arena. In 1989, Huang Yong Ping, Gu Dexin, and Yang Jiechang participated in the exhibition *Les magiciens de la terre* in Paris. Chinese artists began participating in activities of the international art world. Subsequently, the number of exhibitions of Chinese contemporary art in western institutions has increased, and Chinese artists have had more and more opportunities to exhibit abroad. Some have moved to the West and begun to work within the "mainstream" of western contemporary art. They no longer see themselves as simply Chinese artists but as independent, individual artists. At the same time, they bring their experiences of Chinese culture, in particular those of a generation who went through changes ranging from the Cultural Revolution to the Reform and Opening of Doors. This particular set of experiences has become a cultural reserve to support their survival and work in the new context of the West.

These artists arrived at the moment the Cold War was ending. The world order of an East-West division is disintegrating, and the political, economic, and cultural opposition between the two is dissolving as well. We are all confronting a new reality of globalization. A critique of eurocentrism in culture, including a multi-orientational restructuring of western society and of global culture, is being put forward as the new central concern of international cultural and artistic life. These shifts have provided new starting points and opportunities for the Chinese artists who have moved to the West, who already had extremely open attitudes towards western and international art and culture.

Gao Minglu: In the West, Chinese and eastern modern/contemporary culture and art have long been overlooked. The few interested in eastern culture were mostly focused on ancient aspects. Despite the fact that a very dynamic avant-garde art movement began in China in the mid-1980s, it wasn't until the end of the Cold War, and especially after the Tiananmen Incident of June 4, 1989, that exhibitions of Chinese contemporary art were seen outside China.

Now I think that the Chinese artists overseas are becoming objects of a kind of "post-orientalism." Homi Bhabha uses the term "third space" to turn what Edward Said considered as the opposition between the East and the West into a kind of interactive "in-betweenness." It can help in understanding the work of the Chinese artists overseas. Although centered in the 1980s, their backgrounds also include the whole of twentieth-century cultural history in China, that is, the antagonism between eastern and western aspects of China's modern and contemporary culture. However, in my opinion, what is crucial for overseas Chinese artists is not the preservation of Chinese characteristics but rather to act effectively in the third space. This causes a kind of metamorphosis: a shift from dichotomous ideas about East and West to the practice of cultural strategies. More concretely, the artists' task is to make their own Chinese cultural experiences into efficient languages to intervene in the new social reality, instead of holding on to a preconceived idea of Chinese culture. It is important to practice these languages in concrete cultural contexts.

Hou: The third space is replacing a concept of identity based on the traditional opposition between East and West. The invention of the notion of the third space itself is a cultural strategy. In general, western artists don't see art activities as a kind of strategy related to the question of cultural identity, while nonwestern artists living in the West necessarily face the challenge of seeking their own places there. This pushes them to conceive of artwork as a strategy. It is also the foundation of an "immigrant culture" in the West, to which overseas Chinese artists also belong. It is common to cultures composed of different communities: each community or individual can develop its or his/her own strategy of survival.

Gao: I think "immigrant cultures" are different in Europe and the United States, and your sense of it may be linked more to Europe. Some people use the term *diaspora,* a word originally used to describe the Jewish community; it implies being homeless. However, in the US, which is itself a country of immigrants, every race or community has its clear identity. This reduces the feeling of being homeless. Therefore, I believe the concept of diaspora is not relevant to the situation of overseas Chinese artists in the US. This is obvious in New York.

Hou: I published an essay in *Flash Art* titled "Unhomely Art," referring to Bhabha's notion of the unhomely, which he distinguishes from the homeless; it refers to choosing to leave home as a new way of living. "Immigrant culture" should not be isolated from mainstream culture. It should instead channel one's own cultural experience to become an active and effective support in one's intervention in the mainstream. We are now aware that cultural identity is a shifting process. It goes beyond the traditional identity of nation and community. It is a process of negotiation between the individual and all kinds of historical presumptions.

Gao: There are two fundamental points in such strategies. The first is moment, and the second is what Homi Bhabha called the performative.

Hou: Bhabha reminds us that cultural identity has always been a changing, performative process. Today, the question is how to develop effective strategies to open up the "mainstream culture" toward "other cultures" at every moment. Many Chinese artists are aware of this necessity, and their work is becoming increasingly diverse and rich. Even before leaving China some of them emphasized individuality rather than their status as Chinese artists. In the late 1980s, debates about "linguistic purity" and "internationalization" were central in Chinese avant-garde art. Today, many artists abroad insist on their neutrality, trying not to be typecast as "Chinese artists" first. More of them are critiquing and deconstructing the "mainstream" discourses and practices of western art by incorporating their Chinese cultural background at the center of their work. Yet, such a description is certainly an oversimplification. In most cases, they can be included in what you call "post-orientalism." They are aware that introducing Chinese or eastern elements will increase the chances of their work appearing in international art institutions, markets, and media. Also, if post-orientalism is still a kind of orientalism, your and my activities such as organizing exhibitions in western art institutions are ironically limited by such a frame. The challenge is how to reorient western expectations of the oriental toward the unexpected.

The post-orientalist desire to grasp the Other is mainly driven by economic and political interests. This is a "natural" part of the current globalization. Today, nobody can escape from contacts with the Other. As you pointed out, the Tiananmen Incident provided a starting point for such a post-orientalism. Even now, ten years later, the western media still use Tiananmen as an introduction to almost all reports on China, whereas people in China itself hardly talk about it. This is evidence that the West's expectation of China is changing from "purely aesthetic" concerns about the past to a contemporary mutation that is more and more connected to the West itself, where it is now understood China is playing a crucial role in global changes.

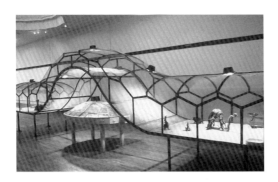

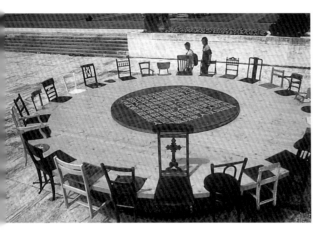

Fig. 40
HUANG YONG PING
Le Pont/Le Théâtre du monde,
1993–95
Musée National des Artes Afrique et
Oceanié

Fig. 41
CHEN ZHEN
Round Table, 1995
Palais des Nations Unies, Geneva

Gao: Plus, China's modernization, which started a century ago, is at a turning point. China is already an indispensable part of the world order, and it has become a veritable "modern China." However, nationalism, which was born with the appearance of modernity, is now reemerging in a new context of globalization. The artists who live overseas have wider experience and more insight into this. They live in a "nomad" situation, a state typical of globalization. This is inscribed concretely in their work.

Hou: Huang Yong Ping once said: "I was more interested in western culture when I was in China. Today, living in the West, I try more to introduce Chinese culture into the western art and cultural context." In fact, Huang Yong Ping is suspicious of both established cultures, eastern and western. From a "transcendent" position, he tries to intervene critically in both and interrupt their "normal" orders and functions, a strategy shared by more and more overseas artists. For Huang, it is a continuation of his Xiamen Dada actions of the 1980s. He has always distrusted established cultural ideas and values and launched critiques and deconstructive operations against them. His central concern is the question of cultural power: who decides the meaning of such notions as "truth" and "correctness." He further asks: Why does western modernist, rationalist culture seem to represent more truly the "Truth"? He reintroduces long-forgotten or suppressed Chinese ideas about the world that are labeled "irrational," or "superstitions," such as the *Yi Jing* (*Book of Changes*), *feng shui,* and *Paopu zi,* to confront and penetrate contemporary culture, society, and values.

Huang aims at deconstructing the power of art institutions—museums, the market, the media, and art histories. He defies institutional authority. A typical example is his *Should We Reconstruct a Cathedral?,* 1991, in Frankfurt. In it, he washed in a washing machine the publications of a famous discussion between some western contemporary masters about the necessity of reconstructing the cathedral of western culture; they were turned into paper pulp. In his *Indigestible Object* in Prato, Italy, 1992, he spread hundreds of kilograms of cooked rice in the center of the Museo de Arte Contemporánea, questioning whether a museum, as digestive organ for art, could assimilate the most digestible object in Chinese life. Other works such as *Le thèâtre du monde: Turtle Table* (1993–95) and *Le Pont* (1996; fig.40), and *Reversed Tomb* (Otterlo, Netherlands; 1994) are strong challenges to the power of the art institution.

Gao: Cai Guo-qiang, on the contrary, never intends to solve the great issues of culture, truth, and so forth. He is interested in more concrete questions. For example, his work in New York's Guggenheim Museum, *Cry Dragon/Cry Wolf: The Ark of Genghis Khan,* 1996, focused on the new fashionability of China in the West and on the fear of the "Chinese threat" in the western

collective unconscious. He may also present the emerging neo-nationalism in China. He makes use of Chinese cultural elements, but his attitude is neutral and he is working at a concrete, in-between moment. It is difficult to interpret whether it is intended as an attack or as glorification. Rather, it is a representation of the immediate cultural context.

Hou: However, Cai Guo-qiang did try to improve the urban environment of a modern city in Mito, Japan, in his work *Mito Project*.

Coming back to Huang Yong Ping. His direct use of the *Yi Jing* ended in 1993. Then he turned to other, more concrete strategies of critique. His 1993 works *Passage* in Glasgow, *Yellow Peril* in Oxford, and *Snake/Man Project* in Columbus, exposed some sensitive problems in the survival of "immigrant culture" in the West. Meanwhile, referring to ancient Chinese ideas, he extended his materials to include animals, insects, and substances usually unacceptable to art institutions as art mediums, in order to test the very limit of the cultural, legal, and moral systems in western society.

The thinking and work of Chen Zhen also target the contemporary "late capitalist" society of the West as well as problems caused by the globalization of the liberal market economy and the environmental degradation of our planet. His strategy is to propose projects of improving such situations based on his "transexperiences" as someone living in between the East and the West (fig. 41).

Yang Jiechang and Yan Pei Ming (fig. 42) are also contributing to the multi-orientationalization of the international art scene with their highly individual works.

The work of Chinese women artists overseas is worth particular attention. They are becoming unprecedentedly active in the art world. Shen Yuan, criticizing the destiny of women in both Chinese and western societies, looks to release the potential power of the female body (fig. 43). Qin Yufen, very differently, achieves a personal aesthetic by poetically reinterpreting Chinese aesthetic tradition.

Gao: I am now considering the issue of the reception of Chinese artists in the West, where, in this crazy time of an information explosion, rapid communication, and the popularization of computers, art has to find languages using images with strong and direct visual impact. This is a way to make communication effective. It also is a new task for Chinese artists.

Hou: To me it seems that today the status of art is becoming less and less clear. It's difficult to speculate that the trend is shifting from idea to image. Everything has its own legitimacy. Of course, new methods of communication, such as the Internet, are bringing about new means of expression. And, as these new communications vehicles are extremely democratic and accessible

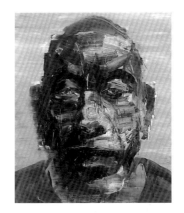

Fig. 42
YAN PEI MING
L' Homme le plus riche, 1996

Fig. 43
SHEN YUAN
Perdre sa salive, 1994

to the masses, they must to a great extent meet the masses' capacity of reception and their aesthetic expectations. This is somehow similar to the problems posed by Pop Art.

Gao: There is the question of what is an effective means of aesthetic communication in the context of globalization. This is, in the end, an "aesthetic" issue. Some Chinese artists living in the West are sensitive to this. Chen Zhen, Cai Guo-qiang, Wenda Gu, and Xu Bing, among others, pay a great deal of attention to such "aesthetic" effects and to images that convey an initially irrational impact. This is a characteristic tendency among them. One sees it in Xu Bing's *Book from the Sky*, 1987–91, Wenda Gu's United Nations series, 1993/1998, and Chen Zhen's purported use of orientalist images and materials. For the Chinese artist, it is the image, material, or object itself which speaks to us, rather than we who assign meaning to them. I think that recently Cai Gou-qiang has become more concerned with this Chinese aesthetic characteristic, and Huang Yong Ping is moving toward this orientation, too.

Hou: Again, there is the question of practicing different strategies in different cultural contexts. In the US, in general, things are supposed to be consumed immediately, and that which cannot be "understood" immediately is condemned to disappear. Therefore, visual effect is most important. In Europe, however, the situation is more complicated. In fact, the new generation of artists of the 1990s trusts less and less the 1980s culture of image consumption. I think that many artists, including Chinese artists, are more interested in keeping a critical distance from mass-media images, in finding how to penetrate them and deconstruct them, rather than simply appropriate them. For example, Wang Du's work intends to provoke doubts about the function of the mass media by deconstructively recycling press images. His recent work reveals our desire to transform our own bodies for the better by biological engineering and aesthetic surgery techniques now being developed. In the meantime, he exhibits the *fin-de-siècle* aspect of the era of high tech, an anxious complex of excitement about technological progress and fear of losing human identity. Because of technological developments, especially the changes caused by computerization, as well as constant international travel, our identities are permanently shifting. Chen Zhen's latest works reveal conflicts between cultures in such a context, while Wenda Gu's "happy ending" project of the United Nations endeavors to propose an optimistic vision of the future. This reflects a common effort on the part of the Chinese artists: how to reposition oneself in such changing times. Their works also share another interesting quality—a sense of humor and irony. Through humor they create a distancing from immediate reality and hence become capable of changing themselves along with the changing world. Today, many artists' works are unpredictable. They are not producing

objects, but opening new spaces through negotiations with contemporary cultural reality. If there is an "aesthetics" of the 1990s, then it is an aesthetics of space. This is a fundamental characteristic of the art in 1990s.

Gao: Ours is a time of "trans."

Hou: In closing, I'd like to bring up one more point. That is, some artists who were born in or grew up in the West who are of Chinese descent and active in the mainstream of contemporary art—such as Ken Lum (Canada), David Diao (US), and Fiona Tan (Netherlands)—are becoming more interested in dealing with their potential relationships to Chinese culture and the Chinese community and in expressing this in their work. This is a good example of the multi-orientationalization in our transitional time!

A list of works in the exhibition at the Asia Society Galleries, New York City, and P.S. 1 Contemporary Art Center, Long Island City, New York, September 15, 1998–January 3, 1999; and at the San Francisco Museum of Modern Art and the Asian Art Museum of San Francisco, February 26–June 1, 1999.

NOTE: The preferred name order of the artist is used; family names appear in *italics*.

蔡國強
太古的烙印—土風
Cai Guo-qiang
Traces of Ancient Explosions, 1985
Gunpowder and oil on canvas. 70⅞ x 49¼ in. (180 x 125 cm). Collection of the artist. Plate 1.

蔡國強
草船借箭
Cai Guo-qiang
Borrowing Your Enemy's Arrows, 1998
Wooden boat, straw, bamboo, arrows, flags, and fan. Length: approx. 32 ft. 9 in. (1000 cm). Collection of the artist.

曹涌
時代、婦女、環境之三
Cao Yong
The Age, Women, and the Environment No. 1, 1995
Oil on canvas. 47¼ x 39⅜ in. (120 x 100 cm). Collection of the artist. Plate 44.

曹涌
關於第四紀前景的緊急播音
Cao Yong
An Emergency Broadcast about the Prospects of the Quaternary Period, 1997
Oil on canvas. 35⅜ x 39⅜ in. (90 x 100 cm). Collection of the artist. Plate 45.

陳慧嶠
想花要比看花深
Chen Hui-chiao
Thoughts of Flowers Go Deeper Than Looking, 1993
Installation with table, roses, and acupuncture needles. Approx. 27½ in. x 78¾ in. x 12 ft. 5 in. (70 x 200 x 380 cm). Collection of the artist. Plate 63.

陳慧嶠
知覺之翼
Chen Hui-chiao
Wings of the Senses, 1994
Stainless steel, needles and thread, and wool. 39⅜ x 39⅜ x 2 in. (100 x 100 x 5 cm). Collection of the artist. Plate 64.

陳順築
集會．家庭遊行一屋
Chen Shun-chu
Family Parade, 1995–96
Installation with framed photographs. Dimensions variable; each photograph 11⅜ x 9½ in. (29 x 24). Collection of the artist. Plate 59.

朱嘉樺
參照(蛋)
Chu Chiahua
Comparison, 1994
Real and metal eggs, porcelain and metal plates. Twelve pieces: each plate diam. 7 in. (18 cm). Collection of the artist. Plate 67.

方勵鈞
素描之三
Fang Lijun
Pencil Drawing No. 3, 1988
Pencil on paper. 22 x 31 in. (54.8 x 79.1 cm). Art Gallery of New South Wales, Sydney—Purchased 1993.

方勵鈞
第二組之二
Fang Lijun
Series 2: No. 2, 1992
Oil on canvas. 79 x 79 in. (200 x 200 cm). Ludwig Museum, Cologne. Plate 27.

方勵鈞
第三組之十五
Fang Lijun
Series 3: No. 15, 1993
Oil on canvas. 66⅞ in. x 8 ft. 6 in. (170 x 260 cm). Courtesy of Hanart T Z Gallery.

方土
天大．地大之九
Fang Tu
Infinite Sky, Infinite Earth, No. 9, 1997
Ink on paper. 90½ x 61 in. (230 x 155 cm). Collection of the artist.

方偉文
海景
Fang Weiwen
Seascape, 1995
Installation with carbon-powder painting, driftwood, paper objects, and salt. Approx. 19 ft. x 22 ft. 11 in. x 26 ft. 3 in. (600 x 700 x 800 cm). Collection of the artist. Plate 61.

耿建翌
第二狀態
Geng Jianyi
The Second Situation, Nos. 1–4, 1987
Oil on canvas. Four canvases: each 67 x 52 in. (170 x 132 cm). Private collection. Plate 22.

谷文達
靜觀的世界
Wenda *Gu*
Pseudo-Characters Series: Contemplation of the World, 1984
Ink on paper. Three hanging scrolls: each 9 x 6 ft. (247.3 x 182.9 cm). Collection Zhen Guo. Plate 3 and figure 24.

谷文達
聯合國—中國紀念碑：天壇
Wenda *Gu*
United Nations Series: Temple of Heaven (China Monument), 1998
Installation with screens of human hair. Approx. 24 x 30 x 27 ft. (732 x 914 x 823 cm). Collection of the artist. Plate 4.

何兆基
雙球上步行
Ho Siu-kee
Walking on Two Balls, 1995
Installation with video, flip book, and two wooden balls. Dimensions variable. Collection of the artist. Plate 71.

洪浩
藏經
Hong Hao
Selected Scriptures, 1995
Silkscreen on paper. Six panels: each 22 x 30 in. (55 x 76 cm). Collection of the artist. Plate 43.

候俊明
新樂園
Hou Chun-ming
New Paradise, 1996
Paint on paper mounted on wood. Seven hinged panels: each 75 x 85 in. (190 x 216 cm). Collection of the artist. Plate 56.

黄志陽
胎形產房
Huang Chih-yang
Zoon, 1996
Ink on paper. Seven hanging
scrolls: each 17 ft. 1 in. x 59 in.
(520 x 150 cm). Collection of the
artist. Plate 58.

黄永砅
賭具：憑運氣作畫
Huang Yong Ping
Roulette Wheel: Paintings Created
According to Random Instructions,
1985
Wooden turntable; ink on canvas.
Turntable: approx. 39 3/8 x 39 3/8 x
31 1/2 in. (100 x 100 x 80 cm); four
paintings: each 59 x 47 1/4 in. (150
x 120 cm). Collection of the artist.
Plate 15.

黄永砅
轉盤
Huang Yong Ping
Turntable, 1988
Wood. Approx. 50 x 40 x 16 in. (127
x 102 x 41 cm). Private collection.

黄永砅
《中國繪畫史》與《西方現代繪
畫簡史》在洗衣機中攪拌了兩分鐘
Huang Yong Ping
"A History of Chinese Painting"
and "A Concise History of Modern
Painting" Washed in a Washing
Machine for Two Minutes,
1993 version
Paper pulp. Approx. 31 x 20 x 20 in.
(80 x 50 x 50 cm). Collection of
Cyrille Putman, Paris. See plate 16.

甘志強
轉移的空間
Kum Chi-Keung
Transition Space, 1995
Bird cages, yellow mud, and
mechanical birds. Approx. 10 ft. 10 in.
x 32 in. x 49 in. (330 x 80 x 125 cm).
Collection of the artist. Plate 70.

李山
胭脂系列之八
Li Shan
The Rouge Series: No. 8, 1990
Acrylic on canvas. 41 1/2 x 58 in.
(105.4 x 147.3 cm). Collection of
the artist. Plate 37.

林書民
征服者
Shu-Min Lin
The Conqueror, 1993
Hologram. 96 x 24 in. (244 x 61 cm).
Collection of the artist. Plate 57.

林天苗
纏了再剪開
Lin Tian-miao
Bound and Unbound 1995–97,
1995–97
Installation with household
objects wrapped in thread, video
projection. Dimensions variable.
Collection of the artist. Plate 53.

劉煒
新一代
Liu Wei
New Generation, 1992
Oil on canvas. 41 x 33 1/2 in. (104 x
85 cm). Collection of Francesca dal
Lago. Plate 39.

劉向東
蚊香消毒
Liu Xiangdong
Using Mosquito Repellent Coils to
Disinfect, 1993–94
Installation with mosquito repel-
lent coils and water. 11 ft. 6 in. x
32 in. x 32 in. (350 x 80 x 80 cm).
Collection of the artist. Plate 51.

劉向東
威尼斯雙年展沒有中國館-藝術法庭
Liu Xiangdong
There Is No Chinese Pavilion in the
Venice Biennale (The Court for
Art), 1993–96
Bird cage, signs. 24 1/4 x 11 7/8 x 11 7/8
in. (54 x 30 x 30 cm). Collection of
the artist.

大尾象小組(林一林 陳劭雄
梁鉅輝 徐坦)
城市大尾象
Long-Tailed Elephant Group (Lin
Yilin, Chen Shaoxiong, Liang Juhui,
and Xu Tan)
Long-Tailed Elephant in a City, 1987
Video documentation of site-specif-
ic events and installations, 1995–97.
Collection of the artists. Plate 50.

馬六明
芬．馬六明(化裝)
Ma Liuming
Fen · Ma Liuming
Performance in Dashan Village,
Beijing, November 13, 1993: three
photographs by Xu Zhiwei, collec-
tion of the artist, plate 29.
Performance in Breda, The Nether-
lands, 1997: photograph by Tang
Di, collection of the artist, plate 30.
Performances at P.S. 1 Contem-
porary Art Center, Long Island City,
New York, October 1998.

文晶瑩
美麗的花
Phoebe Man (Man Ching Ying)
Beautiful Flowers, 1996
Installation with sanitary napkins,
colored eggshells, and chair with
light bulb. Dimensions variable.
Collection of the artist. Plate 65.

毛旭輝
紅色體積
Mao Xuhui
Red Bodies, 1985
Oil on paper mounted on wood.
37 x 42 in. (78 x 105 cm).
Collection of the artist. Plate 24.

毛旭輝
剪刀和沙發之一
Mao Xuhui
Scissors and Sofa No. 1, 1995
Oil on canvas. 47 x 57 in. (120 x
145 cm). Collection of the artist.
Plate 25.

新解浙小組
(王魯炎 陳少平 顧德新)
觸覺藝術
New Analysis Group (Wang Luyan,
Chen Shaoping, Gu Dexin)
Tactile Art, 1988
Photostats. Twelve panels: each
8 x 8 in. (20.3 x 20.3 cm). Private
collection. Plate 17.

潘星磊 杜焕 余大強 馬健
文化吊唁
Pan Xing Lei, To Weun, Tim Yu, and
Ma Jian
Cultural Mourning, performance in
Hong Kong, January 1996
Photograph by He Yanqian.
Collection of Pan Xing Lei. Plate 72.

邱志傑
書寫蘭亭序一千遍
Qiu Zhijie
Writing the "Orchid Pavilion
Preface" One Thousand Times,
1986/1997
Installation with video documenta-
tion; ink-on-paper calligraphy.
Installation approx. 16 ft. 6 in. x 16 ft.
6 in. (500 x 500 cm); calligraphy
29 1/2 x 70 7/8 in. (75 x 180 cm). Cour-
tesy of Hanart T Z Gallery. Plate 8.

任戩
元化
Ren Jian
Primeval Chaos, 1986–87
Ink on polyester mounted on
paper. Approx. 59 in. x 98 ft. 5 in.
(150 x 3000 cm). Collection of the
artist. Plate 2.

任戩
公元2000年
Ren Jian
A.D. 2000, 1991–93
Installation with oil on canvas.
Dimensions variable. Collection of
the artist. Plate 42.

觀念二十一世紀
(盛奇 康木 鄭玉珂 趙建海)
觀念二十一世紀
21st Century Group (Sheng Qi,
Kang Mu, Zheng Yuke, and Zhao
Jianhai)
The Concept of the 21st Century,
performance at the Great Wall of
China, Beijing, 1988
Four photographs. Collection of
Wen Pulin. Plate 48.

舒群
絕對原則
Shu Qun
Absolute Principle, 1985/89
Oil on canvas. 25 x 126 in.
(64 x 320 cm). Collection of the
artist. Plate 19.

宋冬
印水
Song Dong
Printing on Water, performance in
the Lhasa River, Tibet, 1996
Thirty-six photographs. Collection
of the artist. Plate 9.

宋永平 宋永红
一九八六年某日的體驗
Song Yongping and *Song*
Yonghong
*Experiences on a Certain Day in
1986,* performance in Taiyuan,
Shanxi Province, 1986
Two photographs. Collection of the
artist. Plate 21.

宋永平
戲水
Song Yongping
Playing in Water, 1996
Oil on canvas. 51 x 75½ in. (130 x
192 cm). Collection of the artist.
Plate 41.

南方藝術家沙龍(王度 李正天
林一林等)
第一次實驗展之一
Southern Artists Salon (*Wang* Du,
Lin Yilin, *Chen* Shaoxiang, *Liang*
Juhui, and others)
*The First Experimental Exhibition
Part 1,* performance in Guangzhou,
1986
Photograph. Collection of Wang
Du. Plate 46.

南方藝術家沙龍(王度 李正天
林一林等)
第一次實驗展之二
Southern Artists Salon (*Wang* Du,
Lin Yilin, *Chen* Shaoxiang, *Liang*
Juhui, and others)
*The First Experimental Exhibition
Part 2,* performance in Guangzhou,
1986
Photograph. Collection of Wang
Du. Plate 47.

蘇新平
世紀之塔
Su Xinping
Tower of the Century, 1996
Oil on canvas. Three panels: each
76 x 51 in. (194 x 130 cm).
Collection Kent and Vicki Logan,
courtesy of Max Protetch Gallery.
Plate 40.

莊普
"五月"的《獨立宣言》
Tsong Pu
*The "Independence Declaration"
of the May Painting Group,* 1996
Ink and color on paper. Forty-two
panels: each 14⅜ x 10⅜ in.
(36.5 x 26.5 cm). Collection of the
artist. Plate 66.

王功新
老凳
Wang Gongxin
The Old Bench, 1996
Wood, television monitor. Approx.
21½ x 39½ in. (55 x 100 cm).
Collection of the artist.

王廣義
後古典系列．馬拉之死
Wang Guangyi
*Post-Classical Series: Death of
Marat,* 1987
Oil on canvas. 59 x 79 in.
(150 x 200 cm). Private collection.
Plate 20.

王廣義
毛澤東一號
Wang Guangyi
Mao Zedong No. 1, 1988
Oil on canvas. 59 x 141 in.
(150 x 358.1 cm). Private collec-
tion. Plate 34.

王廣義
大批評系列：可口可樂
Wang Guangyi
*Great Castigation Series: Coca-
Cola,* 1993
Oil on canvas. 79 x 79 in. (200 x
200 cm). Collection of the artist.
Plate 35.

王晉
娶頭騾子
Wang Jin
To Marry a Mule, performance in
Laiguanying Village, Beijing, July
28, 1995
Photograph by Shi Xiabing.
Collection of the artist. Plate 31.

王晉
冰．`96中原
Wang Jin
Ice: Central China 1996, installa-
tion with ice and consumer goods,
Zhengzhou City, Henan Province,
January 28, 1996
Photographs by Jiang Jian. Col-
lection of the artist. Figures 2, 30.

王晉
中國之夢．龍袍
Wang Jin
The Dream of China: Dragon Robe,
1997
Polyvinyl chloride, fishing line.
78 x 70⅞ x 15 in. (198 x 180 x 38
cm). Collection of the artist.
Plate 32.

王勁松
天安門前留個影
Wang Jinsong
*Taking a Picture in Front of
Tiananmen,* 1990
Oil on canvas. 49 x 73 in. (125 x
185 cm). Courtesy of Hanart T Z
Gallery. Plate 36.

王勁松
雙親
Wang Jinsong
Parents, 1998
Twenty color photographs. Each:
11⅜ x 15⅜ in. (29 x 39 cm).
Collection of the artist.

王俊傑
十三日羊肉小饅頭
Wang Jun Jieh
*Little Mutton Dumplings for the
Thirteenth Day,* 1998
Installation with table, video,
ceramic dumplings, menu, and fly-
ers. 59 x 4¼ x 47¼ in. (150 x 120
x 120 cm). Collection of the artist.
Plate 68.

王蓬
現實的形成
Wang Peng
Form of Reality, 1994
Four photographs, headphones
and cassette player. Photographs:
each 9 x 11 in. (23 x 28 cm).
Collection of the artist.

王天德
水墨菜單
Wang Tiande
Ink Banquet, 1996
Installation with table, eight
chairs, bottle, and dishes, painted
with ink; and brushes. Approx.
9 ft. 10 in. x 9 ft. 10 in. x 37 in (300
x 300 x 94 cm). Collection of the
artist. Plate 10.

溫普林
公共空間中的衝突
Wen Pulin, compiler
*Documents of Avant-Garde
Performance Art,* 1998
Video documentation of perfor-
mances in Beijing, 1988–98,
including works by Xiao Lu and
Tang Song, Wu Shan Zhuan, Li
Shan, Wang Deren, Zhang Huan,
Song Dong, and the New History
Performers (videographer: Wen
Puqing). Collection of Wen Pulin.

吳瑪悧
碑
Wu Mali
Epitaph, 1997
Video, sandblasted glass. 118 x
138 x 157½ in. (300 x 350 x 400
cm). Taipei Fine Arts Museum.
Plate 62.

吳山專
紅色幽默系列．大字報
Wu Shan Zhuan
*Red Humor Series: The Big
Characters,* 1986
Installation with works on paper.
Dimensions variable. Collection of
the artist. Plate 5.

吳天章
春宵夢
Wu Tien-chang
A Dream of a Spring Night, 1995
Oil and mixed media on canvas. 87
x 71 in. (220 x 180 cm). Collection
of the artist. Plate 55.

吳天章
陽台夢
Wu Tien-chang
A Dream on a Balcony, 1995
Oil on canvas. 79 x 63 in. (220 x
160 cm). Collection of the artist.

蕭魯 唐宋
"中國現代藝術展" 槍擊事件
Xiao Lu and Tang Song
Two gunshots fired at the installa-
tion "Dialogue" in the
"China/Avant-Garde" exhibition,
Beijing, February 1989, 1989
Photograph by Tang Song of per-
formance by Xiao Lu. Collection of
Tang Song. Plate 23.

徐冰
天書
Xu Bing
Book from the Sky, 1987–91
Installation with hand-printed
books. Dimensions variable.
Collection of the artist. Plate 6.

閻秉會
碑
Yan Binghui
The Monument, 1993
Ink on paper. 70⅞ x 38 in. (180.1 x
96.5 cm). Collection of the artist.
Plate 12.

尹秀珍
毛線
Yin Xiuzhen
Woolen Sweaters, 1995
Women's and men's woolen
sweaters, unraveled and wound
yarns, knitting needles.
Dimensions variable. Fukuoka
Asian Art Museum, Japan. Plate 54.

袁旃
歲朝圖
Yuan Jai
The Beginning of the Year, 1996
Color and ink painting on silk. 73 x
36½ in. (186 x 93 cm). Collection
of the artist. Plate 60.

榮念曾
中國禮品
Danny Ning Tsun Yung
Gifts from China, 1994
Eight boxes covered in paper, silk,
or cloth, containing plastic film
capsules, plastic CD containers,
used newspapers, etc. Approx. 16
x 27 x 8 in. (40.6 x 68.6 x 20.3 cm).
Collection of the artist. Plate 69.

張洹
12平方米
Zhang Huan
12 Square Meters, performance in
Dashan Village, Beijing, May 31,
1994
Photograph by Rong Rong.
Collection of the artist. Plate 28.

張洹
為無名山增高一米
Zhang Huan
To Add One Meter to an Unknown
Mountain, performance at Miaofeng
Mountain, Beijing, May 22, 1995
Performers: Zhu Min, Duan Yingui,
Zhang Bingbing, Zhang Huan, Zu
Zhou, Wang Shihua, Cang Xin, Ma
Liuming, Ma Zongren, and Gao
Yang. Photograph by Lu Nan.
Collection of the artist. Plate 49.

張洹
為魚塘增高水位
Zhang Huan
To Raise the Water Level in a
Fishpond, performance at
Nanmofang fishpond, Beijing,
August 15, 1997
Performers: Zhang Huan with
workers and fishermen.
Photographs by Robyn Beck.
Collection of the artist.

張洹
冰床
Zhang Huan
Ice Bed, performance at P.S. 1
Contemporary Art Center, Long
Island City, New York, October
1998.

張培力
X？系列之四
Zhang Peili
X? Series: No. 4, 1987
Oil on canvas. 31½ x 39⅜ in.
(80 x 100 cm). Private collection.
Plate 18.

張培力
關於1988年甲肝的報告
Zhang Peili
A Report on the Hepatitis A
Infection in 1988, 1988
Glass, emulsive gloves, lacquer,
and plaster powder. Five gloves
encased in glass: each 12¼ x 7½ in.
(31 x 19 cm). Private collection.

張培力
水一《辭海》的標準發音
Zhang Peili
Water—The Standard Version
Read from the "Ci Hai" Dictionary,
1992
Video. Performer: Xin Zhibin.
Collection of the artist. Figure 25.

張曉剛
血緣．家庭肖像之二
Zhang Xiaogang
Bloodline: Family Portrait No. 2,
1994
Oil on canvas. 59 x 71 in. (150 x
180 cm). Courtesy of Hanart T Z
Gallery.

張羽
靈光第49號．漂浮的殘圓
Zhang Yu
Light of Spirit Series (No. 49): The
Floating Sphere, 1996
Ink on paper. 68⅞ x 37¾ in.
(178 x 96 cm). Collection of the
artist. Plate 13.

Cai Guo-qiang
Born 1957 in Quanzhou City, Fujian
Province, PRC
Resides in New York
Education and Training: Shanghai
Drama Institute, 1985

Cao Yong
Born 1954 in Lanzhou City, Gansu
Province, PRC
Resides in Lanzhou City
Education and Training: Tianshui
Teacher's School, Gansu Province,
1980

Chen Hui-chiao
Born 1964 in Tanshui, Takwan
Resides in Taipei
Education and Training: Yu-Te Fine
Arts High School, Taipei, 1982, and
study in Paris

Chen Shun-chu
Born 1963 in the Pescadores
(Penghu), Taiwan
Resides in Taipei
Education and Training: Chinese
Culture University, Taipei, B.A., 1986

Chu Chiahua
Born 1960 in Taipei
Resides in Taipei
Education and Training: National
Taiwan Academy of Arts, Taipei,
1982, and Accademia di Belle Arti,
Milan, 1990

Fang Lijun
Born 1963 in Handan, Hebei
Province, PRC
Resides in Beijing
Education and Training: Central
Academy of Fine Arts, Beijing,
1989

Fang Tu
Born 1963 in Guangzhou,
Guangdong Province, PRC
Resides in Guangzhou
Education and Training:
Guangzhou Academy of Fine Arts,
1986

Fang Weiwen
Born 1970 in Brunei
Resides in Tainan, Taiwan
Education and Training: Tung-hai
University, Tai-chung, Taiwan, 1993

Geng Jianyi
Born 1962 in Zhengzhou, Henan
Province, PRC
Resides in Hangzhou, Zhejiang
Province
Education and Training: Zhejiang
Academy of Fine Arts, Hangzhou,
B.A., 1985

Wenda Gu
Born 1955 in Shanghai
Resides in New York
Education and Training: Shanghai
School of Arts and Crafts, 1979,
and Zhejiang Academy of Fine
Arts, Hangzhou, M.F.A., 1981

Ho Siu-kee
Born 1964 in Hong Kong
Resides in Hong Kong
Education and Training: Chinese
University of Hong Kong, B.A.,
1989, and Cranbrook Academy of
Art, Bloomfield, MI, M.F.A., 1995

Hong Hao
Born 1965 in Beijing
Resides in Beijing
Education and Training: Central
Academy of Fine Arts, Beijing,
B.A., 1989

Hou Chun-ming
Born 1963 in Chiayi, Taiwan
Resides in Taipei
Education and Training: National
Institute of the Arts, Taipei, B.A.,
1987

Huang Chih-yang
Born 1965 in Taipei
Resides in Taipei
Education and Training: China
Culture University, Taipei, 1989

Huang Yong Ping
Born 1954 in Xiamen, Fujian
Province, PRC
Resides in Paris
Education and Training: Zhejiang
Academy of Fine Arts, Hangzhou,
B.A., 1982

Kum Chi-Keung
Born 1965 in Hong Kong
Resides in Hong Kong
Education and Training: First
Institute of Arts and Design, Hong
Kong, 1991

Li Shan
Born 1942 in Heilongjiang
Province, PRC
Resides in Shanghai
Education and Training: Shanghai
Drama Institute, 1968

Shu-Min Lin
Born 1963 in Taipei
Resides in New York
Education and Training: Fu-Shin
Arts School, Taipei, 1980, and New
York Institute of Technology,
M.F.A., 1991

Lin Tian-miao
Born 1961 in Taiyuan, Shanxi
Province, PRC
Resides in Beijing
Education and Training: Capital
Normal University, Beijing, B.A.,
1984, and Art Students League,
New York, 1989

Liu Wei
Born 1965 in Beijing
Resides in Beijing
Education and Training: Central
Academy of Fine Arts, Beijing,
1989

Liu Xiangdong
Born 1964 in Fujian Province, PRC
Resides in Fujian Province
Education and Training: Fujian
Normal University, Jinshan, 1985

Long-Tailed Elephant Group
Members: **Lin** Yilin, **Chen**
Shaoxiong, **Liang** Juhui, and **Xu** Tan
Active in Guangzhou, Guangdong
Province, PRC, 1987–present

Ma Jian
Born 1953 in Qingdao, Shandong
Province, PRC
Resides in Hong Kong
Education and Training: Self-
taught writer

Ma Liuming
Born 1969 in Hubei Province, PRC
Resides in Beijing
Education and Training: Hubei
Academy of Fine Arts, Wuhan, 1991

Phoebe Man (**Man** Ching Ying)
Born 1969 in Hong Kong
Resides in Hong Kong
Education and Training: Chinese
University of Hong Kong, B.A.,
1991

Mao Xuhui
Born 1956 in Chongqing, Sichuan
Province, PRC
Resides in Kunming, Yunnan
Province
Education and Training: Yunnan
Academy of Fine Arts, Kunming,
1982

New Analysis Group
Members: *Wang* Luyan, *Chen*
Shaoping, *Gu* Dexin
Active in Beijing, 1988–1995

Pan Xing Lei
Born 1969 in Shenyang, Liaoning
Province, PRC
Resides in Hong Kong
Education and Training: Central
Academy of Fine Arts, Beijing,
1992

Qiu Zhijie
Born 1969 in Fujian Province, PRC
Resides in Beijing
Education and Training: Zhejiang
Academy of Fine Arts, Hangzhou,
B.A., 1992

Ren Jian
Born 1965 in Liaoning Province, PRC
Resides in Wuhan, Hubei Province
Education and Training: Luxun
Academy of Fine Arts, Shenyang,
M.F.A., 1987

Shu Qun
Born 1958 in Jilin Province, PRC
Resides in Wuhan, Hubei Province
Education and Training: Luxun
Academy of Fine Arts, Shenyang,
1982

Song Dong
Born 1966 in Beijing
Resides in Beijing
Education and Training: Capital
Normal University, Beijing, 1989

Song Yonghong
Born 1966 in Hebei Province, PRC
Resides in Beijing
Education and Training: Zhejiang
Academy of Fine Arts, Hangzhou,
1988

Song Yongping
Born 1961 in Shanxi Province, PRC
Resides in Shanxi Province
Education and Training: Tianjin
Academy of Fine Arts, B.A., 1983

Southern Artists Salon
Members: *Lin* Yilin, *Chen*
Shaoxiong, *Liang* Juhui, and others
Active in Guangzhou, Guangdong
Province, PRC, 1985–1987

Su Xinping
Born 1960 in Jining, Inner
Mongolia, PRC
Resides in Beijing
Education and Training: Central
Academy of Fine Arts, M.A., 1989

Tang Song
Born 1962 in Hangzhou, Zhejiang
Province, PRC
Resides in Sydney
Education and Training: Zhejiang
Academy of Fine Arts, Hangzhou,
1989

To Weun
Born 1970 in Guangdong Province,
PRC
Resides in Hong Kong
Education and Training: Hong
Kong Dayi, College of Art and
Design, B.A., 1992

Tsong Pu
Born 1947 in Shanghai
Resides in Taipei
Education and Training: Escuela
Superior de Bellas Artes de San
Fernando de Madrid

Wang Gongxin
Born 1960 in Beijing
Resides in Beijing and New York
Education and Training: Beijing
Normal College, 1982

Wang Guangyi
Born 1956 in Harbin, Heilongjiang
Province, PRC
Resides in Beijing
Education and Training: Zhejiang
Academy of Fine Arts, Hangzhou,
1984

Wang Jin
Born 1962 in Shanxi Province, PRC
Resides in Beijing
Education and Training: Zhejiang
Academy of Fine Arts, Hangzhou,
1987

Wang Jinsong
Born 1963 in Heilongjiang
Province, PRC
Resides in Beijing
Education and Training: Zhejiang
Academy of Fine Arts, Hangzhou,
1987

Wang Jun Jieh
Born 1963 in Taipei
Resides in Berlin and Taipei
Education and Training: Chinese
Culture University, Taipei, B.A.,
1989, and Hochschule der Künste,
Berlin, M.F.A., 1996

Wang Peng
Born 1964 in Shandong Province,
PRC
Resides in New York
Education and Training: Central
Academy of Fine Arts, Beijing,
B.A., 1988

Wang Tiande
Born 1960 in Shanghai
Resides in Shanghai
Education and Training: Zhejiang
Academy of Fine Arts, Hangzhou,
1988

Wen Pulin
Born 1957 in Shenyang, Liaoning
Province, PRC
Resides in Beijing
Education and Training: Central
Academy of Fine Arts, Beijing,
B.A., 1985

Wu Mali
Born 1957 in Taipei
Resides in Taipei
Education and Training: Tamkang
University, Taipei, B.A., 1979, and
Staatliche Kunstakademie,
Düsseldorf, 1986

Wu Shan Zhuan
Born 1960 in Zhoushan, Zhejiang
Province, PRC
Resides in Hamburg, Germany
Education and Training: Zhejiang
Academy of Fine Arts, Hangzhou,
and Hochschule für Bildende
Künste, Hamburg

Wu Tien-chang
Born 1956 in Taipei
Resides in Taipei
Education and Training: Chinese
Culture University, Taipei, B.F.A.,
1980

Xiao Lu
Born 1962 in Hangzhou, Zhejiang
Province, PRC
Resides in Sydney
Education and Training: Zhejiang
Academy of Fine Arts, Hangzhou,
1988

Xu Bing
Born 1955 in Chongqing, Sichuan
Province, PRC
Resides in New York
Education and Training: Central
Academy of Fine Arts, Beijing,
M.F.A., 1987

Yan Binghui
Born 1956 in Tianjin, PRC
Resides in Tianjin
Education and Training: Tianjin
Academy of Fine Arts, B.A., 1986

Yin Xiuzhen
Born 1963 in Beijing
Resides in Beijing
Education and Training: Capital
Normal University, Beijing, B.A.,
1989

Tim Yu
Born 1964 in Hong Kong
Resides in Hong Kong
Education and Training: Chinese
University of Hong Kong, B.A.,
1988

21st Century Group
Members: *Sheng* Qi, *Kang* Mu,
Zheng Yuke, and *Zhao* Jianhai
Active in Beijing, 1986–1989

Yuan Jai
Born 1941 in Chongqing, PRC
Resides in Taipei
Education and Training: National
Taiwan Normal University, Taipei,
B.A., 1962; University of Louvain,
M.A., 1966; Institut Royaux du
Patrimoine Artistique Bruxelles,
1968 (doctoral studies)

Danny Ning Tsun *Yung*
Born 1943 in Shanghai
Resides in Hong Kong
Education and Training: University
of California, Berkeley, 1967, and
Columbia University, New York, 1969

Zhang Huan
Born 1965 in Anyang, Henan
Province, PRC
Resides in Beijing
Education and Training: Henan
University, Kaifeng, B.A., 1988, and
Central Academy of Fine Arts,
Beijing, 1993

Zhang Peili
Born 1957 in Hangzhou, Zhejiang
Province, PRC
Resides in Hangzhou
Education and Training: Zhejiang
Academy of Fine Arts, Hangzhou,
M.F.A., 1984

Zhang Xiaogang
Born 1958 in Kunming, Yunnan
Province, PRC
Resides in Sichuan Province
Education and Training: Sichuan
Academy of Fine Arts, B.A., 1982

Zhang Yu
Born 1959 in Tianjin, PRC
Resides in Tianjin
Education and Training: Tianjin
Academy of Arts and Crafts, 1990

Names of artists in the *Inside Out* exhibition are printed in **bold.**

MAINLAND CHINA

1977

The Cultural Revolution (CR) ends with Mao Zedong's death in October 1976. But the change in leadership does not immediately result in new cultural values. From 1977 to late 1978, artists continue to produce work in the CR style, substituting new leaders for the former cast of characters. However, a few small-scale group exhibitions organized by artists feature landscape and portrait painting, challenging conventions that demand overt political/ideological subject matter in art.

1978

A January exhibition of French 19th-century rustic landscape painting at the National Gallery, Beijing, contributes to the emergence of a new form of critical realism later in the year. This is the first show of foreign art since the beginning of the CR, and parallels an influx of publications on western art. The *Review of Foreign Art* (*Guowai meishu ziliao*), which later changes its name to the *Journal of Art Translation* (*Meishu yicong*), is established in January. Along with *World Art* (*Shijie meishu*), an academic journal of the Central Academy of Fine Arts, it becomes the major periodical source of western art movements of the 1970s and '80s.

Deng Xiaoping introduces economic and social reforms emphasizing increased openness to capitalism and western culture. Intellectuals and the public respond to the initiative with the Beijing Spring Democracy Movement, which

flourishes from November 1978 through 1979. Intellectuals challenge the foundations of Maoist ideology with philosophical and cultural debates on humanism and individual freedom. This questioning spirit and the concurrent influx of western aesthetic ideas catalyze several new art movements.

1979

The *New Spring Painting Exhibition* (*Xinchun huahui zhanlan*) opens in February at Sun Yat-sen Park, Beijing. The show features some 40 artists from different generations, including influential older artists such as Liu Haisu and Wu Zuoren, all of whom advocate an apolitical approach to artmaking. A significant moment in the development of this "New Academicism" occurs in September when several murals are unveiled at the Beijing International Airport. Yuan Yunsheng's *Water-Splashing Festival: Ode to Life,* includes nude female figures, which triggers a serious controversy over nudity in public art. (The mural is boarded over in 1981.)

In February a group of twelve artists in Shanghai organize an exhibition (*Shierren huazhan*) at the Palace of Infants, Huangpu district; it is China's first modernist show since mid-century. The works are influenced by Impressionism and Postimpressionism, considered radical in the post-CR context, although the subjects are traditional (birds, flowers, etc.).

Scar Painting (*Shanghen huihua*) and the Star group (*Xing xing*)

emerge as the two most important art movements of 1979. Both aim at criticizing the realities of contemporary China and often portray the CR negatively.

Scar Painting, part of a broader movement called New Realistic Painting (*Xinxianshizhuyi huihua*), takes its name from a related literary tendency. The term refers to the emotional wounds inflicted on the Chinese—especially intellectuals, students, and older cadre—by the CR. For example, Cheng Conglin's painting *A Certain Month of a Certain Day in 1968* and the illustrations to Zheng Yi's short story "Maple," by Liu Yulian, Chen Yiming, and Li Bin, describe the tragic results of Red Guard battles during the CR.

The Stars are principally self-taught artists (i.e., not trained in the Academy) and are the first influential avant-garde group, challenging both aesthetic convention and political authority. Their use of formerly banned western styles, from Postimpressionism to Abstract Expressionism, is an implicit criticism of the status quo. The group's first exhibition, in September 1979, is a provocative display of work hung without official permission on the fence outside the National Gallery, Beijing. After the exhibition is disrupted by the police, the artists post a notice on Democracy Wall and stage a protest march. The Stars' first formal exhibition (*Xing xing huazhan*), held in Beihai Park, Beijing, in November, includes 163 works by 23 nonprofessional artists.

1980

In March, *Art Monthly* (*Meishu*) publishes an article about the Stars in which the author, Qu Leilei (a painter in the group) proclaims "art for the sake of self-expression" (*ziwobiaoxian de yishu*). The article prompts a debate about art's function that continues for two years. The Stars hold another exhibition (*Xing xing huazhan*) at the National Gallery, Beijing, in August, this time with official approval. The primary intention of the group is to criticize authority by emphasizing self-expressionism (*ziwobiaoxian*), although the show becomes controversial for its overt political content, in particular, Wang Keping's wooden sculpture of Mao as Buddha, a comment on the seeming deification of Mao.

Rustic Realism (*Xiangtu xieshi*), a trend of New Realistic Painting which sometimes overlaps with Scar Painting, becomes prominent by year's end. But while the Scars focus on their own experiences of the CR, the Rustics depict the CR's impact on ordinary people in rural and border regions. Chen Danqing's *Tibetan Series* (*Xizang xuhua*), shown in October 1980 at the graduation exhibition (*Zhongyang meiyuan yanjiusheng biyezhan*) of the Central Academy of Fine Arts, Beijing, and Luo Zhongli's *Father* (*Fuqin*) which wins first prize in the Second National Youth Arts Exhibition (*Di'er jie quanguo qingnian meishu zuopinzhan*) in Beijing, are particularly influential examples of Rustic Realism. Some filmmakers of the New Chinese Cinema are influenced by the style

and incorporate its imagery in their work, for instance, Chen Kaige in *Yellow Earth* (1984), and Zhang Yimou in *Red Sorghum* (1987) and *Raise the Red Lantern* (1991), all critically acclaimed in the West.

The liveliest artistic activity occurs in a few unofficial and quasi-official groups that flourish in various parts of China (Beijing, Shenyang, Kunming, Shanghai). These "oil painting research groups" are devoted to the study of European painting traditions, and represent the peak of New Academicism. Meanwhile, the debate over formalism continues in the pages of *Art Monthly* (May issue) with the publication of "Abstract Aesthetic" (*Lun chouxianmei*) by Wu Guanzhong, a French-trained painter of the older generation who argues against the dominant forms of realism in favor of abstraction, or "no subject, just form."

1981
Rustic Painting continues. Several modernist shows open around the country. In March, the First Xi'an Modern Art Exhibition (*Xi'an shoujie xiandai yishuzhan*), in Xi'an, Shanxi Province, causes a sensation and attracts 60,000 viewers. Modern Chinese ink painting is featured in *Hubei Ink Painting* (*Hubei shiren guohua lianzhan*) in Beijing. New Academic Painting is spotlighted in the *Yunnan Ten-Person Painting Exhibition* (*Yunnan shiren huazhan*), featuring works with "exotic" themes such as minority cultures.

1982
Authorities launch the Anti–Spiritual Pollution Campaign in early 1982, intended to counteract western influences that they believe are undermining the Chinese people's commitment to Communism. The campaign, which continues through late 1984, targets humanism in philosophy and literature, and condemns three westernizing trends in art that have appeared since the end of the CR: individualistic values, "art for art's sake," and abstraction.

In September, the Beijing public is introduced to modern American art through an exhibition of works from the Boston Museum of Fine Arts held at the National Gallery. This is the second major and influential exhibition of foreign art since the CR.

1983
As part of the Anti–Spiritual Pollution Campaign, authorities denounce the January issue of *Art Monthly*—which contains articles about abstract art—as a contaminating influence. The editorial team is replaced. Even in this oppressive context, however, officially sanctioned presentations of western art continue. Exhibitions of Italian Renaissance art, the work of Picasso and Munch, and French contemporary oil painting are held in Beijing.

Aesthetic experimentation continues, too, outside of Beijing. In May, the *Five-Person Exhibition of Modern Artists* (*Xiamen wu ren xiandai yishuzuopin zhan*) in Xiamen, Fujian Province, features conceptual works and ready-made objects by artists—including **Huang Yong Ping**—who will later form the Xiamen Dada group. The show never opens to the public. In September, the *Experimental Painting Exhibition: The Stage 1983* (*Basannian jieduan: Huihua shiyan zhanlan*), which includes ten Shanghai artists, is forced to close soon after the opening and is harshly criticized in the *Shanghai Liberation Daily*.

1984
The *Sixth National Art Exhibition* (*Diliujie quanguo meishu zuopin zhanlian*), held in October at the National Gallery, Beijing, resurrects the political themes and propagandist forms of the CR. The retrograde content and style of the exhibition provokes a widespread backlash among artists, especially the young, laying the groundwork for the emergence of the '85 Movement.

1985
A banner year for the Chinese avant-garde. The Anti–Spiritual Pollution Campaign had ended and the government embarks on a series of liberal reforms. Released from the restraints of the previous three years, avant-gardism flourishes across the arts—literature, dance, music, visual art, film—a phenomenon soon to be dubbed the '85 Movement.

In February, the Chinese Writers Association holds its fourth conference in Beijing, denouncing conservatism and calling for freedom of expression (*chuangzuo ziyou*). A parallel development occurs in the visual arts with the widespread appearance of unofficial groups—more than 80 across the country, 1985–87—in which artists of the younger generation debate, write, and exhibit. These groups sponsor some 150 events during 1985–86, involving at least 2,250 artists. Openly antagonistic to official culture, they champion individualism, freedom of expression, and a radical overhaul of aesthetic concepts and forms; they reject both Chinese traditional art and socialist realism, deploying instead western modern and postmodern styles such as Surrealism, Dada, Pop, and conceptual art.

Avant-garde ideas and artists are promoted in new magazines and newspapers such as *Art Trends* (*Meishu Sichao*), *Fine Arts in China* (*Zhongguo Meishu Bao*), and *Painters* (*Huajia*). Established journals such as *Art Monthly* and *Jiangsu Pictorial* (*Jiangsu huakan*) shift attention to the '85 Movement. Many of the publications' editors are young critics who themselves are involved in the avant-garde.

The new groups can be divided roughly into two types, Rationalist (*Lixing huihua*) and Current of Life (*Shengming zhiliu*). Representative of the Rationalists are the North Art Group (*Beifang qunti*), the Pool Society (*Chishe*), and the Red Brigade (*Hongselu*). The North Art

Group, founded in March in Harbin, Heilongjiang Province (the area formerly known as Manchuria), promotes a "Civilization of the North," which its artists—among them, **Wang Guangyi, Shu Qun, Ren Jian,** and Liu Yian—believe will surpass both western and traditional Chinese civilization. Emulating Surrealism, their paintings often feature landscape elements and abstract forms suggested by the glacial terrain of northern China. Members of the Pool Society, based in Hangzhou, Zhejiang Province, are notable for their biting sense of humor and absurdist spirit. Their first exhibition, *New Space '85* (*'85 xin kongjian huazhan*)—which includes **Zhang Peili, Geng Jianyi,** and Wang Qiang—features "gray humor" paintings, performance works, and conceptual art. The Red Brigade, established in 1987 in Nanjing, Jiangsu Province, consists of the principle organizers of the Jiangsu Art Week Modern Art Festival (*Jiangsu qingnian yishu zhou*), an influential exhibition covering all the arts.

Current of Life artists advocate an anti-urban pastoralism or regionalism, along with the exploration of individual desire, which, they argue, has been suppressed by collectivist rationalization. Many are from remote areas, for instance, Gansu Province, where a group of five artists led by **Cao Yong** organizes the exhibition *Research, Discovery, Expression* (*Tansuo, faxian, biaoxian*); or Kunming, Yunnan Province, the base of the Art Group of Southwest China (*Xinan yishu qunti*), which includes **Mao Xuhui,** Pan Dehai, **Zhang Xiaogang,** and Yie Yong Qing. The ad hoc *Shenzhen Zero Exhibition* (*Shenzhen lingzhan*), so-named because it has no funding or institutional framework, is held on the streets of Shenzhen, a Special Economic Zone (SEZ) in South China. The Three Step Studio's (*Sanbu huashi*) first exhibition in Taiyuan City, Shanxi Province, features installations constructed from ordinary tools used by peasants.

Twenty artists from the Central Academy of Fine Arts, Beijing, organize the *November Exhibition* (*Shiyiyue huazhan*), held at the Forbidden City; these artists later form the Beijing Youth Painting Society (*Beijing qingnan huahui*). Other groups of the Current of Life trend include the New Barbarianism (*Xinyiexinzhuyi,* Nanjing), the Miyang Painting Group (*Miyang huahui,* Hebei Province), and the Hunan Zero Art Division (*Hunan ling yishujituan,* Changsha).

Young, academically trained artists begin to play a forward role, in particular the graduates of the Zhejiang Academy of Fine Arts in Hangzhou. **Wang Guangyi, Zhang Peili, Geng Jianyi, Huang Yong Ping, Wenda Gu,** and **Wu Shan Zhuan** are all leading figures in the '85 Movement and all attended the Zhejiang Academy. The exhibition *Young Art of Progressive China* (*Qianjin zhong de Zhongguo qingnian meishu zuopin zhan*), held in May, brings together work from various academies, including Zhejiang, Beijing, and Sichuan. The most remarkable works in this show combine Neorealism and western Surrealism, an approach typified by Zhang Qun and Meng Luding's *Enlightenment of Adam and Eve in the New Age* (*Xinshidai de qishi*).

Traditional styles are challenged by younger artists. In July, art critic Li Xiaoshan publishes "The End and Death of Chinese Painting" (*Zhongguohua daole quntumolu zhiri*) in *Jiangsu Pictorial.* The essay shocks the traditional painting world and inspires fierce debate between members of the old and new generations. In November, **Wenda Gu** and other Chinese ink painters participate in the exhibition *Recent Works of Traditional Chinese Painting* (*Zhongguohua xinzuo yao-qingzhan*) in Wuhan, Hubei Province, updating ink painting by synthesizing traditional Chinese philosophy and western art styles such as Surrealism. This new form is called *scholar painting* (*xuezhe huihua*).

A retrospective of Robert Rauschenberg's work opens in November at the National Gallery, Beijing, and has a profound impact on the artists of the '85 Movement. This is the Chinese public's first opportunity to see original works by a contemporary western artist. Rauschenberg delivers a lecture at the Central Academy of Graphic Art in Beijing and participates in a discussion with the artists of the Anonymous Painting Group (*Wuming huahui*).

1986
Deng Xiaoping is named Man of the Year by *Time* magazine in January. Deng's cover photo is reproduced as a part of a collage with Rauschenberg's work *China.* The artist is quoted: "It is a great beginning in China today, since there has been a kind of new emotion, new spectacle which had not existed three years ago."

The '85 Movement continues to expand, especially the number of conceptual or anti-art (*fanyishu*) groups. The conceptualists challenge not only propagandist art and traditional academic styles, but new schools of art as well. Their principal goal is to eradicate utopianism, subjectivity, and the artist's hand. Their primary mediums are language and readymade objects. Their conceptual sources are Dada and Chan (Zen) Buddhism; the latter, like Dada, attempts to break free of any doctrine or authority.

In January, the *Last Exhibition '86, No. 1* ('*86 zuihou zhanlan yi hao*), opens at the Zhejiang Art Gallery. Organized by seven young artists of the Zhejiang Academy, including **Wenda Gu** and Song Baoguo, it features readymade objects and performance works. The show is closed by authorities three hours after opening because of the sexual content of some of the works. In April, a Tibetan avant-garde group led by Li Yanping exhibits in Beijing People's Cultural Palace. At the same time, **Wu Shan Zhuan** and fellow artists in Hangzhou

hold two private exhibitions of installations entitled *70% Red, 25% Black, and 5% White* (*Hong 50%, hei 25%, bai 5%*).

The largest of exhibitions of avant-garde work opens in August under the title *Festival of Youth Art in Hubei* (*Hubei qingnian meishu jie*) in the cities of Wuhan, Huangshi, Xianggan, Yichang, and Shashi. About 50 small groups participate and some 2,000 works are displayed in 28 exhibition sites. A striking characteristic of the work is a trend toward fusing vernacular culture, including ancient sources and contemporary styles. Concurrent with the exhibition is the first symposium on the '85 Movement and the Chinese avant-garde, held in Zhuhai, Guangdong Province, attended by critics, editors, and artists representing groups nationwide. One outcome of the conference is a decision to organize a national avant-garde exhibition.

The September exhibition of Xiamen Dada (*Xiamen dada xiandai yishu zhan*), a group led by **Huang Yong Ping,** coincides with Huang's publication of "Xiamen Dada: A Kind of Postmodernism?" (*Xiamen Dada: Yizhong houxiandai?*) in *Fine Arts in China,* in which Huang advocates the synthesis of Dada and Chan Buddhism. He also produces a series of roulette wheel–like compositions based on the *Yi Jing,* or *Book of Changes,* which he uses to direct his painting.

Similar events—performances, happenings, installations, mixed-media exhibits—are held throughout the year by diverse groups, including the Xuzhou Modern Art Exhibition (*Xuzhou xiandai yishuzhan*) in Xuzhou, Henan Province, in May; the *Luoyang Modern Art Space* (*Luoyan yishuchang*), Luoyang, Henan Province, in May; *To Bring into the Light* (*Shai taiyang*) in Nanjing in September; and *Convex/Concave* (*Aotuzhan*), which includes the artists **Li Shan** and Wang Ziwei, in

Shanghai, Xuhui District, in November. The Pool Society—including **Zhang Peili, Geng Jianyi,** and Wang Qiang—creates a series called Yangshi *Taichi No. 1* (*Taiji xilie yihao*) on the banks of Xihu Lake and in the streets of Hangzhou. The Southern Artists Salon (*Nanfang yishujia shalong*), founded by **Wang Du, Lin Yilin,** and others in Guangzhou, organize the *First Experimental Exhibition* (*Diyici shiyanzhan*).

In November, the Chinese Modern Art Research Committee (*Zhongguo xiandaiyishu yanjiuhui*), an association of about 30 critics, is founded in Beijing, in part as a planning committee for the nationwide avant-garde exhibition.

Student demonstrations are staged in a number of Chinese cities in late 1986. Authorities respond with a campaign against "bourgeois liberalism," targeting all new political and cultural thought. The campaign continues through mid-1988, significantly hampering the activities of the avant-garde.

1987
A planning meeting for the national avant-garde exhibition is held March 25–26 in Beijing. The show is given the seemingly neutral working title *Nationwide Exhibition of Research and Communication of Young Art Groups* (*Quanguo qingnian yishuqunti xueshu jiaoliuzhan*). Authorities see through the ruse, however, and on April 4 ban all organized scholarly communication among young people. Then, on April 12, a leader of the Chinese Artists Association (*Zhongguo meishujia xiehui*), a government-approved organization directed by the Chinese Communist Party (CCP), approaches the chief organizer of the exhibition with a request to terminate his activities. Plans for a nationwide exhibition are halted. In May, **Wu Shan Zhuan** and colleagues continue a language project begun in 1986 with a new exhibition called *Red Humor* (*Hongse youmo*). Wu himself creates a

related series entitled *Red Characters* (*Chizixilie*). Other group activities continue, even in remote areas, for example, the *Contemporary Art Association Exhibition of Inner Mongolia* (*Neimenggu dangdaiyishu yanjiu hui*) in Huhehot.

But the '85 Movement is weakening under the dual impact of the government-directed antibourgeois campaign and pressures to produce more commercial work, a result of Deng's 1978 economic measures. The CCP reduces financial support for art during this period, suggesting to artists that they find commercial outlets for the sale of their work (a formerly illegal practice). Avant-garde art, however, is not a valuable commodity in China.

Some important artists begin to move overseas. **Wenda Gu**, for instance, has a solo exhibition at York University Art Gallery, Toronto, in August, then settles in New York City.

1988
The campaign against bourgeois liberalism ends, and some avant-garde activities resume or new ones begin in the autumn and winter.

Solo exhibitions of work by **Xu Bing** and Lu Shengzhong open at the National Gallery, Beijing, in October. **Xu Bing**'s installation, *Book from the Sky* (*Tianshu*), consists of books and scrolls fabricated using traditional Chinese printing techniques and paper, and classical typographic styles. The thousands of hand-carved characters, however, were made up by the artist and are completely unintelligible.

In November, the 1988 Chinese Modern Art Convention (*1988 Dangdai yishu yantaohui*) opens in Tunxi, a famous scenic site in Anhui Province. About 100 artists and critics from across China participate. Their goal is to revitalize the avant-garde movement and raise again the prospect of a national exhibition.

1989
After delays due to political circumstances, financial problems, and the forces of conservatism, on February 5 the first nationwide avant-garde art exhibition opens at the National Gallery, Beijing. Entitled *China/Avant-Garde* (*Zhongguo xiandai yishuzhan*), a total of 293 paintings, sculptures, videos, and installations by 186 artists—including **Wang Guangyi, Xu Bing, Wu Shan Zhuan, Huang Yong Ping**, and **Wenda Gu**—are displayed. **Wang**'s *Mao Zedong No. 1* causes a stir, and his Pop Art–influenced style initiates the Political Pop trend of the early 1990s.

China/Avant-Garde is closed twice by authorities during its two-week run. The first closing occurs just hours after the opening, when **Xiao Lu** and her collaborator **Tang Song** transform their installation, *Dialogue*, into a performance by firing two gunshots into it. The second closure results from anonymous bomb threats sent to the gallery, the municipal government, and the Bejing Public Security Bureau.

Gu Dexin, Huang Yong Ping and **Yong Jiechang** participate in *Les Magiciens de la terre*, an exhibition organized by the Pompidou Centre in Paris. This is perhaps the first time Chinese avant-garde artists are shown in a major international exhibit since the end of the CR. **Huang** leaves China to attend the exhibition and remains in France.

Pro-democracy student demonstrations begin in April. Following the June 4 crackdown in Tiananmen Square and the return of conservatism, the national avant-garde exhibition is castigated as a typical example of bourgeois liberalism.

1990
As a result of the post-Tiananmen tightening down, as well as ongoing commercial pressures, idealist avant-garde activity in China declines drastically and never fully recovers. Art publications suffer as well. In January, *Fine Arts in China*, which played an important role in the avant-garde movement, is closed by authorities. In September, the most popular art journal, *Art Monthly*, which had devoted considerable attention to the '85 Movement, is restaffed with conservatives. One of its editors, Gao Minglu, is ordered to stop all editorial work and spend time at home studying Marxism.

Pockets of avant-gardism remain in the Academy, characterized by a discreet eclecticism combining progressive and conservative forms. Liu Xiaodong, for example, a young teacher at the Central Academy of Fine Arts, Beijing, holds a solo exhibition of oil painting in May. Considered one of the New Generation painters, Liu's work is typical of 1990s Cynicism or Cynical Realism (*Wanshi xianshizhuyi*). Proponents of this sensibility often engage in self-mockery or present the most mundane aspects of everyday life in which they appear to have lost all faith. Another academic exhibition, *The World of Women Painters* (*Nü huajia de shijie*), showcases eight artists—Yu Hong, Jiang Xueying, Wei Rong, Liu Liping, Yu Chen, Chen Shuxia, Li Chen, and Ning Fangqian—widely accepted as the new generation of Chinese women artists.

Xu Bing completes his installation project, *Ghosts Pounding the Wall* (*Guidaqiang*), a series of rubbings from the Jinshanling section of the Great Wall in Hebei Province. The work was two years in the making, and involved more than 100 assistants, 1,500 pieces of paper, and 300 bottles of ink. The combined rubbings total 1,500 meters. After this project, **Xu Bing** moves to the United States.

More and more Chinese avant-garde artists leave for friendlier climes, or at least shift their sights to international venues. In fact, even as outlets for their work dwindle at home, international audiences are receptive to their work, and an increasing number of exhibitions feature Chinese avant-garde artists. For instance, *Chine: Demain pour hier*, sponsored by the French Ministry of Culture and held in Pourrières in July, is curated by Chinese art critic Fei Dawei. It is reported to be the largest exhibition of modern Chinese art ever mounted in a western country. Participating artists include **Chen Zhen, Wenda Gu, Huang Yong Ping, Cai Guo-qiang**, Yang Jiecang, and Yan Pei Ming.

1991
In January, *"I Don't Want to Play Cards with Cézanne" and Other Works: Selections from the Chinese "New Wave" and "Avant-Garde" Art of the Eighties* is held in the Pacific Asia Museum in Pasadena, California. Participating artists include **Geng Jianyi**, He Duoling, Li Luming, Lu Shengzhong, **Mao Xuhui, Xu Bing**, Yu Hong, Zeng Xiaofeng, **Zhang Peili, Zhang Xiaogang**, Ye Yongqing, Zhou Changjiang, and others. A series of lectures and discussions accompany the exhibition.

The Exceptional Passage, another show of Chinese avant-garde art, opens at the Fukuoka Museum in Japan. It includes **Wenda Gu's** *Vanishing 36 Pigment Golden Sections* (*Sanshiliuge huangjin fengelü*), **Huang Yong Ping's** *Emergency Exit* (*Feichangkou*), and works by **Cai Guo-qiang**, Yang Jiecang, and **Wang Luyan**.

In China, artists and critics try to break free of political censorship. The symposium Artistic Creation in the New Period (*Xinshiqi yishuchuangzuo yantiaohui*), held in Xishan, a suburb of Beijing, focuses on contemporary Chinese art and includes such prominent artists and critics as Shui Tianzhong, Liu Xiaochun, Gao Minglu, Li Xianting, Shao Dazhen, and Yi Ying, among others. The symposium is criticized by the conservative-controlled *Art Monthly*.

The New Generation (*Xin shengdai yishuzhan*) opens in July at

Beijing's Museum of Chinese History, a group show of New Generation academic artists, including **Wang Jinsong, Song Yonghong,** and **Liu Wei,** exemplars of the Cynical Realist trend. In December, an exhibition of installation works by Feng Mengbo and Zhang Bo at Beijing Contemporary Art Gallery is closed by authorities. This is the first public installation show since the Tiananmen Square incident of 1989.

1992
A few small-scale avant-garde shows are organized in various cities. The Beijing Art Museum sponsors an exhibit of works by **Liu Wei** and **Fang Lijun.** In May, **Zhang Peili** and **Geng Jianyi** mount an installation and video show at the Diplomat's Hotel, sponsored by the culture section of the Italian Embassy in Beijing. "Pop-Abstract" art is the theme of *A Documentary Exhibition of Contemporary Chinese Art* (*Zhongguo dangdai yishu wenxianzhan*), held in Guangzhou, a slide/photo presentation with commentaries by art critics. *Young Contemporary Sculptors* (*Dangdai qingnian diaosujia*), held at Zhejiang Academy of Fine Arts in Hangzhou, is the first exhibition organized by and for the new generation of sculptors, and includes Zhan Wang and Sui Jianguo.

The first nationwide avant-garde exhibition since the Tiananmen Incident, *Guangzhou First Oil Painting Biennial* (*Guangzhou diyijie youhua shuangnianzhan*), opens in Guangzhou in November. The show is developed under official policies urging economic expansion; an ideal (and naive) goal of the exhibition's organizers is to increase the value of Chinese avant-garde art in both domestic and international markets.
The work of some artists in the Guangzhou Biennial—**Wang Guangyi,** among them—exemplifies Political Pop (*Zhengzhi popu*), a dominant artistic trend in China after Tiananmen, and not especially popular with authorities.

Practitioners combine socialist realist or CR imagery with the irreverent sensibility of American Pop Art. Political Pop and Cynical Realist works are in demand on the international exhibition circuit throughout the early 1990s.

1993
The Chinese avant-garde begins producing work that takes as its subject the problems of consumerism and materialism, increasingly evident in Chinese culture under the impact of a globalized economy. This critique is prominent in the work of the New History Group (*Xinlishi xiaozu*), led by **Ren Jian,** and the Long-tailed Elephant Group (*Daweixiang*), which includes **Lin Yilin, Chen Shaoxiong, Xu Tan,** and **Liang Juhui.**

The New History Group organizes a multimedia event entitled *Mass Consumption* (*Daxiaofei*), which is to include rock music, painting, and a fashion show, scheduled to take place at the new McDonald's restaurant in Beijing on April 28. The work reflects a transition from a focus on the art object to the production process. At midnight on April 27, however, the event is prohibited by the Beijing Public Security Bureau. In November, the Long-tailed Elephant Group produces a series of installations in the Red Ants Bar (*Hongmayi jiuba*) in Guangzhou.

International interest in Chinese avant-garde art heats up, for both ideological and commercial reasons. *China's New Art, Post-1989* opens at the Hong Kong Arts Centre in January, then travels to Australia. The exhibition includes more than 200 works by some 50 artists, including paintings, sculptures, and installations, predominantly of the Political Pop and Cynical Realist stripe.

China's New Art boosts the international cachet of Chinese avant-gardism. In June, thirteen artists from this show—**Wang Guangyi, Zhang Peili, Geng Jianyi, Xu Bing,**

Liu Wei, Fang Lijun, Yu Hong, Feng Mengbo, **Li Shan,** Yu Youhan, Wang Ziwei, Sun Liang, and Song Haidong—are invited to participate in the 45th Venice Biennale. In July, works by **Wenda Gu, Huang Yong Ping, Wu Shan Zhuan,** and **Xu Bing** are showcased in *Fragmented Memory: The Chinese Avant-Garde in Exile,* held at the Wexner Center for the Arts, Columbus, Ohio.

1994
Lack of government support and declining public interest forces avant-garde artists to find alternative venues for exhibiting their work: books, magazines, private homes, less populated rural areas. For instance, artists Zeng Xiaojun, Ai Weiwei, **Xu Bing,** and art critic Feng Boyi fund the publication of *Black Book* (*Heipishu*), a parody of *Red Flag* (*Hongqi*), the official organ of the CCP.

In Shanghai, a new generation of installation artists exhibits in *The Stage 1994* (*1994 Jieduanzhan*), held at Huashan Art School in May. The *Third Exhibition of Chinese Contemporary Art Documents* (*Disanjie zhongguo dangdai yishu wenxian [zisiao] zhan*), held at the library of East China Normal University in Shanghai, consists mainly of slides and videos showing installation and performance works. A similar presentation, *Installation: Location of Language* (*Zhuangzhi: Fangwei yuyan*), continues into 1995.

A number of performances and installations are held in private spaces, a phenomenon dubbed Apartment Art (*Gongyu yishu*). **Ma Liuming,** Zhu Min, and other young artists stage performances in a private space in the East Village (a suburb of Beijing). It is reported that they are arrested because of the work's erotic content, then forced to move. In September, Berlin-based Chinese artist Zhu Jinshi organizes a series of activities under the title *Eye Ear* (*Yaner*) in his own apartment in Beijing. Similarly, **Wang Gongxin** and **Lin**

Tian-miao mount installations in their apartment, open only to the art community.

Only one academic institution, Capital Normal University in Beijing, provides space for the public exhibition of avant-garde art. The *Com-Art Show: China, Korea, and Japan '94,* organized around the theme "Today Is the Dream of the Orient" (*Jinri shi dongfangzhimeng*), presents modern paintings and installation works. The Chinese artists include **Wang Luyan,** Wang Jianwei, **Song Dong,** Li Yongbin, **Wang Guangyi,** Wei Guangqing, Wang Yousheng, and **Gu Dexin.**

In October, Political Pop artists **Li Shan,** Yu Youhan, **Wang Guangyi, Liu Wei, Fang Lijun,** and **Zhang Xiaogang** participate in the 22nd International São Paulo Bienal. It is reported that the content of the works, especially images of Mao, spurs protest among Chinese in Brazil.

1995–1997
In the aftermath of the Cold War, Chinese avant-garde artists have developed a high profile in international art circles but are virtually ignored at home. For international art institutions, the Chinese avant-garde signifies an important underground voice in one of the few remaining Communist countries. On the other hand, China's rapid entrance into the global economy has catapulted Chinese art into the international art market.

In China, however, some artists continue to seek out alternative exhibition spaces. For example, Sui Jianguo, Zhan Wang, and Yu Fan install works in a demolished area of Beijing, while Feng Boyi uses a private space in the eastern suburbs of Beijing for a group show of installation and performance work. The principal viewers of Feng's exhibition are peasant residents of the suburb.

Capital Normal University continues to support avant-garde work

by providing public exhibition space. It sponsors a series of one-person exhibitions under the title *Individual Method* (*Geren fangshi*), featuring installation works by Zhu Jinshi, **Song Dong**, and **Yin Xiuzhen**. In December, the university organizes *Beijing—Berlin Art Exchange* (*Beijing–Bolin yishu jiaoliuzhan*) in which eight Chinese artists participate.

Reality, Today and Tomorrow: An Exhibition of Contemporary

Chinese Art (*Xianshi, jintian yu mingtian*), held in Beijing in 1996, features recent painting, sculpture, installation work, and video by the new generation of artists, including **Fang Lijun**, Zhao Bandi, Zhan Wang, Sui Jianguo, **Song Dong, Wang Jin**, and Sun Liang. The exhibition is organized by a new generation of art critics, Leng Lin, Feng Boyi, Qian Zhijian, Zhang Xiaojun, and Gao Ling. In December 1996, however, the large-scale *Invitation Exhibition of*

Contemporary Chinese Art (*Zhongguo dangdai yishu yaoqingzhan*) is canceled on opening day for reasons unknown.

Meanwhile, the international circulation of Chinese avant-gardism expands geographically to include all Asian and European art capitals, as well as major US museums. Exhibitions include *Avantguardes artístiques xinese* (Centre d'Art Santa Mònica, Barcelona, 1995); *China:*

Zeitgenössische Malerei (Kunstmuseums Bonn, 1996); *Quotation Marks* (Singapore Art Museum, 1997), *Against the Tide* (Bronx Museum of the Arts, New York, 1997); *Cities on the Move* (Vienna Secession, 1997).

Compiled by Gao Minglu, with contributions by Qian Zhijian.

TAIWAN

1971

Taiwan loses the China seat at the United Nations, and embarks on a campaign of economic and social development accompanied by increasing political liberalization. This bid for self-sufficiency, along with the loosening of ties to Taiwan's Cold War supporters, sets the stage for gradual political liberalization, widespread disenchantment with western notions of progress and development, and a search for an authentic Taiwanese identity.

1975

Yen Chia-kan assumes the presidency after Chiang Kai-shek's death. Premier Chiang Ching-kuo, son of Chiang Kai-shek, announces the objectives of the Six-Year Plan for National Economic Development. Taiwan enters its first period of Nativist (*Xiangtu*) consciousness, in which the Taiwanese—Han Chinese who predate the migrations of Nationalist Chinese (*Kuomintang,* or KMT) from the Mainland after the Communist takeover in 1949 as well as indigenous peoples—begin to demand economic and political rights.

This social-political movement is accompanied by a Nativist movement in literature and art that

advocates both an exploration of Taiwan's indigenous cultures and an attack on the Taiwanese tendency to accept all things western. Nativism/*Xiangtu* defines Taiwan's identity as anti-modernist and anti-western, a rejection of the cultural traditions of modernism introduced first by Japan during its colonial occupation (1895–1945) and then by the United States Information Service (USIS) in Taipei. Criticized by some as nostalgic and provincial, the *Xiangtu* movement is also credited with generating a new sensitivity to the environment and the dangers of unchecked modernization. *Xiangtu* artists—influenced by the literary output of grassroots writers as well as American photorealism—turn to nature, rustic subject matter, and Taiwanese folk culture for inspiration, producing romanticized images of rural life in a hyperrealist style. Chou You-rui's series, Banana (*Xiangjiao lianzo*), exhibited at the USIS, is representative of the new aesthetic and receives critical acclaim as a groundbreaking synthesis of Photorealism and *Xiangtu*.

Lion Art (*Xiongshi Meishu*), a monthly journal of art and culture, shifts its focus from traditional Chinese to native Taiwanese art.

Artist magazine (*Yishujia/I shu chia*) is founded and publishes a series of articles by Hsieh Li-fa entitled "The Taiwanese Art Movement during the Japanese Occupation." The KMT's efforts to "sinicize" Taiwanese culture included suppressing Taiwanese artists educated under the Japanese and promoting traditionalist Mainland artists who had migrated with the Nationalists. Hsieh's articles are notable as the first art-historical scholarship to discuss this virtually forgotten generation, and to focus on native Taiwanese rather than traditional Chinese artists.

1976

Taiwan Political Forum (*Taiwan zhengzhi luntan*) is forcibly shut down, its registration license revoked by the Supreme Military Court. A new journal championing native Taiwan, *Summer Tide Forum* (*Xiari xinchao luntan*) quickly fills the void.

Taipei's mayor orders a feasibility study on building a modern art museum in Mu-ja. The market for contemporary art is practically nonexistent and will remain so until the mid-1980s, although a few private galleries open. Grassroots realism and Photo-

realism become the dominant styles in art academies. Solo exhibitions of self-taught painter Hung T'ung at the USIS and sculptor Ju Ming at Taipei's National History Museum are popular with critics and the public; the native background of the two artists, reflected in their work, further enhances the status of the *Xiangtu* movement. Hung T'ung's paintings, inspired by Taiwanese folk art and noted for their brilliant color and use of pictographic symbols, will influence a second wave of Nativist sensibility (*Bentu*) in the late 1980s and '90s.

Artist Liao Chi-ch'un dies. As mentor to the Fifth Moon Painting Group (*Wuyue*, prominent during the 1950s and '60s), Liao had advocated the adoption of western modernism—i.e., Abstract Expressionism and other forms of abstraction—and condemned traditional Chinese art.

1977

Taipei municipal government designates Yuan-shan Number 2 Park for the Taipei Fine Arts Museum. Formerly the site of the country's diplomatic hotel, the selection represents a symbolic gesture conferring government legitimacy on Taiwanese art. Guotai Art

Museum, Taiwan's first private museum, opens in Taipei.

The literary world debates the significance of Nativist writing. *Lion Art* advocates Nativist art and delineates its central characteristics with special issues entitled "Concern for Our Environment" (*Guanhuai ziji zhouzao de huanjing*) and "Form-making and Locale" (*Fengtu yu zaoxing*). *Artist* introduces the work of Chinese artists living abroad, for instance, Photorealist painter Yao Ching-chang (Taiwan-born) and Zao Wou-ki (Mainland-born). Their success in achieving international fame becomes a blueprint for younger Taiwanese artists.

1978
US president Jimmy Carter announces the establishment of formal ties with the People's Republic of China and ends the Sino-American Mutual Defense Treaty. Chiang Ching-kuo becomes president and declares a state of emergency, canceling all elections and ordering all military units to assume positions for national defense.

Xiangtu sensibility—embodied in the slogan "Humanism, Nationalism, Realism" (*Rendaode, minzude, xianshide*)—still dominates the art world, but Taiwanese artists educated abroad begin introducing ideas from the New York contemporary scene about new forms such as earthworks and performance art. Hsieh Li-fa's series on Taiwanese art before 1949 is published as a monograph (see bibliography). The exhibition *Twentieth-Century Spanish Masters* (*Xibanya mingja huazhan*) opens at the Guotai Art Museum and is popular with the public.

1979
The US breaks all formal diplomatic ties with the Kuomintang's Republic of China on Taiwan (Taiwan), and transfers diplomatic recognition to the People's Republic of China (PRC). *Formosa Magazine* (*Meili Dao*) is founded

as the voice of progressive, anti-KMT politics. A rally sponsored by the magazine at Kao-hsiung sparks the Formosa Incident, a confrontation with authorities in which a hundred police officers are injured. In response, the government closes the magazine and arrests its staff and supporters.

Meanwhile, the art world redirects its attention from politics to the commercial gallery market. The work of performance artist Hsieh Te-ching provokes a controversy over whether such work constitutes a valid art form. Li Chung-sheng, mentor to the Eastern Painting Group (Dongfang/Tong fan) and supporter of western-inspired modernism, has his first and only solo exhibition at the Dragon Gate Gallery. The status of Taiwanese native artists of older generations gradually improves. A revival of Kunqu, the classical theater and music of Taiwan, is launched by Kuo Shio-juang.

1980
The family of lawyer Lin Yi-hsiung, a defendant in the Formosa Incident, is attacked while at home; two of Liu's three daughters are murdered. The case dominates the media. Taiwan announces its withdrawal from the International Monetary Fund. Sin-chu Science and Industrial Park opens, a government-sponsored site for high-technology industries and research. The national per capita income in Taiwan reaches US$2,312. The Academia Sinica sponsors the First International Sinology Conference in Taipei. The Taiwan University archaeology team discovers the Neolithic site Bai Nan.

Taiwan's art world expands in step with its booming economy and budding international profile as a modernized society. Many art groups form during the early 1980s, promoting experimentation and avant-garde forms from abroad; their potential will not be fully realized until after the end of martial law in 1987. Government

revenue and private money is devoted to the arts, including the building of an institutional infrastructure—cultural centers in each county and municipality, art museums, private galleries—all of which translates into more frequent exhibitions and a broadening market for art objects.

Nativist activism continues. Newspapers advocate a "return to the native soil" (*huigui bentu*). Artists and cultural workers from central, southern, and eastern Taiwan—in other words, outside the official art world of Taipei in northern Taiwan—organize exhibitions of ink and oil painting, ceramics, and other local crafts, emphasizing vernacular idioms and subject matter. Modernist art makes a comeback, encouraged by government largesse, the institutional demand for art to exhibit, and scholarly as well as popular interest in reconstructing Taiwan's cultural history. These circumstances entice many Taiwanese artists of the 1950s and '60s modernist movement—i.e., the Eastern and Fifth Moon painting groups—who had subsequently left, to return to Taiwan.

The First International Art Festival (*Diyijie guoji yishujie*), sponsored by private entities, is held in eleven cities and counties and features more than 500 artists from fifteen countries. Hsiao Chin, an abstract artist living in Milan, and Hsia Yang and Han Hsiang-ning, photorealists living in New York City, return to Taiwan for symposium talks.

1981
The Taiwan University archaeology team discovers the Neolithic site Chih-shan Yen near Taipei.

Zao Wou-ki's first visit to Taiwan electrifies the art community. Conceptual artist Chung Pu returns from abroad; installation and mixed-media work become popular among younger artists. Influential artist Hsi Te-chin dies; a watercolorist, Hsi was the first to combine modernist and native idioms,

and documented Taiwanese native architecture in a book of photography. An exhibition of work by the Fifth Moon and the Eastern painting groups is held on the twenty-fifth anniversary of their founding. The Cloud Gate Dance Company, Taiwan's first modern dance group, tours Europe.

1982
US-Taiwan trade talks are held in Taipei. The Industrial Development Bureau of the Ministry of Economic Affairs announces a plan to develop high-tech information industries.

The National Art Academy is formally established and admits its first class of students. The mayor of Tainan organizes the *Exhibition of One Thousand Artists of Taiwan* (*Zhonghuaminguo qianren zhanlan*), an event deemed the first official endorsement of the Taiwanese art world. The 101 Contemporary Artists Group (*101 Xiandai yishuqun*) is founded by Lu Tian-yan, **Wu Tien-chang**, Yang Mao-lin, and Yeh Tzu-chi (the last-named eventually emigrates abroad). All are Taiwan-born, graduate from the same art program, and advocate a grassroots sensibility.

The artist Lin Shou-yu returns from Britain and introduces a younger generation of Taiwanese artists to Minimalism, inspiring a new interest in contemporary idioms. *Lion Art* publishes special issues on Mainland Chinese art, and begins reporting news related to current developments in the Mainland art world.

1983
Taipei Fine Arts Museum (TFAM) opens, Taiwan's first museum of modern art. The death of Chang Dai-chen, a traditionalist painter who moved to Taiwan with the KMT in 1949, prompts interest in this generation of artists. The Council for Cultural Planning and Development (CCPD; *Wenjianhui*) organizes the First International Biennial Print Exhibition in Taipei, with 1,140 participants from 49 countries.

Taiwan's film industry is energized by a new generation of directors, including Yang Te-chang, Wu Nien-cheng, Ko Yi-cheng, Jen Juan-hsiang, and Chang Yi. Hou Hsiao-hsien's films, notable for their Nativist sensibility, achieve international acclaim.

1984

Chiang Ching-kuo continues his presidency with a new vice-president, Lee Teng-hui. The *Summer Tide Forum* publishes an article on Taiwan's relationship to the PRC, stimulating debate on the issues of unification and independence.

The magazine *Taiwanese Art and Literature* discusses the current "Nativization" of literature, and the literary community enters the climactic phase of the Nativist movement. A freighter en route from Kao-hsiung to Peng-hu accidentally explodes and sinks, taking with it all 450 artworks for the *38th Provincial Exhibition* (*Disanshibajie quan sheng meizhan*). The artists **Tsong Pu** and Chen Hsing-wan are awarded grand prize at *Contemporary Art Trends in Taiwan* (*Shoujie xian dai huihua xiuzhan wang*), an exhibition held at TFAM. The Taipei Painting Group (*Taibei huapai*) is established by graduates of Chinese Culture University, advocating an art that reflects political and social reality; its members include **Wu Tien-chang** and Lu Tian-yan.

Li Chung-sheng, mentor to the Eastern Painting Group, dies. The CCPD organizes the International Seminar on Chinese Calligraphy (*Zhongguo shufang guoji yantao-hui*).

1985

The Foreign Reserve branch of Taipei's central bank surpasses the US$2 billion mark, and the average per capita income rises to US$3,144. Taiwan's economic boom attracts worldwide attention.

Over a thousand art events are documented for the year. The formation of many young artists'

groups reflects the pluralism of Taiwan's art scene and the broad range of concerns addressed by artists, among them, environmental devastation. The Third Wave Artists Association (*Disanpo huahui*) organizes the exhibition *Rescuing Our Homeland from Pollution* (*Wuran: Guanxin wom-ende jiayuan*) at Taiwan University, and 101 Contemporary Artists Group launches a series of exhibitions entitled *Protecting the Environment* (*Huanbao zhan*).

Lee Tsai-chien's star-shaped red sculpture, *Minimal Infinite* (*Dixiande wuxian*), scheduled for exhibition at TFAM, causes concern among museum personnel that the piece will be misconstrued as a Communist red star. Controversy ensues when the museum director has the sculpture painted gray without Lee's permission, raising issues of freedom of expression.

1986

The 200 members of the non–KMT affiliated Dangwai organize the May 19 Green Movement in Wan-hua, demanding the abolition of martial law (instituted in 1949). The Democratic Progressive Party (DPP) is established, becoming Taiwan's first official opposition party. Concern for the environment prompts a demonstration among the people of Lu-kang, protesting the opening of a local factory by the American Du Pont Corporation.

The Studio of Contemporary Art (*Xiandai yishu gongzuoshi*) is founded by artist June Lai, who soon becomes a pivotal figure for younger artists. The establishment of the Southern Taiwanese Art Association (*Nan Taiwan yishu fengge huahui*) reflects growing confidence among artists in the south in relation to the official art world of Taipei. The National Academy of Art establishes a center for traditional art. The Cultural Ministry sponsors the exhibition *Art China*, a title that raises controversy over who and/or what can be defined as Chinese or Taiwanese.

The First International Ceramic Biennial in Taiwan (*Zhonghua-minguo diyijie taoyi shuangnian zhan*) opens at Taipei's National History Museum. The first solo exhibition of self-taught Chinese ink painter Yu Cheng-yao (at the age of 88) is received with great fanfare by the media and art world.

1987

Martial law is ended. The KMT lifts restrictions on the news media, and permits citizens to visit relatives on the Mainland. Thirty-one community organizations join a demonstration to protest the traffic in child prostitutes. Forty-one organizations form the Association to Promote the February 28 Day of Peace, referring to the Nationalist/KMT suppression of a local uprising on February 28, 1947, in which some 20,000 Taiwanese died. Academics and legislators draft *A Manifesto on the Rights of Workers*. Political pluralism, reflected in myriad political factions based in local cultures, generates a second wave of Nativist consciousness, *Bentu/Pent'u,* which, like the earlier *Xiangtu* Nativism, focuses on defining "Taiwaneseness," but within an urban, modernist construct.

Many artists and cultural groups support these social movements, and the lifting of martial law unleashes a long-simmering critique of Taiwan's social and political order. Artists such as Yang Mao-lin, Kuo Wei-kuo, **Wu Tien-chang**, and Lu Hsien-ming aim pointed visual barbs at the country's political strongmen, and attack the pervasive materialism. Western Neo-Expressionism is recast in Nativist/*Bentu* terms by **Wu Tien-chang** and **Hou Chun-ming**, among others, who combine painterly subjectivism with signs and symbols drawn from folk culture and traditional mythology.

This groundswell of political activism is accompanied by a mutual desire among Mainlanders

and Taiwanese to learn and understand each other's history and culture. In the art world, works by Mainland Chinese artists, promoted by commercial galleries, gradually gain the attention of Taiwanese collectors. The exhibition *Chinese Modern Ink Painting* (*Zhongguo xiandai shuimo zhan*), featuring Mainland Chinese artists and held at Dragon Gate Gallery in Taipei, moves to Sun Yat-sen Memorial Hall, a government institution.

The Executive Yuan authorizes the establishment of the Public Foundation for Art and Architecture (*Gongzhong jianzhuyishu jijinhui*). Nur Sculpture Garden in Pu-li opens, the first of its kind in Taiwan. Hung T'ung dies.

1988

The Labor Union and some twenty other labor groups stage a massive demonstration on May 1. More than 4,000 southern farmers lead a demonstration for farmer's rights; northern farmers join forces in Taipei, leading to a bloody encounter with the police, known as the May 20 Conflict. Some 1,400 members of aboriginal groups gather in Taipei on August 25 to demand the return of their homeland by the government.

Postmodernism takes Taiwan by storm, including lively discussions in the art press. Victoria Y. Lu's "Phenomena of Postmodern Art," published in *Artist,* is particularly influential, along with western writings on postmodernism translated into Chinese. Christo and postmodern American architect Charles Moore arrive in Taipei for exhibitions at TFAM. The museum also organizes the *International Dada Exhibition* (*Dadade shijie*), featuring works by Duchamp and Man Ray, among others.

Artist Magazine and Mainland journal *Fine Arts in China* (*Zhongguo Meishu Bao*) begin editorial exchanges, contributing to wider attempts to develop institutional linkages between the

Mainland and Taiwan. The Provincial Art Museum opens in Tai-chung.

1989
The Ministry of Justice imposes a temporary ban on private contracts between citizens of Taiwan and the PRC. The founder of the journal *Free Era*, Cheng Nan-jung, is accused of treason and resists arrest by self-immolation. The number of domestic stock listings breaks 3 million.

Members of the Stars, a coalition of avant-garde artists from Mainland China, exhibit in Hanart Gallery's *Stars: Ten Years*. A retrospective of Lin Fengmian (Li Fengmin), a leader of China's modernist art movement in the early 20th century, opens at the National History Museum, Taipei. Books and articles about Taiwanese art are published on the Mainland, including a special issue on Taiwan's art scene in *Art Monthly* (*Meishu*), a supporter of avant-garde ideas on the Mainland. *Lion Art* and *Fine Arts in China* begin editorial exchanges.

Alternative exhibition spaces become the primary venues for showing the work of emerging conceptual artists, many returning from education abroad. Up Gallery in the south, Space 2 (*Erhao gongyu*, founded by Hsiao Tai-hsin), and IT Park (*I-Tong/Gongyuan*, established by photographer Liu Ching-tang in 1990) are the most significant. Their goal is to challenge the commanding role and materialist values of official art institutions and the commercial gallery system, as well as the near-exclusive identification of the art world with northern Taiwan/Taipei. Members of Space 2 include **Huang Chih-yang**, **Hou Chun-ming**, Hung Men-ling, and Lien Teh-cheng. IT Park artists—noted for their satirical commentary on contemporary politics in Taiwan and influenced by Pop, Dada, and Arte Povera—include **Chu Chiahua**, **Chen Hui-chiao**, Chen Kai-huang, **Chen Shun-chu**, Ku Shih-yung, Lu Ming-teh, and **Tsong Pu**.

Modern Sculpture in Taiwan (*Zhonghuaminguo xiandai diao-suzhan*) and an exhibition of the Taipei Painting Group open at TFAM. Media attention centers on **Wu Tien-chang's** *Five Periods of Chiang Ching-kuo* (*Jiang Jingguo de wuge shidai*), a series of large satiric paintings of the late president symbolizing the five stages of freedom of expression in Taiwan since 1975; and Yang Mao-lin's *Made in Taiwan* (*Taiwan zhizao*), a four-part work on Taiwan's boom economy and glorification of western values.

1990
Lee Teng-hui becomes the first Taiwanese-born president. The National Unification Committee and the Foundation for Cross-Straits Relations are established. Students demonstrate for democratic reform in Chiang Kai-shek Memorial Square, leading to a national affairs conference to advance constitutional reform. The Taiwanese stock market drops 3,000 points, causing turmoil in the financial markets.

The pluralism of the 1980s continues into the '90s. Feminist **Wu Mali** along with Peng Hui-rong, Lien Teh-cheng, Lee Ming-sheng, and **Hou Chun-ming** form the avant-garde group Taiwan Archives Workshop (*Taiwan danganshi*). Their first exhibition, entitled *A Celebration of President Lee Teng-hui's Inauguration*, is critical of the conservative political culture fostered by the KMT. Reflecting the importance of gender as an identity issue in the 1990s, the Women's Awareness Association (*Funu xinzhi*) sponsors Women's Art Week (*Nuxing yishuzhou*), an exhibition and symposium organized by art critic Victoria Y. Lu at Eslite Center. The CCPD organizes *Environment and Art* (*Huanjing yu yishu yantaohui*), a symposium held at the National Library. *Han Mo*, a journal on Chinese brush art,

begins publication; its appearance coincides with an interest among some artists, among them **Huang Chih-yang** and **Yuan Jai**, in updating traditional Chinese techniques.

Interest in reconstructing Taiwan's native art history continues. *Taiwan Art: 300 Years* (*Taiwan meishu sanbainian*) opens at the Provincial Art Museum in Tai-chung. *A Retrospective of Western-Influenced Art in Taiwan, 1895–1945* (*Taiwan zaoqi xiyiang meishu huiqu zhan, 1895–1945*) opens at TFAM. Art historian Wang Hsiu-hsiung criticizes this generation of artists as old-fashioned and dominated by Japanese-style modernism in a paper (see bibliography) delivered at the symposium *China, Modernity, Art* (*Zhongguo, xiandai, meishu*), held in conjunction with the exhibition; his lecture generates furious debate in the audience.

The CCPD invites artists, scholars, administrators, and representatives of art groups to form the First National Cultural Assembly (*Diyijie quanguo wenhua huiyi*). The Association of Museums in Taiwan (*Zhonghuaminguo bowuguan xue-hui*) is founded.

1991
The Executive Yuan establishes the Research Committee on the February 28 Incident. The DPP adopts Taiwanese independence as its central doctrine. Senior legislators retire, ending the so-called silver-haired era of Taiwan's National Assembly.

The literary and art communities form the United Front of Intellectuals Against Political Repression (*Zhishijie fanzhengzhi lianmeng*). Works by members of the Space 2 collective are damaged in an accidental fire at the gallery. *China Times* sponsors *The Fantastic World of Mirò* (*Milo de menghuan shijie*) at TFAM. *Taipei–New York: Encountering Modernism* (*Taipei–New York: Xiandaiyishu de yuhe*) is held at

TFAM. Art Critic Ni Tsai-chin publishes a series of articles in *Lion Art* (see bibliography), refining and endorsing the notion of Nativism/*Bentu;* the series generates fierce debate.

CCPD organizes the symposium *Artistic Trends in Taiwan* (*Zhonghuaminguo meishu sichao yantaohui*) for TFAM, and opens the Chinese Information and Culture Center in New York with exhibition and performance spaces. The National Gallery in Washington, D.C., and the National Palace Museum in Taipei arrange a US tour of eighteen Ming dynasty treasures, the first time in fifty years that works from the museum's collection have left Taiwan.

1992
The Committee to Erect a February 28 Memorial is formally established.

Legislation for the Arts and Culture Award is passed. The Art Gallery Association of Taiwan (*Zhonghuaminguo halang xiehui*) is founded and charged with organizing Taipei's first International Art Fair (*Zhonghuaminguo hualang bolanhui*). Taiwanese art critics curate a series of exhibitions on avant-garde art: Victoria Y. Lu organizes *New Art, New Tribes: Taiwan Art in the Nineties* (*Taiwan '90: Xinguannian zuqun*) at Hanart Gallery, Taipei; Chen Kai-heng, *Exile and Banishment* (*Liuwang yu fangzhu*) at Up Gallery and Kao Kao Gallery (Tainan); and Huang Hai-ming, *Dis/Continuity: Religion–Shamanism–Nature* (*Yanxu yu duanlie: Zongjiao, wushu, ziran*), accompanying the conference Eastern Aesthetics and Modern Art (*Dongfang meixue yu xiandai meishu yantaohui*) at TFAM. *The First Taipei Biennial of Contemporary Art* (*Diyijie Taibei xiandai meishu shuangnian zhan*) is held at TFAM. Participating artists include Huang Hai-yun, Ku Shih-yung, Lien Teh-cheng, Lu Hsien-ming, Margaret Shiu Tan, and **Tsong Pu**, all of whom are selected for awards.

The government encourages the export of Taiwan art, and Taiwanese artists increasingly appear in international exhibitions. Chou Pang-ling, Ho Huai-shuo, Huang Chin-ho, Kuo Jen-chang, Grace Yang-tze Tong, **Wu Tien-chang**, and Yu Peng participate in *K-18: Encountering the Other*, an exhibition in Kassel, Germany.

1993
Taiwan's foreign reserve reaches US$8.31 billion, ranked highest in the world.

Taiwanese artist Lee Ming-sheng is invited to participate in the 45th Venice Biennale. *Taiwan Art, 1945–1993* (*Taiwan meishu xin-fengmao*) opens at TFAM; critics object to the conservative taste of the curatorial staff as evidenced by the selection of works. *Artist* magazine begins a special monthly column on feminist/women's art issues. Artist/art historian Lin Hsin-yueh curates *Toward the Zenith: Taiwan Contemporary Art* (*Maixiang dianfeng: Taiwan xiandai meishu dazhan*), inviting 55 artists to show large-scale works at Ji-chan 50 Art Space in Kao-hsiung. *Culture and Identity: Art from Austria* (*Wenhua yu ren-tong: Aozhou dangdai yishu zhan*) opens at TFAM to positive response and elicits much discussion on identity issues and nationalism.

1994
Taiwan holds its first democratic elections for provincial governor and the mayors of Taipei and Kao-hsiung. Expanded political activism on the grassroots level leads to the promotion of community cultural development projects by various townships and villages.

The avant-garde group Space 2 disbands. *Post–Martial Law Conceptual Art* (*Jieyanhou de guannian yishu*) opens at Dragon Gate Gallery, with works by **Chu Chiahua** and **Wu Mali** among others. Art critic J. J. Shih brings together installation art from eight commercial galleries for a show at the Apollo Building (*Zhuangzhi*

abolo) in Taipei. The Kao-hsiung Museum of Art opens, southern Taiwan's first public museum. Tai-chung's Provincial Art Museum organizes an exhibition and symposium entitled *Contemporary Chinese Ink Painting* (*Zhongguo xiandai shuimohua dazhan*). Over a hundred artists from the Mainland, Hong Kong, and Taiwan participate, representing the largest cross-straits assembly of artists since 1945. The *Taipei International Ceramic Art Exposition* (*Taibei guojitaoci bolanhui*) is held at Taipei World Trade Center. *China Times* organizes a centennial exhibition of works by Ch'en Ch'eng-p'o and Liu Jin-t'ang, Taiwanese artists under the Japanese occupation, for TFAM. *The 1994 Taipei Biennial of Contemporary Art* (*Taibei xiandai meishu shuangnianzhan*), held at TFAM, features works by **Wu Tien-chang**, Tu She-san, Lai Jun-jun, Ku Shih-yung, and Chien Fu-Shen, all of whom receive the grand awards.

Swen-yi Taiwan Aboriginal Museum opens, the first devoted exclusively to indigenous cultures.

1995
Taiwan's unemployment rate reaches its highest in nine years.

On the occasion of a nationwide arts festival, artists are asked to address the following subjects in their entries: industrial culture, art and urban space, humanity and the environment, and historical nostalgia. Hou Yi-jen curates *Observing Women's Culture in Taiwan* (*Taiwan nuxing wenhua guancha*) for New Phase Art Space in Tainan; the exhibition is sponsored by the Women's Awareness Association in conjunction with dance and theater groups. Margaret Shiu Tan establishes Bamboo Curtain Workshop (*Zhuyuan gongzuoshi*) near Taipei as an alternative exhibition space. *Artist* celebrates Taiwan's flourishing contemporary art scene with its twentieth-anniversary issue, *Artist ⟷ Taiwanese Art: Survey, 1975–1995*.

China Times organizes *The Human Figure Interpreted: Modern Sculpture from the Hirshhorn Museum* (*Rentidiaosuxinshi: Hirshhorn Bowuguan xiandai diaosuzhan*) for TFAM. Dimensions Art Foundation collaborates with the Louvre on an exhibition of Impressionist painting held at the National Palace Museum in Taipei; the unprecedented exhibit draws waves upon waves of visitors. David Rockefeller, trustee of the American Asian Cultural Council visits Taiwan and announces future grants for Taiwanese artists. The National Palace Museum hosts the first official cross-straits gathering of museum directors from Taiwan and Beijing's Central Academy of Arts, Academy of Chinese Painting, and National Museum; Sichuan Academy of Fine Arts; and Guangzhou Art Museum.

The international currency of Taiwanese art rises with the opening of *ArtTaiwan: The Contemporary Art of Taiwan* at the Museum of Contemporary Art in Sydney. Thirty artists participate, including **Chu Chiahua, Hou Chun-ming, Huang Chih-yang**, Lien Teh-cheng, Margaret Shiu Tan, **Wu Mali, Wu Tien-chang**, and Yang Mao-lin. *Flash Art* publishes a Chinese-language edition in Taiwan. Taiwan participates in the 46th Venice Biennale with works by **Wu Mali**, Lien Teh-cheng, Huang Chin-ho, **Huang Chih-yang**, and **Hou Chun-ming**.

1996
Debates over Taiwanese identity, widespread throughout the 1990s, receive official acknowledgment when presidential candidates from both the ruling KMT and the opposition DPP appeal to the Taiwanese people's sense of cultural unity and a shared history. In art, Nativism/*Bentu* is defined in myriad ways, for instance, as a reflection of family background in the work of **Chen Shun-chu**, or the recognition of plural identities seen in **Chen Hui-chiao's** conceptual art. Technique itself may carry the message, as in the work of

southern artists like Huang Hong-der and Lin Horn-wen, who use monochromatic ink washes to capture the essence of local traditions.

Lion Art organizes the symposium *Modern Taiwan Art: Searching for Cultural Identity* (*Hewei Taiwan: Jindai Taiwan meishu yu wenhua rentong*), sponsored by the CCPD and held at the National Library; several months later, the magazine suspends publication after twenty-five years of achievement. A group of artists charges TFAM's director with misconduct and demands an investigation; the director is eventually removed by the mayor of Taipei.

New York's Metropolitan Museum of Art and the National Palace Museum in Taipei arrange a US tour of 476 works from the Palace collection. Concern over the fragile condition of some works, as well as anger that the Taiwan government has agreed to commit NT$80 million to the exhibition, prompts a demonstration by hundreds of citizens in Chiang Kai-shek Memorial Square. In response, the museum organizing committee eliminates the most sensitive works from the show.

1997
Kao-hsiung Museum of Art sponsors the International Symposium on Public Art (*Gongzhong yishu guojixueshu yantaohui*). *Sadness Transformed: The February 28 Commemorative Exhibition* (*Beiqing shenghua 2.28 meizhan*) is held at TFAM, featuring works by **Chen Shun-chu** and **Wu Mali**, among others. Jia-yi Cultural Center organizes an outdoor exhibition of installation art (*Taiwan zhuangzhi yishu zhan*). *River: New Asian Art—A Dialogue in Taipei* is organized by J. J. Shih for the Taipei County Cultural Center, Dimension Art Foundation, and Bamboo Curtain Studio. Feminist art is featured in *Lord of the Rim: In Herself/For Herself* (*Penbian zhuren: Zizai ziwei*) at the Hsin-chuang Cultural Center, with works by Judy Chicago, Yoshiko Shimada, **Wu Mali**, Maggie Wei Hsu, Lin

Chun-ju, and Pil Yun Ahn. TFAM organizes *Facing Faces* (*Mianmu quanfei*) for the 47th Venice Biennale, with works by **Wu Tien-chang**, Yao Jui-chung,

Wang Jun Jieh, Lee Ming-tse, and Chen Chien-pei. *17 Naifs de Taiwan*, organized by TFAM, travels to Halle Saint-Pierre in France and Musée de Louvain-la-Neuve in

Belgium. *Taiwan: Kunst Heute* opens at the Haus der Kulturen der Welt in Berlin, with **Chen Shun-chu**, **Chu Chiahia**, and **Wu Tien-chang**, among others.

Compiled by Kao Chien-hui, Victoria Y. Lu, and Philomena Mariani.

HONG KONG

1967
Labor disputes between factory management and workers erupt into riots, looting, strikes, and terrorist bombings throughout Hong Kong. Newspaper agencies regarded as Communist sympathizers are banned. The unrest lasts for eight months, finally subsiding in December. Hereafter, the government of the British colony of Hong Kong is eager to appear concerned with the welfare of its citizens, which includes being receptive to cultural and artistic activities.

1970
Four Hong Kong Artists opens at City Hall Museum and Art Gallery. The exhibition features the work of Douglas Bland, Cheung Yee, Kwong Yeu-ting, and Lui Shou-kwan, representing the first wave of modernism that began in the 1950s. All of the artists work in abstract and Surrealist modes.

Students of Lui Shou-kwan form the One Art Group, which becomes the leading proponent of the New Ink Painting. Artists in the movement—many of whom were born in Mainland China—include Wucius Wong, Laurence Tam, Cheng Wei-kwok, Irene Chou, Chui Tze-hung, Kan Tai-keung, and Ng Yiu-chung. The movement links classical Chinese ink painting and modernity, steering traditional ink painting toward abstraction.

1972
Hong Kong Technical College is upgraded to Hong Kong Polytechnic and offers a program in design. Many visual artists who

are to become prominent in the 1980s and '90s either are trained or teach there.

1973
Beset by a stock market crash, record inflation, corruption, and an influx of refugees from Mainland China, the Hong Kong government begins a campaign to restore confidence among residents as well as foreign and domestic investors. The institutional and policy changes initiated at this time inaugurate an era of political stability and rapid economic growth.

The Urban Council organizes the first Hong Kong Arts Festival, reflecting a new interest in government-sponsored cultural and entertainment activities. The festival brings international and local artists, musicians, and performers to the annual event.

1974
The Visual Art Society is founded by graduates of an art and design certificate course organized by the Hong Kong University Extramural Studies Department, the only academic institution that offers the systematic study of contemporary art. Members of the Society include Gaylord Chan, Ben Lee, Frank Po, Natasha Yu, Aser But, Cheng Ming, Chung Tai-Fu, Kwok Mang-ho, and others. These artists dominate the art scene for almost a decade. Like the artists of the New Ink Painting movement, they adapt their art to contemporary trends but retain some "Chinese" characteristics.

1975
City Museum and Art Gallery is restructured as the Museum of Art and Museum of History. The Museum of Art becomes one of the principle exhibition venues in Hong Kong, organizing the first Contemporary Hong Kong Art Biennial Exhibition. Distinguishing between "western" and "Chinese" art, the Biennial is one of the first major open art competitions for local artists.

1977
An internal study by the Hong Kong government defines the role of government in developing the arts to include the provision of infrastructure and nurturing of new aesthetic ideas and forms. Subsequently, the government increases support for art education in the schools.

The building for the Hong Kong Arts Centre is completed. The Centre's Pao Galleries become a leading exhibition space in Hong Kong. An independent and not-for-profit arts organization, the Centre aims at bringing drama, dance, music, film, video, visual, literary, and applied arts to a wider public. Curated by Alan Wong and Tao Ho, the inaugural exhibition features works by a group of local artists and by western artists borrowed from various European museums.

1978
Hong Kong University opens a fine arts department, focusing on the history of art.

1981
Deng Xiaoping makes public statements about the PRC recovering control over Hong Kong. Margaret Thatcher visits Beijing to discuss Hong Kong's future. Meanwhile, various proposals are floated in policy circles and the media, including the idea of "one country, two systems" and the designation of Hong Kong, Macau, and Taiwan as Special Administrative Regions. The Hong Kong government establishes eighteen district boards, and holds elections. Young people riot in the central business district on Christmas Eve and New Year's Eve, protesting the widening gap between rich and poor.

A small group of western-trained artists begins to return to Hong Kong after studying overseas, representing a new generation. Many of these artists were born after World War II and work in western mediums. Overall, they are less burdened than the previous generation by the need to bridge Chinese tradition and modernism.

1982
The Chinese government launches a hearts-and-minds campaign in Hong Kong on the basis of Chinese compatriotism, promising to leave its capitalist economy and social system virtually intact. Meanwhile, the press frequently reports the outflow of professional and managerial talent to North America and neighboring countries in anticipation of the territory's return to the PRC (100,000 emigrate during 1982–84).

Beijing and London continue talks on Hong Kong's future; the focal point shifts from China's or Britain's sovereignty to a more Hong Kong–centered outlook, principally, Painting what is to be done for the 5 million people in the territory.

1983

The first Fringe Festival, inspired by Edinburgh's exhibition of the same name, opens at Chater Garden as an alternative to the government-sponsored Hong Kong Arts Festival. The Fringe Festival becomes an annual event and provides an open platform for local amateur and emerging artists to launch events and installations.

Video art begins to receive attention with the *First Hong Kong International Video Art Exhibition,* jointly organized by the Arts Centre and Göethe Institut Hong Kong. A performing arts collective, Zuni Icosahedron (founded in 1982), presents a video art workshop in cooperation with the Hong Kong Arts Festival.

1984

Britain and the PRC sign the Joint Declaration, which states that Hong Kong will become a Special Administrative Region (SAR) of the People's Republic of China as of 1997. It also provides that for the first fifty years of PRC control, Hong Kong's economic and social structure will remain unchanged: the territory will enjoy a high degree of autonomy, except in foreign and defense affairs. At the same time, Mainland officials in Hong Kong look askance at what they consider the overpoliticization of the Hong Kong people, as evidenced by calls for direct elections and the formation of political parties.

Luis Chan: Fifty Years of His Artistic Career, 1935–1985 opens at the Hong Kong Museum of Art. This exhibition is one of the first retrospectives of a nontraditional artist held by the museum. Luis Chan

(1905–1995) was a seminal figure of the Hong Kong art scene from the 1930s onward. Unlike traditional Lingnan School and New Ink movement painters, Chan was the only major artist of the older generation to break free of a traditional-modern style and to create a highly personal aesthetic language that reflected contemporary urban life.

The Arts Centre inaugurates an education program, offering courses on film, visual, literary, and applied arts. The Urban Council and the Hong Kong Arts Festival sponsor a symposium on 20th-century Chinese painting, which brings together international and local scholars for the first time to explore issues of tradition and modernity in the Mainland, in Hong Kong, and on Taiwan. Major exhibitions are held in conjunction with the symposium at the Museum of Art, the Arts Centre, Fung Ping Shan Museum at the University of Hong Kong, and the Art Gallery of Chinese University.

1985

The proposed building of the Daya Bay nuclear power plant incites controversy and raises objections from prominent politicians such as Martin Lee and Szeto Wah, legislative councilors, district board members, and over a hundred community groups convened for a conference on the subject. The opposition focuses on environmental issues and the rights of Hong Kong residents.

Students at Chinese University's fine arts department organize an exhibition at the Arts Centre entitled *Outside the Fearful Wall* to protest the department's conservative approach to interpreting and teaching art. Several Hong Kong video artists found Videotage (combining "video" and "montage"), a not-for-profit organization dedicated to developing local independent video production and international artists exchanges. Members include Ellen Pau, May Fung, Wong Chi-fai, and Mo Man-yu.

1986

The Art of Henry Moore, jointly organized by the Arts Centre, the British Council, and the Urban Council, sets attendance records for a Hong Kong art exhibition. The Moore show fills every public venue save one, the Rotunda Exhibition Hall, which features an exhibition of sculpture by the Taiwanese artist Ju Ming, organized by the Hong Kong Land Company and Hanart T Z Gallery.

1987

Sir David Wilson is appointed governor of Hong Kong. The government rejects calls for a referendum on whether direct elections should be introduced in 1988. In Beijing, Deng Xiaoping is quoted as saying that universal suffrage might not be beneficial for Hong Kong. The exodus of professionals from Hong Kong continues, although during the previous year more than 8,000 former residents returned holding foreign passports.

Out of Context, a weekend alternative exhibition by young avant-garde artists at the "Ghost House" on Kennedy Road, is organized to protest the stranglehold of established art institutions. Participating artists include Antonio Mak, Yank Wong, Josh Hon, Oscar Ho, Ricky Yeung, Ringo Lee, Wong Wo-bik, Holly Lee, Choi Yan-chi, and the New York City–Chinese artist group EPOXY. Such projects set the tone for future art production. Curatorial creativity and experimental exhibitions become the driving forces behind defining and promoting avant-garde art. Meanwhile, institutions like the Museum of Art and the Urban Council are increasingly regarded as conservative, upholding the tradition of the Lingnan School and the modernism propagated by the New Ink Painting movement.

1988

Made in Hong Kong: A History of Export Design, 1900–1960, curated by Matthew Turner of the Hong Kong Polytechnic's School of

Design, opens at the Museum of History. The exhibition contributes to a search for a distinctive Hong Kong cultural identity. *Icons of the Imagination*, curated by Chang Tsong-zung for his Hanart T Z Gallery, brings together a group of Hong Kong painters from diverse backgrounds—including Luis Chan, Hon Chi-fun, Irene Chou, Gaylord Chan—whose work reveals common spiritual inclinations. This exhibition is one of a series that aims to identify the cultural sensibilities of Hong Kong, and is followed by *Private Notes*, with Oscar Ho, Rex Chan, and Yu Peng. Chang Tsong-zung argues that the work of each of these artists attempts to escape public discourse and reflects a private, diarist-like imagination.

The Arts Centre organizes a public art project entitled the Mobile Art Show, curated by Oscar Ho, Christine Loh, and David Clarke and featuring many artists from *Out of Context*.

1989

In January, the first major show of Mainland China's avant-garde is held in Hong Kong at the Hanart T Z Gallery. *Stars: 10 Years* features the work of thirteen members of the Star group, which launched a protest march in Beijing in 1979.

An ad hoc group called Arts Support is formed in response to the student movement in Beijing, along with a fax-art propaganda campaign and art fair. A declaration of solidarity by artists and organizations is published in *Ming Pao Daily*. A massive demonstration is organized by Hong Kong people to protest the imposition of martial law in Beijing in late May. The outpouring of sorrow and anger escalates with the crackdown and shootings in Tiananmen Square on June 4, and over a million Hong Kong people gather for rallies across the territory. Artists organize to reproduce the statue of the Goddess of Liberty at the Academy of Performing Arts.

The Cultural Centre in Tsim Sha Tsui (Jianshazui) opens at the site of the historic railway station, a scenic spot in Hong Kong overlooking Victoria Harbor. The arts community criticizes the Centre's planners for ignoring the local landscape and constructing a building with no windows.

1990

The PRC's National People's Congress drafts the Basic Law, intended to become Hong Kong's constitution. The Hong Kong government informs the PRC via a secret letter that it has no intention of "allowing Hong Kong to be used as a base for subversive activities against the People's Republic of China," referring to the rallies protesting the events of June 4. Furthermore, it notes that "the Hong Kong government has recently rejected a proposal for a permanent site for a replica statue of democracy." The letter's contents are publicized.

In June, artists organize an exhibition at the Arts Centre commemorating the Tiananmen Square massacre, entitled *June Fourth Memorial Exhibition*. The Fringe Club contributes by inaugurating its annual June Art Show, and Arts Support curates a traveling commemorative exhibition sponsored by the Asian-American Art Center in New York City.

Avant-garde activities continue with two experimental exhibitions curated by David Clarke and Oscar Ho for the Arts Centre. Members of the public are asked to contribute items to *In Search of Art*, which showcases cultural tastes rarely acknowledged in established institutions. *One Day in Hong Kong* invites "nonprofessional image makers" to display photographs taken on a designated day in an attempt to create a collective self-portrait of Hong Kong.

The Quart Society is founded by Yeung Tung-loong, Choi Yi-yuan, Frederick Fung, Yank Wong, Fung Kwok-leung, Choi He-chuen, and Hui Ching-shun. Although short-lived, the Society is the first independent, artist-run co-op, and functions as a space for exhibition and informal artist meetings.

1991

Hong Kong expresses its ties to China during terrible floods in Mainland China. A charity concert held at the Happy Valley racetrack attracts more than 80,000 people and raises over HK$100 million for the flood victims.

The Hong Kong Museum of Art opens its new building next to the Cultural Centre with the exhibition *Too French*, featuring contemporary French art and design. The new museum space includes four permanent galleries: Contemporary Hong Kong Art, Historical Pictures, Chinese Antiquities, and Chinese Fine Art. For the first time, an exhibit of local art is permanently on view.

The Arts Centre launches its Hong Kong Culture Series with *The Art of Li Tie Fu*, curated by Oscar Ho. The series takes on the ambitious task of defining a Hong Kong cultural identity through research and exhibition, a project viewed by some as an aggressive bid for cultural—thus political—autonomy. Zuni Icosahedron's Cultural Policy Study Group coordinates an extensive survey of candidates for the Legislative Council (Legco) and cultural committee members for their opinions on cultural issues. Zuni's active role in policy discussions reflects the art community's active engagement and contribution to the formation of government policy. Christie's Hong Kong holds the first sale by any auction house devoted exclusively to contemporary Chinese academic-style oil painting. A painting by Mainland artist Chen Yifei fetches a record HK$1,375,000 (close to US$200,000).

1992

Britain appoints Christopher Patten, a career politician, the governor of Hong Kong.

As a response to criticism that it does not represent the avant-garde, the Museum of Art organizes *City Vibrance: Recent Works in Western Media by Hong Kong Artists*, an eclectic exhibition featuring 49 artists of different generations and artistic training. The older generation is represented by Gaylord Chan, Hon Chi-fun, and Van Lau. Included from the generation of younger artists who began working in the 1980s are Annie Chan Chi-ling, Chan Wai-bong, Chan Yuk-keung, Choi Yan-chi, Antonio Mak, Oscar Ho, Josh Hon, Wong Shun-kit, **Danny Ning Tsun Yung**, Wong Wo-bik, Ellen Pau, Yank Wong, and Ricky Yeung.

1993

The PRC announces that on July 1, 1997, it will replace Hong Kong's Legislative Council with a Provisional Council that will remain in office until the next election in July 1998. The Hong Kong government releases its review of art policy conducted in 1992, leading to much debate within the art community. The government is criticized for ignoring local cultural identity in the report.

The feature exhibition of the January Hong Kong Arts Festival, *China's New Art: Post-1989*, organized by Hanart T Z Gallery and co-presented with the Arts Centre, provides the Hong Kong public with its first large survey of avant-garde art from the Mainland. The success of this exhibition, which features over 150 artworks and reveals the highly articulate agenda of artists in the PRC, challenges local artists to define the role of the avant-garde in Hong Kong. The Arts Centre's exploration of cultural identity is continued in *King of Calendar: The Art of Kwan Wai Nung*, an exhibition featuring the work of a pre–World War II graphic designer. Like *Made in Hong Kong*, this show is one of the first of its kind to showcase local Hong Kong culture and history, and generates tremendous public response.

Art and Space: From Sculpture to Installation, an inaugural installation of the Hong Kong University of Science and Technology Arts Endowment Committee curated by Oscar Ho, argues that new developments in installation art should replace traditional sculptural practices in Hong Kong.

1994

Academics, students, and activists in Hong Kong protest Beijing's prosecution of Xi Yang, a Shanghai-born journalist accused of "spying on state financial and economic secrets and causing great economic losses to the state." Meanwhile, political activists lobby for the creation of a human rights commission to safeguard individual rights after 1997.

In response to criticism of its art policy report, the government establishes the Hong Kong Arts Development Council to replace the Council for Performing Arts, with the Arts Development Council scheduled to commence operation in June 1995 as an independent statutory body with public and private funding. For the first time, the visual arts come under the purview of a government entity.

Ninety-two percent of the entries to the Museum of Art's Biennial Exhibition are rejected, including all of the installation works. One of the overseas adjudicators suggests that the exhibition should be left as an empty space to protest the poor quality of the entries. The incident sparks a controversy over local art and cultural authority.

1995

All 60 seats of the Legislative Council are up for election. Voter turnout reaches 36 percent. The Democratic Alliance for the Betterment of Hong Kong, the so-called China camp, wins 16 seats, while the so-called democracy parties, led by the Democratic Party (DP), win 26 seats. The rest of the 18 moderate members are regarded as sympathetic to the DP.

A 1984 bronze sculpture of a standing male nude by the British artist Elizabeth Frink, entitled *New Man*, originally on display in a commercial building lobby, is classified an "indecent article" by the Obscene Articles Tribunal. According to the Tribunal, the sculpture can only be displayed in a museum or gallery, which, it states, are not "public" spaces. In response, the Arts Centre arranges an impromptu exhibition of the sculpture and holds a forum on freedom of artistic expression. Both the Arts Development Council and members of Legco denounce the Tribunal's ruling. The case generates a strong response from the press and public, and the Hong Kong Young Artists Association organizes the *Penis Exhibition*. (The association is also engaged in political commentary on the 1997 handover of Hong Kong.) The Tribunal's verdict is subsequently dismissed on technical grounds by the High Court and the sculpture returned to its original location.

Hong Kong Sixties: Designing Identity, curated by Matthew Turner for the Arts Centre, becomes controversial for its assertion that Hong Kong's adoption of modernism in the 1960s was propelled by economic and political interests. This show marks the high point of the debate over cultural identity in the increasingly politicized climate prior to the transfer of Hong Kong to the PRC.

The Museum of Art and the Urban Council jointly sponsor *Twentieth Century Chinese Painting: Tradition and Innovation*, which features 137 works by 110 artists. A dozen Hong Kong artists are represented, including Luis Chan, Wucius Wong, and Lui Shou-kwan of the New Ink Painting movement. The exhibition is accompanied by an international symposium.

The Hong Kong University of Science and Technology formally establishes the Center for the Arts,

initiating a series of projects and exhibitions on urban culture, contemporary art, and media art. It also provides a forum for local and international artists, scholars, and policy makers.

1996
Tung Chee-hwa is chosen by a 400-member selection committee (nominated by the PRC) to be Hong Kong's chief executive after June 30, 1997. The committee also appoints 60 officials to the Provisional Legislative Council, 33 of whom are members of the current Legco, elected in 1995.

Para/Site, an alternative nonprofit art space, is founded by Leung Chi Wo and Kith Tsang. Due to the high cost of renting commercial exhibition space, the group intends to position itself "tactically" vis-à-vis the dominant art scene in Hong Kong. Its first show, *Artist-in-Western*, is held at an abandoned shop in Kennedy Town. The group later opens a branch, Para/Site Central, the smallest exhibition space in Hong Kong, hosted by Hanart T Z Gallery. Para/Site includes members of the youngest generation of avant-garde artists—Lisa Cheung, Leung Mee-ping, Patrick Lee, **Phoebe Man** (**Man Ching Ying**), and Sara Wong—who promote internationalist perspectives in their work.

In March, *Outside the White Cube*, curated by Oscar Ho, opens at the Hong Kong Arts Centre, bringing together work by artists from Hong Kong, Mainland China, and Taiwan, following the precedent set in 1994 by the Arts Centre's *Contemporary Photography in Mainland China, Hong Kong, and Taiwan*. Discussion of the future accelerates as 1997 and Hong Kong's transfer to the PRC approaches. Journey to the East, 1997, part of the Hong Kong International Conference on Urban Culture, includes exhibitions and cultural policy forums. Intended to open channels of dialogue between the Mainland, Hong Kong, and Taiwan,

curator **Danny Ning Tsun Yung** structures the events around "one table and two chairs"—a reference to "one country, two systems"—and invites artists from the Mainland (Chen Yanyin, Wang Jianwai), Hong Kong (Choi Yan-chi, Wong Shun-kit), and Taiwan (Margaret Shiu Tan, **Tsong Pu**). Hanart T Z Gallery invites different generations of local artists to reflect on the countdown to July 1, 1997 in the *6.30 Show*, including Wucius Wong and Gaylord Chan of the 1960s–70s generation; Lucia Cheung, Wong Shun-kit, Yank Wong, and Oscar Ho, who emerged in the 1980s; and Eric Wear, **Ho Siu-kee**, Leung Chi Wo, Lo Yin-shan, and Lisa Cheung, artists of the 1990s. At the opening, the ribbon is cut by Christine Loh, a pro-democracy Legco councilor.

As an alternative to the rise of "patriotic" sentiment toward the Mainland, the Arts Centre organizes the exhibition *Being China* (*Being Hong Kong*), which features visions of "China" by 30 local artists from different generations, including **Danny Ning Tsun Yung**, Law Kun-chiu, and Kan Tai-keung. The works range from evocations of a timeless ancient China to touristic images of an exotic land to souvenirs of fashionable 1930s Shanghai. The exhibition represents a significant conceptual move from defining Hong Kong culture to questioning issues of nationhood and nationalism. Related issues are addressed in *Era of Awakening: Reflections on Cultural Colonialism in Hong Kong*, an exhibition of mixed-media works and installations organized by the University of Science and Technology Center for the Arts and the Hong Kong Young Artists Association. The participants—led by Wong Shun-kit, a Shanghai artist who moved to Hong Kong in the 1980s—examine Hong Kong's colonial history and local identity.

Political commentary is also showcased in the work of cartoonist Zunzi in a ten-year retrospective of

his work at the Arts Centre. The extremely popular exhibition prompts public discussion of the potential danger of self-censorship in the arts community post-1997.

In response to its first invitation to an international biennial, Hong Kong represented by video/installation artist **Ho Siu-kee** in the 23rd Bienal of São Paulo, Brazil.

1997
The Preparatory Committee—a 150-person China–Hong Kong body created to oversee the transfer of sovereignty—recommends the repeal of Hong Kong's 1991 Bill of Rights and other civil liberties legislation passed in recent years. The PRC's National People's Congress claims these rights are covered in the Basic Law and repeals the Hong Kong legislation.

On June 30, the sovereignty of Hong Kong is transferred from Britain to the People's Republic of China in an elaborate ceremony, which includes a citywide celebration followed by a five-day public holiday.

The Arts Centre marks the event with a series of performing arts programs and art exhibitions entitled *Hong Kong Incarnated*. The exhibition section, curated by Oscar Ho and entitled *Museum 97: History, Community, Individual*, includes *The Prehistoric Hong Kong Museum*, a fabricated ancient history of Hong Kong by Kith Tsang, **Phoebe Man**, and Sze Yuan, among others. In response to the propaganda campaign enjoining the people of Hong Kong to become "new persons" in the "new Special Administrative Region," the Centre organizes Festival Now around the satirical theme "New Life Movement." Hanart T Z Gallery sponsors a second *6.30* Show. Artists from the 1996 show are joined by Ellen Pau, Kith Tsang, Hay Young, Rex Chan, and Chan Yuk-Keung; the only artist to directly address transitional politics is Eric Wear. Again,

Christine Loh presides over the opening ceremony.

The exploration of nationalism continues with the exhibition *Being Minorities: Contemporary Asian Art*, organized by Oscar Ho and featuring eight artists from the Asia region.

The Pillar of Shame, a bronze conical-shaped sculpture by Danish artist Jens Galschoit commemorating the Tiananmen Square massacre, is displayed in Victoria Park during the annual June 4 memorial rally. Permission for a longer display period is denied by the Urban Council, which owns the park, provoking a debate on political censorship and freedom of expression. After the rally, students from the University of Hong Kong arrange to have the sculpture moved to their campus. Over the next few months, it makes the rounds of other campuses.

1998
The Hong Kong SAR government announces its plan to reexamine the infrastructure of the arts in Hong Kong. The Provisional Legislative Council formally requests the government to produce a comprehensive cultural policy that respects Chinese tradition while maintaining cultural diversity. Meanwhile, the Urban Council plans to build a museum devoted entirely to contemporary art. The Council is also criticized for poor management of its museums.

Discussion of the 1997 handover and its repercussions continues unabated in the arts community. **Danny Ning Tsun Yung** curates *Journey to the East*, 1998, an exhibition and performance art program featuring international and local artists. The event is sponsored by the University of Science and Technology Center for the Arts, Zuni Icosahedron, the Arts Centre, the Institute for Contemporary Culture (founded in 1996), and the International Association of Theatre Critics. *Hong Kong Reincarnated* opens at the Arts Centre, and the Hanart T Z Gallery invites local artists to participate in the third *6.30 Show*.

New Voices, at the Arts Centre, brings together artists from the Mainland, Taiwan, and Hong Kong. The show includes work by Kith Tsang, Chan Yuk-keung, Yank Wong, and Ellen Pau (all Hong Kong), **Li Shan** (Shanghai), and **Wu Mali** (Taipei).

Compiled by Irene S. Leung and Michael S. K. Siu, with contributions by Oscar Ho, Eric Wear, Chang Tsong-zung, and David Clarke.

Selected Bibliography

WORKS IN ENGLISH

Abbas, Akbar. "Hong Kong: Other Histories, Other Politics." *Public Culture* 9, no. 3 (Spring 1997), pp. 293–313.

Anagnost, Ann. "Cultural Nationalism and Chinese Modernity." In *Cultural Nationalism in East Asia: Representation and Identity,* ed. Harumi Befu. Berkeley: University of California Press, 1993.

Andrews, Julia F. *Painters and Politics in the People's Republic of China.* Berkeley: University of California Press, 1994.

Andrews, Julia F., and Gao Minglu. "The Avant-Garde's Challenge to Official Art." In *Urban Spaces: Autonomy and Community in Contemporary China,* ed. Deborah Davis et al. Cambridge: Cambridge University Press, 1995, pp. 221–78.

"Art of the Chinese Diaspora." Special issue of *Art and AsiaPacific* 1, no. 2 (1994).

Barmé, Geremie. "The Chinese Velvet Prison: Culture in the 'New Age,' 1976–1989." *Issues and Studies* 25, no. 8 (1989), pp. 42–62.

_____. "To Screw Foreigners Is Patriotic: China's Avant-Garde Nationalists." *China Journal,* no. 34 (July 1995), pp. 209–34.

Barmé, Geremie, ed. *Shades of Mao: The Posthumous Cult of the Great Leader.* Armonk, N.Y.: M.E. Sharpe, 1996.

Berry, Chris, ed. *Perspectives on Chinese Cinema.* London: BFI, 1991.

Chan, Lauk'ung. "Ten Years of the Chinese Avantgarde: Waiting for the Curtain to Fall." *Flash Art* 25 (January–February 1992), pp. 110–14.

Chan, Sylvia. "The Blooming of a 'Hundred Flowers' and the Literature of the 'Wounded Generation.'" In *China Since the "Gang of Four,"* ed. B. Brugger. London: Croom Helm, 1980, pp. 174–201.

Chang, Arnold. *Painting in the People's Republic of China: The Politics of Style.* Boulder: Westview Press, 1980.

Clark, John. "Problems of Modernity in Chinese Painting." *Oriental Art* 32 (Autumn 1986), pp. 270–83.

_____. "Taiwanese Painting Under the Japanese Occupation." *Journal of Oriental Studies* 25, no. 1 (1987), pp. 63–104.

_____. "Postmodernism and Recent Expressionist Chinese Oil Painting." *Asian Studies Review* 15, no. 2 (November 1991).

_____. "Official Reactions to Modern Art in China Since the Beijing Massacre." *Pacific Affairs* 65, no. 3 (1992), pp. 334–48.

Clarke, David. *Art & Place: Essays on Art from a Hong Kong Perspective.* Hong Kong: Hong Kong University Press, 1996.

_____. "Varieties of Cultural Hybridity: Hong Kong Art in the Late Colonial Era." *Public Culture* 9, no. 3 (Spring 1997), pp. 395–415.

Clunas, Craig. *Art in China.* New York: Oxford University Press, 1997.

Cohen, Joan Lebold. *The New Chinese Painting, 1949–1986.* New York: Abrams, 1987.

Cohen, Myron. "Cultural and Political Inventions in Modern China: The Case of the Chinese 'Peasant.'" *Daedalus* 122, no. 2 (1993), pp. 151–70.

Croizier, Ralph. *Art and Revolution in Modern China: The Lingnan (Cantonese) School of Painting, 1906–1951.* Berkeley: University of California Press, 1988.

_____. "Art and Society in Modern China: A Review Article." *Journal of Asian Studies* 49, no. 3 (August 1990), pp. 587–602.

Dai Jinhua. "Redemption and Consumption: Depicting Culture in the 1990s." *Positions* 4, no. 1 (1996), pp. 127–43.

Dijk, Hans van. "Painting in China After the Cultural Revolution: Style Developments and Theoretical Debates, Part II: 1985–1991." *China Information* 6, no. 4 (Spring 1992), pp. 1–18.

Friedman, Edward. "Democracy and 'Mao Fever.'" *Journal of Contemporary China* 6 (Summer 1994), pp. 84–95.

Fu Shen. *Challenging the Past: The Paintings of Chang Dai-chien.* Washington, D.C.: Arthur M. Sackler Gallery, Smithsonian Institution, 1991.

Gao Minglu. "From the Local Context to the International Context: An Essay on the Critique of Art and Culture." In *The First Academic Exhibition of Chinese Contemporary Art 96–97* (Hong Kong: Hong Kong Arts Centre, 1996), pp. 23–29 (also in Chinese).

Gladney, Dru C. "Representing Nationality in China: Refiguring Majority/Minority Identities." *Journal of Asian Studies* 53, no. 1 (February 1994), pp. 92–123.

Goldman, Merle. *China's Intellectuals: Advice and Dissent.* Cambridge, Mass.: Harvard University Press, 1981.

Goldman, Merle, Timothy Cheek, and Carol Lee Hamrin, eds. *China's Intellectuals and the State.* Cambridge, Mass.: Harvard University Press, 1987.

Hay, Jonathan. "Ambivalent Icons: Works by Five Chinese Artists Based in the United States." *Orientations* 23, no. 7 (July 1992), pp. 37–43.

Hinterthur, Petra. *Modern Art in Hong Kong.* Hong Kong: Myer Publishing Co., 1985.

Holm, David. *Art and Ideology in Prerevolutionary China.* Oxford: Clarendon Press, 1991.

Hou Hanru. "Beyond the Cynical." *Art and Asia Pacific* 3, no. 1 (1996).

_____. "Towards an 'Un-Unofficial Art': De-ideologicalisation of China's Contemporary Art in the 1990s." *Third Text,* no. 34 (Spring 1996), pp. 37–52.

Hua Junwu, ed. *Contemporary Chinese Painting.* Beijing: New York Press, 1984.

Jose, Nicholas. "New Wave Art." *New Asia Review* (Summer 1994), pp. 18–24.

Kao, Mayching. "China's Response to the West in Art." Ph.D. diss., Stanford University, 1972.

_____. *Twentieth-Century Chinese Painting.* New York: Oxford University Press, 1988.

Kraus, Richard. "China's Cultural 'Liberalization' and Conflict Over the Social Organization of the Arts." *Modern China* 9, no. 2 (April 1983), pp. 212–27.

_____. "Art Policies of the Cultural Revolution." In *New Perspectives on the Cultural Revolution,* ed. Christine Wong et al. Cambridge, Mass.: Harvard University Council on East Asian Studies, 1991.

_____. *Brushes with Power: Modern Politics and Chinese Art of Calligraphy.* Berkeley: University of California Press, 1991.

_____. "China's Artists Between Plan and Market." In *Urban Spaces: Autonomy and Community in Contemporary China,* ed. Deborah Davis et al. Cambridge: Cambridge University Press, 1995.

Laing, Ellen Johnston. "Chinese Peasant Painting, 1958–1976: Amateur and Professional." *Art International* 27, no. 1 (January–March 1984), pp. 1–12.

_____. *The Winking Owl: Art in the People's Republic of China.* Berkeley: University of California Press, 1988.

_____. "Is There Post-Modern Art in the People's Republic of China?" In *Modernity in Asian Art,* ed. John Clark. Sydney: Wild Peony, 1993, pp. 207–21.

Lee, Benjamin. "Going Public." *Public Culture* 5 (1993), pp. 165–78 [on Xu Bing].

Lee, Leo Ou-fan. "Two Films from Hong Kong: Parody and Allegory." In *New Chinese Cinemas: Forms, Identities, Politics,* ed. Nick Browne et al. Cambridge: Cambridge University Press, 1994, pp. 202–15.

_____. "Tales from the 'Floating City.'" *Harvard Asia Pacific Review* (Winter 1996–97), pp. 43–49.

_____. "Trans-Chinese: Notes on Language and Sensibility." *Venue* 1 (Fall 1997), pp. 160–72.

Lin Xiaoping. "Those Parodic Images: A Glimpse of Contemporary Chinese Art." *Leonardo* 30, no. 2 (1997), pp. 113–22.

Link, Perry, Richard Madsen, and Paul Pickowicz, eds. *Unofficial China: Popular Culture and Thought in the People's Republic.* Boulder: Westview Press, 1989.

Lu, Sheldon Hsiao-peng. "Postmodernity, Popular Culture, and the Intellectual: A Report on Post-Tiananmen China." *boundary 2* 23, no. 2 (1996), pp. 139–69.

_____. "Art, Culture, and Cultural Criticism in Post–New China." *New Literary History* 28 (1997), pp. 111–33.

Lu, Victoria. "The Rising New Moon: Contemporary Art in Taiwan since 1945." *Art and Asia Pacific* (September, 1993), pp. 40–46.

Lufkin, Felicity. *Images of Minorities in the Art of the People's Republic of China.* Master's thesis, University of California, Berkeley, 1990.

MacRitchie, Lynn. "Precarious Paths on the Mainland." *Art in America* 82 (March 1994), pp. 51–53.

McIntyre, Sophie. "Made in Taiwan." *Art and Asia Pacific* 3, no. 3 (1996), pp. 83–86.

Raddock, David M. "Beyond Mao and Tiananmen: China's Emerging Avant-Garde." *New Art Examiner* (February–March 1995).

Schell, Orville. "Chairman Mao as Pop Art." In *The Mandate of Heaven* (New York: Simon & Schuster, 1994), pp. 279–92.

Silbergeld, Jerome, with Gong Jisui. *Contradictions: Artistic Life, the Socialist State, and the Chinese Painter Li Huasheng.* Seattle: University of Washington Press, 1993.

Spence, Jonathan D. *The Search for Modern China.* London: Hutchinson, 1990.

Sullivan, Michael. *The Meeting of Eastern and Western Art.* Rev. and exp. ed. Berkeley: University of California Press, 1989.

_____. *Art and Artists of Twentieth-Century China.* Berkeley: University of California Press, 1996.

Sun, Shirley. "Lu Xun and the Chinese Woodcut Movement, 1929–1935." Ph.D. diss., Stanford University, 1974.

Taylor, Janelle S. "Non-Sense in Context: Xu Bing's Art and Its Publics." *Public Culture* 5 (1993), pp. 317–27.

Tsao Tsing-yuan. "The Birth of the Goddess of Democracy." In *Popular Protest and Political Culture in China,* ed. Jeffrey N. Wasserstrom and Elizabeth J. Perry. Boulder: Westview Press, 1994, pp. 140–47.

Wang, Chia Chi Jason. "Made in Taiwan." *Art and Asia Pacific* 1, no. 2 (1994), pp. 73–77.

Wang, Yuejin. "Anxiety of Portraiture: Quest for/Questioning Ancestral Icons in Post-Mao China." In *Politics, Ideology, and Literary Discourse in Modern China,* ed. Liu Kang and Xiaobing Tang (Durham: Duke University Press, 1993).

Widmer, Ellen, and David Der-Wei Wang. From *May Fourth to June Fourth: Fiction and Film in Twentieth-Century China.* Cambridge, Mass.: Harvard University Press, 1993.

Wu Hung. "Tiananmen Square: A Political History of Monuments." *Representations* 35 (Summer 1991), pp. 84–117.

Wu, Lawrence. "Kang Youwei and the Westernization of Modern Chinese Art." *Orientations* 21, no. 3 (March 1990), pp. 46–53.

Yen Chuan-ying. "The Art Movement in the 1930s in Taiwan." In *Modernity in Asian Art,* ed. John Clark. Sydney: Wild Peony, 1993, pp. 45–59.

Yorke, A. "The Role of the Artist in Contemporary China: Tradition and Modern Attitudes to Art Appreciation." *Journal of the Oriental Society of Australia* 20–21 (1988–89).

Zha Jianying. *China Pop.* New York: New Press, 1995.

WORKS IN CHINESE

Yishujia ↔ Taiwan meishu (Artist ↔ Taiwanese Art: Survey, 1975–1995), ed. Ni Tsai-chin. Taipei: Artist Magazine, 1995.

Cai Yuanpei. *Meiyu lunji* (Art Education). Changsha: Hunan Educational Press, 1987.

Chen Yingde. *Haiwai kan dalu yishu* (Mainland Art Abroad). Taipei: Art Publishers, 1987.

Gao Minglu. "Bawu meishu yundong ('85 Art Movement)." *Meishujia tongxun* (Artists' Journal) 1986.3 (June 1986), pp. 15–23.

_____. "Meishu, quanli, gongfan: Zhengzhi popu xianxiang" (Kitsch, Power, and Complicity: The Political Pop Phenomenon) *Xiongshi Meishu* (Lion Art) 297 (November 1995), pp. 36–57.

Gao Minglu et al. *Zhongguo dangdai meishushi, 1985–1986* (History of Chinese Contemporary Art, 1985–1986). Shanghai: Shanghai People's Press, 1991.

Ho Huai-shuo, ed. *Jindai Zhongguo meishu lunji* (Essays on Modern Chinese Art). Vols. 1–6. Taipei: Artists Press, 1991.

Hsiao Ch'iung-jui. "Zhanhou Taiwan meishu dashiji" (A Chronology of Postwar Taiwanese Art). *Yanhuang Yishu* (Yanhuang Art) 10–19 (1990–1991).

_____. *Taiwan meishushi yanjiu lunji* (Studies in Taiwanese Art History). Taipei: Tung Da Publishing, 1991.

_____. *Wuyue yu dongfang—Zhongguo meishu xiandaihua yundong ziazhanhou Taiwan zhi fazhan, 1945–1970* (The Fifth Moon and Eastern Painting Groups: Chinese Modern Art Movements in Postwar Taiwan, 1945–1970). Taipei: Dongda Press, 1991.

Hsieh Li-fa. "Sanshi niandai Shanghai, Dongjing, Taibei de meishu guanxi" (Artistic Links Between Shanghai, Tokyo, and Taipei during the 1930s). *Xiongshi Meishu* (Lion Art) 160 (1984).

_____. *Riju shidai Taiwan meishu yundong shi* (The Taiwanese Art Movement during the Japanese Occupation). 3d ed. Taipei, 1992.

Jaoyubu dierci quanguo meishu zhanlianhui zhuanji (Second National Art Exhibition of the Ministry of Education), vol. 2, *Xiandai shuhuaji* (Modern Calligraphy and Painting); vol. 3, *Xiandai xihua tu' an diaokeji* (Western Painting, Design, and Sculpture). Shanghai: Commercial Press, 1937.

Kao Chien-hui. *Dangdai wenhuayishu sexiang* (Fine Art: Unorthodox Visual Culture in the 1990s). Taipei: Artists Press, 1996.

Kuo, Jackson, ed. *Taiwan shijue wenhua* (Taiwanese Visual Culture). Taipei: Artists Press, 1995.

Lang Shaojun. *Lun Zhongguo xiandai meishu* (Chinese Modern Art). Nanjing: Jiangsu Art Press, 1988.

Li Hua, Li Shusheng, and Ma Ke, eds. *Zhongguo xinxing banhua wushi nian* (Fifty Years of the New Chinese Print Movement). Shenyang: Liaoning Art Press, 1981.

Li Song. *Xu Beihung nianpu* (A Biography of Xu Beihung). Beijing: People's Art Press, 1985.

Li Xianting. "Zhengzhi popu he wanshi xianshizhuyi" (Political Pop and Cynical Realism). *Meishu Xinchao* (New Wave Art), no. 1 (1993).

Lin Hsing-yueh. *Taiwan meishu fengyun sishi nian* (Forty Years of Taiwanese Art). Taipei: Independence Evening News Publication, 1987.

_____. "Jushi niandai bentu qianweiyishu de zhanwang" (Prospects of Native [Taiwanese] Avant-Garde Art in the 1990s). *Xiongshi Meishu* (Lion Art) 256 (1992), pp. 40–69.

Liu Ching-fu. "Xiandaizhuyi de shiyanqi." In *Taiwan meishu xinfengmao* (Taiwan Art, 1945–1993), ed. Lin Ping. Taipei: Taipei Fine Arts Museum, 1993, pp. 24–28.

Liushi nian wenyi dashiji, 1919–1979 (A Record of Sixty Years of Major Events in Literature and Art), ed. Drafting Committee for the Fourth Congress of Literary and Art Works. Beijing: Theory and Policy Research Center, Ministry of Culture, Literature, and Art Research Institute, 1979.

Liu Xilin. *Yihai chunqiu: Jiang Zhaohe zhuan* (Spring and Autumn in the Sea of Art: A Biography of Jiang Zhaohe). Shanghai: Shanghai Calligraphy and Painting Press, 1984.

Lu Peng and Yi Dan. *Zhongguo xiandai yishu shi, 1979–1989* (A History of Chinese Modern Art, 1979–1989). Changsha: Hunan Art Press, 1992.

Lu, Victoria. "Zhongguo nuxing Yishudi Fazhan yu gimeng" (The Development of Chinese Feminist Art). *Yishujia* (Artist) 231 (1993).

_____. "Tanxun Taiwan bashi niandai yishu fengge" (A Study of Taiwanese Art Styles in the 1980s). In *Taiwan shijue wenhua* (Taiwanese Visual Culture), ed. Jackson Kuo. Taipei: Artists Press, 1995), pp. 210–15.

Meishu (Art Monthly). Beijing: Chinese Artists Association, 1952–.

Meishu Sichao (Art Trends). Hubei: Hubei Artists Association, 1985–.

Meishu Xinchao (New Wave Art). Taipei, 1993–95.

Ni Tsai-chin. "Xifangmeishu Taiwanzhizao" (Western Art, Made in Taiwan). *Xiongshi Meishu* (Lion Art) 242 (1991), pp. 114–33.

_____. "Zhongguo shuimo, Taiwan quwei" (Chinese Ink, Taiwanese Taste). *Xiongshi Meishu* (Lion Art) 244 (1991), pp. 150–59.

_____. "Taiwanmeishu zhongde Taiwanyishi" (Taiwanese Identity in Taiwanese Art). *Xiongshi Meishu* (Lion Art) 249 (1991), 136–57.

Pai Hsüeh-lan. "Taiwan zaoqi xiyang meishu zuopin zhan" (Early Exhibitions of Western-style Art in Taiwan). *Xiongshi Meishu* (Lion Art) 228 (1990), pp. 113–19.

Ruan Rongsheng and Hu Guanghu. *Zhonghua minguo huihua shi* (The History of Art in the Republic of China). Chengdu, 1991.

Tao Yongbai. *Zhongguo yuohua, 1700–1985* (Chinese Oil Painting, 1700–1985). Nanjing: Jiangsu Art Press, 1988.

Wang Hsiu-hsiung. "Taiwan diyidai xihuajia de baoshou yu quanweizhuyi ji duizhanhou Taiwanxihua de yixiang" (The Conservatism and Authority of Taiwan's First Generation of Painters and Their Influence on Postwar Western-Style Painting in Taiwan). In *Zhongguo, xiandai, meishu* (China, Modernity, Art). Taipei: Taipei Fine Arts Museum, 1990, pp. 137–74.

Wu Pu. "Menghun suoji de tudi: Fang Guangfuchu zeng dao Taiwan de jiwei dalu huajia" (Visits to Some Mainland Artists Who Emigrated

to Taiwan in the late 1940s). *Xiongshi Meishu* (Lion Art) 221 (1989), pp. 60–76.

Xiongshi Meishu (Lion Art) 297 (November 1995). Special commemorative issue on the '85 Movement.

Yen Chüan-ying. "Taiwan zaoqi xiyiangmeishu de fazhan" (The Development of Early Taiwanese Western-Style Art). *Yishujia* (Artist) 168–170 (1989).

Yishujia (Artist). Taipei, 1975–.

Zhang Shaoxia and Li Xiaoshan. *Zhongguo xiandai huihua shi* (History of Modern Chinese Painting). Nanjing: Jiangsu Art Press, 1987.

Zhongguo Meishu Bao (Chinese Art). Beijing: Central Academy of Fine Arts, 1985–.

Zhongguo, xiandai, meishu (China, Modernity, Art). Taipei: Taipei Fine Arts Museum, 1990.

Zhu Boxuong. "Juelanshe xiaoshi" (A Brief History of the Juelan Association). *Meishujia* 31, pp. 23–25.

Zhu Boxuong and Chen Ruilin. *Zhongguo xihua wushi nian* (Fifty Years of Western Painting in China). Beijing, 1989.

Zhu Pu. *Lin Fengmian*. Shanghai: Shanghai Art Press, 1988.

EXHIBITION CATALOGUES

Against the Tide. New York: Bronx Museum of the Arts, 1997.

Andrews, Julia F., and Gao Minglu. *Fragmented Memory: The Chinese Avant-Garde in Exile*. Columbus: Wexner Center for the Arts, Ohio State University, 1993.

Another Long March: Chinese Conceptual and Installation Art in the Nineties. Breda: Fundament Foundation, 1997.

ArtTaiwan: Biennale di Venezia 1995. Taipei: Taipei Fine Arts Museum, 1995.

Cai Guo Qiang: Flying Dragon in the Heavens. Humlebaek, Denmark: Louisana Museum, 1997.

Cai Guo Qiang: From the Pan-Pacific. Iwaki City: Art Museum, 1994.

Chang Tsong-zung. *Man and Earth: Contemporary Paintings from Taiwan*. Denver: Asian Art Coordinating Council, 1994.

Chang Tsong-zung et al. *Quotation Marks: Contemporary Chinese Paintings*. Singapore: Singapore Art Museum, 1997.

China's New Art, Post-1989. Hong Kong: Hanart T Z Gallery, 1993.

China: Zeitgenössische Malerei. Bonn: Kunstmuseums, 1996.

Chūgoku gendai bijustsu '97/Chinese Contemporary Art 1997. Tokyo: Watari Museum of Contemporary Art, 1997.

Configura 2: Dialog der Kulturen. Erfurt: Configura-Projekt, 1995.

Contemporary Chinese Painting: An Exhibition from the People's Republic of China. San Francisco: Chinese Culture Foundation of San Francisco, 1983.

Des del País del Centre: Avantguardes artístiques xineses. Barcelona: Centre d'Art Santa Mónica, 1995.

Dushi zhongde siran: Renwen yu wuzhi de duehua (Urban Nature: A Dialogue between Humanism and Materialism). Taipei: The Empire Art Educational Foundation, 1994.

The First Academic Exhibition of Chinese Contemporary Art 96–97. Hong Kong: China Oil Painting Gallery Limited, 1996.

Gebrochene Bilder: Junge Kunst aus China. Unkel/Rhein: Horlemann, 1991.

Hong Kong Sixties: Designing Identity/Xiangang liushi niandai. Hong Kong: Hong Kong Arts Centre, 1995.

Hou Hanru and Hans Ulrich Obrist, eds. *Cities on the Move*. Vienna: Secession, 1997.

Huang Hai-ming. *Dis/Continuity: Religion, Shamanism, Nature*. Taipei: Taipei Fine Arts Museum, 1992.

"I Don't Want to Play Cards with Cézanne" and Other Works: Selections from the Chinese "New Wave" and "Avant-Garde" Art of the Eighties. Pasadena: Pacific Asia Museum, 1991.

In & Out: Contemporary Chinese Art from China and Australia. Singapore: Lasalle-SIA College of the Arts, 1997.

In Between Limits. Seoul: Sonje Museum of Contemporary Art, 1997.

Jose, Nicholas, and Yang Wen-i, eds. *ArtTaiwan: The Contemporary Art of Taiwan*. Sydney: Museum of Contemporary Art and G+B Arts International, 1995.

Lu, Victoria. *New Arts, New Tribes: Taiwan Art in the Nineties*. Taipei: Hanart T Z Gallery, 1992.

New Phase Art of Taiwan. Tainan: New Phase Art Space, 1992.

Noth, Jochen, Wolfger Pohlmann, and Kai Reschke, eds. *China's Avant-Garde: Counter-Currents in Art and Culture*. Berlin and Hong Kong: Haus der Kulturen der Welt and Oxford University Press, 1994.

Reckoning with the Past: Contemporary Chinese Painting. Edinburgh: Fruitmarket Gallery, 1996.

Site of Desire: 1998 Taipei Biennial. Taipei: Taipei Fine Arts Museum, 1998.

Six Contemporary Chinese Women Artists. San Francisco: Chinese Culture Foundation of San Francisco, 1991.

The Stars: Ten Years. Hong Kong: Hanart T Z Gallery, 1989.

Taiwan: Kunst Heute. Aachen and Berlin: Ludwig Forum and Haus der Kulturen der Welt, 1996.

Taiwan meishu xinfengmao/Taiwan Art, 1945–1993, ed. Lin Ping. Taipei: Taipei Fine Arts Museum, 1993.

Taiwan: Facing Faces. Taipei: Taipei Fine Arts Museum, 1997.

Three Installations by Xu Bing. Madison: University of Wisconsin, Elvehjem Museum of Art, 1992.

Tracing Taiwan: Contemporary Works on Paper. New York: Drawing Center, 1997.

Turner, Caroline, ed. *Tradition and Change: Contemporary Art of Asia and the Pacific*. St. Lucia: University of Queensland Press, 1993.

Wenda Gu: Dio e i Suoi Figli/God and Children: Italian Division of United Nations, 1993–2000. Milan: Enrico Gariboldi/Arte Contemporanea, 1994.

Zhongguo xiandai yishu zhan / China/Avant-Garde. Beijing: China Art Gallery and Guangxi People's Art Press, 1989.

Acknowledgments

When I first met Vishakha Desai in 1992, she mentioned her desire to organize an exhibition of contemporary Chinese art. Although the rich and prodigious output of artists in Mainland China, Hong Kong, and Taiwan has achieved international recognition in recent years, at the time of my first conversation with Vishakha, Chinese avant-garde art was virtually unknown. I want to begin by thanking Vishakha for perceiving its importance at such an early date, and for offering me the opportunity to speak about it to Western audiences from my perspective as a Chinese critic and curator.

Needless to say, capturing the breadth and complexity of current art production in three distinctive cultures with intertwining histories is a daunting task, and I have relied on the generosity and collaborative spirit of artists, critics, museum staffs, and many others. First, let me thank all of the artists who agreed to participate in the exhibition. In Taiwan and Hong Kong, many artists extended their hospitality and gave of their time to make my visits both productive and comfortable; in Beijing, Wang Mingxian, one of my closest friends, devoted much energy to locating artists and documents, and Wang Gongxin generously provided introductions to artists. In New York, Chou You-rui helped me contact many Taiwanese artists. I am grateful to Victoria Y. Lu in Taiwan, and David Clarke and Chang Tsong-zung in Hong Kong, each of whom provided invaluable research materials and curatorial suggestions, expedited communications with artists, and contributed to the catalogue. Thanks also to Wu Hung, Norman Bryson, Leo Ou-fan Lee, and Hou Hanru for their insightful catalogue essays.

The curatorial teams and staffs at the Asia Society Galleries, the San Francisco Museum of Modern Art, P.S. 1 Contemporary Art Center, and the Asian Art Museum of San Francisco have supported the exhibition with dedication and contributions too numerous to recount here. In particular, Gary Garrels, Colin Mackenzie, and Caron Smith provided much-needed curatorial guidance, for which I extend heartfelt appreciation. Alanna Heiss, director of P.S. 1, graciously facilitated our collaboration. I am indebted to Jane Tai, the Asia Society Galleries' exhibition manager, whose extraordinary efforts underpinned the work of many. Teresa Lai of the Asia Society handled myriad details unflinchingly and kept the records straight. Joseph N. Newland, Kara Kirk, Alexandra Chappell, Susan Chun, and Philomena Mariani compiled and edited a vast amount of material into a sophisticated catalogue, and I am grateful to each of them. Various galleries, including Hanart, Max Protetch, Holly Solomon, and Tuten—longtime supporters of many artists in the exhibition—as well as The Drawing Center provided assistance and information. I want to express my gratitude to all the lenders for generously allowing their works to be shown, many for the first time in the West; to Qian Zhijian and Kao Chien-hui for their assiduous research efforts; to Ma Jian for facilitating studio visits in Hong Kong; to Celeste Terra and Flora Zhang for research and editorial assistance; and to Oscar Ho for advice.

Finally, I thank my parents, who have always supported me spiritually, and Song Jianming and my son Gao Weinan, who have been sympathetic listeners since this project's beginnings.

Gao Minglu
Guest Curator

The organization of *Inside Out: New Chinese Art* has been a unique collaborative partnership, bringing together the talents and experience of a diverse group of artists, curators, critics, and museum professionals. This has been an extremely rewarding experience for me, and I would like to express gratitude for the tremendous efforts of Gao Minglu, who initiated this project and served as its primary curator. I would also like to thank my collaborators at the Asia Society Galleries, Vishakha N. Desai and Colin Mackenzie, as well as Caron Smith, formerly of the Galleries. We are delighted to be presenting a portion of this exhibition at the Asian Art Museum of San Francisco, and I am indebted to Emily J. Sano, director, and Michael Knight, curator of Chinese art, for their early and steadfast interest in uniting our two institutions in this endeavor.

Numerous staff members at the San Francisco Museum of Modern Art played critical roles in the coordination of the *Inside Out* installation at SFMOMA. I would like to acknowledge the particular efforts of Lori Fogarty, deputy director for curatorial affairs; Tina Garfinkel, head registrar; Lorna Campbell, assisstant registrar, exhibitions; Megan Hickey, secretary, Department of Painting and Sculpture; Ruth Keffer, curatorial assistant; Barbara Levine, exhibitions manager; Kent Roberts, installation manager; J. William Shank, chief conservator; Marcelene Trujillo, exhibitions assistant; and Greg Wilson, museum technician.

While primary responsibility for the organization of the exhibition was taken by the Asia Society, SFMOMA was charged with the production of this publication. A book of this scope and complexity could not have been accomplished without the herculean efforts of its editor, Joseph N. Newland, and we are enormously grateful for the enthusiasm and dedication he brought to this undertaking. SFMOMA staff members Kara Kirk, director of publications and graphic design, and Alexandra Chappell, publications assistant, gracefully shepherded this volume through every phase of its creation and earned our sincere gratitude. We are also indebted to numerous colleagues at the Asia Society who contributed their time and energy to this volume, particularly Susan Chun and Colin Mackenzie. Doris Chun expertly translated Victoria Y. Lu's essay. Manuscript revisions were made by Mary Ryan, and intern Delphine Daniels provided editorial assistance.

The design of this publication is the work of Catherine Mills, former SFMOMA director of graphic design and publications. She was assisted in this endeavor by David Betz, and we are especially appreciative of the creativity and patience they brought to this process.

We are delighted to be copublishing this volume with the University of California Press, and we are grateful indeed to James H. Clark, director; Deborah Kirshman, fine arts editor; Sarah Dry, copublications coordinator; and Jennifer Toleikis, editorial assistant, for their enthusiasm for this partnership.

And finally, I would like to express great appreciation to John R. Lane, former director of the San Francisco Museum of Modern Art, who was an early and enthusiastic advocate of this undertaking. David Ross, his successor at the Museum, has also embraced this project wholeheartedly, and offered invaluable support.

Gary Garrels
Elise S. Haas Chief Curator and Curator of Painting and Sculpture
San Francisco Museum of Modern Art

Organizing an exhibition is always a challenging endeavor, as anyone who has ever done it knows. What makes *Inside Out* unusual, however, is the collaborative effort that produced it, involving four institutions and the coordination of as many staffs. I would like to thank Gary Garrels of SFMOMA for his thoughtful input on the content and organization of the exhibition. On the New York side, we are grateful to our colleagues at P.S. 1 Contemporary Art Center. Director Alanna Heiss and her colleagues Klaus Bisenbach, Martin Fritz, Antoine Guerrero, Marian Zialla, and Josette Lamoreux have been exceedingly generous with their time and resources and have shown exceptional flexibility in responding to our installation requests. I would also like to extend my thanks to Dr. Yu Yuh-chao, director of the Chinese Information and Cultural Center

and Ms. Luchia Lee, curator of the Taipei Gallery, for their valuable advice and support of the exhibition and the accompanying programs. Asia Society staff members managed all aspects of the exhibition with their usual diligence, skill, and good humor. My predecessor, Caron Smith, laid the groundwork for the exhibition. Jane Tai, exhibition manager, and Amy McEwen, registrar, assisted by Perry Hu and Teresa Lai, maintained a firm grip on thousands of details. Susan Chun, publications manager, lent her expertise to many aspects of this catalogue and coordinated the production of all other written materials related to the exhibition, while Philomena Mariani, Qian Zhijian, and Kavita Singh sharpened their content. The excellent public programs accompanying the exhibition were organized by Rachel Cooper, Winnie Lee, Sunita Mukhi, and

Linden Chubin, while Nancy Blume and Tom Yu ably handled exhibition tours and docent training. Samantha Hoover and Rayne Madison contributed graphics skills and a clearheaded calm. Administrative support was patiently provided by Mirza Burgos. The Marketing and Public Relations staff—Karen Karp, Susie Park, Hylton Joliffe, Janet Gilman, and Heather Steliga—tackled the difficult task of introducing complex subject matter to the public and the media. Alison Yu and Atteqa Ali have worked tirelessly to raise funds for the exhibition, and Kevin Quigley and Robert Radtke have lent their expertise to position the exhibition within the broader China context.

Wendell Walker should be congratulated for his engaging exhibition design, as should Zack Zannoli for his sensitive lighting. Michael Rock and Penelope Hardy

of 2 x 4 Design produced the striking design for the graphic materials.

I would also like to thank our curatorial advisors, including Tom Sokolowski, director of the Andy Warhol Museum, Professor Jonathan Hay of the Institute of Fine Arts, New York University, and Victoria Y. Lu of Shih Chien University, Taiwan, for their valuable advice on the exhibition.

Finally, we owe a deep debt of gratitude to guest curator Gao Minglu. His good humor in responding to our myriad requests for information about the artists and the art—from the mundane and practical to the most abstruse and philosophical—has never cracked. Gao's passion for contemporary Chinese art has infected all of us at the Asia Society and sustained us at times when we felt that the exhibition would overwhelm us.

Colin Mackenzie
Curator and Assistant Director of the Galleries
Asia Society

Index

Italic page or plate numbers indicate illustrations.